The Theory and Practice of Motion Design
Critical Perspectives and
Professional Practice

The Theory and Practice of Motion Design
Critical Perspectives and Professional Practice

Edited by
R. Brian Stone & Leah Wahlin

Routledge
Taylor & Francis Group

NEW YORK AND LONDON

First published 2018
by Routledge
711 Third Avenue, New York, NY 10017

and by Routledge
2 Park Square, Milton Park, Abingdon, Oxon OX14 4RN

Routledge is an imprint of the Taylor & Francis Group, an informa business

Library of Congress Cataloging in Publication Data

A catalog record for this book has been requested

ISBN: 978-1-138-49079-6 (hbk)
ISBN: 978-1-138-49080-2 (pbk)
ISBN: 978-1-351-03454-8 (ebk)

Typeset in FF Unit and FF Unit Slab, designed by Erik Spiekermann, Christian
Schwartz and Kris Sowersby in 2009.

Edited by R. Brian Stone and Leah Wahlin
Cover design by Meredith Dixon
Interior design by R. Brian Stone
Production by Savannah Storar
Project management by Leah Wahlin
Printed in Canada

CVLTVRED MIND
SKILLFVL HAND

Author Notes & Acknowledgements

The Department of Design resides in one of the oldest and grandest buildings on the campus of The Ohio State University. An inscription over the doors of Hayes Hall reads, "The Cultured Mind The Skillful Hand" and serves as a reminder of the human-centered nature of design. It speaks to the pairing of concept and execution at the heart of effective, compelling, and creative communication. It also places into perspective the need for balance. The education of motion designers as well as the practice of motion design require balance. The full potential of the time-based narratives described in this collection is only fully realized by masterful execution.

As editors and collaborators, we have benefited from the balance of our similarities and offsetting differences. We are educators situated in both academia and professional practice in our own careers. Given his grounding in design, Brian's voice and experience are explicitly represented in the "Introduction" and "Notes from the Classroom," but Leah has shaped the narrative of those chapters and the project as a whole, approaching the work from her background in technical communication and rhetoric.

The Cultured Mind The Skillful Hand also tells us that design is crafted by people for people. Without the assistance, guidance, critique, and support of so many, this project would not have been made possible. Special thanks go out to Dave Bull, Jessica McManus, Brittany Layton, Kate Noel, Chris Brown, Yuanqing Zhao, Melissa Quintanilha, Chris Myers, and the Cooperistas.

R. Brian Stone
I appreciate the ongoing support of my colleagues in the Department of Design at The Ohio State University with particular acknowledgment to Peter Megert, Paul Nini, Peter Chan, and Liz Sanders. It is important to pay tribute to all my teachers who have given me a solid grounding to live by design. Lastly, thank you to Professor Ken Hiebert, author of *Graphic Design Sources*, for introducing me to the idea of moving images in the context of design. It has taken hold of me and I hope that my work as a teacher of motion design does justice to your legacy, your willingness to venture into this realm of motion design.

I have had the good fortune of interacting with students from many parts of the world. With each engagement comes an opportunity to learn and grow. Each student has brought to bear a unique aesthetic and perspective on how motion may be used to communicate, entice, or excite. I have learned as much

from them as they have from me and I thank you all for your efforts to exceed my expectations at every turn.

In parallel I have worked with some remarkable design professionals. They have been extremely generous in sharing their processes and strategies. Some I have collaborated with and others have simply been mentors.

The field is replete with talent, but educators and practitioners often find themselves working in parallel tracks. The impetus for this book was to intersect those tracks—to provide a forum, or, more accurately, a starting point for dialogue between the academia and students that worked across academia and professional practice, intersecting all of these application areas (and the ones we haven't even imagined yet) that will define our work in the coming years.

I wish to dedicate this project to my students, who inspire through their curiosity, energy, and diligence, to my friends, as we laugh and grow in the face of all things, good or bad, and my family, for their unconditional love, encouragement, and nurturing. –Squatchee

Leah Wahlin

I am always glad to work on a project that allows me to step outside of my own disciplinary boundaries, especially one like this that aims to foster broad, complex critical thinking and conversation in its own right.

Special thanks to Graham—one of the supportive and wonderful people around me who make life better, easier, and more fun. I am grateful for my inter-disciplinary existence in the Department of Engineering Education and my stellar colleagues there. To all our authors and contributors—thank you for your wonderful work and your commitment to this project. If you find yourselves in Columbus, give us a call and we'll take you out for pancakes.

To connect with us and to see the works discussed in this book *in motion*, please visit **motionresource.com**.

Table of Contents

Section 6: Educating Motion Designers

Since the real impact of motion design is in the actual experience of viewing and interaction, we have developed a companion web site to connect you to many of the examples described in the text. **www.motionresource.com**

R. Brian Stone
The theory and practice of motion design

Motion Design is both work and play. It is expressive, seductive, and informative. It is akin to the movements of a beautiful dance performance, the gentle patterns of a light rain, or the wispy plume from a candle. It draws its influence from many sources and is an inherently collaborative and transdisciplinary activity. It engages the disciplines of graphic design, animation, cinema, journalism, music, computer science, broadcast media, and mixology. It is an incredibly rich, dynamic, active canvas involving creativity, choreography, and orchestration.

Motion Design is not about knowing how to use software, nor is it the gratuitous flashing graphics that we see on local television for a car dealership or appliance store. It is a creative mindset that enables us to construct multi-dimensional narratives that stimulate the senses, trigger emotion, hold our attention, and enhance understanding.

Motion Design is about the careful and purposeful use of moving images, content, and sound to convey messages. It is thoughtful, delightful, and grounded in human, not technology-centric, principles. Motion Design spans a continuum of application spaces, from the practical to the experimental, and its utilization has taken us to new places.

Motion Design is more than an emergent form of communication. It has permeated a broad range of applications, including brand building and identity design, product interfaces, kinetic data visualizations, TV and film title design, exhibition design, environmental graphics, and dynamic advertisements. It is an expressive and captivating way to reveal change through deliberate use of sequence and time.

This book, *The Theory and Practice of Motion Design: Critical Perspectives and Professional Practice*, is a collection of essays that capture the broad range of thinking that encompasses the field at this moment in time. It brings together an international and diverse range of perspectives from some of the field's leading designers, scholars, and thought leaders. It is not meant to be a comprehensive or exhaustive academic chronicle, but a lively discussion—intended to embrace the evolution, illuminate points of convergence, provoke new ideas, encourage new methods, and establish new partnerships.

So, why is this the time to be talking about motion design? What role does it play in our lives?

A point of convergence

We have a deep-seated reaction to motion. Arguably, it is part of our DNA, our biology—a component of our survival mode as a species. Our eyes continuously search around us, and our attention is most often caught by movements on which we concentrate and interpret. According to Eleanor Gibson's theory of perceptual learning, this likely developed as a survival skill (see Adolph & Kretch, 2015). Humans have the ability to observe objects along a continuous path and interpret that these objects cover and uncover parts of the background against which we see it. We are thus able to distinguish a predator moving in the brush... and, perhaps, we can then avoid being eaten.

Figure 1
Humans have developed the keen ability to distinguish and understand movement.

Motion Design represents a convergence of media, philosophy, and activity. It is the synthesis of visual and animation design principles used to communicate and/or amplify the meaning of messages. This is accomplished by showing dynamic spatial change over time, utilizing the layering of temporal elements such as movement, speed, sound, rhythm, depth, layering, responsiveness, and direction.

Content must be carefully considered in that certain concepts or narratives are better constructed and communicated over time. Content generally exists on a continuum of time dependent—time independent messaging. At one end, static, anchored messages, like a poster, have no requirement of change, and therefore are independent of time. To the other extreme, certain messages may be in a constant state of change such as human and animal locomotion, chemical reactions, weather conditions, or population growth.

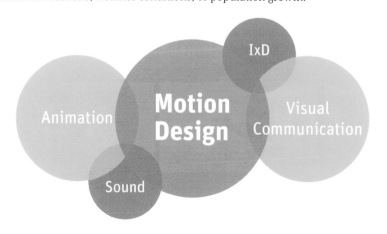

Figure 2
Motion Design is a synthesis of many complementary activities.

Principles and best practices on how we observe, evaluate, and critique work need to be understood and applied from animation, visual communication, and related fields. There are distinct yet important concepts in these areas that require integration as one studies and applies motion design. Motion design has expanded well beyond the purview of graphic designers, filmmakers, and photographers.

Biologist, illustrator, and designer Eleanor Lutz uses motion design from a scientific perspective, showing the intricate nature of biology and animal behaviors. Her motion design enables us to see and understand movements that would never be seen with the naked eye.

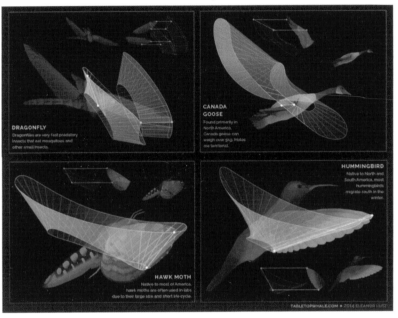

Motion design has permeated the space of television and mobile through refresh screens, interface behaviors, and transitions. For instance, on launch of the Roku streaming TV application, the logotype rotates in an interesting and whimsical way, rather than using a typical page load indicator. To introduce the features of the mobile-based learning app Elevate, the user is guided through 4 screens, which elegantly transition from one to the other. Motion design is purposefully applied in a way that carries forward graphic elements from screen to screen, creating a holistic presentation of the feature set.

Figure 4

The Roku streaming video service startup screen.

Source: Kern, 2013

 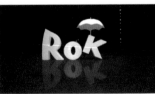

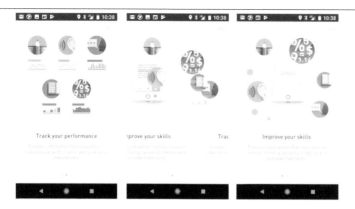

Figure 5
The beautiful transitions of the Elevate cognitive training app guide users through its feature set.

Source: Elevate Labs, 2014.

Motion design is realized in emotive iconography in Facebook's animated reactions. After more than a year in development, this feature made it so users were able to react to a friend's post with something other than a thumbs up gesture. Facebook developed this family that effectively shows a range of emotions by the distinct character of expression and motion aesthetics.

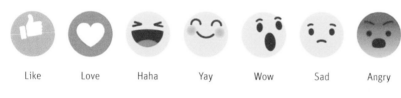

| Like | Love | Haha | Yay | Wow | Sad | Angry |

Figure 6
An extension of the Like button, Facebook's reactions express love, laughter, delight, surprise, sadness, and anger.

Source: WJHL, 2016.

We are no longer constrained to the printed surface. Electronic media has more easily enabled us to craft and distribute kinetic messages. We now have the near ubiquitous screen as an active changing surface. Designers are faced with new communication challenges that not only include what is on the screen, but at what times do elements enter and exit the screen. Words, graphics, objects, elements, and textual components move on and off screen like actors on a stage, all in a sequence of events to tell stories and construct meaning, as seen in this commercial produced by leftchannel for Giant Eagle.

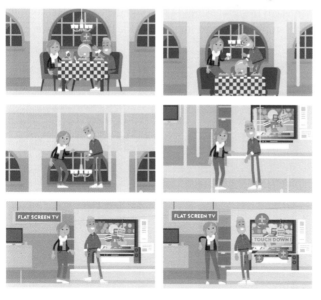

Figure 7
leftchannel created a series of broadcast spots for supermarket chain Giant Eagle using a fun, graphic motion aesthetic to highlight the features of their fuelperks program.

Source: leftchannel, n.d. Copyright by leftchannel. Reproduced with permission.

Yesterday—Looking Back

While this is an exciting time in the evolution and ubiquity of motion design, our fascination with moving images goes much further back. Designers, cinematographers, and photographers have been thinking about motion as a communication strategy for decades. For example, the work of Eadweard Muybridge has been well documented—his studies using multiple cameras to capture the movements of animal locomotion pre-date the flexible perforated film strip. Jon Krasner (2008), in his book entitled *Motion Graphic Design: Applied History and Aesthetics*, lays out a brief history of humankind's depiction of motion through the arts. Early cinematic inventions such as the Thaumatrope and Zoetrope have played a role in how motion communication is constructed and perceived by audiences.

Krasner (2008) discusses several innovators such as Hans Richter, Man Ray, Mary Ellen Bute, and Oskar Fischinger who contributed to our understanding of narrative, form, film, light, and kinetics. Just as notable, graphic designers helped shape the space we now refer to as motion design. The "New" Graphic Design or "neue Grafik" of the late 50s to mid 60s gave rise to a visual language that tested the boundaries of print media and movement.

Even without the technological authoring tools we have at our disposal today, designers and educators of the 50s and 60s understood the power of representation through kinetic means. Swiss designer Peter Megert's poster for an exhibition of kinetic arts experimented with the effect of motion. Entitled "Light and Movement," the poster created the illusion of kinetic activity as people viewed it while walking by. Although working in a static medium, Megert and his contemporaries recognized the captivating power of communicating the idea of movement—the concepts of activity and time. Another influential reference emerged from the work of Peter von Arx in his book, *Film Design*, which provided clear and rational explanations of the fundamentals of motion pictures as they relate to design education and communication. Through the work of their students, von Arx and his colleagues present the dimensions of film and the interwoven complexity of the medium, setting the context for many of the metaphors we use in present day authoring and education.

Figure 8
Peter Megert's "Light and Movement" exhibition poster conveys movement and kinetic energy.

Copyright 1965 by Peter Megert. Reproduced with permission.

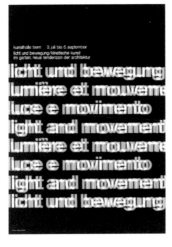

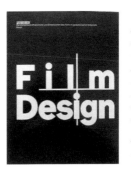

Figure 9
Studies conducted at the AGS Basel, Graduate School of Design produced this seminal book by Peter von Arx on film and design education.

Source: von Arx, 1983.

As time progressed, American graphic designers Richard Greenberg and Saul Bass, who both amassed an impressive catalogue of award-winning motion-picture title sequences (of which several notable examples are discussed in the following chapters), paved the way for many of our contemporary motion designers such as Kyle Cooper, Garcon Yu, and Karin Fong. Their work in main title design gave rise to a new appreciation and awareness for the discipline and continues to be a central touchstone for thinking about the work of motion design.

Tomorrow—Looking Forward

One of the underlying themes in this text is the question of how we can prepare and shape what comes next in the world of motion design. We are witnessing an exponential rise in the application space, now inclusive of interaction design, product interfaces, kinetic data visualizations, brand building, title design, dynamic advertisements, exhibits and environments. Considering its emerging importance in our industry, the time is right to bring together a collection of work that examines how motion design has evolved, what forces define our current understanding and implementation of motion design, and imagine and make real the future of motion design as it unfolds around us.

This collection's essays and interviews approach motion design in two overarching areas of focus—as a set of theoretical questions and a creative professional practice. We intend to encourage deeper dialogue between practitioners and academics, expressed through the voices of both. Through this collection, it is our intent to aid in the discipline's advancement, promote collaboration and exploration, and celebrate the scholarship and broad range of professional activity in the space of Motion Design, as it was, as it is now, and as it hopes to be in the future.

For those working in academia, there are a lot of important questions being asked and theoretical frameworks being developed around the principles of motion design. These principles are being explored, examined and developed from several points of orientation. However, at times, academia provides limited opportunities to actually synthesize or apply those theories, reach a large segment of end users, and evaluate the outcomes over time. On the other hand, in professional practice, innovative uses of motion design are reaching broad audiences behind a push to produce work and learn on the go. In this case, though, the insights gained via this design process are not easily shared between companies or agencies, and the reason for the design decisions may be dictated by instinct and expedience, not necessarily a defined theoretical framework.

To be clear, there is nothing inherently wrong with approaching motion design through the lens theory or in professional practice; there are simply very real and reasonable limitations in the purview of each perspective. With this collection, however, we see a great opportunity to facilitate dialogue that aims to advance and illuminate motion design for those who work in both spheres. It is also important to note that the voices of educators and practitioners are not siloed in the book—the chapters are organized not by rigid interpretation

of role or career path into the two camps, but thematically as we attempt to highlight the cross-sections of shared interests in the theory and practice of motion design. We also recognize that many contributors to this book do not belong solely to one camp or the other, but, like us, find themselves working in both spheres at different times.

Part 1: Theoretical Perspectives, our contributors explore underlying ideas of motion design—its position in the design world, the science behind how we perceive and respond to motion, and its opportunities for growth as an intellectual discipline.

Section 1: Interdisciplinary Influences and Origins discusses the theory and practice of motion design as an amalgamation of activities emanating from art, cinema, experimental filmmaking, narratology, animation, design, and technological developments. This multitude of perspectives make it exciting and intriguing, but also challenging to teach and discuss. Dan Boyarski offers a historical perspective of typography's connection to motion design, complemented by Dr. Clarisa E. Carubin's discussion on the evolution of motion design through its definitions and scope. Camila Afanador-Llach and Jennifer Bernstein look at the interdisciplinary nature of motion design through the lens of teaching.

Section 2: Communication Theory takes on the challenge of developing new theories around how to communicate messages and structure narrative or experiences in the context of time-based, non-linear forms with dimensions of sound, text, and movement. Bruno Ribeiro, Michael Betancourt, and Spencer Barnes look at ways people craft narratives using motion and the ways in which meaning (connotative and denotative) is created in the context of motion design.

Section 3: Science and Perception explores issues around cognition and visual perception as it relates to reading and consuming moving messages. Elaine Froehlich and Daniel Alenquer discuss the science of perception from a biological and psychological perspective.

Part 2: Practice & Application, turns our focus to the "on-the-ground" experiences and perspectives of people actively working in motion design, or applying it through research. In this realm, motion is evolving to meet the needs of consumers and clients in exciting ways, and these chapters will offer a glimpse into the thought processes, strategies, and ideas that are bringing motion design to our eyes and fingertips every day.

Section 1: Brand Building and Identities illuminates the evolution of visual identity systems from static to kinetic forms. One could argue that most people today get exposure to brand identities through screen based applications. Jakob Trollbäck, David Peacock, Guy Wolstenholme, and Jon Hewitt describe this transition as a proactive means to communication the value, narrative, and attributes of brand identity and brand promise.

Section 2: Interface and Interaction Design acknowledges the role that motion plays in communicating the behaviors and semantics of responsive

systems. Jeff Arnold discusses how motion aids in establishing a language of interaction. Gretchen Rinnert, Aoife Mooney, and Marianne Martens describe motion design as a collaborative activity in their development of a letterform-focused iPad app for children, while Andre Murnieks provides a glimpse into the future with a speculative project centered on responsive motion to voice activation.

Section 3: Narrative and Storytelling provides insight to how motion is applied in a sequence of events to reveal meaning, foreshadow stories, establish context, or present transformative narratives. Kyle Cooper and Karin Fong share with us their inspirations and processes for designing vivid, captivating, and iconic main titles. Adam Osgood describes a changing landscape for illustrators and examines the burgeoning role of and opportunities for animated illustration as part of modern digital narratives.

Section 4: Space and Environments provides a framework for the use of motion design in the context of small and large scale exhibitions. Supported with several concrete examples, Cotter Christian and Catherine Normoyle look at the multitude of motion design variables that impact one's perception of context and place. Christina Lyons provides a complementary narrative on motion as a key component in crafting interactive, personalized exhibition experiences for different audience profiles.

Section 5: Experimental Visualizations and New Applications features examples of works and ideas that explore the use of motion for purposes of discovery, provocation, insight, or expression. Steven Hoskins shares his explorations with split screen composition; Matt Pasternack shows the use of motion and story to describe a complex product ecosystem. Isabel Meirelles discusses the synthesis of information design and motion design as a means to translate data into visual forms that aid in deep understanding.

Section 6: Educating Motion Designers is a dynamic and evolving area that benefits from the input of both professional educators and practitioners. It is in our collective interest that we share best teaching practices with our colleagues while leveraging the lessons learned in the field. I provide an overview of my years in the field and a discussion of my teaching philosophy, looking at how motion design education has and should continue to evolve. Heather Shaw offers an approach to teaching that utilizes graphic notation. This leads us into a threaded conversation of reflections and advice from notable motion design practitioners Kyle Cooper, Daniel Alenquer, Karin Fong, Guy Wolstenholme, Jon Hewitt, Isabel Meirelles, and Jakob Trollbäck. They share with us their vision, expectations, and points of motivation with particular emphasis on advising students.

We believe a strength of this collection is its ability to give voice to a range of perspectives and areas of expertise. We hope *The Theory and Practice of Motion Design: Critical Perspectives and Professional Practice* will help shape the thinking and work of educators, students, and practitioners, along with those who interact with motion designers, commissioning or responding to their work. Visual communication and product designers, cinematographers,

interaction designers, marketers and consumers of moving images will all benefit from a deeper understanding of motion design.

R. Brian Stone, Associate Professor, The Ohio State University

References

Adolph, K. E. & Kretch K. S. (2015) Gibson's theory of perceptual learning. *International Encyclopedia of the Social & Behavioral Sciences, 10,* 127-134. Retrieved from http://www.psych.nyu.edu/adolph/publications/AdolphKretch-inpress-GibsonTheory.pdf

Elevate, Inc.. (2018). Elevate – Brain Training (Version 5.4) [Mobile application software]. Retrieved from https://itunes.apple.com/us/app/elevate-brain-training/id875063456?mt=8

Kern, M. (2013). *Roku bootup animation* [Video]. Retrieved from https://www.youtube.com/watch?v=4pGqCLYA6aQ

Krasner, J. (2008). *Motion graphic design: Applied history and aesthetics* (2nd ed.). Boston: Focal Press.

leftchannel. (n.d.) *Giant Eagle fuel perks* [Video]. Retrieved from http://leftchannel.com/motion-graphics-and-animation-work/giant-eagle-fuel-perks/

von Arx, P. (1983). *Film design: Peter von Arx explaining, designing with and applying the elementary phenomena and dimensions of film in design education at the AGS Basel School of Design.* New York: Van Nostrand Reinhold.

WJHL. (2016). *New Facebook emoticons* [Video]. Retrieved from https://www.youtube.com/watch?v=wFU1XmqIMIg

Theoretical Perspectives

Section 1

Interdisciplinary Influences and Origins

"Motion is an abstract language with the potential of being understood across cultures, so it follows that type in motion may point to a form of communication without boundaries. How that form evolves remains to be seen."

Dan Boyarski
Liberating Words from the Printed Page

It is known by different names—type in motion, motion graphics, kinetic typography, moving letters, and so on. What the names describe is a computer or movie screen filled with type that moves around, letterforms that morph, or words that appear and disappear to a musical beat. On the quieter side, there are measured sequences of words that tell a story, give instructions, or reveal a poem in silence. Examples today abound in film titles, music videos, television advertisements, web sites, apps, and information/service kiosks.

What is common to these examples is typography that doesn't stand still. In contrast to static or fixed type in printed matter, where ink is married to paper, type that relies on time as a design element produces dynamic form that is synonymous with new media, movies, and computers. These forms, shaped by time and motion, are often compared to performances of dance, music, and theater. There has never been a time when this much attention has been paid to type in motion. We have books and articles on the subject, courses of study, design firms specializing in motion graphics, and conferences and exhibitions devoted to showing and understanding this work. Motion is an abstract language with the potential of being understood across cultures, so it follows that type in motion may point to a form of communication without boundaries. How that form evolves remains to be seen.

While we celebrate type in motion today, with easy access on our screens, it is instructive to look back over history to understand our fascination with motion and our attempts to capture and replicate it. Some of the earliest marks made by Western man in caves located in France and Spain attempt to depict hunts in progress. Hunters chase a large animal, shooting arrows at it, a scene forever frozen in time. Life is motion and artists over history have attempted to portray events in life, often by capturing a moment or a movement in time. The results have been paintings and sculptures, stories and dances, and more recently, photographs and films. In a 1956 *Paris Review* interview, the writer William Faulkner observed, "The aim of every artist is to arrest motion, which is life, by artificial means and hold it fixed so that a hundred years later, when a stranger looks at it, it moves again since it is life" (Stein, 1956).

Dynamic typography precedents
Graphic designers have a rich legacy of book design to build upon. Long before the advent of the moving picture (movies) in 1895, there were occasional attempts at giving life to type in print. A delightful example is Lewis Carroll's contribution, in his 1865 book *Alice's Adventures in Wonderland*, to visualize

"The Mouse's Tale" which sets words in the shape of a mouse's tail. This 19th century "example of the use of typographic form to reflect the subject of the text" (Spencer, 1983, p. 12) is exploited by Guillaume Apollinaire fifty years later in France with his *Calligrammes* (visual poetry), explorations in creating pictures with typographic arrangements. Setting type in prescribed shapes was not new; early handset books in Europe, for example, sometimes set the colophon, at the end of the book, in a particular shape, more for visual effect than semantic rationale. But in Carroll's "The Mouse's Tale," word and image are one, a unique fusion of the verbal and visual (Figure 1).

The Futurists and Dadaists in the early decades of 20th century Europe wrestled with typography in ways that challenged the vertical and horizontal strictures of the printed page. They used type to visually suggest sound and motion, as in Lucio Venna's 1917 piece, "Circo Equestre." Here, dynamic composition captures the liveliness of a one-ring circus, complete with words like "Silenzio!" and "Braa.....voooooo!" that are yelled out by the ringmaster and the crowd. Type becomes image, and we are given the chance to see and hear the excitement of the event (Figure 2).

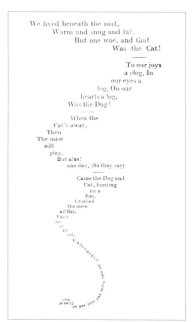

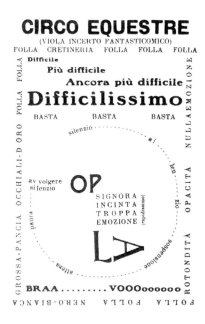

Figure 1, 2
"The Mouse's Tale" from Alice's Adventures in Wonderland *by Lewis Carroll (1865). (left)*

Source: Spencer, 1983, p. 12.

"Circo Equestre" by Lucio Venna (1917). (right)

Source: Spencer, 1983, p. 23.

Another classic example is Apollinaire's 1916 "Il Pleut/It's Raining" (Figure 3), which draws diagonal lines of rain with words. Drawing pictures with type, sometimes referred to as concrete poetry, was but one avenue in this rebellion against typographic convention; other avenues included dynamic page compositions that featured a range of typefaces, sizes, weights, and arrangements. As the century progressed, other designers and artists, such as Malevich, Lissitzky, Zwart, and Tschichold, continued this assault on convention with their dynamic, expressive, and asymmetrical typography.

Figure 3
*"Il Pleut/It's Raining"
by Guillaume
Apollinaire (1916).*

*Source: Spencer,
1983, p. 19.*

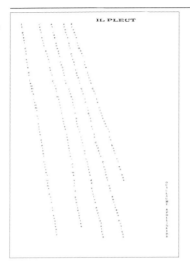

Massin's *The Bald Soprano* in 1964—a book that re-presents Eugene Ionesco's
absurdist play in printed words and images—raises dynamic typography to
a new level. Massin's visually rich rendering of the spoken word allows the
reader to hear different actors speak their lines in a far more engaging and
faithful manner than conventional type ever could (Figure 4). It is sobering
to appreciate the fact that this dynamic typography was achieved long before
computers arrived on the scene to help "manipulate" type. The lesson here
is that the tool is ultimately less important than the idea. True, while today's
computers and software afford us a playground for broad exploration, that
exploration has to be driven by an idea, often a desire to try something new,
unconventional, and even absurd. The marriage of new thinking with new
technologies has long been part of our history.

Figure 4
*Massin's
visualization of
Ionesco's play*
The Bald Soprano.

*Source: Ionesco,
1964*

How it started for me

As a graphic designer educated in the United States in the mid-1960s, I learned about typography, photography, illustration, and the thoughtful and skillful arrangement of those elements on single or multiple pages. These were formal, aesthetically-driven considerations, with occasional technical questions when we dealt with pre-press and printing issues. We never discussed time as an element for consideration, except in the context of deadlines. While in school, my heroes consisted of graphic designers like Glaser and Rand, photographers like Avedon and Penn, illustrators like Saul Steinberg, Folon, and the San Francisco psychedelic poster artists, musicians like the Beatles, Dylan, and Reich, and film directors like Fellini, Bergman, Ray, and Kurosawa. They all fed my visual and cultural education, the effects of which would not be felt for a decade or more.

Like most everyone, I grew up watching movies, both live action and animated, which I loved. Time as a design element became relevant when I began experimenting with a 16-mm movie camera and basic animation in graduate school in the early 1970s. I delighted in manipulating countless individual images, each with a minor change, and viewing them at 24 frames a second to produce the illusion of movement. Moving shapes, colors, and textures fascinated me, as did resulting patterns and rhythms. I discovered that I could work with time as a design element, one that I could control with as much precision as needed to produce the desired visual effect. 24 frames a second became the grid for decisions on speed, pacing, rhythm, and duration of elements on the screen. To quote a student I taught many years later, "I now appreciate how long and how short a second really is." My heroes then were experimental filmmakers like Sharits, Emschwiller, Brackage, and especially McLaren.

Norman McLaren, an animator at the National Film Board of Canada, produced visually stunning and technically challenging short films during his 46 years at the Film Board, from 1941 to 1987. A unique technique of his was to work directly on clear film strips, by painting or scratching with a variety of paints and tools, allowing him to bypass the camera entirely. By projecting the resulting sequences, he created pure film motion—animated painting in the purest sense. This avenue of exploration into often abstract film animation has today been eclipsed by the more commercially lucrative animated stories of the Disney and Pixar kind. Thankfully, there has always existed a fringe element of experimental animators pushing the boundaries of the medium and ever-evolving technology.

As a grad student, I emulated McLaren's way of working by applying strips of Letraset dots directly on clear 16mm film. Like McLaren, I didn't know what the resulting film would look like until projecting it. A love of experimentation drove me to continue trying out different patterns of dots, combinations of dots, and even dots on the sound track, another McLaren trick of producing hand-made sound.

Kinetic typography

Fast-forward to 1994, when I was preparing an assignment for an Advanced Typography course at Carnegie Mellon. I realized that I was limiting students to type on paper, not unlike the way I was taught thirty years before. I wondered why I wasn't dealing with type in new formats and environments—for example, type that moved, similar to what we see in movies, on television, and computer screens. Why not liberate type from the page and give it motion and life? I also had in hand an early version of MacroMind Director, so I came up with a project that tasked the students to visualize spoken words in a dynamic way, making use of this new software. The results were stunning!

These early examples fell into two categories. One group used time to sequence the appearance of words or phrases in meaningful ways, while the other used time to animate words and move them across the screen. The key factor in all of them was the control available in making a word, phrase, or punctuation appear *precisely* when the designer wanted the viewer to see them. Each method produced videos that communicated ideas and feelings in ways unique to the time-based medium of computers. When comparing the differences between paper-based and computer-based communication, it became clear that the former dealt with the presentation of words on a page, words fixed in position, never changing. The latter dealt with a controlled presentation of words, based more closely on the spoken word than the printed word.

Visually interpreting spoken word is similar to live performance. Students start the project by reading their words out loud, listening carefully to their speed, volume, and pacing, then visually notating the written text. This notated text becomes the basis for early storyboards of how the live reading sounded. These may be done by hand or with Adobe Illustrator to produce "mood frames" prior to executing the final dynamic sequence on computer.

Figure 5
Student project samples from "Visual Voice."

(left to right) Copyright 1999 by Hyunjung Kim. Copyright 2011 by Anne Brodie. Copyright 1998 by Michael Maeder. Reproduced with permission.

The visual representation of how words sound when spoken aloud is at the heart of kinetic typography, as I have taught it over 22 years. Yes, there are many examples of moving type on screens— film titles (artofthetitle.com), music videos, personal explorations online—and I admire many of them for their ideas and artistry, while others tend towards meaningless and gratuitous motion. But what truly intrigues me is this representation of spoken word and the emotional response from an audience. Having heard comments over the years from those truly engaged when watching some of these videos—they laughed, they teared up—led me to question if words presented in a time-based manner could truly affect people on an emotional level. My conclusion

is yes, they can when 1) the words are well written, often in a monologue or dialogue format, and 2) they are presented in a manner that resembles the delivery, pacing, and nuance of spoken words. Giving visual voice to these words suggests that we hear with our eyes, a reference to Shakespeare's *A Midsummer Night's Dream* in which Bottom speaks of (paraphrasing) "man's eyes hearing, and man's ears seeing." Here we have words in visual performance, not unlike a stage or film performance. Time as a design element is common to stage, dance, and film productions. In fact, controlling and manipulating time is at the heart of live performance, and kinetic typography is but one form of live performance.

Inspired by stage performance, I tell my students that their words on screen are like actors on stage. Each letter or word or graphic element is an actor that needs direction on its entrance, performance, and exit. For example, a word makes its entrance with a slow fade, taking about two seconds. Its performance is to remain in place, vibrating slightly, for about three seconds. And its exit is again a slow fade, this time taking close to four seconds. The word/actor is given direction which produces behavior and personality. Each actor needs to be designed as part of a complete performance, much like a director working with actors or a choreographer working with dancers in shaping a whole and unified performance. Every year, I continue to be surprised, delighted, and moved by my students' work and I know there remains much to be explored in this rich area of communication design.

Figure 6, 7, 8, 9
Giving visual voice to a passage from Jack Kerouac's On The Road.

Copyright 2000 by Jim Kenney. Reproduced with permission.

Time-based information design

Not all time-based pieces can or should be related to the spoken word. Some pieces are information-based, not performance-based, and these have to be treated differently. These information-rich pieces take advantage of presenting information in a dynamic, time-based manner. Time is a key element and, like most narratives, involves a sequence of facts/events with a beginning, middle, and end. Organizing information in a logical and clear sequence is a valuable exercise for a design student. Considering the audience you wish to reach and the goals for your piece, you proceed to design a clear and compelling sequence of word, image, and sound.

Explaining a simple fact is a good introductory project. Take one fact and explain it in 15 or 30 seconds. These constraints remind me of basic typography projects where the typeface, point size, and weight are all prescribed (only one of each), along with format size and color (black and white). From strict constraints emerge many ideas, some good, some weak, and some brilliant. When creating an explanatory video, when to use words? When to use an image in place of words? What is the communicative value of color, texture, and symbols? What does sound, not necessarily music, add to the rhetorical mix? And how does motion add to clarifying information—its content, structure, details, and navigation?

My favorite project in this genre is called Visualizing Information Space. I give each student a different artifact—a book, magazine, web site, or a film—and ask that they thoroughly familiarize themselves with its content and structure. I encourage them to begin visualizing the content and structure on large sheets of paper using lists, mind maps, diagrams, doodles—any method or technique that begins to explain the complexity and richness of content and structure. I stress new ways of visualizing, because it is easy to rely on a handful of software tools that generate flow diagrams or tree structures. My problem with these tools is that the results generally all look alike, with very little to distinguish one from the other. Their generic graphic language often hides the truth and complexity of the information.

As the project evolves, the paper visualizations are translated into dynamic time-based pieces on computer. The translation of "flat maps" on paper to a time-based narrative interests me. There are some analog map conventions that transfer to digital representations, such as spatial relationships, the use of symbols, color, and type. But I challenge the students to explore the unique qualities and potential of time-based media, with word, image, sound, and motion at their disposal. The results over the years have been illuminating. This is more than graphic design migrating to a dynamic screen, although it may be instructive to list long-held principles of page/map/diagram design and ask how many still pertain to this new digital environment. It is important for design students to appreciate the potential of time-based information design—presenting information over a given span of time. Does the sequence clarify the information? Does it help the viewer create their own mental model of the information space? Is it engaging? We can become experts in time-based communication as we have been experts in printed communication.

Figure 10
Zooming in and out of information space.

Copyright 1995 by Michael Lemme. Reproduced with permission.

We are learning to appreciate time-based conventions familiar to filmmakers, stage directors, and choreographers. Issues of spatial design in all three dimensions—x, y, and z (too often forgotten by graphic designers)—are critical to expanding our visual vocabulary beyond a two-dimensional page.

Shifts in scale, focus, lighting, color, and motion can all work in concert to convey information in compelling and accessible ways. Working with time to carefully sequence the display of information affords us control over what our audience sees when we want them to see it. It is specifically this issue of control that distinguishes print from digital information design. Even the best graphic designers realize that their best page or poster designs, with clear hierarchy supported by accessible typography, do not ensure that all readers will read the page as planned.

Dynamic interfaces

A connection between kinetic typography and interface design makes sense when one considers interface elements as comparable to typographic elements on screen. In other words, the semantic and syntactic considerations given to words on screen, as in kinetic typography, should be given to dynamic interface elements as well. Issues of visual representation, behavior, and transition are worthy of serious exploration beyond conventional graphical user interfaces (GUI) established with personal computers in the early 1980s, from the Xerox Star to the early Macintosh. In a relatively short period of time, we saw an increase in dynamic elements on screens, primarily icons that one clicked on and dragged to another icon to execute a command. That was certainly a lot simpler than memorizing and typing strings of code to execute the same command. At the time, the primary challenges to interface designers were screen size (real estate), low screen resolution, and the computer's processing speed.

Resolution and processing speed improved markedly over the decades, while real estate continues to challenge us today with multiple screen sizes and responsive layouts. The proliferation of apps on smartphones has raised the ante on dynamic interfaces. Motion as communication, not decoration, has given new emphasis to clarifying information and navigation on screens. A recent paper by Rebecca Ussai (2015)—*The Principles of UX Choreography*—makes a case for considering Disney's early principles of motion as inspiration when designing apps. She points out, "The most fluid, delightful, and intuitive experiences were always the ones that put detail into motion design." And the detail she refers to tends towards more realistic and believable motion, which helps breathe life into abstract and inanimate objects on screen.

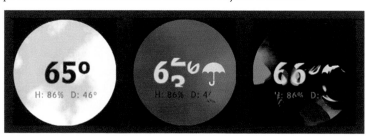

Learning lessons from our kinetic typography and time-based communication explorations over the past two decades, here are three principles that continue to guide our thinking about data visualization and dynamic interfaces.

1. Sequence. When presenting a large amount of data online, such as the contents of a major museum or a patient's health history, consider a sequenced revelation of data, rather than overwhelming with all the data at once. With appropriate chunking of content and a sequenced revelation of its parts, a user may begin to grasp the content's structure. Spatial relationships of data chunks may be introduced and clarified with meaningful sequence. Navigational opportunities may likewise be introduced (possibly in z-space?); the goal being to help users create a mental map of the information landscape they are about to traverse. Figure 10 is a good example of using z-space.

2. Macro/micro. Any good map provides two views of the information landscape: a big picture (macro) view and close-up (micro) views of specific areas. These views allow us to seamlessly move back and forth as we familiarize ourselves with the map and make decisions about where to go. Similarly, a good interface always has available both macro and micro views of the data. People will explore the information landscape in different and personal ways, attempting to make sense of it. Offering them the chance to zoom in and out of the data helps them understand and personalize the information space. Access to these multiple views should be clear, logical, and easy to navigate. Avoid dramatic changes in the way information is presented as the views shift; instead, consider meaningful transitions that help orient the viewer at any point in the landscape.

3. Transitions. Transitions between macro and micro views, or transitions between states or modes of interface elements, should be meaningful. As mentioned above, avoid making drastic changes to the information view. Most current web interfaces are still paper-based, with flat "pages" of text and graphics. Click on a linked word, and the old page disappears, replaced by a new page. The transition is often abrupt, much like a cut in film editing. Rarely do we see transitions comparable to a fade or a zoom in film, which adds not only grace to the shift in state, but allows for a sequenced appearance of new data, which can be cognitively meaningful.

Whereas a page from a book presents information simultaneously to the reader, who then has to make sense of it all with the help of good typography (we trust!), a screen of data does not have to behave like a paper page at all. We have the opportunity to sequence what the viewer sees, and in doing so, help them make sense of the data more quickly than if it were presented on paper. There is much to be studied here, and more user research would be helpful.

Reading on screen, in its broadest definition, is still not fully understood, and as a result, we rely too readily on print conventions for a medium that is unlike the printed page. We are still in the midst of a transition from book culture—static, linear, physical—to a digital culture—dynamic, non-linear, virtual, and interactive. In doing so, we borrow conventions from book culture

that are familiar, but not always applicable to the digital environment. It is our responsibility as dynamic information designers to be inventive stage directors, choreographers, and sound designers, as we shape information for display on screens of various sizes, for use in various situations, by people with various needs and desires.

 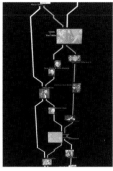

Conclusion

Communication design has emerged from graphic design with a broader definition of problem spaces to tackle and new technologies to explore. The printed page is joined by exhibition spaces, interactive apps, wearable digital devices, and assistive robots—all with communication as a goal. We have seen the introduction of courses that deal with web design, motion graphics, code and form, dynamic information design, and virtual spaces. Team work is as prevalent as solo work. Interdisciplinary collaboration and user research shape our design process. We are designing systems, services, and environments, with the goal of human engagement and response.

But it ultimately comes down to the human element that drives the work we do—the work of connecting people with each other through communication artifacts, many of them digital, that we carefully shape. With time as a critical design element, we have the opportunity to reconsider print and book conventions that have guided our thinking over the past five centuries and develop new attitudes and skills that shape content into performances and experiences that engage, inform, and delight. How we meet that challenge remains to be seen, but I trust we—practicing designers, students, and faculty—will do so bravely, creatively, and responsibly.

Postscript

The new book demands new writers!
El Lissitzky, 1923

Daniel Boyarski, Professor Emeritus, School of Design, Carnegie Mellon University

Concepts around kinetic typography developed over many years and some parts of this chapter were previously presented in other papers.

"Type in Motion", TypoJanchi exhibition catalog, edited by Ahn, Sang-Soo, Seoul Art Center Design Gallery, Seoul, South Korea, 2001

"Designing with Time: A Personal Reflection", lecture and paper, Proceedings of the International Design Cultural Conference, Seoul National University, Seoul, South Korea, 2003

"Kinetic Typography: A New Direction for Communication Design" lecture and paper, Arizona State University, Institute of Design & Arts, Tempe, Arizona, 2004

References

Ionesco, E. (1964). *The bald soprano. Typographical interpretations by Massin.* New York: Grove Press.

Spencer, H. (1983). *Pioneers of modern typography.* Cambridge: MIT Press.

Stein, J. (1956). William Faulkner, The Art of Fiction No. 12. *The Paris Review, Issue 12.* Retrieved from https://www.theparisreview.org/interviews/4954/william-faulkner-the-art-of-fiction-no-12-william-faulkner

Ussai, R. (2015). *The principles of UX choreography.* Retrieved from https://medium.freecodecamp.org/the-principles-of-ux-choreography-69c91c2cbc2a

Clarisa E. Carubin

The Evolution of the Motion Graphic Design Discipline Seen Through Its Definitions Over Time

This chapter traces the evolution of the motion graphic design discipline through its definition. The intention of this review is to inform and benefit readers, motion graphic design professionals, educators, theorists, and students, to delineate and better understand the scope and objectives and to help to build a body of knowledge of the motion graphic design discipline.

The following study identifies and analyzes the existence of various terms defining the discipline through time. Definitions of this emerging discipline are given by different authors and motion graphic designers and are found in literature reviews of texts, journals, and papers. These definitions are arranged in chronological order to better visualize the evolution of the term as well as the limits and scope of the discipline.

The definition of motion graphic design is one that reveals the history of a discipline that was born in the animation studios (Halas & Manvell, 1962). The discipline grew and was self-defined as a field that takes roots in the elements of graphic design (Woolman, 2004; Sandhaus, 2006; Crook & Beare, 2016) and also in the convergence of other disciplines (Herdeg & Halas, 1967; Halas & Manvell, 1970; Halas, 1984; Goux & Houff, 2003; Woolman, 2004; Kubasiewicz, 2005; Sandhaus, 2006; Krasner, 2008; Betancourt, 2013).

The literature review from searches of texts, journals, and research papers found the definitions of the discipline provided by different authors as well as the evolution of the term observed over time.

Evolution of motion graphic design on a timeline
This timeline shows all definitions of motion graphic design found, covering more than 50 years of the discipline.

Film & TV graphics ⊙

1967

Herdeg and Halas (1967)
Film & TV Graphics

Definition: Both graphic design and film arts have substantially contributed in their own ways to the visual revolution which is taking place in our lifetime. The discovery of motion pictures was inevitable. It followed the discovery of photography and the Introduction of electricity, a marriage of the two providing for the essential element of movement, which in turn provided for an incredible extension of visual horizons. (Herdeg & Halas, 1967, p. 8)

Term to define the discipline:
Film and TV graphics

Film & TV graphics ⊙

1976

Herdeg (1976)
Film & TV Graphics 2

Identifies four basic periods since the invention of moving pictures in the development of film and television graphics:
1. The discovery of the technique of continuous projection of images in terms of frame-by-frame animation
2. Dedicated to improving the technical potential of the frame-by-frame animation
3. It arises from the need to expand the graphic style and subtract it from the natural movement and photorealism
4. The digital and electronic revolution

1999

Bellantoni and Woolman (1999)
Type in Motion

Definition: Identify four areas vaguely related attempting to give form to this new discipline, time-based typography, kinetic typography, dimensional typography, and motion graphics. (Bellantoni & Woolman, 1999, p. 9)

Terms to define the discipline:
Motion graphics
Type in motion

Motion graphics ⊙ **Motion graphics** ⊙

2001

Curtis (2001)
Flash Web Design: The Art of Motion Graphics

Definition: Similarly, in motion graphics, the motion can be more important and have more impact than the graphic element being moved. The way you choose to move or not to move an element across the screen can enhance the meaning of that element greatly. (Curtis, 2001, p. 4)

Term to define the discipline:
Motion graphics

Curran (2001)
Motion Graphics

Definition: Motion graphics is a term used to describe a broad range of solutions that graphic design professionals employ for creating a dynamic and effective communication design for film, television, and the Internet. (Curran, 2001, p. 3)

Term to define the discipline:
Motion graphics

Audiovisual design ⊙

2003

Ràfols & Colomer (2003)
Diseño Audiovisual

Definition: A form of instrumental communication, with a functional character, but without autonomy. (Ràfols & Colomer, 2013, p. 11)

Term to define the discipline:
Audiovisual design

Goux and Houff (2003)
>On Screen >In Time

Definition: Within this relatively new field, diverse disciplines converge to yield a variety of applications. Part advertising, entertainment, animation, videography, cinematography, editing, packaging, storytelling, art and craft, this medium may best be described, simply, as design of the moment. (Goux & Houff, 2003, p. 13)

Terms to define the discipline:
Motion graphic design
Motion graphics

1962 ⊙ **Design in motion**

Halas and Manvell (1962)
Design in Motion

Definition: The simplest form of animation is a succession of static images that relate to each other in design and take up their positions on the screen in a sequence the significance of which is determined by some other factors for example, the animated credit-titles of a film, or certain kinds of cinema or television commercial. (Halas & Manvell, 1962, p. 13)

Term to define the discipline:
Design in motion

1970 ⊙ **Mobile graphics**

Halas and Manvell (1970)
Art in Movement

Definition: Animation is at its purest in the art of mobile graphics. (Halas & Manvell, 1970, p. 7)

Term to define the discipline:
Mobile graphics

1984 ⊙

Halas (1984)
Graphics in Motion

Definition: He approaches the definition of motion graphic design through its object of study when he lists the essential requirements that a designer specialized in this discipline must have.

Terms to define the discipline:
Design in motion
Design in movement
Graphics in motion
Motion graphics

2000 ⊙ **Typographic animation**

Woolman and Bellantoni (2000)
Moving Type

Definition: Spatio-temporal typography is kinetic, the characters move, the reader's eye follow. It is ephemeral. The experience is fleeting. Nothing is left when it is over, except an impression. These events are, for the most part, intangible, as they exist in the virtual world of the computer monitor, video screen, or cinematic projection. (Woolman & Bellantoni, 2000, p. 6)

Term to define the discipline:
Typographic animation

2002 ⊙ **Motion**

Heller and Fernandes (2002)
Becoming a Graphic Designer

Definition: Motion is the umbrella term for a discipline practiced by designers who create movement on either silver or cathode ray screens. (Heller & Fernandes, 2002, p. 184)

Term to define the discipline:
Motion

Figure 1

Timeline of motion graphic design according to the evolution of its definition and scope.

Copyright 2017 by Clarisa E. Carubin.

2004

Motion graphic design

Motion design ⊙

2005

Kubasiewicz (2005)
Motion Literacy

Definition: Communication through motion involves issues of both "what" is moving through the screen, such as typographical, pictorial or abstract elements; and "how" that something is moving. The "how" question refers to the kinetic form and its grammar (Kubasiewicz, 2005, p. 181)

Term to define the discipline:
Motion design

Woolman (2004)
Motion Design

Definition: Motion graphic design is not a single discipline. It is a convergence of animation, illustration, graphic design, narrative filmmaking, sculpture, and architecture, to name only a few. (Woolman, 2004, p. 6)

Term to define the discipline:
Motion graphic design

2006

Motion graphics ⊙

Drate et al. (2006)
Motion by Design

Definition: Today this concept has evolved though a convergence of graphic design and film technology into a whole new form of storytelling. (Drate et al., 2006, p. 9)

Term to define the discipline:
Motion graphics

2006

Soar y Hall
Images Over Time

The definitions of motion graphics are many and varied and the term itself seems to be losing ground to motion and motion design (Soar & Hall, 2006, p. 30)

Terms to define the discipline:
Motion graphics
Motion
Motion design

Motion graphics

Sandhaus (2006)
Los Angeles In Motion: A Beginner's Guide From Yesterday To Tomorrow"

Definition: Motion graphics is the contemporary term used to describe a broad field of design and production that embraces type and imagery for film, video, and digital media including animation, visual effects, films titles, television graphics, commercials, multi-media presentations, architecture, and digital/video games. (Sandhaus, 2006)

Term to define the discipline:
Motion graphics

2007

Motion graphics

2008

Motion graphic design ⊙ | **Motion design** ⊙

Krasner (2008)
Motion Graphic Design

Definition: Designing in time and space presents a set of unique, creative challenges that combine the language of traditional graphic design with the dynamic visual language of cinema into a hybridized system of communication. (Krasner, 2008, p. xiii)

Term to define the discipline:
Motion graphic design

Heller and Dooley (2008)
Teaching Motion Design

Definition: With motion as the glue, combining graphics, typography, and narrative storytelling is the new inclusive commercial art. (Heller & Dooley, 2008, p. xii)

Term to define the discipline:
Motion design

Gallagher y Paldy (2007)
Exploring Motion Graphics

Definition: The art of motion graphics is as dynamic as its name implies. It gives life to inanimate words and images, encoding them with a message for an intended audience. Motion graphics are text, graphics, or a combination of both that move in time and space and use rhythm and movement to communicate. (Gallagher & Paldy, 2007, p. 3)

Term to define the discipline:
Motion graphics

2012

Motion design

Dopress Books (2012)
Moving Graphics

Definition: Motion Design is a branch of graphic design in that it uses graphic design principles in a film or video context (or other temporary evolving visual medium) through the use of animation or filmic techniques. (Dopress Books, 2012, p. 2)

Term to define the discipline:
Motion design

2013

Motion graphics ⊙

Betancourt (2013)
The History of Motion Graphics

Definition: Converging in the final decades of the twentieth century, broadcast design, mobile graphics, the absolute film, titles or even simply animation have all been used to identify what would become motion graphics. (Betancourt, 2013, p. 11)

Term to define the discipline:
Motion graphics

2016

Motion graphics

Shaw, Shaw & Cone (2016)
Design for Motion

Definition: Motion design is composition changing over time. (Shaw, 2016, p. 115)

Terms to define the discipline:
Motion design
Graphic design in motion

Crook and Beare (2016)
Motion Graphics

Definition: Simply put, motion graphics encompasses movement, rotation, or scaling of images video, and text over time on screen, usually accompanied by a soundtrack. (Crook & Beare, 2016, p. 10)

Term to define the discipline:
Motion graphics

Other terms
Motion graphics
Motion graphic design
Motion design

Definitions of motion graphic design in chronological order

One of the first works found in the literature of motion graphic design is *Design in Motion*; in this book, Halas and Manvell (1962) show different forms of design made by animation artists. The designs are created especially for motion and are accompanied by sound, specifically music. Halas and Manvell (1962) utilize the term *graphic animation* when they refer to motion graphic design and describe it as a "drawing that expands and develops over time" (p. 10). They define the discipline of motion graphic design through its object of study:

> The simplest form of animation is a succession of static images that relate to each other in design and take up their positions on the screen in a sequence the significance of which is determined by some other factors for example, the animated credit-titles of a film, or certain kinds of cinema or television commercial. (Halas & Manvell, 1962, p. 13)

It is noteworthy to look at a later work of Herdeg and Halas (1967) entitled *Film & TV Graphics*, here the authors attempt to define the discipline of motion graphic design as the union of two broader disciplines: film and graphic design, with photography and electricity. The authors recognize that both graphic design and film arts have substantially contributed in their own ways to the visual revolution that is taking place in our lifetime. They state that moving pictures are taking over from the printed world and that "the penetration of moving images is as deep as it is wide" (p. 8).

Eight years after the publication of their first book, Halas and Manvell (1970) published a second book titled *Art in Movement*. In this work, Halas and Manvell (1970) define the discipline of motion graphic design as "animation at its purest in the art of mobile graphics," and they refer to the discipline with the term *mobile graphics* (p. 7).

For Halas and Manvell (1970), kinetic art provides a clear bridge between graphic art and film. They refer to motion graphic design as "a form of film-making that lies somewhere in between animation and the actuality of live-action photography"; making use of both, but treating photography as a starting point only (p. 185).

In *Film & TV Graphics 2*, Herdeg (1976) identifies four basic periods since the invention of moving pictures in the development of film and television graphics, the third period being the most relevant for the graphic design profession. The first period is the discovery of the technique of continuous projection of images in terms of frame-by-frame animation at the beginning of the century.

In the second period, Herdeg (1976) points out as dedicated to improving the technical potential of the frame-by-frame animation, which results in a more delicate animation with color and sound.

The third period of development occurs after the war, both in Europe and in the USA. It arises from the need to expand the graphic style and subtract it from the natural movement and photorealism. For Herdeg (1976) the significance of this period relies from a historical change that the graphic designer experiences in the animation studio. For the first time, the graphic designer becomes an equal partner with the animator and the film technician, a balance that is still maintained today.

The fourth and final period defined by Herdeg (1976) is given by the digital and electronic revolution that caused an expansion of the art of animation in other domains such as special effects in film.

In his book, *Graphics in Motion*, Halas (1984) raises the need for an interrelated knowledge among new production methods and tools available in the design profession. Halas approaches the definition of motion graphic design through its object of study when he lists the essential requirements that a designer specialized in this discipline must have. For the author said professional should be able to:

> Relate individual pictures to each other in order to represent an idea as a whole; to communicate ideas in space and time; to understand motion mechanics; to be able to relate sound with motion; to have a sense of timing; to apply graphic organization to technical needs; to be able to use light adequately as a raw material. (Halas, 1984, p. 11)

To Halas, it is essential to consider the relationship between motion graphic design and those related professions. It is also important to trace the influences on the current stage of development, which could lead to a better understanding and appreciation of the techniques of motion graphic design. The author believes that in this century, few professions have been confronted with such dramatic changes as that of graphic design. Its scope has been enlarged from printed media to many other media, most of them entirely new.

Halas emphasizes that motion graphic design can be more effective if it can establish a close and harmonious relationship with other forms such as music and choreography and achieve a rhythmic parallel with them. On the contrary, the motion graphic design will be less attractive and its potential value unexplored if the relationship between music and choreographic opportunities is neglected nor unbalanced. For the author, motion graphic design is based on additional factors beyond the value of the design itself.

It is interesting to note the variety of terms with which the author refers to this new profession. In just over two pages of his book, three different terms can be found to describe it as *design in motion, design in movement,* and *graphics in motion* (Halas, 1984, p. 11–12), he also refers to the discipline with the term *motion graphics* (Halas, 1984, p. 177).

Bellantoni and Woolman (1999), in their book *Type in Motion*, identify four areas vaguely related attempting to give form to this new discipline: "time-based typography, kinetic typography, dimensional typography, and motion graphics" (Bellantoni & Woolman 1999, p. 9).

In a subsequent work, entitled *Moving Type*, Woolman and Bellantoni (2000) rely on the fundamentals of typographic design combined with principles of time-based media such as film and animation. The authors focus their study on spatio-temporal typography, and define it as kinetic, ephemeral, and mostly intangible. Woolman and Bellantoni (2000) refer to the discipline with the term *typographic animation*.

> Spatio-temporal typography is kinetic, the characters move, the reader's eye follow. It is ephemeral. The experience is fleeting. Nothing is left when it is over, except an impression. These events are, for the most part, intangible, as they exist in the virtual world of the computer monitor, video screen, or cinematic projection. (Woolman & Bellantoni, 2000, p. 6)

Continuing on the timeline, we can highlight the work of Curran (2001), *Motion Graphics*, to whom skills such as "design, filmmaking, writing, animation, information architecture, and sound design are combined into a single profession" (p. 3). According to the author, the demand for Internet design has introduced a large number of graphic designers to the world of motion graphic animation. Curran (2001) utilizes the term *motion graphics* to define this emerging discipline:

> Motion graphics is a term used to describe a broad range of solutions that graphic design professionals employ for creating a dynamic and effective communication design for film, television, and the Internet. (Curran, 2001, p. 3)

It is important to highlight the wide range of disciplines (design, film-making, writing, animation, to name a few) that, according to Curran (2001), laid the foundations of motion graphic design.

Curtis (2001), in his book *Flash Web Design: The Art of Motion Graphics*, defines the discipline of motion graphic design using an expression of Marshall McLuhan *"the medium is the message"*:

> Similarly, in motion graphics, the motion can be more important and have more impact than the graphic element being moved. The way you choose to move or not to move an element across the screen can enhance the meaning of that element greatly. (Curtis, 2001, p. 4)

The author uses the term *motion graphics* to refer to the discipline and defines motion as a universal language understood by everyone in a greater or lesser degree. He believes that the language of the motion graphic designer

could grow to the need of no translation. The author's concern is based on communicating beyond national boundaries and displaying a global visual language. Curtis (2001) believes that the challenge for designers is "to move toward a global visual language, a language made by simple symbols and motion; a symbology that is currently and constantly being created" (pp. 5–6).

In the book *Becoming a Graphic Designer*, Heller and Fernandes (2002) denote that the graphic design field has many sub-disciplines that require bodies of knowledge and intense experience. They recognize that graphic design is a more attractive profession because of these multidisciplinary opportunities.

According to the authors, a current surge in the use of motion designers for film and television production, has developed into a popular specialty that they define with the generic term *motion*:

> Motion is the umbrella term for a discipline practiced by designers
> who create movement on either silver or cathode ray screens. (Heller &
> Fernandes, 2002, p. 184)

Similarly to Halas (1984), Heller and Fernandes (2002) list the skills and knowledge that a motion designer must have. The authors believe that motion designer professionals should be able to:

> Think in terms of movement and create a narrative or abstract sequences
> that fuse into a graphic entity. He should have a fairly extensive
> apprenticeship at an optical house or design firm. Training in (or exposure
> to) film and sound editing and cinematography is recommended. Should
> also have experience with editing programs. (Heller & Fernandes, 2002,
> p. 185)

Goux and Houff (2003) in their book › *On Screen› In Time*, refer to motion graphic design as craft that has become recognized as a valuable and important field of design. The authors believe that few disciplines have the ability to capture our attention and our imagination as effectively as motion graphic design. Goux and Houff (2003) indistinctly use the terms *motion graphics* and *motion graphic design* when they refer to the discipline. They define it as the following:

> Within this relatively new field, diverse disciplines converge to yield
> a variety of applications. Part advertising, entertainment, animation,
> videography, cinematography, editing, packaging, storytelling, art and
> craft, this medium may best be described, simply, as design of the moment.
> (Goux & Houff, 2003, p. 13)

In foreign language publications, the work of Ràfols and Colomer (2013) can be highlighted. In their book *Diseño Audiovisual* (Audiovisual Design), first printed in 2003, the authors suggest that this term hasn't had much success

since the first edition. They also say that the term designates something that already has for years been used, but with a vague name. They identify audiovisual design as the youngest of the design disciplines that has grown up with film, developed with television, and reached its full potential with the computer.

Ràfols and Colomer (2013) indicate audiovisual design as an added value that gives prestige, but exists in terms of other realities. In other words, it is a reality that does not speak of itself, but something else. They define it as a form of instrumental communication, with a functional character, but without autonomy. To them, advertisement, television, film titles, multimedia, or video clips, all have the same communication system: the audiovisual design, identified as an interdisciplinary discipline.

Woolman (2004), similarly to Ràfols and Colomer (2003), recognizes motion graphic design as an interdisciplinary discipline. In his book *Motion Design* he defines motion graphic design as the convergence of many other disciplines.

> Motion graphic design is not a single discipline. It is a convergence of animation, illustration, graphic design, narrative filmmaking, sculpture, and architecture, to name only a few. (Woolman, 2004, p. 6)

To Woolman (2004), the term *graphic* is important because it includes formal content with a graphic emphasis on symbols, icons, and illustrated two- and three-dimensional objects, often synthesized with live action. Moreover, it underlines the premise of the graphic design movement, under the notion of point, line, and plane of Paul Klee.

Kubasiewicz (2005) approaches a definition of motion graphic design by recognizing that "communication through motion involves issues of both 'what' is moving through the screen, such as typographical, pictorial or abstract elements, and 'how' that something is moving. The 'how' question refers to the kinetic form and its grammar" (p. 181).

For the author, motion and communication design are being integrated more than ever into a single discipline, being the combination of motion and typography, the most extensively exhibited practice of motion graphic design. He refers to the discipline with the term *motion design* and he stresses that motion is not the goal in itself, but a way to serve the purpose of communication. The author says that "motion is integral to design" (Kubasiewicz, 2005, p. 183).

To Kubasiewicz (2005), effective communication through motion implies familiarity with the grammar of the kinetic form, defined in spatial and temporal parameters. The kinetic form has the potential to transmit a series of notions and emotions over time, and it is the combination of kinetic form with other "languages" that generates multiple opportunities for designers to create meaning.

In the article "Los Angeles in motion: A beginner's guide from yesterday to tomorrow," Sandhaus (2006) uses the term *motion graphics* as a contemporary term, and describes the discipline as a field of study of design with a wide range of production in other professional fields. She states:

> Motion graphics is the contemporary term used to describe a broad field of design and production that embraces type and imagery for film, video, and digital media including animation, visual effects, films titles, television graphics, commercials, multi-media presentations, more recently architecture, and increasingly digital/video games. (Sandhaus, 2006)

In an article published in the journal *Eye*, entitled "Images Over Time," Soar and Hall (2006) acknowledge that the available definitions of motion graphics are many and varied. They add that the term itself seems to be losing ground to *motion* and *motion design*, taking it as an indicator the how-to and showcase books published on the topic.

The authors also name other terms that are used to describe a field that appears to be opening up:

> Other monikers that fall into this general arena include Web motion, interactive design, experience design, graphic films, experimental graphics, video design, and "the new graphic landscape of moving image." (Soar & Hall, 2006, p. 30)

In the book *Motion by Design*, several motion graphic design professionals provide a definition of the discipline. Among these definitions, David Robbins notes that "today this concept has evolved through a convergence of graphic design and film technology in a whole new way of storytelling" (Drate, Robbins, & Salavetz, 2006, p. 9). In another definition, Garson Yu points out the difference between two types of motion graphics, for film and for television as they serve different purposes:

> Cinema motion graphics, within the context of motion graphics generally represent a convergence of graphic design, film, video, and photographic technology. Television motion graphics tend to have in-your-face visuals and eye-catching layouts. Cinema motion graphics are more about image-making and storytelling. Both design approaches are legitimate, but they serve different purposes. While TV motion graphics are intended for fast reading, cinema motion graphics encourage the contemplation of a story that unfolds slowly. (Drate et al., 2006, p. 21)

Gallagher and Paldy (2007) provide a comprehensive definition of motion graphic design in their book *Exploring Motion Graphics*. They use the term *motion graphics* to refer to the discipline, and imply that it is as dynamic as its

name suggests. This is because it gives life to words and images, codifying a message to an audience with the use of motion, time, space, and rhythm:

> The art of motion graphics is as dynamic as its name implies. It gives life to inanimate words and images, encoding them with a message for an intended audience. Motion graphics are text, graphics, or a combination of both that move in time and space and use rhythm and movement to communicate. (Gallagher & Paldy, 2007, p. 3)

As said by Gallagher and Paldy (2007), motion graphic design appeals to our sense of urgency by giving us a large amount of information in a small space, delivered in snippets in a short period of time.

Heller and Dooley (2008) use the term *motion design* when they refer to the discipline and observe that graphic designers are migrating into fields previously considered exotic, but now are endemic. The authors give a creative definition about the field, which is:

> With motion as the glue, combining graphics, typography, and narrative storytelling is the new inclusive commercial art. (Heller & Dooley, 2008, p. xii)

According to Heller and Dooley, teaching motion graphic design is a consequence of the increased integration of two key disciplines, graphic design and illustration, with kinetics.

In his book *Motion Graphic Design,* Krasner (2008) indicates that the fourth dimension of time has enhanced the landscape of thinking among graphic designers. For the author, the evolution of motion graphics mandates the need for effective communication and motion graphic designers that can design for different media. Krasner states that motion literacy is one of the most fundamental storytelling devices of motion graphic design.

Krasner defines motion graphic design as a set of unique and creative challenges combined with graphic design language and the dynamic visual language of cinema. He says:

> Designing in time and space presents a set of unique, creative challenges that combine the language of traditional graphic design with the dynamic visual language of cinema into a hybridized system of communication. (Krasner, 2008, p. xiii)

In the book *Moving Graphics*, the term motion design is used to describe the discipline as a branch of graphic design. Additionally the book says:

> Motion Design is a branch of graphic design in that it uses graphic design principles in a film or video context (or other temporary evolving visual

medium) through the use of animation or filmic techniques. (Dopress Books, 2012, p. 2)

For Betancourt (2013), "Kinetic typography, combined with the heritage of the abstract synesthetic motion picture, defines the field of motion graphics" (Betancourt, 2013, p. 198). In his book, *The History of Motion Graphics*, he denotes that motion graphic design emerged from the combination of two major historical factors: the aesthetics that developed around the synesthesia in both color music and abstraction, and from the translation of typography into kinetic typography:

> Abstract film is the origin of motion graphics and provides the foundational conventions of how images relate to sound, the formal shape of the field, and the most basic elements of visual technique and technological application. (Betancourt, 2013, p. 40)

For Krasner (2013), motion graphic design is the evolution of a static discipline to a practice that incorporates a broad range of communication technologies in film, television, and interactive media industries. According to the author, motion graphics presents a set of unique, creative challenges that combine the language of traditional graphic design with the dynamic visual language of cinema into a hybrid system of communication (Krasner, 2013, p. xii).

Of the latest published books in motion graphic design, it should be noted of the definition that Crook and Beare (2016) elaborate on the discipline in their book *Motion Graphics*:

> Simply put, motion graphics encompasses movement, rotation, or scaling of images, video, and text over time on screen, usually accompanied by a soundtrack. (Crook & Beare, 2016, p. 10)

The authors believe that this definition is extremely simple, as it only refers to the actual physical process, without specifying the scope of the discipline, nor differentiating motion graphic design from other forms also derived from the media as animations and visual effects.

Crook and Beare (2016) prefer the term *motion graphics* to refer to the discipline and reflect on its origins; for the authors, it derived from *motion graphic design* and therefore shares many similarities with the discipline of graphic design. Some of these include the use of simplification and abstraction to reduce the image to a schematic form and it is meant to communicate this without being narrowed down to only the visual. The authors point out that "the term *motion graphics* was first used by American animator John Whitney, when in 1960 he named his company Motion Graphics Incorporated" (Crook & Beare, 2016, p. 10).

Another recently published work in motion graphic design is that of Shaw (2016), *Design for Motion*. In this work the authors define the discipline of motion graphic design as "composition changing over time" (p. 115). Shaw (2016) mention that the term motion graphics has been accepted by designers and filmmakers but "while the term is still in use today, it is rapidly giving way to its wiser and more relevant successor, 'motion design,'" and that both terms "are derived from the same longer term: 'motion graphic design'" (p. xv).

The authors propose a slight rearrangement of the words and the addition of a preposition so that the result is *graphic design in motion*. Shaw (2016) suggest that this subtle change is the key to understanding the true power of the field.

Shaw (2016) insinuate that motion graphic designers need a deep understanding of other creative disciplines like painting, visual effects, sound design, music composition, computer science, and choreography. They recognize that motion design is an emerging field and they define its scope by combining motion media and graphic media. As in motion media, the authors refer to disciplines such as animation, film, and sound; and as in graphic media, the authors refer to disciplines such as graphic design, illustration, photography, and painting. The fundamental difference between motion media and graphic media, according to Shaw is that the first one changes over time while the latter remains static, without change (p. 1).

Conclusion

Several observations emerge when looking at the evolution of the discipline of motion graphic design through its definitions over time.

The first definition found of motion graphic design is also the most revealing as to the origins of the discipline. The authors Halas and Manvell (1962) define the discipline as: "the simplest form of animation is a succession of static images that relate to each other in design." In a later work, Halas and Manvell (1970) emphasize this idea saying that: "Animation is at its purest in the art of mobile graphics" (p. 7). With these definitions, the authors lay the foundations of a discipline that was raised in the animation studios using animation as a technique and graphic design as a visual language.

In this attempt to find the roots of motion graphic design, some authors (Curran, 2001; Woolman, 2004; Goux & Houff, 2003; Shaw, 2016), create confusion in the search for a clear definition and lay the foundation of motion graphic design on a wide range of disciplines, thus making the boundaries, objectives, and scope of it impossible to trace. If we consider this multidisciplinary approach of the field, then the area of expertise required to become acquainted in motion graphic design would be so vast that it would be practically impossible to achieve in a lifetime.

This fact highlights an interest for theorists and design professionals to delineate and better understand the scope and objectives of the discipline of motion graphic design. In this attempt, some authors approach to the definition of the discipline of motion graphic design through its object of

study, and enumerate the essential requirements and skills that a designer specialized in this discipline must have (Halas, 1984; Curran, 2001; Heller & Fernandes, 2002).

The origins of *motion graphic design* as a term is uncertain; however tracing the term in the timeline, it was first mentioned by Goux and Houff (2003). Other terms that can also be found are *motion graphics*, and *motion design*. Nevertheless, if we look at the timeline of motion graphic design definitions, the terms most repeated and used interchangeably over time to define the discipline are: *motion graphics* and *motion design*.

This alternation in the use of terms confirms the theory of some authors such as Ràfols and Colomer (2003) who claim that the discipline is named with a vague designation, and that the definitions available on motion graphic design are many and varied. So, the term seems to be losing ground to *motion* and *motion design* (Soar & Hall, 2006). This lack of consistency in the definition moves to the present, where we can corroborate that even today, the same struggle remains for supremacy of one term or another like in Crook and Beare (2016) or Shaw (2016).

This ambiguity in the use of terms to define the discipline of motion graphic design can also be seen in the same author, and in the same publication (Halas, 1984; Woolman, 2004). Halas (1984) refers to the discipline as *design in motion, design in movement, graphics in motion or motion graphics* (Halas, 1984, pp. 11–12, 177). Goux and Houff (2003) use indistinctly the terms *motion graphics* and *motion graphic design* when they refer to the discipline (Goux & Houff, 2003, p. 15). Woolman (2004) meanwhile, underlines the importance of the word graphics because it includes formal content that has an emphasis on the graphic, such as symbols, icons, and illustrations of objects. Moreover, it highlights the idea of the graphic design discipline as the foundation of motion graphic design; however, this attempt seems unconcluded when the title of his book *Motion Design* (Woolman, 2004) does not include the word *graphics*.

Based on the definitions found, and observing the evolution of the term on the timeline, the terms most repeated are *motion graphics* (appears eleven times), *motion design* (appears five times), and *motion graphic design* (appears three times). However based on the trajectory of the latest publications, the term seems to be leaning towards *motion graphics* and *motion design*. While *motion graphics* implies noun or artifact, *motion design* addresses more the process or verb. The spirit of the book addresses both; designers may not even need to choose between these two terms since it is best to allow them to describe their work in a way best suited to their frame of reference and activity.

Another observation that emerges when looking at the timeline is the frequency in publications on the topic. From the late twentieth century and early twenty-first century, this frequency increases. It is suggestive to see that from the book of Bellantoni and Woolman (1999), publications on the subject intensify, having a publication on the topic almost every year.

To conclude, what seems to be a common denominator in most of the definitions discussed in this chapter, is that motion graphic design resides on three major disciplines that build its body of knowledge. They are graphic design, film, and animation. The discipline of motion graphic design utilizes graphic design and film as its visual language of expression and communication, with a clear function of that taken from the graphic design discipline: to convey a message to an intended audience, with a technique and medium that clearly resembles to those from animation and film.

Dr. Clarisa E. Carubin, University of Rhode Island

Acknowledgments
Dr. Joan Morales i Moras, University of Barcelona
Dr. Raquel Pelta Resano, University of Barcelona
Dr. Emiliano C. Villanueva, Eastern Connecticut State University

References
Bellantoni, J. & Woolman, M. (1999). *Type in motion.* New York: Rizzoli.

Betancourt, M. (2013). *The history of motion graphics.* Rockville, MD: Wildside Press.

Crook, I. & Beare, P. (2016). *Motion graphics. Principles and practices from the ground up.* New York, NY: Bloomsbury.

Curran, S. (2001). *Motion graphics. Graphic design for broadcast and film.* Gloucester, MS: Rockport Publishers, Inc.

Curtis, H. (2001). *Flash web design: The art of motion graphics.* Indianapolis, IN: New Riders.

Dopress Books. (2012). *Moving graphics: New directions in motion design.* (1st ed.). Barcelona, Spain: Promopress.

Drate, S., Robbins, D., & Salavetz, J. (2006). *Motion by design.* London: Laurence King.

Gallagher, R. & Paldy, A. M. (2007). *Exploring motion graphics.* Clifton Park, NY: Thomson Delmar Learning.

Goux, M. & Houff, J. A. (2003). ›*On screen*›*In time.* Mies: RotoVision.

Halas, J. (1984). *Graphics in motion.* New York, NY: Van Nostrand Reinhold.

Halas, J. & Manvell, R. (1962). *Design in motion* (1st ed.). New York, NY: Hastings House.

Halas, J. & Manvell, R. (1970). *Art in movement.* New York, NY: Hastings House.

Heller, S., & Dooley, M. (2008). *Teaching motion design.* New York: Allworth Press.

Heller, S. & Fernandes, T. (2002). *Becoming a graphic designer.* New York: John Wiley.

Herdeg, W. (1976). *Film & TV graphics 2: An international survey of the art of film animation* (2nd ed.). Zurich: Graphis Press.

Herdeg, W. & Halas, J. (Eds.) (1967). *Film & TV graphics: An international survey of film and television graphics* (1st ed.). Zurich: The Graphis Press.

Krasner, J. (2008). *Motion graphic design. Applied history and aesthetics.* Burlington, MA: Focal Press, Elsevier.

Krasner, J. (2013). *Motion graphic design. Applied history and aesthetics.* (3rd ed.). Oxford: Focal Press.

Kubasiewicz, J. (2005). *Motion literacy.* In Heller, S. *The education of a graphic designer* (2nd ed.). New York, NY: Allworth Press.

Ràfols, R. & Colomer, A. (2003). *Diseño audiovisual* (1st print). Barcelona: Gustavo Gili.

Ràfols, R. & Colomer, A. (2013). *Diseño audiovisual* (9th print). Barcelona: Gustavo Gili.

Sandhaus, L. (2006). Los Angeles in motion: A beginner's guide from yesterday to tomorrow. *SEGD Design, Iss. 11.*

Shaw, A. (2016). *Design for motion: Motion design techniques & fundamentals.* New York: Focal Press, Taylor & Francis Group.

Soar, M. & Hall, P. (2006). Images over time. *Eye, 60.* Retrieved from http://www.eyemagazine.com/feature/article/images-over-time

Woolman, M. (2004). *Motion design.* Mies, Switzerland: RotoVision.

Woolman, M. & Bellantoni, J. (2000). *Moving type* (1st ed.). Crans-Près-Céligny, Switzerland: RotoVision SA.

Camila Afanador-Llach
Motion in Graphic Design:
Interdisciplinary References for Teaching

"[U]nlike the kinetic experience of turning a printed page to sequence information, time now becomes an unusually powerful and persuasive design element" (Helfland, 2001, p. 106).

How can motion be taught in the graphic design curriculum? Time-based assignments in the graphic design curriculum bring an opportunity to integrate knowledge and methods from multiple fields. With this in mind, studio-based learning of motion design should not be solely focused on the process and execution of motion pieces using computer software. Students have a richer learning experience when framed as critical making: "learning that includes hands-on practice, the processing of enhanced seeing and perception, and contextualized understanding" (Somerson & Hermano, 2013, p. 19). The understanding of the interdisciplinary context in which motion design emerged, provides a multi-layered set of conceptual tools through which students can critically engage and develop time-based projects.

In this chapter I analyze a set of concepts, examples, and techniques from comics, filmmaking, and animation among others, in the context of motion design education. The inclusion of various conceptual and practical ideas from parallel visual disciplines contributes to motion design studio-based teaching and learning.

Motion in Graphic Design Education

Motion graphics have been part of the scope of work of graphic designers for a long time. In the words of Steven Heller, motion constitutes one of the most significant changes in graphic design practice over the past decades (Heller & Dooley, 2008). As other disciplines, graphic design has rapidly evolved under the influence of computer software for desktop publishing. Specialized software tools "have altered the tasks of graphic designers, enlarging their powers as well as burdening them with more kinds of work to do" (Lupton, 2011, p.13). This is the case of motion design, a broad area of work where designers create time-based pieces of visual communication or incorporate principles of motion to interactive and communication experiences at different scales. With this new reality in mind graphic design programs have had to find ways to incorporate motion design into the curriculum to prepare students for diverse professional futures.

In 2008, Steven Heller and Michael Dooley edited a book compiling syllabi from courses on motion design. Organized from freshmen through graduate courses, the book includes detailed descriptions of class assignments, presenting a comprehensive survey of motion design as proposed by educators around the United States. There are commonalities in language, references, and assignments between courses. The terms time-based media, time-based communication, and time-based design are often used to delimit the field and differentiate from printed media. Time is used as a descriptor to group together motion graphics, computer animation, kinetic typography, and visual narrative. The interdisciplinary nature of motion design manifests itself through the contents and bibliography of the courses compiled in the book. The assignments in the majority of cases ask students to deliver a specific product, mostly animations and videos.

These kinds of assignments correspond mostly to what Suguru Ishizaki (2003) calls *static* design. The videos and animations that are often the resulting product of these class assignments are static or fixed in the sense that "its design solution does not involve changes in the content or the information recipient's intention" (Ishizaki, 2003, p. 8). In contrast, he uses the term *dynamic design* to define forms of digital communication where information itself and the way it is received changes depending on user needs. This description matches today's dynamic and responsive communication systems and suggests the strong link between motion and interactive design. This relationship was not especially prominent in the formulation of motion design courses back in 2008. It would be necessary to look at motion in the graphic design curriculum today to assess new methods and approaches to the use of video, animation, and motion as it appears in other areas of design.

The way in which motion has been incorporated into BFA programs varies between each institution. In many cases, whole courses are devoted to the creation of motion design pieces like the ones mentioned before. A contrasting example is the approach to motion design education practiced in Massachusetts College of Art and Design. They integrate motion broadly into the curriculum framed in the context of dynamic media communication (Kubasiewicz & Lucid, 2015). Motion design then is not defined as a set of products but as a language of communication that should be present in different domains of graphic design education. This alternative view of what motion means is a flexible approach where other areas of graphic design like interactive design and data visualization are considered in relationship to motion.

Teaching and learning motion design usually involves at different levels, the evolution of ideas and concepts in narrative forms as well as the development of techniques and skills with specific software tools. In computer animation courses, motion is often introduced in relation to the laws of physics. The "bouncing ball" assignment is an example where students have to animate a cycle of a bouncing ball mimicking its behavior in the physical world (Figure 1). Studying movement as it happens in everyday life is also a standard way

to awake students' sensibilities towards motion. At the same time students engage with narrative structures in assignments based on the documentation of personal experiences that serve as content to tell a story. Assignments that use poems and song lyrics as content to create typographic animations are also frequently proposed. In some cases, assignments start with a direct connection to a printed form of graphic design like a poster that serves as a storyboard for a time-based piece. The links to traditionally printed forms of graphic design unveil the still noticeable influence of print in digital design.

Assignments in graphic design and visual communication courses include the creation of animated logos, flipbooks, public service announcements, movie titles, and word opposites. Anything that involves typography in motion on a screen could be considered as pertinent to motion design in the context of graphic design education. Typography is a key area of work for graphic designers and in connection to motion is described in the subarea of kinetic typography.

Regardless of definitions and subareas in motion design, software tools are instrumental for graphic design education. The creation of design artifacts requires the use of specialized software packages. In motion design pedagogy, instructors facilitate students' use of computer software for making class exercises and projects. A balance of learning to be a designer, learning software tools, and learning how to apply new tools is part of the pedagogical experience. Placing emphasis on every stage of the design process, research, ideation, sketching, production, and iteration, is fundamental to assure that there is a clear intention from students when using motion for communications purposes. The consistent use of software for the creation of motion graphics over the past decades indicate that we cannot talk about motion design without acknowledging how software is central to the way design work is produced.

The role of software
The capabilities of software tools commonly used in the classroom in the last decades may be related to common approaches to motion design education. In the 2008 compilation of motion design courses, the most common design

software listed by professors in their syllabi included After Effects, Flash, Photoshop, ImageReady, Illustrator, Final Cut, Macromedia Director, and Audacity, among others. Since then, some programs like ImageReady and Flash have been discontinued. Now Adobe offers specialized software for video production, 3-D character design, and game development using ActionScript, the programming language behind Flash. Adobe Creative Cloud is the dominant provider of specialized software for all the areas of graphic design. The original intention for which each software application was produced delimits specialized areas of design connected as well with the design industry demands. Assignments in the motion design classroom often include the use of the mentioned software tools. A critical engagement with these tools can provide more rewarding learning experiences.

The concept of *media remixability* was proposed by Lev Manovich (2007) to analyze the hybrid visual language of motion graphics that resulted after the emergence of After Effects in 1993. This visual language has its remnants to these days in film and television titles and other animated sequences that are often the resulting product in graphic design assignments. Manovich explains that the emergence of After Effects allowed for contents, techniques, languages, and aesthetics of different media to get remixed forming what he calls a new metamedium. His definition places motion graphics in the center of a multidisciplinary landscape where "united within the common software environment, cinematography, animation, computer animation, special effects, graphic design, and typography have come to form a new metamedium" (Manovich, 2007, p. 70). It is difficult to define the degree to which software has influenced the development of the field but certainly it has contributed to today's visual language of motion design and is a testimony of design possibilities with the available technology.

What pedagogical strategies can design educators use to ensure a critical stance towards the use of software? A design course is not a course about learning a specific computer application. Courses in design are about students becoming better designers, exploring different processes and understanding the history and context of the design practice. The expectation should be that students would learn to use software to produce their ideas and not come up with ideas based on what they know they can do with a specific software application. The latter approach can be the way to initially engage in learning but should not limit the exploration of the potential of software tools. For example, students learning After Effects can use preset animations available in the program to produce intended effects or results. The type of effects include for example appear, drop, fade, blur, scale, dissolve, flying in, pop, and grow. The overuse of presets and default options leaves too many decisions in the hands of those who designed the software making the production process a limited and not very challenging experience for students. Emphasizing the design process is then essential for design students to learn software framed by critical making. By asking larger questions about motion and communication, assignments can connect concepts to a larger context of visual communication.

The Vocabulary of Motion Design

The semantics of motion design are fundamental in teaching and learning as they provide a common language for further dialogue among educators and practitioners in the field. Part of the terminology we use when teaching motion in the context of graphic design comes from cinema and animation. When working with motion for display on screens we rely on conventions and techniques adopted from the vocabulary of cinema like a 'cross-fade' and a 'split-screen' (Kubasiewicz, 2005). In the same way, vocabulary originally from animation makes its way to the graphic design process for example through the use of storyboards. Some of the language appears to be conditioned to the capabilities and options included in software tools, which very often reference a principle before performed by analogue means, then introduced and reinterpreted in design software. A collection of recurrent words in motion design course names in Heller and Dooley's book is presented in Figure 2. A view of what motion means today in the context of graphic design education broadens the horizon to a larger scope of work. Key terms like: dynamism, interactivity, experience, conditional motion, and responsive design among others complete a more inclusive understanding of motion design today.

Particular language appears when focusing on specific realms of graphic design. Graphic designers work with attributes of typography such as size, color, kerning, tracking, line spacing, alignment, hierarchy, contrast, legibility, texture, forms, and counter forms. These attributes are still relevant when using typography for screen layouts but in addition, when working with motion, designers manipulate parameters of typography related to behaviors over time. Barbara Brownie (2015) argues that type classifications do not yet incorporate additional features that are present in what she calls temporal typography. She undertook the task to develop a classification system including both spatial and temporal factors present in kinetic typography. She differentiates between the serial presentation of text and kinetic typography where the behavior of type transcends that of moving from one place to the other and includes experimental and fluid transformations to the text. The

diagram by Barbara Brownie (Figure 3) makes a distinction between the various categories and subcategories of behaviors exhibited in contemporary temporal typography. These behaviors are classified using a combination of existing and new terms proposed by her.

Figure 3
*The categories
of behaviors
exhibited
in temporal
typography.*

*Source: Brownie,
2015. Copyright by
Barbara Brownie.*

Brownie's classification attempts to map the field of kinetic typography in a thorough and comprehensive way that goes beyond typography moving around the computer screen without specific purpose. She looks mainly at examples from branding, title sequences, and kinetic poetry to identify and clarify concepts like motion, change, global motion, and local transformations. In a field that lacks definite theory, these classifications can help to provide common language when referring to specific cases in motion design pieces. The language proposed from a theoretical perspective might differ from the one that emerges in the daily practice of motion design.

A contrasting perspective that gives an idea of the varied areas of application of motion in graphic design is Google's *Material Design Guidelines* where motion is a key element in user experience to describe spatial relationships, functionality, and intention ("Material Motion," n.d.). The framework behind Material Motion is applied to mobile apps designed by Google where motion aids focus on specific areas of the screen, hints what will happen after a particular interaction, establishes relationships between elements, and imprints character and delight to interactive experiences. In their approach to motion design they draw inspiration from the observation and study of real-world forces. They describe the motion as responsive, natural, aware, and intentional, creating a sense of choreography and continuity in the experience of using their apps.

A vocabulary to talk about motion design becomes richer every day with new areas of application. An interesting exercise would be to create a glossary of terms in the style of the one presented by James Pannafino (2012) in *Interdisciplinary Interaction Design*. The aim of his book is to enhance the understanding of the interdisciplinary theories that are part of the field of interaction design. To do so he compiles concepts and ideas and traces their origin. A similar compilation for motion design would be fundamental in

mapping the field and rigorously tracing back key ideas that explain the current practice of motion design.

From Other Fields

Contextualized understanding of motion design requires that we look outside of graphic design to include concepts, metaphors and examples from other fields that enrich the learning experience of students. In the same way, including basic historical background can provide a larger picture of the origins and evolution of the field to students that are digital natives.

Motion design as choreography

When working on print, designers manipulate the visual properties of type and other graphic elements to create layouts. In visual identity projects, where a design system is developed, information is communicated through a single medium (e.g. a book, a poster, a brochure), or through multiple media. When using motion in visual design, designers also have to decide how typography and other graphic elements move, behave, and transition from one another, attaching expressive qualities to them. Since choreography is the practice of designing the sequence of steps and movements in dance and other staged activities, it serves as metaphor to the series of decisions that designers make when using motion in visual communication. Analogies to theater, choreography and performance provide rich references for students to imagine the type of decisions they will have to make when designing with motion.

How can typographic messages express more than their meaning through the qualities of their motion? Should they? Can the language of dance and performance enrich the vocabulary of designers seeking to use motion in communication processes? In the past, several authors have made references to performance and choreography in relationship to design and typography on the screen. In her essay "The Big Reveal and the Dance of the Mouse," designer Jessica Helfland (2001) describes typography on the computer screen and its potential, observing that "this new theatrical typography is content, revealing its subtext, reinforcing its context, captivating and catapulting the viewer toward new cognitive layers of suggestion, increased meaning and added depth" (p. 115). Referring mostly to typography for interactivity, Helfland also imagines typographic choices as actors on TV that communicate through posture and characterization.

Likewise, in his paper "After Effects or Velvet Revolution," Manovich (2007) compares the designer to a choreographer who "creates a dance by 'animating' the bodies of dancers—specifying their entry and exit points, trajectories through space of the stage, and the movements of their bodies" (p. 73). Attaching human-like characteristics to the elements of a time-based composition can serve as a foundation for students to articulate their intentions of using motion as a layer of meaning. Design students have the opportunity to *dramatize* imagining the computer screen as a *theater* stage and the textual and graphic content as actors getting ready to perform. The comparison in this case is relevant mostly for animation as it implies a serial appearance of graphic elements on the screen.

In his proposed theoretical framework for dynamic communication design, Ishizaki (2003) refers to the role of the designer in digital contexts making a comparison with a director of an improvisational dance performance. In different contexts, choreography becomes a way to express the transit from designing compositions in static media to choreographing experiences in digital design artifacts. The Internet is full of "kinetic typography" examples, which consist of animations of moving text synchronized with the voice of a narrator or song lyrics usually produced in After Effects. Aside from the level of delight that animated text on the screen can provide, the relationship between reading and listening is evident in these examples. Type in motion is used to express the subtleties of the spoken language and enhance meaning. Rather than only looking at recent examples of animated type, the study of concrete poetry can engage students in thinking of the role of motion in how we experience language, which will be explored in the following section.

Concrete poetry / Kinetic poetry

In kinetic poetry the movement of words add meaning to the poem. There is a tension between reading and experiencing a text when presented in motion. For example, Barbara Brownie (2015) talks about kineticism in terms of performance and looks specifically at kinetic poetry in its visual aspect and sound evocation. Perception challenges may arise if in addition to a visual presentation with kinetic behaviors, a voice-over reads the text. In kinetic poetry the audience encounters a hybrid experience where layers of perception of a message shape its meaning (p. 85). In concrete or visual poems meaning is conveyed visually and sometimes motion is expressed without having to exist in a time-based medium.

The connection between the written and the spoken word are central to concrete poetry. The visual dimensions where text and image are intertwined to produce meaning also express a connection between the visual arts and literature. Examples of concrete poetry (see Figure 4) are relevant to engage students with motion as a concept for creating visual compositions. A question on motion being represented in static media becomes central. There is a sense of succession and repetition in some concrete poems that imply rhythm and motion which have also been explored in relation to sound.

Ideas of motion and sound in a single image have been widely explored by artists and designers throughout history. Like forms of printed graphic design that suggest motion or evoke sound, concrete poetry lives in the action of reading. In motion design that is centered in typography, the words convey meaning on their own but their meaning is completed by the visual treatment and by its motion. If we look at one of the examples of concrete poetry and think of it as a single frame of a motion piece, we can imagine transformation over time. Motion is already communicated by the static layout leaving space for possible interpretations of a temporal experience. Studying motion represented in a single image can be a starting point for students to create sequences as depicted in comics and storyboards.

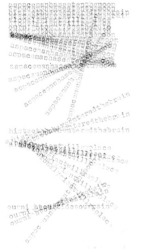

Adler: A Space Man has Eaten the Moon, 1975, typed page

Time frames in comics

Students trained mostly in print design can gain great insight when introduced to time and motion from the perspective of a printed medium like the comic. Comics bridge time in static media with time as experienced in time-based media. In comics time and space coexist in the printed page and a visible relationship between past, present, and future creates the illusion of motion (McCloud, 1993). What can be emphasized, as a learning strategy, is the thinking process that goes with drawing panels to create a sequence of events over time.

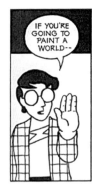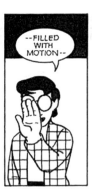

This thinking process expresses how the planning and sketching process in time-based projects could start. For example, comic artists have the challenge of representing motion in single images. McCloud (1993) questions how it is possible to show time in comics, if it is a printed format where time stands still. The same question can be asked in the context of motion design in reference to the storyboard as the static visual tool where time and motion need to be represented. The strategy of many comic artists to imply motion is to use "motion lines" to show the path and attributes of a specific motion,

as shown in Figure 5. The use of these diagrammatic lines is part of the visual language students can explore when creating storyboards for their projects. Not all motion design assignments in graphic design education require the craft of a linear narrative structure with the traditional beginning, middle, and end. But establishing relations between frames regardless of an underlying narrative structure helps students develop skills to understand the implications of time and motion in their work.

The storyboard

Creating storyboards is fundamental in the design process for motion design assignments. Storyboards are useful visual tools for breaking up a sequence into key moments in time and planning the execution of a piece. Storyboarding serves the design process for sketching, planning, and communicating ideas in early stages through final production. Different assignments require that students spend time sketching as a crucial part of the visual thinking process in order to develop concepts and ideas. In addition to experiencing the process of creating motion pieces based on tools from animation and cinema, students benefit from understanding the origins of the storyboard to frame their design practice in a larger historical context.

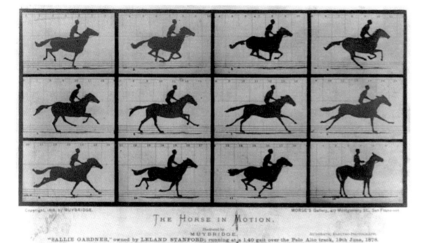

Figure 6
The Horse in motion. "Sallie Gardner," owned by Leland Stanford; running at a 1:40 gait over the Palo Alto track, 19th June 1878/ Muybridge. Twelve frames showing motion of a race horse.

Source: Muybridge, c1878. No known restrictions on publication.

Central examples to be introduced and discussed in the classroom include late nineteenth and early twentieth pieces. Storyboarding as the practice we know today used in cinema and animation, has been around for a long time. Due to their visual similarities with a storyboard, the serial photographs of Muybridge (Figure 6) are a good reference in this area, although he "was not concerned with planning for motion, but rather capturing and revealing it" (Pallant & Price, 2015, p. 28). An example of storyboarding as a planning tool can be found in Einsenstein's scheme for the film Alexander Nevsky in 1938 (Figure 7). Divided in picture frames to plan for the scenes that needed to be shot, composing the music to match the idea and a pictorial composition planning the movement in each shot.

The level of detail that can be defined in a storyboard is often hard to accomplish for students in part because they are new to the process of planning for motion. Part of graphic design education involves students becoming aware that every decision regarding their projects is important as it is paying close attention to details. In the production phase of assignments there are things that sometimes don't go as planned and problem-solving skills come into play in these situations.

Figure 7
Sergei Eisenstein. The first part of the scheme (1–8) from the scene before the battle in the film Alexander Nevsky *(1938). The scheme shows the shots (picture frames), music, length, frame composition, and diagram of movement for the scene.*

Source: "File:Vertical montage," 2017. Public Domain in Russia.

Devices and formats

In the history of motion pictures, it is traditionally explained that "the illusion of motion is based on the optical phenomena known as persistence of vision and the phi phenomenon" (Sklar & Cook, 2016). Taken together, these phenomena make possible that we perceive still frames as continuous movement when projected at the proper speed. These explanations have been used widely to explain how the eye perceives movement. Early cinema and animation devices provide students with historical background for motion design and the analogue means by which animated sequences can be produced. Examples include the *phénakistoscope* invented in 1832 that used the persistence of vision principle to create the illusion of motion using rotation and repetition. Likewise, the *zoetrope* used a cylinder to display a sequence of photographs or drawings showing the progression of motion. Similarly, the *praxinoscope* used a strip of pictures placed around the inner surface of a spinning cylinder using mirrors. All examples illustrate very well

Figure 8
Phénakistoscope, praxinoscope and zoetrope.

Copyright 2016 by Camila Afanador-Llach.

the basic principles of motion pictures and help contextualize motion design way back, before computer software became central to the process of creating motion graphics.

The introduction of the basic concepts of animation can be done using a hands-on approach. A familiar printed form for graphic designers, the book, is also a device to introduce principles of animation to students. Intimately connected to cinema, the flipbook as a form exemplifies the basic principles of motion pictures and animation.

From the flipbook to the animated GIF
Making analogies between printed and screen-based media is a pedagogical strategy to create bridges between both. Traditionally printed, static forms of graphic design can be transformed to have dynamic qualities, to reimagine their purpose and the way they communicate. Along with different optical toys discussed in the previous section, the flipbook talks about a transition from photography to cinema. The understanding of this sequencing of images is the key to understand animation. The flipbook not only has the potential to be the product of an assignment, it is an explanatory device of the fundamental principles of animation. There are multiple concepts that can be introduced using the flipbook such as sequence, narrative, frames, and time. Through these concepts students can explore change over time by editing, organizing, visualizing, and experiencing the resulting motion. Creating the illusion of motion by doing frame-by-frame animation introduces students to concepts before they start working mostly with computer animation software.

Short looping animations can be traced back to early animation devices and they can be thought of as precursors to the animated GIF. Younger students might not be aware that the early web was a very different place than it is today. Internet connections used 56 kbps modems connecting via phone lines, making load times extremely long. In this context, the GIF (graphics interchange format) was born—a low fidelity format that could be easily loaded in web browsers. Very common in the early 90s, animated GIFs have had a comeback in the Internet becoming prominent symbols of popular culture. The animated GIF brought motion into the computer screen early on in the form of a loop. This type of animation is often perceived as fluid and never-ending, where you cannot discern between beginning and end. GIFs are a flexible format to explore perception and communication in introducing students to motion.

Filmmaking and design process
In the design process for motion design assignments we can look at filmmaking as a reference for outlining a series of steps to follow. Manovich (2007) links both filmmaking and graphic design by saying that "the After Effects interface makes filmmaking into a design process, and a film is re-conceptualized as a graphic design that can change over time" (p. 74). To break down the workflow for an assignment, the filmmaking process of pre-

production, production, and post-production can serve as basis to outline the design process. How can this process be scaled down and adapted to classroom projects?

Traditionally in filmmaking, pre-production is the part of the process during which all of the decisions necessary to start shooting are made: writing, technology basics, planning, scheduling, storyboarding, set design, and tools to use. During the production stage everything planned in pre-production takes place. And in the post-production stage final steps to finalize the project take place: color correction, editing, sound design, special effects, among others. In filmmaking, distribution and exhibition of movies are the steps to follow when the project is finalized. This process can be scaled down into graphic design assignments and at the same time make a reference to filmmaking. A process of research, sketching, and planning can be understood as pre-production, where ideas are born, sketched out, and presented in storyboards. The making of the piece using specific computer software could be considered the production stage. The process of refining, receiving feedback, and iteration could become the post-production stage. During the design process of an assignment, presenting to the class and receiving critique loops back the process for students to work on the next iteration.

Movie titles as prologue
The movie title assignment brings to the forefront the relationship between cinema and graphic design. Movie title sequences from the 1950s and 60s brought together graphic designers like Saul Bass and Pablo Ferro to work with renowned movie directors. In these collaborations graphic designers and directors "not only redefined the medium but also helped to shape a new era of graphic design in which modernism and abstraction became the vocabulary for a postwar consumer culture" (Radatz, 2011, p. 136). As explained by Barbara Brownie (2015) movie title sequences can be described as a prologue for the narrative while serving the purpose of introducing the cast and creators.

The relationship between the purposes of a movie title sequence with that of the prologue of a book highlights the importance of the title sequence as a graphic design piece of its own. Designing the title sequence of a movie can be compared to having been invited to write the prologue of a book. The format also allows for unlimited creative freedom and interpretation.

Moving Forward
The previous examples and references were collected to propose directions in introducing motion to the curriculum with recognition of the many disciplines that contribute to the field. From motion as studied in physics, to motion pictures and animation, to choreography, to time in comics and the representation of motion in static media as exemplified in concrete poetry, to storyboarding and the filmmaking process. As it pertains to many areas of knowledge, motion can be framed in many different dimensions to encourage graphic design students to build critical design skills while understanding the larger context, history, and practice of motion design.

Motion design courses tend to focus on animation and video editing as the main avenue through which to explore time-based design. Not all the uses of motion within graphic design, however, imply moving text to convey meaning and emotions. Motion has extended functions in interactive design as is evident in today's vast landscape of app development. The format and uses of motion in graphic design are evolving and expanding with creative approaches to the use of the computer and with user-centered design. Some of these areas involve generative systems, experimental typography, animated typefaces, and motion in user experience design.

The broadly known commercial software tools are not the only means for working with motion. Nowadays, programming is a crucial source of creation among all areas of design. As programming becomes central to how designers create their work, with the next generation of design educators and digital natives we will see new forms of motion design created with code. An underlying question that should be central in graphic design education towards motion is that of intention, concept, and impact in the communication process. This means, aside from experimental approaches, establishing context and enhancing experience and communication. Unfortunately, for example on the web there is a prominent relationship between motion and distraction due to the overload of ads making extensive use of moving elements to catch the viewer's attention. They intrude and distract from good reading experiences and clear access to content. An area of exploration to include in design education is the relationship between animation and user experience design in the way we experience the web.

Asking students to use motion as a pivotal element in communicating messages and creating experiences involves solving a fundamental tension between receiving a message on the screen and experiencing its motion. In consequence, motion is not the goal in design assignments—motion is an element that is present in the nature of a visual narrative or is an element that aids the resolution of a specific design problem. Designer Matthias Hillner (2005) referring to kinetic typography said that we could synchronize emotional expression and intellectual significance with the way an audience naturally perceives information. Further along he asks, "How can we judge whether or not motion benefits the communication process?" (Hillner, 2005, p. 166). From the standpoint of graphic design, it is more meaningful to question motion on its capacity to enhance communication and engage students in this critical dimension.

Camila Afanador-Llach, Assistant Professor of Graphic Design,
Florida Atlantic University

References

Adler, J. (1975). A space man has eaten the moon. Retrieved from http://ww3.rediscov.com/sacknerarchives/FULL/39436S.JPG

Brownie, B. (2015). *Transforming type: New directions in kinetic typography.* London, UK: Bloomsbury Academic.

de Melo e Castro, E.M. (1962). Pêndulo. Retrieved from http://ww3.rediscov.com/
sacknerarchives/FULL/15466SA.JPG

File:Vertical montage. Eisenstein. 2nd part of ex..jpg. (2017, June 22). Wikimedia
Commons, the free media repository. Retrieved January 8, 2018 from https://
commons.wikimedia.org/w/index.php?title=File:Vertical_montage._Eisenstein._2nd_
part_of_ex..jpg&oldid=248824819.

Helfand, J. (2001). *Screen: Essays on graphic design, new media, and visual culture.*
New York: Princeton Architectural Press.

Heller, S., & Dooley, M. (Eds.). (2008). *Teaching motion design: Course offerings and
class projects from the leading undergraduate and graduate.* New York:
Allworth Press.

Hillner, M. (2005). Text in (e)motion. *Visual Communication, 4(2),* 166–171.

Ishizaki, S. (2003). *Improvisational design: Continuous, responsive digital
communication.* Cambridge: The MIT Press.

Kubasiewicz, J. (2005). Motion Literacy. *The Education of a Graphic Designer.* New York:
Allworth Press. 181–183.

Kubasiewicz, J., & Lucid, B. (2015). Type on wheels: Brief comments on motion
design pedagogy. *Motion design education (MODE) summit.* Dublin Ireland,
June 3–5, 2015. Routledge.

Lupton, E. (2011). The designer as producer. In Blauvert, A. & Lupton, E.
(Eds.), *Graphic Design: Now in Production,* 12–13. Minneapolis, Walker Art Center.

Manovich, L. (2007). After Effects or velvet revolution. *Artifact, 1(2),* 67–75.

Material motion - Material design guidelines. (n.d.). Retrieved October 12, 2016, from
http://material.google.com/

McCloud, S. (1993). *Understanding comics: The invisible art.* New York:
HarperPerennial.

Muybridge, E. (c1878). *The Horse in motion. "Sallie Gardner," owned by Leland Stanford;
running at a 1:40 gait over the Palo Alto track, 19th June 1878 / Muybridge*
[Photograph]. Retrieved from http://www.loc.gov/pictures/item/97502309/

Pallant, C., & Price, S. (2015). *Storyboarding: A critical history.* Basingstoke, GB:
Palgrave Macmillan.

Pannafino, J. (2012). *Interdisciplinary interaction design: A visual guide to basic theories,
models and ddeas for thinking and designing for interactive web design and digital
device experiences.* Assiduous Publishing.

Radatz, B. (2011). *Design in motion. Graphic design now in production.* Minneapolis:
Walker Art Center, 135–136.

Sklar, R. & Cook, D. (2016, March 11). History of the motion picture. Retrieved from:
https://www.britannica.com/art/history-of-the-motion-picture#ref507889

Somerson, R., & Hermano, M. (Eds.). (2013). *The art of critical making: Rhode Island
School of Design on creative practice.* Hoboken, NJ: John Wiley & Sons.

"Whether the context of motion design is a motion graphics sequence or interactive experience, principles of Gestalt, narrative, and animation can be combined to educate designers about how to work with form and composition, narrative structure, and demonstrate the significance of references to nature in designing for time and motion."

Jennifer Bernstein
Re-framing Design: Engaging Form, Meaning, and Media

Maybe because of a background in theater, once I began to study graphic design, I was drawn to one of its most experiential modes: design for time and motion. The limits of technology in the early 1990s, when I was in graduate school, caused me to abandon the computers and software current at the time, in favor of a bizarre mixture of Super 8 film, 35mm slides controlled by a "dissolve unit," combined by re-photographing their superimposed projections back onto Super 8 film before splicing and taping a final edit.

Years later, here we are in a completely changed design landscape. The profession has evolved along with changes in technology and development of a global culture, resulting in an expansion of what designers actually *do*. (And it keeps changing.) Where once the terms "graphic art" and "graphic design" were a fitting name for a profession that primarily dealt with static representations, many design programs have adopted the more open terms "communication design" or "visual communication" to reflect the discipline's evolution.

Design practitioners and educators have been working through the many issues raised in design criticism over the last twenty to thirty years, such as the role of form and content, objectivity and subjectivity, audience and user, artifact and system, solution and parameter, designer and co-creator, individual expression and distributed collaboration.

Undergraduates in many design programs today still begin their studies as many of us did—learning the fundamentals of composition and typography, looking back to pioneers of design and formal theory, along with contemporary examples and ways of thinking. Design for motion and interaction has been integrated in many cases, but often as the subject of a specific course or elective, rather than as another core design literacy being addressed at the sophomore (or even foundation) level.

The scope and nature of design has changed tremendously. The question continues to be raised: has this sufficiently influenced design pedagogy and practice? Ellen Lupton and Jennifer Cole Phillips's *Graphic Design: The New Basics* (first published in 2008 with a second edition in 2015) directly addresses the need to change design fundamentals, but does not do so in a transdisciplinary way that also explains how these concepts relate to one another.

With all of these changes in mind, young designers still need to learn how to "see," create a composition, build a visual hierarchy, and work with typography. Design educators are challenged to prepare designers for a wide range of possible paths, while also making them aware of the constantly evolving character of contemporary design practice.

Many design educators have wrestled with these questions within our design studios and professional conferences, and enacted potential solutions in our classrooms. The speed of technology has also had an impact, with design educators grappling with the question of how (or if) to incorporate software tools and coding into design fundamentals. But we can address many of the changes we see in design practice while focusing on principles. Because motion design—one of the key drivers of change in design today—crosses disciplinary lines, we must look to other spheres to understand the medium, and utilize its strengths and affordances toward a more integrated pedagogy. To understand, practice, and teach motion design in the twenty-first century, we need to develop a theoretical framework that acknowledges its interdisciplinary nature and integrates it into our design fundamentals. This challenge is not new. In 1965, Armin Hofmann wrote:

> Adding a new dimension means an extension of the principles of design, not merely in the sense of a numerical increase of existing disciplines, but rather in the sense of completing a constantly expanding unit.
>
> (p. 10)

If we consider the scope of design education and practice as beginning with an understanding of formal principles (structure), expanding to address the creation of meaning (message), and finally addressing how all aspects (form, meaning, and media), can this assist us in integrating theories from different disciplines, and starting to build a more coherent framework?

Form

Whether the context of motion design is a motion graphics sequence or interactive experience, principles of Gestalt, narrative, and animation can be combined to educate designers about how to work with form and composition, narrative structure, and demonstrate the significance of references to nature in designing for time and motion. While each of these sets of ideas is discrete, they share a focus on the relevance of structural relationships, whether in a static or time-based composition.

An understanding of spatial relationships and the development of visual acuity are primary skills for a graphic/communication designer. In the West, there is a tradition of teaching designers how to develop these abilities through formal studies, many of which were brought to the U.S. by designers and educators such as László Moholy-Nagy (1895–1946) and Josef Albers (1888–1976), among others. What became much of our basic design curriculum we can trace back to the work of Klee, Kandinsky, and Moholy-Nagy who used Gestalt psychology as a scientific rationale for their work. These artists sought

a "universal" formal language, rooted in aspects of human perception, and the idea of a "language" of design as a "vocabulary" of elements—point, line, plane, color, and texture, and a "grammar" of formal contrasts—dark/light, static/dynamic, positive/negative (Lupton & Miller, 1996, p. 22).

A core notion of the Gestalt principles of perceptual organization that has had a great influence on design education is the idea that "the whole is greater than the sum of its parts"; our understanding of any element depends on its location and function in a larger pattern. Human beings perceive the world as complete objects, not as independent parts. Even more, as Rudolf Arnheim (1904–2007) explains, vision is not a mechanical recording of "sensory elements," but rather "a truly creative apprehension of reality" (Arnheim, 1974, p. 5). Based on perception, we are inclined to see pattern as a structure in its simplest form, the Gestalt concept of *Pragnanz*. Similarly, the figure/ground principle describes how our perception tends to separate a dominant shape "figure," from what we relegate to background, or "ground" (p. 63).

Principles from Gestalt psychology such as grouping by "similarity" or "proximity," "figure/ground," and "closure," among others, are integral to how designers create visual hierarchies and compelling compositions, whether designing for print or interaction. Yet much of Gestalt, as it has been integrated into design education so far, has focused on the nature of static composition. But some theorists also addressed temporal considerations, including Arnheim and Wolfgang Köhler (1887–1967) before him. Klee's *Notebooks: Volume 1: The Thinking Eye*, is an articulation and documentation of his study of form, and shows his great interest in motion. In her concluding note in Klee's *Pedagogical Sketchbooks*, Sibyl Moholy-Nagy describes his notion of "line as a point progression" (Klee, 1956).

In *Art and Visual Perception*, Arnheim (1974) writes, "Grouping by similarity occurs in time as well as in space. Any aspect of percepts—shape, brightness, color, spatial location, movement, etc.—can cause grouping by similarity" (p. 79). To demonstrate this point, one of the main theorists of Gestalt psychology, Wolfgang Köhler (1947), writes "Suppose that I knock three times at short intervals on my table, and that after waiting for a second I repeat the performance, and so forth. People who hear this sequence of sounds experience groups in time" (p. 151). In Köhler's example we can imagine how these sounds would "group" in time. Temporal aspects of perception are analogous to their static counterparts.

Within the context of an interface, motion elements can utilize some of these principles as well. For example, an action that a user takes and the

visual feedback that results (such as hovering over an element triggering an animation or transition from one state to another) will group with other actions that display similar behaviors. Other applications within interaction design include grouping similar kinds of information, creating predictable visual patterns, as well as patterns of user behavior.

In a time-based example, a title sequence for *The Life Aquatic* (Figure 2), grouping by similarity and proximity is evident in the bubbles themselves. In addition, the pacing of the sequence uses changes in direction of the bubbles' movement to "group" sections of the larger title sequence. In this way, the grouping created within the sequence begins to define a sequential, narrative structure.

Figure 2
Student title sequence The Life Aquatic.

Copyright 2008 by Jen Ling Lai. Reproduced with permission.

Narrative theory grew out of an understanding that narrative is a basic human strategy for making sense of our experiences. The discipline defines such things as: what constitutes a narrative, its structures, elements, uses, and effects. For our purposes, it will be sufficient to focus on the notion of narrative structure and its relevance for telling stories and creating meaningful experiences.

We can all reflect on how we use narrative strategies even in simply relating the events of our day to a friend, or recalling a memory. Experience itself is varied, chaotic, and frenetic, but when we relate events to others, we create stories to give order and structure to what otherwise would be disorderly and unfulfilling. As Chandler (2007) writes, "Turning experience into narratives seems to be a fundamental feature of the human drive to make meaning" (p. 115). Gerald Prince writes in "On Narratology (Past, Present, Future)":

> To study the nature of narratives, to examine how and why it is that
> we construct them, memorize them, paraphrase them, summarize
> and expand them, or organize them in terms of such categories as plot,
> narrator, narratee, and character is to study one of the fundamental ways—
> and a singularly human one at that—in which we *make* sense.
> (McQuillan, 2000, p. 129)

Narrative provides us with a basic structure that is present in all stories: beginning (exposition) › middle (climax) › end (denouement / resolution). This progression—called the "narrative arc"—describes how one always ends in a different place than where one began, and something meaningful happens along the way. This structure underlies all films, novels, and musical compositions. The structure of a narrative sequence might be pages of a book, or frames / scenes of a film or motion piece. Either way, as Christian Metz (1974) writes in his "Notes Toward a Phenomenology of the Narrative," "The 'event' is still and always the basic unit of the narrative" (p. 24).

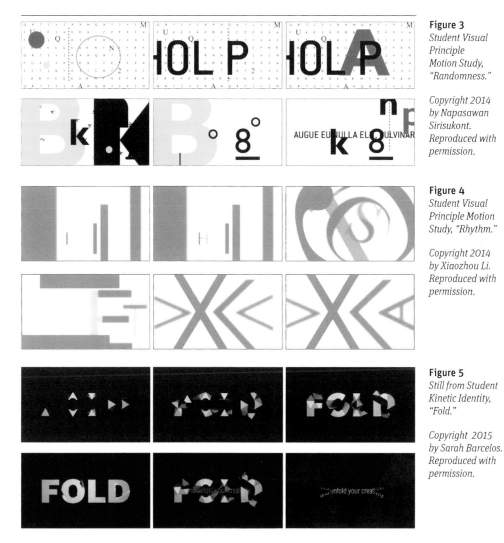

The appearance of Macromedia Flash in 1996 greatly changed the potential of web interfaces and online experience. Static "web pages" were often replaced with fluid, dynamic, and experimental ideas of what interactive experiences could be like. Artist-designers like Jonathan Harris created experimental Flash-based work like "The Whale Hunt" which tells the story of living with a family of Inupiat Eskimos in Barrow, Alaska (Figure 6). In this interface, "events" are depicted as still photographs which move to change their visual representation and organization. Each becomes a different navigational "mode" with which the audience / user can experience the same story from a different point of view. For example, a grid of scenes from the film becomes a user-interface that moves and shifts with the user's mouse; the timeline of the story morphs into a circular navigation wheel.

An event has been described as the "smallest narrative unit" (Metz 1974, p. 24). An interactive experience is comprised of multiple events, instigated by the user over the course of their experience. As Bal writes, "An *event* is a transition from one state to another state" and "to *act* is defined here as to

cause or to experience an event" (McQuillan, 2000, p. 83). The user becomes part of the narrative, as actor (through their act of making a choice within the system), and the system responds causing an event (a transition to another state). In this way, we might say that the user functions as an actor during an interactive experience.

In "The Whale Hunt" we see some examples of the role of motion within interactive experiences, such as navigational structures that animate to provide different options to access the experience, visual feedback from the system, and in the results of various micro-interactions by the user.

While the industry standard for creating kinetic elements on the web has become JavaScript, and the open-source potential of HTML5 and CSS3—the desire to utilize the strengths of motion within interactive experiences seems only just beginning again. More and more browsers are supporting CSS animations and transitions, allowing for nuanced animation of individual elements, or entire images, like those seen in Bryan James' *In Pieces* (Figure 7) created completely by animating CSS polygons. The fast-paced evolution of code languages owes a great deal to the "Open Source"[1] movement and, of course, this will continue. HTML / CSS will surely be replaced by a new platform in the future.

Working with time-based media involves understanding not only what is moving or happening before us, but how it is moving / behaving. In 1981, Walt Disney Studio animators Ollie Johnston and Frank Thomas published the book *The Illusion of Life: Disney Animation* describing their philosophy of animation, and outlining a set of twelve principles still used today. These principles focus on how characters, objects, or elements perform over time. In some ways, similar to Gestalt's foundation in human perception, the animation principles define a set of behaviors that also relate to nature—in this case to what we witness in our experience of the physical world. Their main purpose is to produce the effect that characters are conforming to the

basic laws of physics, therefore making their motion more real and "natural." In their view, even inanimate objects and shapes need to become "characters" so that they can be imbued with emotions that the audience will identify with: "It makes little difference whether the characters who have these feelings are human, animals, make-believe creatures, or even inanimate objects given a personality" (Johnston & Thomas, 1981, p. 502).

Taking this idea and applying it to design for time and motion, we see that elements need to take on qualities of the real world, through a display of kinetic "behaviors." In his book, *Motion Graphic Design: Applied History and Aesthetics*, Jon Krasner (2013) discusses the behavior of elements in a motion sequence as having "birth, life, death," referencing the narrative structure inherent in motion design, and yet another example of how these principles make reference to human experience (p. 56).

One of the most important principles in the set of twelve defined in *The Illusion of Life* is "Squash and Stretch." This axiom describes how when a fixed shape flows across the paper / stage / screen, it will appear more natural if movement is seen within the shape itself, especially if it meets some kind of resistance. The most common example of this is a bouncing ball whose form, once it hits a surface, is seen first to "squash" (its mass extending horizontally), followed by a "stretch" action, (its mass extending vertically) before it bounces upward, as seen in Figure 8 (Johnston & Thomas, 1981, pp. 47–48). Another important principle is that motion is not perceived at a constant rate by the human eye, but rather appears to have a "Slow In and Slow Out." The animators discovered that without this quality, their sequences ended up having an unnatural and mechanical quality. In their book, Johnston and Thomas write, "Walt continued to ask us to analyze the actions more carefully, and to understand how the body worked, since this was the only way to get the caricature of realism he wanted" (p. 62). Similarly, the third principle, "Arcs," describes how living organisms do not behave in a rigid, autonomous manner, but rather their movements always describe an arc in some way (p. 62).

Figure 8
Stills from Student Motion Study.

Copyright 2015 by Michael Cocciadiferro. Reproduced with permission.

Design fundamentals can begin with an exploration of formal principles in static compositions, advance to studies that explore how they function in static visual sequences, and finally move into full-motion, time-based investigations. Just as the scope of design has expanded to include motion, so has our vocabulary of structure and forms. Although designers cannot avoid learning and working with technologies, building knowledge about a broad range of principles can be independent of them, and provide a wide base for understanding the scope of current design practice. A simple series of compositions can be translated into a "flipbook" (Figure 9). Later, once

designers become more advanced, these principles can be applied to working with more complex technology, such as motion graphics and programming tools / software.

When discussing formal relationships, Principles of Gestalt, narrative, and animation can provide a theoretical basis for integrating motion into design education. Although we may not have always considered these concepts part of a "universal" language of form, now that motion and interaction design are pervasive, that may need to change. In addition, their references to human experience and perception may in part explain why motion design and kinetics is a powerful modality within graphic / communication design.

Meaning

> *"Recognition of a form is only the first step toward the conveying of meaning. Processing a form, deciphering it, is the second step."*
> *– Kenneth Hiebert (1998) in* Graphic Design Sources

Designers have been discussing the relationship between form, content, and meaning since the profession was first established. In design school, traditional formal exercises are followed by an integration of signs such as words and images, and a discussion of how meaning is created. While aspects of human perception and experience influence how we understand forms, it has been established that an audience's interpretation of symbolic, non-representational figures is determined by culture and context (Chandler, 2007, p. 148).

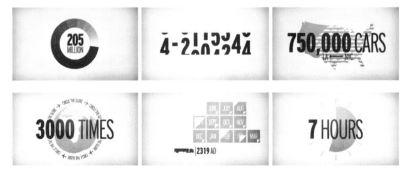

In basic terms, semiotics is the study of signs and how they are interpreted. A sign is the smallest unit of meaning, and comprised of several parts. Concepts from semiotics are often used as a methodology for creating / imposing meaning in graphic design, and reference the work of Ferdinand de Saussure (1857–1913), Charles Sanders Peirce (1839–1914), and Roland Barthes (1915–1980) (Chandler, 2007). Saussure's structure is two-part, composed of *signifier* (the material form of the sign) and *signified* (the concept it evokes). Peirce's model, on the other hand, has three parts, the *representamen, interpretant*, and *object* or (more simply) sign vehicle (form of the sign), sense (sense made of the sign), and referent (what the sign stands for) (Chandler, 2007, pp. 15–28). Semiotics focuses on not only what we might ordinarily think of as "signs," such as language, but anything that can "stand for" something else (Chandler, 2007, p. 2). Words are often used as an example to explain how signs do not have any intrinsic meaning, and only become significant once they are invested with meaning by a community that uses them (Chandler, 2007, p. 260).

In his influential book *Image–Music–Text*, Roland Barthes analyzes how culture and ideas are encoded in photographs, and function in film (what he calls cinema). In "The Rhetoric of the Image" he describes how the photograph contains three different types of messages: the coded "linguistic" message, the coded iconic or "symbolic" (connoted) message, and a non-coded iconic or "literal" (denoted) message (Barthes, 1977, pp. 41–42). His essay "The Third Meaning: Research on Some Eisenstein Stills" takes this further, describing a third "obtuse" meaning, which he identifies as the key to what distinguishes how a film communicates. He writes, "The filmic is that in the film which cannot be described, the representation which cannot be represented" (p. 64). Soviet theorist Lev Kuleshov (1893–1953) proposed a hypothesis that film's effect is not based on the content of shots, but the edits that connect them together (Kuleshov, 1975). In Sergei Eisenstein's (1988) essay "Beyond The Shot," he calls this "the montage of attractions" in which "the combination of two 'representable' objects achieves the representation of something that cannot be graphically represented. For example: the representation of water and of an eye signifies 'to weep,' the representation of an ear next to a drawing of a door means 'to listen'" (Taylor, 1988, p. 139).

As French film theorist Christian Metz (1931–1993) writes in *Film Language: A Semiotics of the Cinema*, "A motionless and isolated shot of a stretch of desert is an image [...] several partial and successive shots of this desert waste make up a description [...] several successive shots of a caravan moving across the desert constitute a narrative." A narrative requires a sequence of images / ideas. Metz (1974) continues, "[I]n narrative, the signified is temporalized [...] The basic figures of the semiotics of the cinema—montage, camera movements, scale of the shots, relationships between the shots, relationships between the images and speech, sequences" (p. 88, 94).

In 2002, a group of researchers conducted a quantitative study to find out whether motion, as an element within interactive media, had identifiable

and consistent meanings and affordances. They based their study, in part, on the seven stages of action that Donald Norman describes in *The Psychology of Everyday Things:* Before Executing Action (attraction), Executing Action (engagement), and After Executing Action (extension). Motion on screen includes specific components: objects, behaviors, space, and time: "Motion occurs when there is a change of behavior of objects in space through time" (Jeamsinkul & Poggenpohl, 2002).

Their experiment examined three different types of "motion meaning," including interpretive meaning, emotional response, and motion affordance. Their premise: that designers could utilize this kind of knowledge to create more effective and natural ways of employing motion to enhance user experience. In this fascinating study, experiments revealed that it might be possible to develop from the findings a "motion language" to be utilized by designers.

The study found that although participants from Eastern and Western cultures interpreted motion differently in a few ways, emotional responses to motion were consistent. Similarly, there was no difference between female and male participants' responses. Emotional response categories included: Boring-Interesting, Unpredictable-Predictable, Idle-Active, and Annoying-Pleasing (Jeamsinkul & Poggenpohl, 2002).

For graphic/communication design, a discussion of semiotics can provide a framework for how meaning is created in a narrative structure, whether static or dynamic. The juxtaposition of images (or words + images), or shots (scenes + sound) in a time-based work, function in the same way. In a static composition, the meaning is constructed when elements are juxtaposed and therefore understood "in relationship" to one another (Figure 11).

In a time-based work, visual juxtaposition is also in play, but messages are conditioned by filmic pacing, duration, and velocity, as well as built by the sequencing of the elements themselves—in the "gap" between elements / instances—their "signified" happening solely in the mind of whomever is audience / interpreter (Figure 12). In the context of motion's role within interaction design, could we consider the separate "moments" of a user's experience akin to jump cuts in a film—a kind of graphic juxtaposition? If we did, we could see a user's experience as itself building a "montage of attractions" through which "the combination of two 'representable' objects achieves the representation of something that cannot be graphically represented" (Eisenstein in Taylor, 1988, p. 139).

Throughout this discussion, we have talked about motion in several different ways. First, we have considered it as a medium for communication, such as a motion graphics work. In this context, motion becomes a signifier, part of the substance of the expression (the "material" of the medium). Motion's affordances include time (duration), pacing, rhythm, sequence, narrative, and behavior.

For interaction design, we have discussed motion as a design element and potential "language" with a grammar for how users perceive, feel, and respond. In this participatory context, motion also increases the "experiential" quality of the interaction. In an interface, motion might be used to draw our attention, indicate that something has happened (visual feedback), indicate that something has changed location (slide, zoom, fade), or allow the experience to build upon itself (hide/reveal). Sometimes we see this in the discrete interactions and micro-interactions within an interface, or in the way that the entire experience is constructed—the computer screen becomes the user's point of view from which vantage she / he can manipulate what is seen and experienced in 2D space (Figure 13).

Although the distinction between signifier and signified has at times been compared to "form" and "content," the idea of the form as "container" is considered problematic by later theorists, the argument being that this structure would suggest that meaning can be extricated from the content, and does not address the role of interpretation, or that form in itself can contribute to meaning (Chandler, 2007, p. 56). Saussure saw both the signifier and the signified as immaterial "psychological" forms, "the actual inscription being irrelevant, because it does not affect the system," but later theorists chose to restore the materiality of the signifier (Chandler, 2007, p. 51).

In 2009, following up on his essay "Designer as Author," Michael Rock addressed these issues in "Fuck Content." He writes, "If content is the source of form, always preceding it and imbuing it with meaning, form without content (as if that were even possible) is some kind of empty shell." Rock explains that the previous essay was misinterpreted as a call for designers to claim the mantle of authorship. Instead, his point seems to be one of reclaiming the value of form-making as essential to meaning and communication. He writes, "Shaping itself is a profoundly affecting form [...] As a popular film critic once wrote, 'A movie is not what it is about, it's how it is about it.' Likewise, for us, our What is a How. Our content is, perpetually, Design itself" (Rock, 2009). All of this suggests a culmination of McLuhan's famous confluence of medium and message, updated for today's design labor economy and a more up-to-date view of the subtle delineations of form and content in an ever more technologized practice.

Media
In his book *The Language of New Media*, theorist Lev Manovich (2001) asserts that the adoption of software tools in the 1990s by filmmakers, graphic designers, and animators drastically changed the relationship between different media, and forever altered the boundaries between them. Where formerly filmmakers and designers used completely different technologies to create, now their tools, methods, and techniques converged. The result is, according to Manovich, a new landscape in which media has been "liberated from its traditional physical storage media—paper, film, stone, glass, magnetic tape" (p. 83).

Manovich (2001) proposes that this has not only affected creative practice in several disciplines, combining elements from three different cultural traditions, but has also resulted in a language of "cultural interfaces" and a new aesthetic:

> A digital designer can freely mix pages and virtual cameras, table of contents and screens, bookmarks and points of view. No longer embedded within particular texts and films, these organizational strategies are now free floating in our culture, available for use in new contexts. In this respect, printed word and cinema have indeed became interfaces—rich

sets of metaphors, ways of navigating through content, ways of accessing and storing data. (p. 83)

In 2006, Manovich continues this line of thinking in his essay "Import / Export: Design and Contemporary Aesthetics." Here, he describes how the issue goes beyond the use of the same tools, to the impact of the literal importing and exporting of files between different kinds of authoring software, resulting in a "metamedia" which allows remixing techniques of different media within one project. An effect of the software revolution is that "the whole language of contemporary graphic design was fully imported into the moving image area—both literally and metaphorically" (Manovich, 2006, p. 8). In 2001, Jessica Helfand seems to reflect on this as well:

[I]f the viewer moves through the information, and the information itself is moving, it is this kinetic activity—this act of moving that circumscribes our perception, dominates our senses, and becomes, in a very noticeable sense, the new prevailing aesthetic. (p. 38)

In the twenty-first century, a lot of discussion has been centered on design practice changing from an artifact-focus to a system and experience-focus. Maybe motion—whether functioning as medium, element, or language— beyond greatly contributing to the experiential quality of an expression, is actually the primary force that has catalyzed this blending of media to create different kinds of experiences at all. Lisa Strausfeld's "Financial Viewpoints" from 1994 is a relatively early good example, the audience/user is situated "inside" of a cinematic space, which moves, changes, and responds to actions in 3D space (Figure 14).

Figure 14
Stills from "Financial Viewpoints."

Copyright 1994 by Lisa Strausfeld. Reproduced with permission.

In *Narrative as Virtual Reality*, Marie-Laure Ryan (2015) proposes that the concept of "virtual reality" (VR) can be revised from a technological frame to one used to develop a "phenomenology of reading, or more broadly, of experiencing art" (p. 2). Although we do not have sufficient space here to fully discuss her ideas, she raises concepts that seem pertinent to our topic.

Ryan (2015) traces the history of Western art to demonstrate a rise and fall of "immersive ideals" in the nineteenth century that are then supplanted by "an

aesthetics of play and self-reflexivity" that eventually produced the "ideal of active participation" of the audience / user:

> The feature of interactivity conferred upon the text by electronic technology came to be regarded as the fulfillment of the postmodern conception of meaning. [The reader] participates in the construction of the text as a visible display of signs. (p. 5)

The dynamic digital surface of the screen allows for a wide scope of options for representation, from the appearance of a 2D surface, to varying levels of realism, depth, photographic, static, and moving images. The aesthetics of illusion, and resulting sense of "immersion" displayed in the nineteenth century, is replaced in the twentieth century with a move toward "interactivity"—the interpretive role of the audience / viewer (Ryan, 2015).

Where immersion suggests a kind of loss of self / body (blamed for society's fears of VR), active participation and interactivity insert a measure of control into the immersive media, and put distance between the audience / user and the experience itself.

Motion, it seems, can span this breadth. As the mode of expression for a graphics sequence, motion provides a linear, directed experience with qualities of "immersion." On the other hand, motion as an element and device within interactive media provides a non-linear, active, exploratory, and participatory experience. This encompassing nature of motion makes it appropriately analogous to how we observe the convergences of media today.

Contemporary media theorist Janet Murray (2011) seems to share some of Manovich's focus on media convergence, but goes further to assert that all media that share electronic bits as their material, belong to one medium—the digital medium:

> It is the designer's task to work at all three levels of media making— inscription, transmission, and especially representation—to accelerate the collective project of inventing a new medium by creating and refining the conventions that will bring coherence to new artifacts and enhance their expressive power. (p. 39)

Murray identifies four affordances of the digital medium significant for representation: procedural, participatory, encyclopedic, and spatial. Motion in digital media and the kinetic qualities of interaction design utilize these affordances in various ways. The procedural and encyclopedic nature of the medium are the algorithms that fuel different software used to create kinetic elements, such as AfterEffects, JavaScript, and HTML / CSS. Motion also employs the participatory and spatial affordances of the digital medium, allowing users to instigate changes within an experience through direct,

kinetic manipulation. Spatial affordance provides an audience and/or user a window into a dynamic space, or virtual entrance, locating the user inside the space itself.

In 2001, Casey Reas and Ben Fry developed Processing, a "software sketchbook" which "relates software concepts to principles of visual form, motion, and interaction" (Fry & Reas, 2014, p. 1). A pioneering but still great example, this project clearly demonstrates the procedural and encyclopedic nature of the digital medium, and the notion that, in Reas' and Fry's words, "Every programming language is a distinct material" (Figure 15).

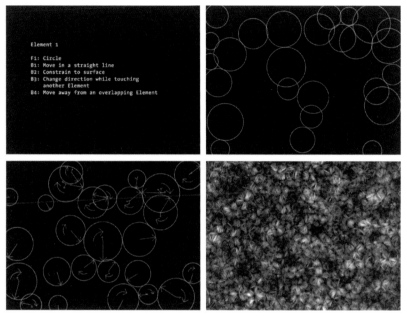

A brand identity that was developed with Processing for the MIT Media Lab also demonstrates these qualities (Figure 16). The logo is generative, an algorithm originating the creation of 40,000 different logo variations, in twelve different color combinations. This example (and others like it) also demonstrates a fascination with motion as an aesthetic in itself, and the possibilities of fluid systems of forms, rather than fixed visual solutions.

Motion and fluidity itself might be considered one of the significant metaphors for our transmedia condition in this century. Today, very little is static. It's difficult to stay informed about changes in technology, let alone our complex globalized condition. Even a "fixed width" website is a "flow" of content into viewport and browser, constantly being reformatted and translated into visual form through style sheets, and often a browser's own resilient / resistant logic of "defaults."

Motion can also be seen as a formal language influencing what we create. In the Alzheimer Nederland identity by Studio Dumbar, motion is central to the logo's invention (Figure 17). A brand identity, once considered the unwavering "standard" to represent an organization with strict guidelines, can also be turned upside-down, using the aesthetics of motion to create a family of forms, related by an underlying idea, yet visually different (Figure 18). The logo for a landscape architecture firm by Sagmeister & Walsh is shaped by interactions with elements of water, wind, and earth. Designers are storytellers, and an identity system is just that. Today designers need to be able to work between different media, understanding their strengths, and how to translate a concept into different forms. Although the idea of "transmedia storytelling" was first coined to describe a phenomenon in entertainment where "integral elements of a fiction get dispersed" across multiple delivery channels—this idea could be used to describe many projects that designers presently take on (Jenkins, 2009, p. 85).

Based on the breadth of our current mediascape, storytelling across multiple media is a logical focus of many design studios. Creating a narrative and disseminating its substance across brand identity, interactive experiences, motion, print, and social media is commonplace. And designers need to understand the core issues of the current times, but with the emergence of a participatory culture, where all kinds of people are creating, communicating, and collaborating—everyone does!

In 2006, The MacArthur Foundation launched *Confronting The Challenges of Participatory Culture*, a five-year digital media and learning initiative to help determine how digital technologies are changing the way young people learn, and to define a new set of media literacies (Jenkins, 2009, p. xi). Integral to this study is the notion that our culture encourages expression,

Figure 18
SWA Identity.

*Copyright 2015
by Sagmeister
& Walsh.
Reproduced with
permission.*

civic engagement, creating, and sharing, and that new literacies need to be identified and nurtured. In the 2009 white paper, Jenkins discusses scholar Gunther Kress' articulation of the issue:

> [M]odern literacy requires the ability to express ideas across a broad range of different systems of representation and signification (including 'words, spoken or written; image, still and moving; musical...3D models...'). Each medium has its own affordances, its own systems of representation, its own strategies for producing and organizing knowledge. Participants in the new media landscape learn to navigate these different and sometimes conflicting modes of representation and to make meaningful choices about the best ways to express their ideas in each context. (pp. 87–88)

The breadth and nature of design practice has changed enormously in the last decades, and this course will undoubtedly continue. The increasingly interdisciplinary nature of design requires us to reconsider our design fundamentals, preserve our traditions, and to build a new framework—one that integrates motion as one of its core principles, rather than a peripheral and separate modality. By examining different principles of design practice and education, we have seen them in relationship to one another, pointing towards potential avenues for building a new and integrated framework.

Jennifer Bernstein, Assistant Professor, Graphic Design Coordinator, Department of Arts, Culture and Media, Graphic Design Faculty, Rutgers University-Newark

Principal, Creative Director, Level Group (New York City)

Note

[1]The "Open Source" movement began in the late 1990s with an interest in the collaborative development of software source code. The term was coined in 1998 when the OSI (Open Source Initiative) was formed. https://opensource.org/history

References

Arnheim, R. (1974). *Art and visual perception: A psychology of the creative eye.* Berkeley: University of California Press, rev. ed, 1974.

Barthes, R. (1977). *Image-Music-Text.* London: Fontana.

Chandler, D. (2007). *Semiotics: The basics* (2nd ed.). London: Routledge.

Fontsmith. (2014). *FS Millbank* [Interactive microsite]. Retrieved from http://www.fsmillbank.com/#/fs-millbank

Fry, B. & Reas, C. (2014). *Processing: A programming handbook for visual designers and artists.* Cambridge: The MIT Press.

Harmon, C. (2011). *Oil'd.* [Video]. Retrieved from https://vimeo.com/harmondesign

Harris, J. (2007). *The whale hunt.* [Interactive website]. Retrieved from http://thewhalehunt.org/

Helfand, J. (2001). *Screen: Essays on graphic design, new media, and visual culture.* New York: Princeton Architectural Press.

Hiebert, K. (1998). *Graphic design sources.* New Haven: Yale University Press.

Hofmann, A. (1965). *Graphic design manual.* Niggli: Niggli Verlag.

James, B. (2014). *In pieces: 30 species. 30 pieces. 1 fragmented survival. A CSS-based interactive exhibition celebrating evolutionary distinction* [Interactive website]. Retrieved from http://www.species-in-pieces.com/

Jeamsinkul, C., & Poggenpohl, S. (2002). Methodology for uncovering motion affordance in interactive media. *Published in Visible Language, 36* (3). Retrieved from https://www.questia.com/read/1P3-265280001/methodology-for-uncovering-motion-affordance-in-interactive

Jenkins, H. (2009). Confronting the challenges of participatory culture: Media education for the 21st century. *MacArthur foundation report on digital media and learning.* Cambridge: MIT Press.

Johnston, O. & Thomas, F. (1981). *The illusion of life: Disney animation.* New York: Hyperion.

Klee, P. (1956). *Notebooks, Volume 1: The thinking eye.* New York: Lund Humphries.

Köhler, W. (1947). *Gestalt psychology.* New York: Liveright Publishing.

Krasner, J. (2013). *Motion graphic design, applied history and aesthetics.* New York & London: Focal Press.

Kuleshov, L.V. (1974). *Kuleshov on film: Writings by Lev Kuleshov.* (R. Levaco, Trans.). Berkeley: University of California Press.

Lupton, E., & Miller, A. (1996). *Design writing research.* New York: Princeton Architectural Press.

Lupton, E., & Phillips, J.C. (2015). *Graphic design: The new basics* (2nd ed.). New York: Princeton Architectural Press.

Manovich, L. (2001). *The language of new media.* Cambridge: The MIT Press.

Manovich, L. (2006). Import/Export, or Design Workflow and Contemporary Aesthetics. Retrieved from http://www.manovich.net

McQuillan, M. (Ed.) (2000). *The narrative reader.* London: Routledge.

Metz, C. (1974). *Film language: A semiotics of the cinema.* (M. Taylor, Trans.). Chicago; University of Chicago Press.

Murray, J. (2011). *Inventing the medium, principles of interaction design as a cultural practice.* Cambridge: The MIT Press.

Reas, C. (2010). *Stills from process compendium lecture.* [Video]. Retrieved from https://vimeo.com/22955812

Rock, M. (2009). Fuck content. Retrieved October 14, 2016 from http://2x4.org/ideas/2/fuck-content/

Ryan, M.-L. (2015). *Narrative as virtual reality 2: Revisiting immersion and interactivity in literature and electronic media.* Baltimore: Johns Hopkins University Press.

Taylor, R. (Ed.) (1988). *Sergei Eisenstein, Selected writings volume I: 1922–34.* (R. Taylor, Trans.). London: British Film Institute.

Section 2
Communication Theory

Bruno Ribeiro
Figures of Speech and Motion Design

The rhetoric of visual language is not that different from the spoken or written language. Visual designers tell stories through the same rhetorical devices, whether consciously or not, because it is through rhetoric that humans find sense and meaning of the novelty. We use metaphors, hyperboles, and metonymies to convey our message.

For Hanno Ehses, "Shaping the appearance of any visual object involves rhetoric" (Ehses & Lupton, 1996). He also explains that, "Language is never simply a form of expression: it is a functional tool that is manipulated to achieve desired ends" and combats the prejudice and misunderstanding that associates rhetoric with fraud, seduction, deceit, and sheer ornamentation. Ehses explains that rhetoric is concerned with "the appropriate use of language to facilitate human affairs."

It was Gui Bonsiepe who, in the 1960s, first drew the analogy between rhetoric and design, aiming to establish foundation and vocabulary for analysis (Joost & Scheuermann, 2006). His essay "Visual-verbal rhetoric" was the first attempt to apply the vocabulary and distinctions of verbal rhetoric to visual communication. Bonsiepe did an analysis of a compilation of visual communication work through the lens of figures of speech, such as metaphor, metonym, and exaggeration (Bonsiepe, 1999).

The purpose of this chapter is to analyze figures of speech and relate them to motion design. Sometimes, the figures of speech are used to add personality through a specific style, capturing the audience's attention and avoiding boredom. But in many cases, the figures of speech, also called figures of thoughts, are the intrinsic structure of the thought behind the discourse. Either way, Joost and Scheuermann (2006) explain "an intrinsic characteristic of rhetoric: its actions are intentional. That means: rhetorical means are used to achieve a previously designated objective — whether it be the intention of educating the public, amusing it or arousing emotions."

As professionals, we can't afford to use figures of speech without carefully consider their implications to the message being conveyed. Everybody who uses a language may use figures of speech, most of the times without knowing that they are using them or even having studied any rhetoric. Professional writers, however, need to carefully choose their words and rhetoric devices. Without stretching the analogy too much, we can state that designers are bound by similar rules. We may have used visual rhetoric in the past, without acknowledging it, but by naming and recognizing the use of rhetoric devices, we are able to apply them more consciously.

Furthermore, through the lens of figures of speech, educators and practitioners can establish a vocabulary to discuss and analyze the effectiveness of communication.

This chapter doesn't aim to exhaust the possibilities of correlating literary rhetoric and visual communication. Rather, it shows some examples of motion design and compares them with figures of speech and briefly discuss the effect of the rhetoric devices in the message communicated by each example. The goal, however, is not to explain the reasons behind the effectiveness of each of those devices. "In this duo [between theory and practice], theory is not responsible for explaining *why* something works—rather more, it provides the description of *what* works *when*" (Joost & Scheuermann, 2006).

Metaphor

"'Metaphor' was defined by Aristotle (Poetics XXI, 1457b) as giving the thing a name belonging to something else, the transference being on the grounds of analogy" (Coulson, 2006). It "is now seen as one of the foundations of all language, and its use, being constitutive of meaning, is seen as normal, grounded in experience, and offering guidance to linguistic expression" (Steen, 2006).

In its oldest definition, a metaphor is an analogy that draws attention to similarities between different subjects or domains. "Famous metaphorical quotations may illustrate this phenomenon, from the Bible's *The Lord is my shepherd* through Karl Marx's view of religion as *the opium of the people*, to George W. Bush's repeated use of the *axis of evil* to refer to Iran, Iraq, and North Korea" (Steen, 2006).

In motion design, a metaphor is used by exploring similarities of two distinct domains, either to convey information more clearly or for stylistic reasons. We can look at the opening credits for Alfred Hitchcock's 1960 movie *Psycho*. In the story, the character Marion Crane is stabbed to death in the shower, in what has later become one of the most iconic scenes in all of cinema. For the opening credits of the movie, Saul Bass used fragmented typography, as if it had too been sliced with a knife, as a metaphor for what happens to the character in the movie plot. The result is an intriguing sequence that sets the tone for Alfred Hitchcock's movie.

Figure 1
Opening credits by Saul Bass for the film Psycho.

Source: Hitchcock, 1960.

Metaphor, however, is not only used when there is perceived or consciously achieved similarity between two subjects or domains. It is also used to create structure where there is none. In the book *Metaphors We Live By*, George Lakoff and Mark Johnson (1980) argue that the "human *thought processes* are largely metaphorical" (p. 6). The authors exemplify that in the way we talk about argument as war ("Your claim is *indefensible,*" "I *demolished* his arguments.")

reflects how we think about argument and structures the action we perform when arguing. Lakoff and Johnson also use the concept of time as money or a limited resource ("*spend time*," "*cost* me an hour," "*running out* of time") as an example of a system of metaphorical concept to structure how we think.

A sustained metaphor through the whole discourse is called allegory. In the case of graphical user interface (GUI) found in personal computers since the 1980s, for example, it is what structures our process of interacting with the computer, through representations of physical elements found in real offices, such as files, folders, trash cans, etc., instead of the complexity of command lines and programming languages. Motion has been part of the interface metaphors as well. With the use of a mouse, we have moved files in our hard drives (or other disks) from one digital location to another by dragging icons on the screen, as if they were physical objects, such as a stack of paper being put away into envelopes or physical folders. Furthermore, in cases where the metaphorical window is too small to show all its content at once, we can digitally scroll it, as if they were physical frames or even medieval manuscript rolls.

Figure 2
Example of a window with a scrolling bar in the graphical user interface of the original Apple Macintosh.

More recently, with the advance of technology and popularity of smart phones and tablets, we have started to swipe, push, and pinch on the multi-sensor glass interface. More than stylistic decisions, those metaphorical interactions create the structure that makes it possible for us to use those devices. Without any apparent command line, any mice, or any physical keyboards, the interface becomes the product. On a touch screen, the tap is a direct substitute for a mouse click, in many operations. In those cases, we tap virtual buttons, without much motion involved in the task. But in cases that involve rearrangement, for example, it is the dragging that makes them possible. Furthermore, swiping and other gestures have become to touch screen devices what keyboard shortcuts have been to traditional desktop computer, a means to faster complete tasks. The main difference is that, because gestures are tied to metaphors of interactions with physical objects, they are more memorable and also more enjoyable.

Metonymy

Metonymy is a figure of speech where we replace a word or a phrase with another word or phrase to which it is cognitively associated. Most of the times, it is used for reduction, and it can be found frequently in our everyday life. "Metonymies can be based on many cognitive and culturally based conceptual

Figure 3
*Example of how
to swipe to interact
with the application
Mail on Apple's
iPhone.*

relationships. To give only two examples […]: in 'Napoleon lost at Waterloo,' metonymy is based on the controller-controlled relationship; in 'The kettle is boiling,' metonymy is based on the container-contents relationship" (Nerlich, 2006). In the first example, "Napoleon" is used in place of the French Army; in the second example, it is the water contained in the kettle that is boiling, not the kettle itself. These relations are so inherent to our communication that the cognitive load is very low. The recipient of the message understands it without being caught in the literal meaning of an actual kettle being boiled, which would not even make sense. In these cases, the use of metonymy for succinctness is almost unconscious.

In rhetoric, "using metonyms [speakers] tell you more while saying less" (Nerlich, 2006). In visual and motion design, designers may convey more information with fewer lines and more concise visual representations. In the short animation *Cinematics* by the designer Pier Paolo (2014), the concept of visual metonymy is explored in multiple layers. The movies are being represented through simplified representation of their main characters in famous scenes. The characters and scenes, in turn, were reduced to few recognizable elements. They are all examples of a specific class of metonymy called synecdoche, where a part represents the whole, or vice-versa.

In the students' work *Skylines* (2015), by Ariel Cheng, Catie Halliday, and Emily Wang, the drawing lines are a metaphor for the cities being built, as the lines and fillings of the drawings mirror the process of constructing the buildings in the cities. The freely interpreted skylines are metonymic representation of London, Venice, and Rio de Janeiro. The cities are reduced to few recognizable, though intentionally inaccurate, visual elements.

Hyperbole

Hyperbole is an exaggeration, as in the sentence, "It's a million degrees today." The effect is not realistic, but an emphatic statement that should not be taken literally.

In the book *Disney Animation: The Illusion of Life*, Frank Thomas and Ollie Johnston (1984) detailed their "12 Principles of Animation." One of the principles presented in the book is *exaggeration*: "When Walt [Disney] asked for realism, he wanted a caricature of realism. [...] Walt would not accept anything that destroyed believability, but he seldom asked an animator to tame down an action if the idea was right for the scene" (p. 33). It may sound like a contradiction, but Disney knew that believability came from perception and not reality.

In the logo introduction for Pixar Animation Studios, a lamp bounces four times on the top of the letter 'I' before crushing it. The motion that the letter does after each time it is hit by the lamp is exaggeratedly stretched to convey the elasticity of the letter that makes the lamp jump in the air.

For United Kingdom's Channel 4's coverage of the 2016 Paralympic Games in Rio, Jump Design created a visual identity based on hyperbolic representation of British athletes as superhumans: "Jonnie Peacock proudly struts with resplendent feathers. [...] David Weir transforms into an unstoppable 'Weir Wolf'. Hannah Cockroft engulfs her competitors with the power of a hurricane. [...] Richard Whitehead blasts through his competition in the final 100m" (Jump Design, n.d.). The footage from previous competition is also accelerated to emphasize the alleged superpowers of the athletes. The high-speed effect is especially successful in the end, when it shows the runner with a jet pack on his back accelerating and passing several athletes in the race.

Figure 7
Promotional video for Rio Paralympics on Channel 4.

Source: Jump Design, n.d.

Zeugma

In the literary rhetoric, zeugma is a figure of speech in which one element is used with its literal and non-literal meanings in different parts of the sentence, as in the English proverb, "Eggs and oaths are soon broken." The verb "break" is used literally when referring to the broken eggs, but it is also being used figuratively when referring to the broken oaths.

In motion design, it is not unusual to see an element changing its meaning or function. We can consciously break the consistency of visual elements, by changing their scale, color, orientation, perspective, or context to achieve a humorously surprising effect.

In the opening credits, by Olivier Kuntzel and Florence Deygas, for the movie *Catch Me If You Can* (2002), elements change their meanings with the change of scale. It is almost like they were visual puns. The surprising element makes the opening credits interesting by the unexpected turns in the sequence, mimicking the plot of the movie and its somewhat incredible action. The change of meaning is a representation of the different roles that the main character, Frank Abagnale Jr., plays through disguises during the movie.

Figure 8
Opening credits for the movie Catch Me if You Can.

Source: Spielberg, 2002.

In the closing title sequence for the movie, *The Incredibles* (2004), in little more than five seconds, sparkles become musical notations, which, in turn, after changing color, perspective, and orientation, becomes the road where the heroes of the movie chase a villain.

In the student work, *Tarantino Movies*, by Matt Brennan, Jordon Gonzales, and Habib Placencia (2016), the sequence to represent *Pulp Fiction* begins with two characters looking to the city. After zooming out, the red sky of the first scene transitions into a cherry in a milk-shake. In turn, by changing the orientation of the milk shake, its straw becomes a paper roll used to inhale drugs, in a key scene of Quentin Tarantino's movie.

As we can see by the examples above, zeugma is a figure of speech that can be used to transition from one scene to another. Just like in literary rhetoric, the effect is a surprising and engaging twist in the discourse.

Antithesis

Antithesis is "the rhetorical contrast of ideas by means of parallel arrangements of words, clauses, or sentences (as in 'action, not words' or 'they promised freedom and provided slavery')" ("Antithesis," n.d.). It is the antagonism of two ideas to emphasize one of them or both. In motion design, the antagonism can be emphasized by color schemes, typography, or any other contrast in the visual language. But video also allows the contrast to be expresses through change of pace, music, or other sound effects.

In the video "First step," a collaboration between Buck (2013) and YCN Studio for the UK-based counseling service ChildLine, a dialog between an abused child and a counselor is presented without any spoken words; all the lines are written on the screen, while the audience hears sound effects. When the

child is talking, the background is dark, typography is fragmented, and sound is erratic, to represent all the confusing and difficult thoughts an abused child will likely have when they decide to call such a service. In contrast, the counselor is represented with clear typography over a light background, with some soothing sounds, to represent the guidance the child will receive from the service. The result is a powerful representation of how the service can help in such situation.

Anaphora

Anaphora is a scheme, a figure of speech that relates to how the words are presented, rather than the meaning of the words or phrases. In literary rhetoric, anaphora is the "repetition of a word or expression at the beginning of successive phrases, clauses, sentences, or verses, especially for rhetorical or poetic effect. Lincoln's "we cannot dedicate—we cannot consecrate—we cannot hallow—this ground' is an example of *anaphora*" ("Anaphora," n.d.).

The student's work "Food for thought," by Madison Mar (2014), begins with seven sentences that share the same beginning, changing only the last word.

Your [brain] holds all of your thoughts.
Your [brain] holds all of your knowledge.
Your [brain] holds all of your worries.
Your [brain] holds all of your aspirations.
Your [brain] holds all of your fears.
Your [brain] holds all of your dreams.
Your [brain] holds all of your memories.

In this case, anchoring the beginning of the sentence does not add emphasis, but clarity to the message. Each word is added on its own at a slow pace, so the audience can read each word calmly but does not forget what was the beginning of the sentence. The effect of anaphora in motion design is, then, different than in literary rhetoric and, in this case, it could be read as:

Your [brain] holds all of your thoughts... knowledge... worries...

aspirations... fears... dreams... memories.

Rhyme, Assonance, and Alliteration

Rhyme is the repetition of sounds, especially in the end of words and lines. Assonance, also called "vowel rhyme," is the repetition of the same vowel sound with different consonant sounds, as in "rise high in the bright sky". Alliteration is the repetition of consonant sounds in two or more neighboring words, such as in the verses, "*D*eep into that *d*arkness peering, long I stood there won*d*ering, fearing, / *D*oubting, *d*reaming *d*reams no mortal ever *d*ared to *d*ream before," (italics added) from the poem, "The Raven" by Edgar Allan Poe. All of them are, then, repetition of sounds, often used in poetry. In motion design, we can see elements being visually echoed in different roles for stylistic effect.

In the introductory video of Apple's Worldwide Developer Conference, by Apple (2013), we can observe dots and lines being used throughout the sequence. This form of repetition can be categorized as *visual alliteration*. Just like the repetition of consonants in verbal discourse, the repetition of shapes brings cohesiveness and surprise at the same time.

Figure 13
Introductory video of Apple's Worldwide Developer Conference.

Source: Apple, 2013. Copyright 2013 by Apple Inc.

For the presentation of Nike's soccer shoes Magista 2, FutureDeluxe (2016) created a motion picture using the distinct neon colors of the shoes. The repetition of the same color palette in different shapes and contexts can be categorized as *visual rhyme*. The cohesive and consistent color palette is the basis for the message to be conveyed and what makes the video memorable and effective.

Figure 14
Promotional video for Nike's Magista 2 shoes.

Source: FutureDeluxe, 2016.

In 2013, Brandia Central revealed their logo for the European Soccer Tournament, to be held in France in 2016, through a short animation video that combines both *visual alliteration* and *visual rhyme* (Figure 15). Both the color palette and the reduced shapes are repeated throughout the video, making it cohesive, surprising, and delightful.

Figure 15
Promotional video for the launch of the logo for the European Soccer Tournament.

Source: Brandia Central, 2013.

Chiasmus

"Chiasmus is a verbal figure of repetition whose second half inverts the order of the elements in the first half: 1–2–3 >< 3–2–1" (Nänny & Fischer, 2006). The second paragraph of Ernest Hemingway's "Soldier's Home" is an example of such symmetrical structure in literature:

> There is a *picture* which *shows* him on the *Rhine* with two *German girls* and another *corporal*. Krebs and the corporal look too big for their uniforms. The *German girls* are not beautiful. The *Rhine* does not *show* in the *picture*. (Hemingway, 1925 as cited in Nänny & Fischer, 2006) (Italics added by Nänny & Fischer)

In this promo video for Uber Technologies Inc. (2014), we can see the "1–2–3 >< 3–2–1" structure. In the first half of the video, we see the company's logo, on a generic map background, setting the start of the user's experience with the product. Then, it transitions to the interaction of the user with the phone application to initiate the process of requesting a car ride. Then, we see the car and the end of the requesting process. In the second half, we see the car and the driver, showing the experience of riding the car. Then, we see only the phone with the application again, when the user reviews the ride. Finally, there is the same image of the logo on a generic map to set the end of the user's experience with the product.

We also notice that the mirrored position of the phone emphasizes the symmetrical structure of the narrative. The chiastic pattern mimics the product interaction , conveying that it's easy to get in and out of the car.

Figure 16
Concept of Chiasmus used in a promotional video.

Source: Uber, 2014.

Cliché

Cliché is a term used to identify a phrase or opinion as overused and unoriginal. It implies value judgement and condemn its use as annoying. What can be considered a *cliché* is very subjective and will vary from person to person, according to one's cultural references, domain expertise, etc. There are, however, "several high-profile phrases in circulation that most people would agree to stigmatize: for example, *at the end of the day* 'when everything has been taken into consideration', the *name of the game* 'the main idea or intention', *in this day and age* 'now'" (Ayto, 2006). Just like in writing, painting, music, or any other form of manifestation, the key problem of *clichés* is the overuse of what once began as novelty and later could have been perceived as a new trend.

In motion design, the use of *clichés* has been equally condemned. One example is the pre-built effects in the most popular applications, such as Adobe After Effects. The overuse of such effects makes them lose the intended impact to the point of being only irritating.

Such overuse of effects is not restricted to amateurs, by any means. If we look at the logo sequences from the movie industry, we can notice that many of them have used flares, three-dimensional shapes, and variations of orange and blue. What once could have been perceived as new is now just a repetition of an old formula with very little distinction among them. The result is that most of those sequences are equally forgettable (Figure 17).

Figure 17

Logo introductions for the studios: 20th Century Fox, Universal, and Warner Bros.

Source: 20th Century Fox, 2015 (from the official trailer of The Martian, 2015); Universal, 2003 (from Hulk, 2003); Warner Bros., 2014 (from Godzilla, 2014).

It could be argued that the use of the same visual language and effects would quickly and effectively communicate, by association, that they belong to the industry they are in. But the context of a short clip before a movie is enough to convey that it is a presentation of a company in the film industry. Therefore, studios could surprise their already captivated audience with distinct and memorable visual language.

Catachresis

In literary rhetoric, catachresis refers to a few different types of figures of speech. The word originally meant a semantic misuse or error. It can be defined as the "use of the wrong word for the context" or the "use of a forced and especially paradoxical figure of speech (as *blind mouths*)" ("Catachresis," n.d.). It also means the replacement of a word with a more ambiguous synonym. Examples classified as catachresis also include respected authors that use mixed metaphors for stylistic reasons.

In visual rhetoric, we can call an (unintended) catachresis when the message is not conveyed as intended by the designers. When the message is perceived by most recipients differently than intended by the sender, it is the perception

that counts. Or, as the drawing professor in my design school used to say: "If you drew a horse that looks like dog, it is a dog."

In the student work, *Minute* (2012) by Cullen Arroyo, the assignment was to choose a word with two meanings and, through motion, communicate one of its meanings. The student chose the word "minute," meaning, "extremely small." When he scaled down the word, with no references, the motion could be perceived as zooming out, rather than shrinking (Figure 18).

To fix the problem, the student scaled the word in two movements, shrinking the word vertically and then horizontally. Making his intention clear, the student avoided the unintended meaning (Figure 19).

Figure 18, 19
Stills from student motion sequence Minute.

Copyright 2012 by Cullen Arroyo. Reproduced with permission.

Another example where a student had to consciously avoid miscommunication of his intent, was the work *Plan, Travel, Relax* (2016) by Dylan Stefanisko. In a five-second movie, an airplane leaves a laptop computer screen, flies over a map, and then drops a cocktail umbrella on someone's drink. In Stefanisko's first drafts, the camera would follow the airplane making it appear stationary, with the background passing behind it. The student, then, changed his video to asynchronous movements of character and camera, conveying that the airplane takes us far, rather than let us stay at home and see the world pass us by.

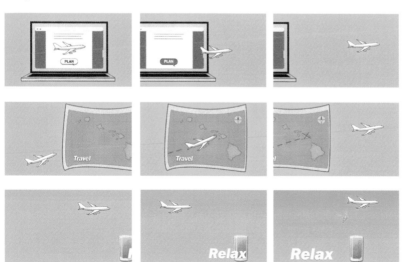

Figure 20
Stills from student motion sequence Plan, Travel, Relax.

Copyright 2016 by Dylan Stefanisko. Reproduced with permission.

Conclusion

As stated in the introduction, this chapter doesn't aim to list all figures of speech that are applied to motion design or to exhaust all possible examples for each one of them.

There will always be disagreements about one example falling into one figure of speech or another. But this is hardly my concern. Rather, I am more interested in establishing a vocabulary that can be appropriated by each practitioner or educator for their needs. Ideally, we would all use the same words with same meanings, but that is not how words work, let alone interpretation of rhetoric. My hope, then, is that it helps you to better communicate with your co-workers (and I include students and instructors in this category) when discussing solutions in the motion design space.

Also, by studying previous work through the lens of visual rhetoric, we establish a set of paths to explore in our own process. We apply old solutions to our new problems, modifying and adapting as needed. It helps, then, alleviate the anxiety of trusting our intuition or depending on genius-like inspiration.

Being more conscious and intentional when applying rhetoric devices to our work and using the appropriate language for the message, the audience, and the media makes the communication more precise, the content more enjoyable, and the work more memorable and distinct.

Bruno Ribeiro, Assistant Professor, California Polytechnic State University

References

Anaphora. (n.d.). Retrieved July 12, 2016, from http://www.merriam-webster.com/dictionary/anaphora

Antithesis. (n.d.). Retrieved July 12, 2016, from http://www.merriam-webster.com/dictionary/antithesis

Apple. (2013). *WWDC 2013 Keynote* [Video]. Retrieved October 1, 2016, from https://developer.apple.com/videos/play/wwdc2013/100

Ayto, J. (2006). Idioms. *In encyclopedia of language & linguistics. (Vol. 5, pp. 518–521).* Boston, MA: Elsevier.

Bonsiepe, G. (1999). *Interface: an approach to design.* Maastricht: Jan van Eyck Akademie.

Brandia Central. (2013). Uefa euro 2016: Ooh là là, it's football art. Retrieved October 1, 2016, from http://www.brandiacentral.com/uk/work/ooh-la-la-its-football-art/

Buck. (2013). ChildLine: First step. Retrieved October 1, 2016, from https://vimeo.com/65337755

Catachresis. (n.d.). Retrieved July 12, 2016, from http://www.merriam-webster.com/dictionary/catachresis

Coulson, S. (2006). Metaphor and conceptual blending. *In Encyclopedia of language & linguistics. (Vol. 8, pp. 32–39).* Boston, MA: Elsevier.

Ehses, H. H. J., & Lupton, E. (1996). *Rhetorical handbook: An illustrated manual for graphic designers : design papers 5.* Halifax, N.S.: Nova Scotia College of Art and Design.

FutureDeluxe. (2016). *Nike Magista 2* [Animated video]. Retrieved October 1, 2016, from http://futuredeluxe.co.uk/work/nike-4/

Hitchcock, A. (Producer & Director). (1960). *Psycho* [Film]. United States: Universal Studios. Retrieved October 1, 2016, from http://www.artofthetitle.com/title/psycho/

Joost, G., & Scheuermann, A. (2006). Design as rhetoric: Basic principles for design research. Retrieved from http://www.geschejoost.org/files/design_as_rhetoric.pdf

Jump Design. (n.d.) Rio Paralympics 2016. Retrieved October 1, 2016, from http://www.jumpdesign.co.uk/work/c4-paralympics/

Lakoff, G., & Johnson, M. (1980). *Metaphors we live by.* Chicago: University of Chicago Press.

Nänny, M., & Fischer, O. (2006). Iconicity: Literary texts. *In Encyclopedia of language & linguistics. (Vol. 5, pp. 462–474).* Boston, MA: Elsevier.

Nerlich, B. (2006). Metonymy. *In Encyclopedia of language & linguistics. (Vol. 8, pp. 109–113).* Boston, MA: Elsevier.

Paolo, P. (2014). *Cinematics* [Animated video]. Retrieved October 1, 2016, from https://www.behance.net/gallery/14304321/Cinematics

Spielberg, S. (Producer & Director). (2002). *Catch me if you can* [Motion picture]. United States: DreamWorks Pictures.

Steen, G. (2006). Metaphor: Stylistic approaches. *In Encyclopedia of language & linguistics. (Vol. 8, pp. 51–56).* Boston, MA: Elsevier.

Thomas, F., & Johnston, O. (1984). *Disney animation: The illusion of life.* New York: Abbeville Press.

Uber. (2014). Learn the Uber basics. Retrieved October 1, 2016, from https://www.youtube.com/watch?v=G8VjcZeuvmo

Walker, J. (Producer) & Bird, B. (Director). (2004). *The incredibles* [Motion picture]. United States: Walt Disney Pictures & Pixar Animation Studios.

"The relative independence of title sequence designs from the demands of drama and narrative in Hollywood's feature films has allowed them a degree of formal experimentation..."

Michael Betancourt

Understanding Text::Image Composites in Title Sequences

Title sequence design has varied greatly in duration, complexity, and independence from the rest of the film over its more than 125 years of history in the United States (Stanitzek, 2009, pp. 44–58). As feature films became the primary type of production, the visuals, running time, and quantity of title cards increased during the 1910s and '20s paralleling the audience's understanding of them. Throughout this history, meaning-creating structures have remained relatively constant. Understanding the semiotics of their interpretation gives insight into their production; applying these formal structures to design requires a consideration of *how* text and image can form singular "statements" for their audience. There are three types of text::image relationship, and contemporary title sequences tend to use a combination of them at different points in a single design.

The basic modes of interpretation were in common use by the 1930s: the calligram and figure-ground mode, distinguished by their formal design (Betancourt, 2015a, pp. 239–252). The figure-ground mode employs text and image that remain separate, independent "fields" (the *figure* and the *ground*) that have no immediately apparent relationship, nor do they imply a connection. While superimposed text over photography used in title sequence designs are the focus of this discussion, the three interpretive modes identified can apply to any text–image composite. The use of the more complex text::image relationships in a title design is closely linked to the identification of that sequence as noteworthy.

The composited arrangements of text and image either invoke the direct link of a textual label attached to its identifying image (Figure 2), or the composition does not propose an immediately obvious association (Figure 1 or Figures 3 & 4). The lexical aspect of these distinct modes is precisely the reason for their appearance and deployment in title sequences. For audiences, these familiar semiotic modes of text–image relationship (figure-ground, the calligram, and the rebus) render visual designs "transparent" in exactly the same way that written language functions without the need for a self-conscious consideration of the individual letterforms. Each mutually exclusive mode interprets the elements contained by a specific title card (image, text). The two primary modes (figure-ground and calligram) provide a methodology for organizing and designing title sequences that renders their comprehension immediate for the viewer; however, the title sequence as a whole may employ different modes individually as/in particular title cards. The third, rebus mode provides

a model for rhetorical meaning through metonymy and synecdoche that illuminates the shifting interpretations and recognitions of how text–image composites relate between each title card and the whole sequence. These modes' heuristic application comes from marking the differences between title designs that produce complex sequences commenting on the main narrative and those, such as the figure-ground mode, that do not.

Theory and Design

What is of interest to the designer in a theoretical approach to design is very different from what is of interest to critical analysis. Theories that designers employ tend to be heuristic, concerned with the material production of work; critical theories are hermeneutic, addressing meaning and significance without concern for productive technique. There is little overlap between heuristic theories and the hermeneutics of use to analysis other than semiotics, which offers a description of general methods producing meaning that can be used hermeneutically and heuristically.

The relative independence of title sequence designs from the demands of drama and narrative in Hollywood's feature films has allowed them a degree of formal experimentation atypical of these productions generally, and suggests a general theory for the analysis, discussion, and design of text–image composites. The development of this approach to titles follows from the lack, noted by media historian Jan-Christopher Horak in his book *Saul Bass: Anatomy of Film Design*, of any formal design theory. Instead, a collection of traditional views about the "ideal" relationship of title sequence to drama have been circulating since (at least) the 1950s. Established approaches to title design follows a hagiography of noteworthy designers—Saul Bass, Maurice Binder, Pablo Ferro, et. al who received on-screen credit—whose work was a model to emulate, neglecting uncredited designers' work as of lesser interest and significance (Billanti, 1982, pp. 60–69, 70–71). These anecdotal approaches do not develop general theories, nor do they propose methods for discussing or analyzing the resulting designs (Horak, 2014).

The three modes described in this analysis are adapted from Michel Foucault's analysis of text::image in Rene Magritte's painting in his book *This Is Not a Pipe*; Foucault's theory about the semiotics of text::image composites as an ordering and dominating expression of vision-as-knowledge can be adapted for a general application to title sequences. Foucault's theorizing of interpretation organized and ordered through a specifically visional dominance equates seeing with understanding, and is embodied precisely in metaphors of vision-as-knowledge; observers gain power over the observed. He uses this conception of sight as a foundation for exploring text–image composites, through what Foucault termed the "empirical gaze" in *The Birth of the Clinic* (Foucault, 1975). Seeing dominates what is seen; *vision* is Foucault's central paradigm for comprehension, linking visual experience to knowledge contained by language in a relationship of telling::showing. Vision transforms entanglements of text::image, rendering the image supplemental (secondary) to language.

The Figure-Ground Mode

The figure-ground mode is the most basic text-image structure. Audience perception of the relationship between typography and image determines the resulting meaning: whether the typography and photography are recognized as being illustratively linked, or remain as separate, distinct "fields" on screen. In the figure-ground mode there is no link between text and image, they are simply shown at the same time. Individual parts of the image remain in separate 'fields' articulated independently: there is no intersection between text and image, and they remain unrelated: historically, it is common for the superimposed text to entirely obscure the background photography. The independence of text-image elements is reflective of categorical differences between connotation (language) and denotation (image): the text is *read*, while the image is *seen* (Barthes, 1991, p. 141).

Figure 1

The Figure-Ground Mode shown in all six title cards from the film Rumba.

Source: Le Baron & Gering, 1935.

The figure-ground mode remains consistent. Designs produced in 1935 and in those made more than seventy years later in 2011 employ the relationship in the same way: in *Rumba* (1935) the list of names are superimposed over a collection of dancing women; in *Unknown* (2011) the credits are superimposed over the opening shots of the story. Both *Rumba* and *Unknown* were chosen as examples for the figure-ground mode because they are specifically average, typical representatives of the same standard approach. In *Rumba*, the dancing shadow-women provide a rhythmic background disconnected from the music. Their presence is merely to provide a motion counterpoint to the stillness of the typography. As there are only six title cards in a two minute sequence, this movement is essential to creating a dynamic composition since the text is entirely stationary. In contrast to *Rumba, Unknown* is organized as an "invisible" prologue sequence, integrated with/into the opening shots of the drama (Betancourt, 2018, pp. 120-146). It does not obscure the important actions on screen.

What is important about these in *Unknown* is the live action photography, not the credits. The type is placed within the photographic composition in empty space ("type hole") that does not interfere with the photography; this approach to narrative integration was pioneered by Wayne Fitzgerald's uncredited design for *Touch of Evil* (1958) (Betancourt, 2013). The text is superimposed,

arranged not to obstruct the narrative background, but is otherwise unrelated to it. Although the narrative runs continuously, eliding the independence of the title sequence from the rest of the film, the formal relationship of figure-ground remains unchanged. The "end" of the titles in *Touch of Evil* is only marked by the theme music ending; in *Unknown,* the end is not clearly marked. Integrations of title cards and narrative background require the distinction of text from image that defines the figure-ground mode. The design must simply place the text so it doesn't obscure the narrative imagery.

The Calligram Mode

The calligram functions as a "label" in relation to the background photography in a link commonly used to precisely identify the actors. Both the figure-ground and calligram modes can (and often do) appear side-by-side within the same title sequence. These relations of text-image depend on the recognition of text–image as fused. Foucault defines calligrams in *This Is Not a Pipe* as entangled text-image combinations where identification and illustration converge, establishing their meaning through the subordination of seeing to reading through a process of enculturation begun in childhood, since the calligram and its structure of image and text are commonly employed in elementary readers for young children:

> In its millennial tradition, the calligram has a triple role: to augment the alphabet, to repeat something without the aid of rhetoric, to trap things in a double cipher. [...] The calligram aspires playfully to efface the oldest oppositions of our alphabetical civilization: to show and to name; to shape and to say; to reproduce and to articulate; to imitate and to signify; to look and to read. Pursuing its quarry by two paths, the calligram sets the most perfect trap. By its double formation, it guarantees capture, as neither discourse alone, nor a pure drawing could do. (Foucault, 1982, p. 20–22)

Text and image are doubles for each other, teaching their connection as both a function of relationship—the text naming the fruit, 'apple,' and the image depicting that fruit converge—and of design, where the proximity and placement of text–image creates a form that reappears as both title cards and as subtitles in motion pictures. In a calligram, reading::seeing are a dual articulation of the same idea. The image and the text do not compete for the audience's attention and understanding, but are fused into a singular unit. In seeing the text placement that produces the apparent linkage of name to live action photography—typically in close proximity to the subject—the audience understands that this text is presented as a label; other text placements that do not produce such an immediate connection are not understood as calligrams, but as figure-ground.

Understanding this direct relationship of text-to-image explains the role of calligrams in the title sequence: they identify the actors even when the rest of the sequence is structured by the figure-ground mode. In *Unknown*, a live action shot of actor Liam Neeson at an airplane window is simultaneously accompanied by the words "Liam Neeson" appearing next to his head (Figure

2). Similar direct relationships appear in Danny Yount's main-on-end design for *Sherlock Holmes: A Game of Shadows* (2011): the credit "Robert Downey, Jr." appears slightly overlapping the actor's image as "Sherlock Holmes." In these title cards, this linkage of connotation and depiction reiterates the text as the image: in both sequences, the actor—"Robert Downey, Jr." or "Liam Neeson"—simultaneously appears on screen, identified and labeled with their name; calligrams appear in title designs precisely because of this mutually reinforcing illustration. The distinction between figure-ground and calligram distinguishes this title card from the earlier ones in the sequence. Even though they also contain images of "Sherlock Holmes," type placement identifies their design as figure-ground, while the slight overlap and proximity of name to image renders the calligram's connections explicit. The audience recognizes this name is a label identifying this man as the actor, connecting his name to his image on screen; this recognition of text-as-label specifically defines the calligram mode.

Calligrams link actors with their real world names, serving an essential function in commercializing cinema by identifying the "star" independently of the role played. It connects reading::seeing as mutually reinforcing illustrations through a logic of similarity and duplicitous naming/showing that acknowledges the fictitious nature of the drama: the name that the actor responds to on screen is not their own; the calligram counteracts this effacement of real identity by inscribing the "true name" of the actors onto their images, contradicting their behavior in the narrative: "Robert Downey, Jr." is *not* "Sherlock Holmes" except within the film. This superimposed text is non-diegetic, external to the "reality" on screen, reiterating the enclosed, independent nature of the drama through (paradoxically) instructing the audience in the *real* identity of the actor distinguished from their character in the story. The audience knows all of this in advance, and the pleasures and attractions of dramatic realism employed in Hollywood films emerge from accepting the fictional "world" (Lackey, 1973).

Figure 2
The Calligram Mode shown in the title card stating, "Liam Neeson" from Unknown.

Source: Silver, Goldberg, Rona, & Collet-Serra, 2011.

The duality of reality and fiction created by the calligram reiterates Foucault's understanding that calligrams demonstrate the "clinical gaze" by actively imposing order through a translation of visual experience into the knowledge contained by language—the label printed on screen: sight actively imposes a hierarchical order on the world. Thus the calligram embodies a subversive

duality. By confusing the image with the text, it asserts the principles that make this hierarchy possible (it combines text and image into a mutually dependent relationship asserting what appears to be a singular meaning), while the drama seems to undermine the certainty of the label (the actor responds to a different name than the one shown).

Distinguishing between real names and dramatic roles asserted through the calligram marks the boundary of the fictional realm within the film itself. The dualities of naming and showing actors is part of the conventionalized realism of dramatic film, where instead of rupturing the illusion, it draws attention to it as such, allowing the audience to acknowledge this realism is a construct in a complicit, knowing fashion. The complexity and contradiction between text and image in the calligram's naming of actors rather than their characters becomes apparent once the drama begins: the actor named in the titles is not typically called by their real name in the drama. This mismatch is foundational; the actors who appear on screen are playing a role, different and distinct from their identities when *not* playing that role in the motion picture. The role of calligrams is to subordinate image to language: it establishes the boundaries of comprehension—the limits of interpretive and conceptual understanding—in the title sequence, this is the distinction *between* actor and character. This separation of live actor from fictional role presented/constructed in the film is governed by a set of conventions not least of which is the framing and staging of the film itself to hide and render invisible all the technologies required for its production.

The Rebus Mode

The rebus develops a dialectical contrast between image and typography via a rhetorical juxtaposition—metonymy and synecdoche. There are both simple and complex versions of the rebus mode. The simple version depends on the image for the rhetorical meaning; in the complex version, the graphic style of the letters provide this rhetorical content. Identifying rhetoric depends on the audience making connections invoked through the mismatch of one term with another—the text–image relationship draws attention to itself through the ambiguous form of the "rebus" or word-image puzzle (Barthes, 1972, pp. 114–116). The new meaning, a rhetorical excess (Barthes, 1972, pp. 109–159), is a poetic transformation revealing itself through recognized, but absent, links and connections invoked in the mismatch of text and image (Barthes, 1972, pp. 114–116). The rebus is defined by how it realizes indirect connections between text–image; the simple (and most common) rebus implies its meaning by juxtaposing an *independent* text with a conceptually related image, making the title card into a visualized metaphor or analogy.

The rebus draws from the audience's past experience with recognizing implied connections: the imaginative (poetic) juxtaposition of text and image. Ambivalence is central to rhetoric, an elliptical combination that challenges established meaning by deflecting the image towards its metonymic potential. The various roles "played" by the cartoon panther in David DePatie and Friz Freleng's design for *The Pink Panther* (1963) reflect allegorical connections: the choices of "photographic subject," "conductor," or "typing" all direct

Figure 3
*The Simple Rebus
Mode shown in
the title card
from* To Kill A
Mockingbird.

*Source: Pakula,
Peck, & Mulligan,
1962.*

attention to the activity associated with the text. Each title card plays with the relationship between action (performed by cartoon panther) and production role: cinematography, music composition, screenwriting. This form is commonly used in title cards for production credits, distinguishing the unseen work of technicians from the actors playing their roles.

In discovering the connection of text::image contained by the title card shown in Figure 3 that states, "screenplay by Horton Foote," superimposed over a photograph of a crayon in Steven Frankfurt's design for *To Kill A Mockingbird* (1962), the audience must recognize the links and ellipses between a crayon used by children to draw and scrawl words and the structured, carefully organized process of writing a screenplay. The superimposed text on this image is not a calligram. The crayon in *To Kill a Mockingbird* does not illustrate, "written by Horton Foote," in the way that the actor illustrates his name "Liam Neeson" in *Unknown*. Yet there *is* an apparent link in *To Kill a Mockingbird*: these cards employ the familiar logic of metonymy—this crayon does stand for the act of adapting the screenplay from the novel. It is a strictly linguistic connection translated into visual form, deferring their connection until the audience acknowledges the relationship of text and associated image. These erratic features of language are specifically discontinuous, requiring imaginative leaps to join them in a logic of synthesis arising from a dialectical conjunction of elements, each specifically distinct from another.

Rhetoric is incompatible with illustration—the picture is *not* the statement made by the text. Neither is dominant; text and image have equal weight in their interpretation. This precarious balance animates their meaning, forcing them to fuse into the rebus. The simple connections of *crayon–writing* are relatively direct links whose metonymy emerges from *how* the image stands-in for the activity identified by the text: writing is linked to crayon in an immanent relationship between the thing depicted and the activity named. By acknowledging this link, the audience recognizes the nature of these actions and their meaningful re-presentation on screen. Categorical classifications of text and image remain unchallenged: text remains linguistic, while image remains graphic. The metaphor rendered visual depends on perceived

connections via metonymies between image and text. Their conceptual recognition directs attention away from the illustrative. Until the linkage is made between image and text—a sudden burst of comprehension produced by deciphering these dialectics—the rebus remains unrecognized, masquerading as the figure-ground mode.

Indirect connections transform images into text via *metonymy*—the crayon evoking action of writing itself—mobilizing past knowledge and experience to unravel the rebus' associative meanings. The same affirmation of dominant order visualized in calligrams (and title sequences generally) changes into an explicit assertion of that order in the rebus. Forcing a consideration of an allegorical meaning, independent of the images/texts alone, deflects photography's representational status, transfiguring "connotation" to become "denotation," as Foucault (1982) notes about the changed meanings produced by the rebus:

> The similar develops in series that have neither beginning for end, that can be followed in one direction as easily as in another, that obey no hierarchy, but propagate themselves from small difference among small differences. Resemblance serves representation, which rules over it; similitude serves repetition, which ranges across it. (p. 44)

The rebus renders the image as denotation; Foucault's distinction of semblance and resemblance describes the movement from mimetic depiction into the realm of semiotics where images become text in the shift between reading::seeing. Abandoning immanent recognition for a generalized meaning, necessarily rhetorical, defines the rebus. The crayon comes to resemble the associated activity—writing—as cyphers functioning not by their representation specificity (resemblance) but thorough abstraction as general signs; this rhetorical deflection is characteristic of the rebus. The similarity between depiction and concept invoked through the text resolves the rebus as a visualized metaphor whose meaning comes from a forced similarity between ambivalent image and the lexical meaning. Foucault's "similitude" is this condition of language, of terms whose meanings emerge from their contextual transformation; it produces what he identifies as rhetoric:

> It uses the possibility to repeating the same thing in different words and profits from the extra richness of language that allows us to say different things with a single word. The essence of rhetoric is in allegory. (Foucault, 1982, p. 21)

Where a calligram's joining of text to image produces a doubling or reinforcing of the same meaning, its dialectics creates a *new* meaning different from what the image shows. The rebus transforms depiction (which always aspires to be what it shows) into a sign whose meaning is *other* than the depiction. Rhetoric is not just a series of terms arranged, but their deflection and transformation via juxtaposition in series, one term altering the meaning of next—these changes happen fluently for the audience—as when "lightning" modifies

and is transformed by "bug" (nobody confuses the meaning of "lightning" and "lightning bug"). The rebus resolves image as a sign, i.e. as connotation (language).

By transforming *vision* into *reading* the rhetorical shift around crayon/writing in Frankfurt's design allegorically allows these references to move beyond the immediate and superficial representation of writing by this crayon to become at the same moment also a statement about the nature and source of that writing—the choice of *this* crayon, worn and thick, which appears in use elsewhere in the title sequence rubbing over type to reveal the films' title, drawing a bird—is necessary to firmly identify the writing as a child's story; the narrative is from a child's perspective. The entire sequence is implicated in this single title card. Thus the association of crayon with "written by Horton Foote" suggests the point of view employed in the film, beyond just the metonymic linkage of writing with an implement. The apparent challenge to vision-as-knowledge is a chimera since selection of a *particular* image (photography is always specific) foreshadows and anticipates the drama, making this opening a "paranarrative" (Betancourt, 2018, p. 101). Relations of title cards to drama are common in the rebus—the encapsulation of the film in the opening renders its metanarrative of the film that follows as a puzzle (rebus) because its lexicon is the drama itself: the story unfolding *after* the title sequence is over decodes the title design. Nevertheless, the decoding is spontaneous, a recognition of relationship and meaning the audience performs fluently. Differences between reading::seeing are fundamental, but familiar roles, readily navigated.

Allegory transforms representation into metaphor, in the process shifting the significance of what is seen so its material form serves interpretative ends; instead of *being*, it *signifies*. The particularities of the image matter, but only in so far as they engage this new function, as a rebus born in the dialectical relations of text–image. Re-reading the image as language characterizes the simple variant of the rebus. In denying the representational mimesis of photography, the dominance of vision affirms the established hierarchies of thought and interpretation. These recognitions and shift happen readily and fluidly, this process being instantaneous since it is the same sequence of shifts between image and language commonly employed in reading text itself.

The complex rebus
The complex rebus develops a rhetoric around the *form* of the type and its *arrangement* on screen. The typography becomes an additional "image" commonly ignored in other modes. Shifts in the design and presentation of the text—its graphic style and dress—offer meanings not contained by the text itself. In Pablo Ferro's first title design, created for *Dr. Strangelove, or how I learned to stop worrying and love the bomb* (1964) has two distinct sections: a voice-over narrative preamble accompanying aerial footage of cloud-shrouded mountains running 40 seconds, and the title sequence itself, running approximately 110 seconds and containing 16 title cards made of irregular compositions mostly filling the screen with outlines of spindly hand-drawn letterforms that either fade-in and -out, or dissolve one into the next, overlaid

Figure 4
The Complex Rebus Mode shown in all 16 title cards from Dr. Strangelove, or How I Learned to Stop Worrying and Love the Bomb.

Source: Kubrick, 1964.

onto eight live action shots (Heller, 2005, pp. 74–79). The film is a satire on the cold war, the title sequence compresses these thematics through the design and the particulars of the lettering used *for* the title cards. The screen design draws attention to them as *graphics*, denying language to assert the words-as-image, a reversal that requires an additional layer of interpretation—the rebus.

In contrast to other title sequences of the time, the title cards in *Dr. Strangelove* are clearly hand-drawn. Irregular lines and wobbly letters form asymmetrical compositions where the outlines of words fill the screen, but their graphic character does not obscure the live action background. Their combination is comical, the use of hand drawn "type" and the odd sizes and arrangement of text suggests commentary on the events shown in the live action—without directly making any critical or comic statement; this additional meaning foreshadows the satiric drama to follow. Shifting from "letter" to "graphic" opens language onto other types of meaning—a *formal* rhetoric of shape and design that violates fundamental conceptions of typography as primarily a vehicle for reading in an existential challenge to the Modernist conception of typography as focused on legibility, as Jan Tschichold theorized in 1926: "The essence of the new [Modernist] typography is clarity" (Tschichold, 1998, p. 66). This reversal defines the complex form: language becomes something that must be *seen* rather than *read*, in the process undoing the semiotics of writing to give primacy to the visuality normally hidden in/by "reading." Rejecting language returns lettering to its foundations—graphics composed and superimposed over other, photographic materials in a reflexive (and thus potentially critical) re-assertion of *sight* as organizing process rendering meaning possible.

Displacement and transformation are hallmarks of rhetoric, rendering its meanings apparently natural and immediate, hiding what creates their significance: the excess meaning of the rebus in *Dr. Strangelove* is contained by neither text nor image. The critical meaning of the title cards in the *Dr. Strangelove* title sequence is contextually determined by their subversive relationship to then-dominant Modernist conceptions of order expressed

through typography and design. The oscillation between reading::seeing establishes the complex variant as a repudiation of demands for an untheorized legibility common to Modernist design noted by Horak in his discussion of Saul Bass (Horak, 2014, pp. 89–92). In a rare theoretical discussion of typographic form, graphic designer Douglas C. McMurtrie identifies this "modern approach" in 1929 with a denial of the graphic nature of both the typography and its arrangement:

> "Pretty" layouts on the one hand, and exceedingly bizarre arrangements on the other are to be frowned upon as diverting attention from the message itself to the physical form of its typography, which is always to be considered not as an end in itself, but only as a means to the end that the message can be read. (McMurtrie, 2001, p. 147)

This Modernist bias against the rebus may be the reason for its relative rarity. His denial of meanings presented through the design and composition affirm Foucault's systems of control and order focused on vision. This dominant system and its hierarchical roles is parodied by the excessively mismatched and out-of scale credits in Ferro's design: the title sequence itself acts as an affirmation of these (challenged) systems. The names appear in a certain order, at certain sizes agreed upon governed by traditions and often formally written into the contracts. The "designer title" (re)introduced by Saul Bass in 1954 with *Carmen Jones* and visibly "signed" with his on-screen credit makes the prestige and egotism of having a spot in title sequence a feature of title design itself—precisely the concern with dominance and the projection of power that the *Dr. Strangelove* title sequence satirizes as a futile attempt at demonstrating virility (Rosen, 1970). This critique emerges through the mismatched scale of names/roles and screen-filling compositions of text. The same aspirational, dominant virility is reiterated throughout the narrative as well—the eponymous doctor's "ten women to each man" required for the survival of the human race being the most self-evident example.

Yet, the shifts between text-as-language and text-as-graphic are insufficient to create an allegorical meaning without their contrasting superimposition over the B-52 bomber refueling. The instrumental counterpoint of Laurie Johnson's "Try a Little Tenderness" and the sexual innuendo of airplanes mating midair authorizes the satiric/parodic meaning of the rebus: the sequence begins with a view of the refueling line from below (resembling a large metal phallus); only three shots are backgrounds for superimposed type: two from inside the refueling plane, looking down onto the B-52 bomber, and a side view of the fuel line linking the two aircraft. Repetitions joined by a cut—back inside the refueling plane—make a longer sequence than the quantity of footage otherwise allows, rendering the background recognizable even when obscured by a large quantity of text.

The complex rebus depends on instabilities of text/graphics in counterpoint to live action imagery; the dialectic of typography, graphics and live action in *Dr. Strangelove* is not merely a function of the hand-lettering. The title card

designs reinforce the graphic identification of the letter-forms as both image *and* text. Disproportionately large words are self-aggrandizing in contrast to their actual contents: the giant "AND" accompanied by a list of ten names, or the equally outsized "DESIGNER" paired with a small "KEN ADAM" or medium-sized "PRODUCTION" where the name is smaller than the role performed. Even without hand-lettering, the composition of text on screen parodies the title sequence's self-importance: "MAIN TITLES BY PABLO FERRO" is wedged in-between much larger names—Ferro has repeatedly claimed his credit was *literally* an after thought, added at the last minute (Walters, 2004, pp. 58–62).

Similar in approach to the complex rebus, Kyle Cooper's design for *Se7en* (1995) employs white, scratched text on black title cards combined with a montage of close-up and extreme close-up live action photography. There is a tension to this design between control and catastrophe—the same ambiguity Foucault identified as the fundamental condition of the rebus: cyphers whose meaning depends on their abstraction as general signs. The rebus emerges from how these text/graphics mimic mechanical camera errors. Streaks and smears of hand scratched type reproduce misregistrations of film in the camera as it is being shot, creating irregular flutters, stutter and jitter on screen. "Glitches" in film exposure make the text *partially* illegible, drawing attention to it as the product of a mechanical, autonomous process, but multiple variants of each title card insure their legibility (Betancourt, 2015b). The minimal superimpositions in this design alternate between live action and typography so each receives full attention; the distinctions between title card and image remaining almost inviolate during the title sequence's two minute running time.

While the clear distinction between text–image in *Se7en* might appear to be an original approach to title sequences, the occasional superimposition and slight overlaps between title cards and live action suggests the separation may be a compromise to allow for a greater degree of graphic manipulation of the texts in the title cards. In spite of the distortions and "noise" introduced by the simulated mechanical errors, these title cards remain highly legible, a fact that invites a consideration of *how* the scratched-in letters shift between being graphic and language as the sequence develops. The difference between the credits-as-language (text) and credits-as-broken technology (streaking, jittery graphics) is a conflict between two incompatible systems of interpretation apprehending these images as signifiers of either textual information or technological failure—a pairing that uneasily coexists throughout the title sequence. The resulting tension and conflict within the title cards themselves is accentuated by both the choice of music, Nine Inch Nails' *Closer*, and the disturbing and apparently obsessive and psychotic activities shown by its synchronized live action montage.

Vision as a dominating and controlling force structures the background montage sequence to *Se7en*: of particular note is the photocopied picture of a child whose eyes are blacked out with a marker; later in the sequence his entire face will be obliterated. The (extreme) close-ups function throughout this design as a focusing of attention on particular actions that due to their

isolation in each shot assume an iconic character. Collapsing the difference of text–image reintroduces the affect of visual design into the meaningful interpretation of titles; this concern for issues of composition, style, and dress of type is not problematic for the audience. Each image is fragmentary, yet when considered as a sequence suggests repeated, obsessive activities performed over time. This instability of the typography as text undermines the distinctions between reading::seeing that are the foundation of written language, ambivalently questioning the order this separation creates. The insertion of title cards in between these live action shots thus acts as narrative ellipses within this sequence; yet this elliptical understanding is precisely a function of their juxtaposition, the mismatch between title card and photograph—both shift between being images and being signs for obsession and madness.

Semiotic complexity announces title design as an independent production paralleling the drama—a paranarrative—this formal distinction between opening design and narrative reinforces the enclosed filmic "world" as separate from mundane reality. *Dr. Strangelove, To Kill a Mocking Bird* or *Se7en* as exemplary designs, recognized as noteworthy because these shifts between illustration and rhetoric create a reflexive commentary on the drama, is the idealized function for a title sequence generally, and is a complex rhetoric closely linked to the identification of a sequence as critically "noteworthy."

Michael Betancourt, Ph.D., Professor of Motion Media Design,
Savannah College of Art & Design

References

Barthes, R. (1991). *The responsibility of forms: Critical essays on music, art, and representation (R. Howard, trans.)*. Berkeley: University of California Press.

Betancourt, M. (2013). *The History of motion graphics: From avant-garde to industry in the United States*. Rockport: Wildside Press.

Betancourt, M. (2015a). The calligram and the title card. *Semiotica, 204,* 239–252.

Betancourt, M. (2015b). Critical glitches and glitch art. *Hz 19* np. Retrieved from http://www.hz-journal.org/n19/betancourt.html

Betancourt, M. (2018) *Title sequences as paratexts: narrative anticipation and recapitulation*. New York: Routledge.

Billanti, D. (1982, May–June). The names behind the titles. *Film Comment, 18* (2), 60–69; 70–71.

Foucault, M. (1975). *The birth of the clinic*. New York: Vintage.

Foucault, M. (1982). *This is not a pipe*. Berkeley: University of California Press.

Heller, S. (2005, January–February). Pablo Ferro: for openers. *Print, 59*(1), 74–79.

Horak, J. (2014). *Saul Bass: Anatomy of film design*. Lexington: University of Kentucky Press.

Kubrick, S. (Producer & Director). (1964). *Dr. Strangelove or: How I learned to stop worrying and love the bomb* [Motion picture]. United States: Columbia Pictures.

Lackey, D. P. (1973). Reflections on Cavell's ontology of film. *The Journal of Aesthetics and Art Criticism, 32* (2), 271-273.

Le Baron, W. (Producer) & Gering, M. (Director). (1935). *Rumba* [Motion picture]. United States: Paramount Pictures.

McMurtrie, D. C. (2001). *The philosophy of modernism in typography.* Texts on type, ed. Steven Heller and Phillip Meggs. New York: Allworth Press.

Pakula, A.J. & Peck, G. (Producers) & Mulligan, R. (Director). (1962). *To kill a mockingbird* [Motion picture]. United States: Universal Pictures.

Rosen, B. (1970). The man with the golden arm. *The Corporate Search for Visual Identity.* New York: Van Norstrand.

Silver, J., Goldberg, L., Rona, A. (Producers), & Collet-Serra, J. (Director). (2011). *Unknown* [Motion picture]. United States: Warner Bros. Pictures.

Stanitzek, G. (2009, Summer). Reading the title sequence. *Cinema Journal, 48*(4), 44–58.

Tschichold, J. (1998). *The New Typography (*R. McLean, trans.). Berkeley: University of California Press.

Walters, H. (2004, December). A Pablo Ferro feature. *Creative Review, 24*(12), 58–62.

Spencer Barnes

Toward the Cumulative Effect of Expository Motion Graphics: How Visual Explanations Resonate with Audiences

Frequently, people experience events and encounter concepts that deserve more than a cursory interpretation to be fully understood. Usually, the comprehension of complex phenomena requires specialized knowledge that an average person does not readily possess. For example, if one were to ask, "What factors cause the Northern Lights (i.e., aurora borealis) to be iridescent?" the person would need a functional knowledge of astronomy, chemistry, and physics in order to arrive at an answer to their question. The acquisition of multiple knowledge bases becomes very impractical considering the amount of complex phenomena to which people are constantly exposed. However, visual explanations address this problem by consolidating information about a given topic and making it more understandable for laypersons (i.e., people that lack discipline-specific knowledge about a topic).

A visual explanation renders an account of a phenomenon and provides a description of its characteristics in order to produce an understanding of a topic and people encounter visual explanations of subject matter on a daily basis as a result of being exposed to different types of media. For example, during television news broadcasts anchors routinely segue into animations that depict the event that is being verbally described and digital news packages typically include animations that depict the content of its feature stories (Hernandez & Rue, 2016; Jacobson, Marino, & Gutsche, 2015). In the context of television news coverage an animation could depict the path of a wildfire and help to demonstrate the scale of the wildfire whereas in a digital news package about tennis an animation could help a viewer appreciate the experience of receiving and returning the serve of a tennis champion (Roberts, Ward, & White, 2015).

Within both of the preceding contexts these animations, also known as *motion graphics*, offer an efficient solution for presenting visual explanations and informing an audience about a topic (Shaw, 2016). A motion graphic is a dynamic visual communication product that is comprised of a continuous sequence of animated typography and animated 2D and 3D computer generated imagery that have been composited together, output to a digitally native file format, and displayed in a mediated environment (Brinkmann, 2008). Through the use of animation, motion graphics are able to communicate a visual explanation in its entirety ranging from the behavior

of the explanation's phenomenon to the effects of its presence. The next section covers what explanations are and how they are expressed.

Explanations, visual explanations, and motion graphics

According to Brewer, Chinn, and Samarapungavan (2000) "an explanation provides a conceptual framework for a phenomenon (e.g., fact, law, theory) that leads to a feeling of understanding in the reader or hearer" (p. 280) and there are two fundamental elements contained within all explanations, an explanandum and the explanans (Keil, 2006). An explanandum is the content that is to be explicated, meaning that it serves as the subject matter of the explanation, and it could be a concept, event, or phenomenon. The explanans performs two roles within an explanation: 1) it provides a description of the context, origin, behavior, life cycle, and implication(s) of the phenomenon and 2) it delineates the causation and covariance associated with the phenomenon prior to, during, and after its instantiation (Clark, 2000; Keil & Wilson, 2000). The latter activity of the explanans informs the nature of the explanation because causation can be described relative to the occurrence of the phenomenon. In a *mechanistic explanation* the explanans presents antecedent causation or the processes or mechanisms that bring about the existence of a phenomenon and how they do so. The explanans of a *functional explanation* presents successive causation or the "objectives," outcomes, and implications of the phenomenon after it comes into existence (Lombrozo, 2006; Lombrozo and Gwynne, 2014). The explanans is critical to the efficacy of any type of explanation because it presents relevant information that recursively amplifies and supports the explanandum (Rottman & Keil, 2011).

Consider a written explanation about dust devils (i.e., whirl winds). The explanadum would concern dust devils and their occurrence in semiarid regions of the United States. If the explanation was mechanistic its explanans may describe how dust devils form when hot air near the ground quickly rises through a low pressure pocket of cooler air. If the explanation is functional then its explanans may describe how the circulation of a dust devil allows it to pick up finite debris and other particles, give the suspended particles an electrical charge because they collide with each other while circulating within the dust devil, and ultimately create small magnetic fields. Throughout this chapter this specific explanation will serve as a recurring example because it is adaptable to a variety of expository formats and can be easily dissected.

While visual explanations share similarities with verbal or written explanations in terms of an explanandum, explanans, and the goal of conveying an understanding, the strength of a visual explanation lies in its capacity to comprehensively render an account of subject matter (Ploetzner & Lowe, 2012; Ploetzner & Schlag, 2013). This is accomplished by two means: 1) by a visual explanation's ability to synthesize mechanistic and functional explanatory approaches where both the antecedent causation and successive causation associated with a phenomenon are expressed, and 2) through the use of animation since visual explanations are housed within graphics (Crook & Beare, 2016). If the aforementioned explanations

about dust devils were to be transformed into one visual explanation, then the circumstances surrounding the formation of a dust devil, its movement through environments, and how it produces a magnetic field via charged particles would all be displayed in sequence (see Figure 1).

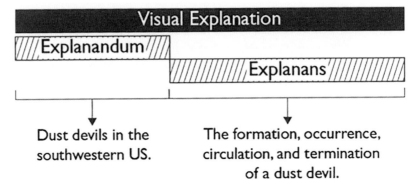

Martinez (2015) defined animation as a mechanism that "generate[s] illusory movement by producing and displaying an artificial arrangement of motion graphic positions without reproducing the positions of real-time movement" (p. 42) and animation represents temporal and spatial change related to an object (Lowe & Schnotz, 2014). Animation enables the phenomenon of interest to be set in motion and it permits different aspects of the phenomenon's development and progression to be sequentially depicted. In general, motion graphics leverage animation to make the action pertaining to the visual explanation observable from multiple angles and different distances.

Technically, a completed motion graphic is an animated composition that is constructed from several elements that are composited together, which include digital matte paintings, computer generated imagery (2D and 3D), typography, and audio (e.g., narration and/or a soundtrack; Skjulstad, 2007). Digital matte paintings are immersive backdrops or vistas that serve as the motion graphic's environment or setting (Lasseter, 2011; Vaz & Barron, 2002). The phenomenon of interest is the hero object or agent (hero) and it is usually made from 3D computer generated imagery and it exhibits a high degree of motion. The hero is integral to a motion graphic because it initiates causal action, drives narrative structure, and enables viewers to anticipate what will happen next within the motion graphic (Cohn & Paczynski, 2013). Typography, 2D computer generated imagery (e.g., graphic elements such as lines and arrows), and any audio serve to annotate the visual activity concerning the hero or happening in the motion graphic's environment. The virtual camera that allows the designer to traverse the composition can also be animated in order to produce dynamic shots such as pans, dollies, and zooms (Woolman, 2004). Visual effects applications such as Adobe After Effects and the Foundry's Nuke are used to arrange all of preceding items into layers or plates and animate them (see Figure 2), composite the plates together, and finish the composition (e.g., color grading) and output it in the form of a motion graphic (Gress, 2015).

plates

Rationale

Despite the entertainment value of motion graphics, many people in the world of journalism have recognized that the quality of motion graphics can vary depending on who produces them and how they are produced. The staffs of some news organizations maintain a team of graphics editors, which are journalists that specialize in researching, reporting, and editing as well as presenting visual content (i.e., "designing news") (Franchi, 2013, p. 174). These news organizations tend to generate more robust motion graphics than news organizations that do not have adequate staffing with respect to a graphics department or graphics editors. Xaquín Veira (2012), a graphics editor at *The New York Times*, concluded that some motion graphics do not efficiently communicate visual explanations and he asserted that, "many motion graphics are nothing more than a set of visual metaphors strung together to support the hypothesis voiced by the narrator, but the cumulative effect is weak" (p. 65). The term *cumulative effect* refers to the impact made by a motion graphic upon the activity of viewing and understanding its visual explanation.

The purpose of this chapter is to articulate the cumulative effect and further define it according to several factors that affect the efficacy of a visual explanation's presentation by a motion graphic. These factors include a motion graphic's appearance, narrative structure, and cognitive processing affordances as well as immersiveness. The following sections provide a description of each factor beginning with its definition and theoretical basis. Afterwards a framework for the cumulative effect will be introduced and, finally, there will be a discussion of the author's own inquiries into the framework.

Factors of the Cumulative Effect

Appearance

The appearance of a motion graphic dictates an audience's attraction to its visual explanation because appearance determines how well the visual explanation is represented. A motion graphic is designated as high fidelity if it contains photorealistically rendered objects and lighting and depth cues,

and a motion graphic is designated as low fidelity if it does not contain these attributes. High fidelity motion graphics are iconic, meaning that they strive to maintain a realistic appearance and an almost complete correspondence to the actual phenomenon depicted by their visual explanations. Low fidelity motion graphics are more abstract and only display their visual explanations' essential information. Figure 3 displays comparable shots from two motion graphics about blue Atlantic marlin. Notice that the shot from the high fidelity motion graphic looks more complex and has more allure whereas the shot from the low fidelity motion graphic looks flat and lacks a substantial amount of environmental detail. Most individuals would anticipate that they could easily learn more information about blue Atlantic marlin from the high fidelity motion graphic and that they would learn less information from the low fidelity motion graphic. However, the theory of naïve realism contends otherwise.

 The theory of naïve realism originated from cognitive psychology research into the efficacy of visual displays and the theory asserts that people have certain expectancies about visual displays of information based solely upon appearance (Smallman & St. John, 2005a). People erroneously assume that appearance reflects the comprehensibility of a motion graphic's visual explanation and they hold a counterintuitive belief that if a motion graphic's appearance is more detailed (e.g., realistic) then there is a greater likelihood that the motion graphic facilitates learning. Essentially, people fail to realize that there is a threshold at which performance deteriorates as a result of an excessive amount of information (Smallman & St. John, 2005b). The reason this happens is because high fidelity visual displays contain many *seductive details* which are "interesting but irrelevant details that are not necessary to achieve the instructional objective" (Rey, 2012, p. 217) and inevitably do not make a significant contribution to the communication of a message.

In the case of the high fidelity motion graphic displayed in Figure 3 underwater light fog and caustics are not essential to one's understanding of the behavior of blue Atlantic marlin and these elements of the motion graphic may in fact cause a person to become distracted away from relevant information about the fish. The theory's main principle is that some visual displays incorporate illustrative and decorative items that appeal to people

although these items impede the accurate transmission and reception of a message, and that these seductive details act as visual clutter that misdirect a person's attention towards irrelevant information and makes it difficult for the person to recognize and isolate objects and action that are relevant for comprehending the visual display (Bracken, 2005; Rooney & Hennessey, 2013; Rosenholtz, Li, & Nakano, 2007; Tran, 2012). Therefore, the theory asserts that the use of high fidelity visual displays will lead to a substantial decrement in the accuracy and response time associated with comprehension whereas the use of a low fidelity visual display will lead to superior comprehension (Hegarty, Canham, & Fabrikant, 2010).

Naïve realism is exhibited as a behavior when someone has an intuition or preference to use a high fidelity visual display (e.g., high fidelity motion graphic) to complete a learning or problem-solving task when a low fidelity visual display (e.g., low fidelity motion graphic) will suffice and provide better task performance. The author's prior research has extended the theory to motion graphics. An intuition is a person's expectancy about the efficacy of a motion graphic based on its appearance. A prospective intuition is an expectancy recorded prior to a person viewing a motion graphic whereas a retrospective intuition is an expectancy recorded after a person has viewed a motion graphic. Prospective intuitions are based on a viewer's "assumptions and expectations about the task demands and relative utility of different display formats, while retrospective intuitions reflect participants' experiences with the task" (Smallman & Cook, 2011, pps. 597–598). Prospective intuitions indicate one's preferences for a specific type of motion graphic (high fidelity or low fidelity) and their prediction about its effectiveness, and retrospective intuitions measure how effective a particular type of motion graphic was during task performance. Prospective intuitions serves as a baseline for retrospective intuitions and their comparison permits one to observe whether naïve realism is being exhibited. Intuition rating trials record intuition by presenting still frames from alternative yet comparable motion graphics to viewers and requiring them to predict which motion graphic will best support learning (see Figure 3).

Narrative structure

The exposition of a motion graphic is a visual explanation (Crook & Beare, 2016) and it is presented in the form of a narrative that advances according to an event structure that consists of several interdependent parts: establishers, initials, peaks, releases, conjunctions, and refiners. The theory of visual narrative grammar maintains that each component performs a specific role within a narrative arc and drives the exposition in a meaningful way (Cohn, 2013). Establishers (E) introduce the setting or environment of the narrative and provide the viewer with any other information that may be acted upon further in the narrative. An initial (I) displays the beginning of a narrative's causal action or event(s) whereas a peak (P) displays the climax, objective, and completion of that action or event. Releases (R) provide closure by showing the aftermath and bringing resolution to the narrative. See Figure 4 for a schematic of the EIPR narrative structure.

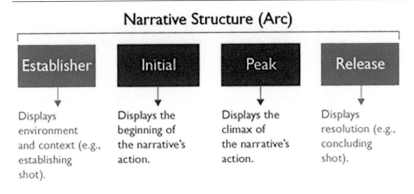

Figure 4
Narrative structure according to the theory of visual narrative grammar.

Copyright 2016 by Spencer Barnes.

When organized together these components produce the EIPR narrative structure, which has been shown to provide an intuitive and coherent presentation of exposition (Cohn, Paczynski, Jackendoff, Holcomb, & Kuperberg, 2012). In a series of studies where participants were required to complete the tasks of reconstructing a set of visual narratives from comic panels and deciding which panel(s) were expendable, and identifying which panels were missing from another set of visual narratives, Cohn (2014) determined that I and P were the most critical components of the EIPR narrative structure whereas E and R played more peripheral roles. Without its core units a narrative losses its coherence because I and P provide an active depiction of information as they "show the central parts of events and thereby directly depict causal relations" (Cohn, 2014, p. 1356) while E and R are more passive and only supply referential information that lays a foundation for the narrative's central units. The interdependence between the units is based on I and R being causally related to P, and E contextualizing the remaining parts of the narrative structure. Finally, refiners and conjunctions amplify narrative components in order to grant viewers a detailed examination of exposition (Cohn, 2015). Refiners replicate components at different levels of detail, for example, an I could be repeated (e.g., EIIPR) so that viewers can see the commencement of an event or situation from a different angle. Conjunctions accentuate narrative units by adding new information to a unit whereas refiners do not. Typically, with refiners the action of the narrative is paused and with conjunctions the action is still progressing toward the subsequent narrative unit.

A motion graphic adheres to narrative structure via its "cinematography" meaning that each of the motion graphic's shots and/or scenes directly correspond to a narrative component (Bordwell & Thompson, 2008; Cohn, 2013). Reconsider the visual explanation about dust devils. If it were presented by a motion graphic employing the EIPR narrative structure, the first shot (E) may pan through a desert environment and the following shot (I) may

depict the circulation of a small amount of debris that begins to revolve more rapidly and gain speed. Next, a dolly shot (P) may show the full formation of the dust devil and how the whirlwind traverses the desert environment. In the final shot (R) the virtual camera could zoom into the body of the dust devil in order to show how the suspended particles inside the whirlwind collide and inherit an electrical charge (see Figure 5). The narrative structures of motion graphics can readily be evaluated by adapting methods from Cohn (2014) and comparing two motion graphics with varying narrative structures against one another (e.g., IP vs. EIPR) with respect to how well people comprehend each motion graphic's visual explanation and rate the coherence of each motion graphic.

Figure 5
Shots from the dust devil motion graphic. Establisher (upper left), initial (upper right), peak (lower left), and release (lower right).

Copyright 2016 by Spencer Barnes.

Cognitive processing affordances

In order to process and comprehend a motion graphic's narrative and its visual explanation an individual must construct a mental model. A mental model is one's conceptualization of the information that they acquire from external visual, auditory, and tactile stimuli. It allows a person to reason by mentally organizing knowledge about information and mentally simulating (e.g., reenactment) the information and its characteristics, conditions, and associated experience(s) (Johnson-Laird, 1980, 1996, 2005; O' Malley & Draper, 1992). The development of a mental model begins when a person starts viewing a motion graphic and they begin recognizing each component of the motion graphic's narrative (e.g., E, I, etc.) as an individual event unit that packages activity related to the motion graphic's visual explanation (Cohn, 2013; Hagmann & Cohn, 2016). The separate components are identified each time the viewer perceives a shift or change in the action of the narrative (Zacks & Tversky, 2001). Specifically, a viewer's expectancies about the activity occurring in the narrative can be maintained as long as the action remains constant in terms of the environment in which it takes place, the hero(es) involved, and causation (Zacks, Speer, & Reynolds, 2009). However, a viewer realizes that they are encountering a new event unit when the characteristics of the action change and the course of the narrative's activity can no longer be anticipated. This partitioning continues until the viewer has watched the entire motion graphic.

As the person decomposes the motion graphic's narrative they simultaneously parse the animation contained within every event unit (i.e., narrative component). The animation parsing process is executed recursively such that the viewer examines the action exhibited by the hero of the event unit as well as the action of ambient objects in the environment or background and the motion of the camera providing the viewpoint and framing for the motion graphic (Torre, 2014). Analyzing the animation this way is essential because it enables the viewer to observe the temporal and causal dependencies of the elements in the event unit (Radvansky & Zacks, 2010), subsequently attribute meaning to activity of the event unit, and interpret the event unit relative to any others that have already been encountered (Lowe & Boucheix, 2016; Lowe & Schnotz, 2008, 2014). Ultimately, the viewer constructs a mental model of the narrative by consolidating their interpretations of the event units and assembling them into a comprehensive mental description of the narrative and the visual explanation. Once a mental model is generated it may still undergo adjustments based on one's further exposure to event units in the narrative meaning that one's conceptualization may be altered to reflect new incoming information while retaining information that was previously acquired from the narrative and motion graphic (Kurby & Zacks, 2012). Figure 6 provides a diagram of the animation parsing process.

Figure 6
Diagram of the animation parsing process.

Copyright 2016 by Spencer Barnes.

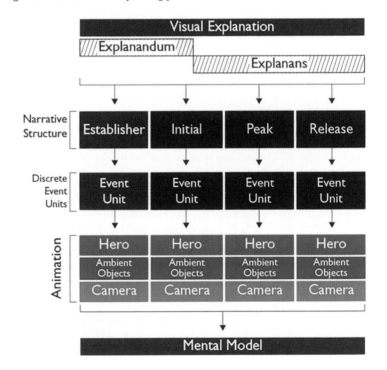

The animation parsing process is also influenced by the appearance of the motion graphic. Recall that naïve realism involves the misdirection of a viewer's attention toward the seductive details incorporated in a motion graphic (Sitzmann & Johnson, 2014; Smallman & Cook, 2011) and the viewer consequently fails to focus on important information within the motion graphic that is relevant to learning about the visual explanation. Each time

a person parses a narrative component's animation they are determining what information to focus on. If a person is *naïve* they may parse the animation according to the most illustrative element(s) in the motion graphic as opposed to parsing the animation based on the hero and its action throughout the narrative, which could lead to a lack of comprehension and an erroneous mental model. However, if a person is not *naïve* then they will parse the animation according to the appropriate information (e.g., hero, etc.) and develop an accurate mental model.

Let's apply the animation process to the peak (P) shot in the aforementioned motion graphic housing the visual explanation about dust devils (see Figure 5). When a person first views the shot in the motion graphic they will immediately recognize that the shot pertains to a different component (or event unit) of the motion graphic's narrative structure due to a change in the action that is being depicted (i.e., a dust devil is forming and circulating). Next, the person should notice that the dust devil is the hero of the shot simply because it is the only visual element within the peak shot that is exhibiting a substantial amount of activity and motion, and the landscape remains static and the camera does not move. After viewing the entire shot and its animation the person should now be able to conceptualize what they have viewed and reconcile this information with their prior knowledge and the other shots that they have already seen from the motion graphic. Ultimately, the person forms a mental model about dust devils based upon the motion graphic's visual explanation.

Mental models are created and exist in working memory, one of the most critical areas of human cognitive architecture because it is where conscious cognition (i.e. thinking) takes place (Sternberg, 2009). There is mental effort associated with both maintaining and utilizing a mental model because working memory is resource-based and has a finite capacity (Baddeley, 2012; Miller, 1956; Wickens & Holland, 2000). Cognitive load theory encompasses how cognitive demands are placed upon working memory, how working memory responds to those cognitive demands, and the theory is "concerned with the manner in which cognitive resources are focused and used during learning and problem solving" (Chandler & Sweller, 1991, p. 294). According to cognitive load theory working memory ceases to function efficiently when its capacity is exceeded and once this occurs a person must exert more mental effort to engage in cognitive processing and they experience cognitive load as a result (Sweller, 1988, 2010).

Maintaining a mental model requires that it be kept active and accessible while one is thinking, and utilizing a mental model involves extracting information from it and using that information to make inferences and predictions about the mental model's subject matter. As these activities cause working memory to reach its capacity limits a person has to allocate and exert more mental effort to process the mental model which eventually causes the person to experience more cognitive load (Moreno & Park, 2010). When mental models are not in use they are stored in long-term memory, which is a perpetually infinite cognitive repository for knowledge.

Behaviorally, cognitive load is indicated by the difficulty one has comprehending information (e.g., a visual explanation) and by the difficulty that they have completing tasks that require an understanding of that information (Schnotz & Kürschner, 2007). The most succinct way to measure cognitive load during or following task performance is through the use of Paas' 9-point cognitive load scale (Paas, 1992; Paas & Van Merrinboer, 1993). The premise of the instrument is that individuals are capable of indicating the amount of cognitive load that they are experiencing (Paas, Tuovinen, & Van Gerven, 2003) and the instrument asks people to indicate how much mental effort they exerted when completing a preceding task (e.g., viewing a motion graphic or answering comprehension questions). Van Gog, Kirschner, Kester, and Paas (2012) recommended that cognitive load measurements should be administered iteratively during tasks and averaged in order to get an accurate measurement and avoid any inflation or bias because people have a tendency to misestimate the amount of cognitive load that they experience.

Immersiveness

Aside from the exertion of mental effort (i.e., cognitive load) another cognitive response to processing a motion graphic's narrative is immersion. Immersion (or transportation) is "absorption into a narrative" (Green & Brock, 2000, p. 704) and it indicates that cognitive processing is proceeding efficiently (i.e., working memory has not been exhausted and one's mental effort is directed towards learning). Gerrig (1993) observed that immersion should seem to feel effortless by the viewer that is becoming immersed in a story and his proposition implies two things:

1) that the cognitive processing associated with generating a mental model should not be intense enough to disrupt the experience of immersion, that is, the focus of one's attention on the action occurring in the narrative (Green et al., 2008); and

2) that during immersion a person's mental model is incrementally updated and enhanced with incoming information from the narrative (Bailey & Zacks, 2015).

The primary tool used to measure the amount of immersion that a viewer experiences is the transportation scale-short form and it is administered after a person reads a story or views a motion graphic. The instruments items ask people about how well the narrative captivated them, how well they conceptualized the narrative, and how the narrative made them feel (Appel, Gnambs, Richter, & Green, 2015).

A Framework for the Cumulative Effect

The presentation of the characteristics of the motion graphics should inevitably lead to a discussion of how these attributes work together to inform the viewing experience associated with a given motion graphic. The cumulative effect of a motion graphic is predicated by four antecedent characteristics of the motion graphic: its appearance, its narrative structure, its cognitive processing affordances, and its immersiveness. Each of the factors

addresses different aspects of the activity of viewing and understanding a motion graphic's visual explanation. Appearance concerns the appeal of the motion graphic and the depiction and salience of information that is relevant and irrelevant to the communication of its visual explanation. Narrative structure informs the organization of the motion graphic via its cinematography and the subsequent format in which the visual explanation is communicated. Both appearance and narrative structure are external properties of a motion graphic because they address the design and infrastructure of the visual communication product prior to an audience's interaction with it.

The opportunity for and the extent of cognitive processing refers to how a person is able to generate a mental model from the information acquired from a motion graphic about its visual explanation and it depends on the person's working memory. Cognitive processing occurs during a recursive parsing process where a viewer analyzes a motion graphic's animation and constructs a conceptualization of a visual explanation within working memory (see Figure 6). Two consequences may result from cognitive processing: 1) cognitive load or 2) immersion. Cognitive load demonstrates that one has exerted mental effort due to the finite capacity of working memory being exceeded. Immersion (or transportation) demonstrates that cognitive processing is proceeding in an efficient manner and that a person is dedicating mental effort toward comprehension and not reacting to working memory constraints. Cognitive processing (e.g., mental models) and immersiveness are internal to the audience because they occur after one watches a motion graphic and each construct represents an audience's response or reaction to the motion graphic after interacting with it.

The confluence of appearance, narrative structure, cognitive processing affordances, and immersiveness constitutes the cumulative effect of a motion graphic and the cumulative effect can be defined as the impact that this synthesis of factors has on the integrity of the motion graphic's presentation of a visual explanation. Thus, how well a visual explanation is transmitted to and received by an audience is contingent upon the cumulative effect.

Figure 7 presents a diagram of the cumulative effect framework and demonstrates where the primary attributes of a motion graphic make their strongest contributions to the cumulative effect. Both appearance and narrative structure are involved in the production of a motion graphic and these are the attributes to which a person is immediately exposed upon viewing the graphic. As the viewing process continues the person engages in cognitive processing in an attempt to conceptualize the information (i.e., visual explanation) that they have acquired from the motion graphic.

The cumulative effect framework can be readily applied to the production of motion graphics when a motion designer (or graphics editor) collaborates with a subject matter expert (e.g., physicist, engineer, etc.) to develop a visual explanation. The subject matter expert's role is to develop an explanation of a topic and verify the visual explanation's authenticity whereas the motion

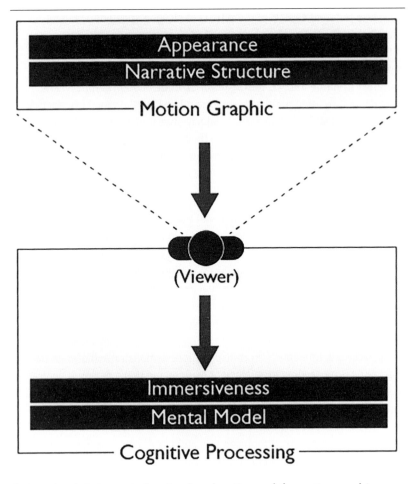

Figure 7
*Diagram of the
cumulative effect
framework.*

*Copyright 2016 by
Spencer Barnes.*

designer's role is to create the visual explanation and the motion graphic
that will contain it. The motion designer should engage in two activities
consecutively: 1) determining the appearance of the final motion graphic
and 2) delineating the narrative structure of the final motion graphic. The
first activity would require the creation of multiple style frames that display
alternative yet comparable appearances in order for decisions to be made
about the degree of realism in aesthetic, action, and motion that will be
incorporated into the motion graphic. The second activity involves the
production of assets such as matte paintings and 3D computer generated
imagery as well as the cinematography that corresponds to EIPR narrative
structure. The cognitive processing aspect of the cumulative effect
framework begins once the motion graphic is completed and viewed by
its intended audience.

The author's own research has attempted to incrementally apply parts of
the cumulative effect framework to investigations of motion graphics and
visual explanations. Throughout the course of four studies it was observed
that people's exhibition of naïve realism is informed by their most recent
intuition(s) about the appearance of motion graphics, when offered choices
of which motion graphics to view people overwhelmingly choose to watch

high fidelity motion graphics (see Barnes, 2016b), that viewing low fidelity motion graphics enables better comprehension than high fidelity motion graphics (see Barnes, 2017b), successive exposure to motion graphics enables the precision of a person's cognitive processing to be enhanced regardless of the nature of the viewed motion graphics (high fidelity or low fidelity; see Barnes, 2016a), and in certain scenarios a full EIPR narrative is not necessary to enhance a viewer's understanding of a visual explanation as long as a motion graphic's action and context are salient (see Barnes, 2017a). However, all of these studies individually examined the separate factors that contribute to the cumulative effect framework and none of the studies explored the cumulative effect in its entirety.

This chapter sought to discuss how certain qualities of motion graphics inform and impact the efficacy of the presentation of visual explanations. Implicit in this discussion is the fact that animation (and motion) serves as an excellent storytelling tool, efficiently communicates exposition, and sequentially advances a narrative (Shaw, 2016). Along with the proper aesthetic, animation allows a designer to translate exposition into a dynamic temporal experience for an audience in order to produce an understanding of a topic. While this chapter articulates the cumulative effect and makes a contribution to visual explanation research future inquiries should endeavor to investigate the application of the cumulative effect and its framework to a variety of contexts where motion graphics are employed (e.g., broadcast news, heads up displays, etc.).

Spencer Barnes, Ed.D., Associate Professor, University of North Carolina at Chapel Hill

References
Appel, M., Gnambs, T., Richter, T., & Green, M. (2015). The transportation scale-short form. *Media Psychology, 18*(2), 243–266.

Baddeley, A. D. (2012). Working memory: Theories, models, and controversies. *Annual Review of Psychology, 63*, 1–29.

Bailey, H., & Zacks, J. (2015). Situation model updating in young and older adults: Global versus incremental mechanisms. *Psychology and Aging, 30*(2), 232–244.

Barnes, S. (2016a). Studies in the efficacy of motion graphics: How the presentation of complex animation implicates exposition. *Journal of Entertainment and Media Studies, 2*(1), 37–76.

Barnes, S. (2016b). Studies in the efficacy of motion graphics: The effects of complex animation on the exposition offered by motion graphics. *Animation: An Interdisciplinary Journal, 11*(2), 146–168.

Barnes, S. (2017a). Studies in the efficacy of motion graphics: The impact of narrative structure on exposition. *Digital Journalism, 5*(10), 1260–1280.

Barnes, S. (2017b). Studies in the efficacy of motion graphics: The relation between expository motion graphics and the presence of naïve realism. *Visual Communication. doi: 10.1177/1470357217739223.*

Bordwell, D., & Thompson, K. (2008). *Film art: An introduction* (8th ed.). Boston, Massachusetts: McGraw Hill.

Bracken, C. C. (2005). Prescence and image quality: The case of high-definition television. *Media Psychology, 7*(2), 191–205.

Brewer, W. F., Chinn, C. A., & Samarapungavan, A. (2000). Explanation in scientists and children. *Explanation and Cognition* (279–298). Cambridge, Massachusetts: MIT Press.

Brinkmann, R. (2008). *The art and science of digital compositing: Techniques for visual effects, animation and motion graphics* (2nd ed.). Boston, Massachusetts: Morgan Kaufmann Publishers.

Chandler, P., & Sweller, J. (1991). Cognitive load theory and the format of instruction. *Cognition and Instruction, 8*(4), 293–332.

Clark, A. (2000). Twisted tales: Causal complexity and cognitive scientific explanation. *Explanation and Cognition* (145–166). Cambridge, Massachusetts: MIT Press.

Cohn, N. (2013). Visual narrative structure. *Cognitive Science, 34*(3), 413–452.

Cohn, N. (2014). You're a good structure, Charlie Brown: The distribution of narrative categories in comic strips. *Cognitive Science, 38*(7), 1317–1359.

Cohn, N. (2015). Narrative conjunction's junction function: The interface of narrative grammar and semantics in sequential images. *Journal of Pragmatics, 88,* 105–122.

Cohn, N., & Paczynski, M. (2013). Prediction, events, and the advantage of agents: The processing of semantic roles in visual narrative. *Cognitive Psychology, 67*(3), 73–97.

Cohn, N., Paczynski, M., Jackendoff, R., Holcomb, P., & Kuperberg, G. (2012). (Pea) nuts and bolts of visual narrative: Structure and meaning in sequential image comprehension. *Cognitive Psychology, 65*(1), 1–38.

Crook, I., & Beare, P. (2016). *Motion graphics: Principles and practices from the ground up.* New York: Bloomsbury.

Franchi, F. (2013). *Designing news: Changing the world of editorial design and information graphics.* Berlin: Gestalten.

Gerrig, R. (1993). *Experiencing narrative worlds: On the psychological activities of reading.* New Haven, Conneticut: Yale University Press.

Green, M., & Brock, T. (2000). The role of transportation in the persuasiveness of public narratives. *Journal of Personality and Social Psychology, 79*(5), 701–721.

Green, M., Kass, S., Carrey, J., Herzig, B., Feeney, R., & Sabini, J. (2008). Transportation across media: Repeated exposure to print and film. *Media Psychology, 11*(4), 512–539.

Gress, J. (2015) *[Digital] visual effects & compositing.* San Francisco, California: New Riders.

Hagmann, C., & Cohn, N. (2016). The pieces fit: Constituent structure and global coherence of visual narrative in RSVP. *Acta Psychologica, 164,* 157–164.

Hegarty, M., Canham, M. S., & Fabrikant, S. I. (2010). Thinking about the weather: How display salience and knowledge affect performance in a graphic inference task. *Journal of Experimental Psychology: Learning, Memory, and Cognition, 36*(1), 37–53.

Hegarty, M., Smallman, H. S., Stull, A. T., & Canham, M. S. (2009). Naïve cartography: How intuitions about display configuration can hurt performance. *Cartographica, 44*(3), 171–186.

Hernandez, R. K., & Rue, J. (2016). *The principles of multimedia journalism: Packaging digital news*. New York City, New York: Routledge.

Jacobson, S., Marino, J., & Gutsche, R. E. (2015). The digital animation of literary journalism. *Journalism , 17*(4), 527–546. doi: 10.1177/1464884914568079

Johnson-Laird, P. N. (1980). Mental models in cognitive science. *Cognitive Science, 4*(1), 71–115.

Johnson-Laird, P. N. (1996). Images, models, and propositional representations. In M. de Vega, M. J. Intons-Peterson, P. N. Johnson-Laird, M. Denis, & M. Marschark (Eds.), *Models of visuospatial cognition* (90–127). New York: Oxford University Press.

Johnson-Laird, P. N. (2005). Mental models and thought. In K. Holyoak & R. J. Sternberg (Eds.), *The Cambridge Handbook of Thinking and Reasoning* (185–208). Cambridge, UK: Cambridge University Press.

Keil, F. (2006). Explanation and understanding. *Annual Review of Psychology, 57*, 227–254.

Keil, F. C., & Wilson, R. A. (2000). Explaining explanation. *Explanation and Cognition* (1–18). Cambridge, Massachusetts: MIT Press.

Kurby, C., & Zacks, J. (2012). Starting from scratch and building brick by brick in comprehension. *Memory & Cognition, 40*(5), 812–826.

Lasseter, J. (2011). Setting the stage. In Walt Disney Animation Studios (Eds.), *Layout & Background* (1–3). New York City, New York: Disney Enterprises Inc.

Lombrozo, T. (2006). The structure and function of explanations. *TRENDS in Cognitive Science, 10*(10), 464–470.

Lombrozo, T., & Gwynne, N. (2014). Explanation and inference: Mechanistic and functional explanations guide property generalization. *Frontiers in Human Neuroscience, 8*(700), 1–12.

Lowe, R. K., & Boucheix, J. (2016). Principled animation design improves comprehension of complex dynamics. *Learning and Instruction, 45*, 72–84.

Lowe, R. K., & Schnotz, W. (2008). *Learning with animation: Research implications for design*. New York City, New York: Cambridge University Press.

Lowe, R. K., & Schnotz, W. (2014). Animation principles in multimedia learning. In R. E. Mayer (Ed.), *The Cambridge Handbook of Multimedia Learning* (513–546). New York City, New York: Cambridge University Press.

Martinez, O. O. L. (2015). Criteria for defining animation: A revision of the definition of animation in the advent of digital moving images. *Animation: An Interdisciplinary Journal, 10*(1), 42–57.

Miller, G. A. (1956). The magical number seven, plus or minus two: Some limits on our capacity for processing information. *Psychological Review, 63*(2), 81–97.

Moreno, R., & Park, B. (2010). Cognitive load theory: Historical development and relation to other theories. In J. L. Plass, R. Moreno, & R. Brünken (Eds.), *Cognitive Load Theory: Theory and Application* (9–28). New York City, New York: Cambridge University Press.

O' Malley, C., & Draper, S. (1992). Representation and interaction: Are mental models all in the mind? In Y. Rogers, A. Rutherford, & P. A. Bibby (Eds.), *Models in the Mind: Theory, Perspective and Application* (73–92). New York City, New York: Academic Press.

Paas, F. (1992). Training strategies for attaining transfer of problem-solving skill in statistics: A cognitive-load approach. *Journal of Educational Psychology, 84*(4), 429–434.

Paas, F., Tuovinen, J. E., Tabbers, H., & van Gerven, P. W. M. (2003). Cognitive load measurement as a means to advance cognitive load theory. *Educational Psychologist, 38*(1), 63–71.

Paas, F., & Van Merriënboer, J. J. G. (1993). The efficiency of instructional conditions: An approach to combine mental effort and performance measures. *Human Factors, 35*(4), 737–743.

Ploetzner, R., & Lowe, R. (2012). A systematic characterisation of expository animations. *Computers in Human Behavior, 28*(3), 781–794.

Ploetzner, R., & Schlag, S. (2013). Strategic learning from expository animations: Short- and mid-term effects. *Computers & Education, 69*, 159–168.

Radvansky, G., & Zacks, J. (2010). Event perception. *WIREs Cognitive Science, 2*(6), 608–620.

Rey, G. D. (2012). A review and meta-analysis of the seductive detail effect. *Educational Research Review, 7*(3), 216–237.

Roberts, G., Ward, J., & White, J. (2015, July 10). What It's Like to Face a 150 M.P.H. Tennis Serve. *The New York Times*. Retrieved from http://www.nytimes.com/interactive/2015/07/10/sports/tennis/facing-a-150-mph-tennis-serve.html.

Rooney, B., & Hennessy, E. (2013). Actually in the cinema: A field study comparing real 3D and 2D movie patrons' attention, emotion, and film satisfaction. *Media Psychology, 16*(4), 441–460.

Rosenholtz, R., Li, Y., & Nakano, L. (2007). Measuring visual clutter. *Journal of Vision, 7*(2), 1–22.

Rottman, B., & Keil, F. (2011). What matters in scientific explanations: Effect of elaboration and content. *Cognition, 121*(3), 324–337.

Schnotz, W., & Kürschner, C. (2007). A reconsideration of cognitive load theory. *Educational Psychology Review, 19*(4), 469–508.

Shaw, A. (2016). *Design for motion: Fundamentals and techniques of motion design.* New York City, New York: Focal Press.

Sitzmann, T., & Johnson, S. (2014). The paradox of seduction by irrelevant details: How irrelevant information helps and hinders self-regulated learning. *Learning and Instruction, 34*, 1–11.

Skjulstad, S. (2007). Communication design and motion graphics on the web. *Journal of Media Practice, 8*(3), 359-378.

Smallman, H. S., & Cook, M. B. (2011). Naïve realism: Folk fallacies in the design and use of visual displays. *Topics in Cognitive Science, 3*(3), 579–608.

Smallman, H. S., & John, M. S. (2005a). Naïve realism: Limits of realism as a display principle. *Proceedings of the Human Factors and Ergonomics Society Annual Meeting 2005, 49*, 1564–1568.

Smallman, H. S., & John, M. S. (2005b). Naive realism: Misplaced faith in realistic displays. *Ergonomics in Design: The Quarterly of Human Factors Applications, 13*(6), 6–13.

Sternberg, R. J. (2009). *Cognitive Psychology.* Belmont, California: Wadsworth.

Sweller, J. (1988). Cognitive load during problem solving: Effects on learning. *Cognitive Science, 12*(2), 257–285.

Sweller, J. (2010). Cognitive load theory: Recent theoretical advances. In J. L. Plass, R. Moreno, & R. Brünken (Eds.), *Cognitive Load Theory: Theory and Application* (29–47). New York City, New York: Cambridge University Press.

Torre, D. (2014). Cognitive animation theory: A process-based reading of animation and human cognition. *Animation: An Interdisciplinary Journal, 9*(1), 47–64.

Tran, H. (2012). Exemplification effects of multimedia enhancements. *Media Psychology, 15*(4), 396–419.

Van Gog, T., Kirschner, F., Kester, L., & Paas, F. (2012). Timing and frequency of mental effort measurement: Evidence in favour of repeated measures. *Applied Cognitive Psychology, 26*(6), 833–839.

Vaz, M.C., & Barron, C. (2002). *The invisible art: The legends of movie matte painting.* San Francisco, California: Chronicle Books.

Viera, X. G. (2012). A diverse and driven crew at the New York Times. A look at one of the world's most admired graphics desks. In SND-E (Ed.), *Malofiej 19: International Infographics Awards* (52–65). Pamplona, Spain: Universidad de Navarra.

Wickens, C. D., & Hollands, J. G. (2000). *Engineering psychology and human performance* (3rd ed.). Upper Saddle River, NJ: Prentice-Hall Inc.

Woolman, M. (2004). *Motion design: Moving graphics for television, music video, cinema, and digital interfaces.* Switzerland: Rotovision.

Zacks, J., Speer, N., & Reynolds, J. (2009). Segmentation in reading and film comprehension. *Journal of Experimental Psychology: General, 138*(2), 307–327.

Zacks, J., & Tversky, B. (2001). Event structure in perception and conception. *Psychological Bulletin, 127*(1), 3–21.

Section 3

Science and Perception

Elaine Froehlich
Motion Attracts Attention

How the Brain Recognizes and Interprets Motion

This is Elmar. My dad surprised me one early summer evening when his boss pulled up with her on his trailer. He'd bought her at a sale barn in Virginia and made the long trip home. That first night she stayed in the lower section of our old, classic, Pennsylvania barn. The next morning, I opened the top half of the Dutch door for her to see her new world. She was standing directly in front of me, the bottom half of the door hitting her at mid-chest, the top half hanging free in the air to the right of my head. She was medium-sized but a powerfully built horse with a wide body that promised strength. Her chest was solid and well-muscled.

As I stood there those chest muscles fluttered slightly under her skin. It happened fast. I did not have time to think. The actual time must have been a fraction of a second. On impulse I dove to the left. The memory of 1200 pounds of hot determination flying past me like a freight train as she went straight through the bottom half of the door sobers me still.

That subtle twitching of Elmar's chest muscles communicated danger to me at a level beyond my control and I responded instinctively, without the advantage of conscious thought. If I had hesitated at all, the collision with horse and door might have produced dire consequences for me.

The fundamental tools of human perception are the senses and the brain. Our brains represent an expression of biology on the earth. The way we operate and the way we think are reflections of that biology. The search to unlock the mysteries of the brain has uncovered astonishing phenomena. The brain's

system for interpreting visual signals shows remarkable coordination between many simple cellular responses happening in multiple areas at the same time.

The visual brain's main job is the "acquisition of knowledge" (Zeki, 1999, p. 58). The visual cortex is one of the largest areas of the brain. Processing visual input goes on constantly, consuming large amounts of energy. The brain processes visual input in parallel, through multiple channels, simultaneously splitting stimuli into the separate, autonomous areas to be deciphered (Zeki, 1999). Humans naturally respond favorably to motion in the environment. Communicating through the use of motion makes compelling attractions for the human mind.

Within the brain's visual processing center, some things are known, some under conjecture and some remain a mystery. Seeing is an active, modular process. Visual signals sent from the eyes are taken apart and interpreted separately in different parts of the brain at the same time (Zeki, 1999, pp. 58–59). It is unclear exactly where in the brain the act of understanding happens, though evidence indicates at least some signals are understood where they are processed in the visual cortex. Using repeatable experiments to map functional areas of the brain permits researchers to understand how the different subdivisions work.

Science looks to trauma to understand how the brain works. When patients suffer damage to visual processing areas of their brain, evaluating the resulting changes in their perception helps understand that area's job in interpreting visual input. Testing also indicates that the visual cortex plays a part in memory. When someone sustains damage in this area, memory problems can result. The visual cortex also enables imagination, a process seated in the visual center of the brain, indicated by cases where imagination has been impaired due to brain damage (Zeki, 1999, pp. 40–41).

Perception versus reality
The brain shows an amazing propensity to ignore information. Since our brains evolved for survival, human perception brings into consciousness what it needs to ensure a successful response to the environment. We think we perceive objective reality but in fact, we register what we need to know in order to survive in this dangerous world.

Our brains continuously record every detail from every sensation in our immediate environment down to the tiniest impressions. Our bodies move all the time; our heads move with our bodies and our eyes scan continuously. They never rest. As they scan the visual field, our eyes make small tremors known as "saccades." The eyes jerk as fast as they can, stopping from time to time as they build up small details into three-dimensional images (Zeki, 1999, p. 144). If the sensations described above were all registered consciously it would be challenging to focus on any of them. Fortunately our brains ignore the majority of these practically infinite details.

The world consists of constant motion. At the macro and micro levels dynamic forces keep the universe together through revolution and radiation in the solar system; strange atomic forces attract or repel tiny particles of elements and

don't forget all the organic processes, blood flow, breathing, moving, eating and other biological functions that occur constantly in living organisms. Oddly, when we stop to pay attention, the world around us seems to be mostly still. What experience of movement do we interpret differently from the scientific facts of motion? By nature, we ignore huge amounts of data that are coming at us all the time in the way of motion.

For example, our eyes move several times per second. We blink often. Our heads shift and turn and our muscles flex and relax, constantly shifting the optic input on our retina: "Sense impressions are highly unstable and interrupted. But an obvious characteristic of perception is its stability and continuity. The world does not seem to move as the retinal image moves over the retina" (Kepes, 1965, p. 61). We also relate to the world as having a direction indicated by gravity operating on our body mass. As our bodies move up, down, left, right, forward and backward, we relate to the earth as being in the down direction: shifting body position does not alter that sense of constancy of direction. "Just as the visible world does not seem to rotate 90° when one lies down on his side, although the retinal image does, so the tangible ground and the direction of gravity do not seem to swing upward. [...] Instead of the ground changing, one feels that he has changed and the earth has not" (Kepes, 1965, p. 63).

Our perception of the world as a constant and ourselves as variable inhabitants reflects a subjective point of view. The reasons for that seem obvious once you think about them. If all the motions of our organism were recorded just as they happen, distinguishing information important to survival would be much more difficult.

The visual system
Once motions have been recorded, sorted, parsed and interpreted in our brain, we decide what they mean to us. How is motion turned into an understood event?

The brain's processing of visual information can be understood by observing the organic structures in the system that creates sight. The first step in collecting visual signals starts with the eyes. Imagine a small hill covered with grass and wild flowers. A tall pine stands slightly to the left. Under the pine a well-used picnic table waits for its next party. If you are standing a few yards away you might notice the tree swaying in the breeze. The hardware of the visual system, eyes connected to brain, collects these images.

A layer of cells at the back of the eyeball, covering the curved surface inside the eye called the retina, collects light impulses. Light passes through the lens of the iris, inverting the image of the scene. Images are recorded on the retina upside down and backwards. It contains rods and cones. Rods register in dim light and contain no color receptors, while cones register in daylight and have structures for recognizing color (Zeki, 1993, p. 25).

In a small pit at the back of the eye lies the Fovea. The Fovea contains no rods and its receptors only register the illumination of daylight. Cells of the Fovea

are concentrated near the center. This arrangement creates a system where the majority of the cells of the retina record visual data in general and the tiny, central Fovea focuses on fine details (Zeki, 1993, p. 24).

The retina and the Fovea connect to the nerves that transmit visual input to the brain. The brain ignores the blind spot created where the nerves connect to the retina, building up one smooth, continuous image. This connection of the retina to the brain makes it the most external element of the brain's neural network of sight.

Receptive fields in the brain

In general, brain cells register input by paying attention to signals from the body that register within specific areas called "receptive fields" (Zeki, 1999, p. 100). For each area in the body there is a corresponding brain cell that responds to a stimulus from that precise location. In the visual cortex those inputs come as visual signals from the eyes. Each cell has a receptive field of a specified size that processes a small area of the visual field. Cells in the different areas of the visual cortex have receptive fields of different sizes. They process visual information in small chunks, meaning the act of seeing is handled in modular pieces in several areas at once (Zeki, 1999, p. 120).

Signals from the eyes are separated to be processed in different areas at the same time. Those receptive fields might be large or small in size and can overlap multiple times. If a composition of vertical and horizontal lines is far enough away from the subject to fill one receptive field it will be processed by a single brain cell. Bringing that same composition closer to the subject fills the receptive fields of several cells that then cooperate in registering the image. Brain science is still trying to explain how cells know which part of an image they are processing and how those parts relate to parts being processed in other cells. For input that includes motion, that includes knowing how parts of an image connect across time (Zeki, 1999, pp. 127–128).

Framing the visual field

Physics tries to explain the world from an objective perspective. Experiments uncover information that transcends human perception to detect reality.

What we see and what we understand are very different things. Scientific descriptions help to clarify motion as it exists from motion as it is perceived. The way we understand motion can be described by saying, "Motion in a strict physical sense, is a change of position with respect to a reference system of space coordinates" (Kepes, 1965, p. i). "Framing" refers to those visual cues that permit the motion to be observed. "Motion is primarily displacement of an object in relation to other objects" (Kepes, 1965, p. 52). We perceive motion as an attribute of the moving object. The "frame of reference" determines which object appears to be displaced.

Let's consider the way the motion is framed. Motion is always relative or it cannot be observed. According to Georgy Kepes (1965), Object Relative Displacement, "the displacement of one object in relation to another object in the field of vision" (p. 53), allows observation of a moving object based on nearby objects. Either the motion appears relative to an object in the scene or it appears in relation to an edge, a framed space, a field, a background; in fact the objects seen as relative may be different things or may change from one object to another during the motion. The relative object(s) may or may not also be in motion.

When designers use motion, the way they frame the scene influences the way it will be understood. In *Sight, Sound, Motion: Applied Media Aesthetics*, Herbert Zettle (2008) observed: "We ordinarily perceive motion only when something changes its position more or less continuously relative to a more stable environment" (p. 247).

Moving objects are viewed as dependent on the immobile framework. Some objects will function as a framework and be read as immobile. In our picnic table landscape above, a fly buzzing around the picnic basket would be perceived as being in motion around the stationary picnic basket. If someone picked up the basket and ran away with it, we would perceive the moving fly following the now mobile picnic basket against the immobile hillside (Arnheim, 1974, p. 380).

Or imagine an example with a dot moving so slowly the motion becomes imperceptible. Add a second, stationary dot near the first one. The motion of the first dot will be observable again. The motion of the first dot remains visible as long as the dots stay relatively near each other. As the space between the dots increases, the moving of the dot becomes harder to see again. In this case comparison of the original dot with the stationary dot reveals its motion. The stationary dot acts as the "frame" for the motion (Kepes, 1965, p. 53).

Researchers Karl Dunker and Erika Oppenheimer outlined concepts dealing with dependence. Motion is visible because it is viewed in relationship with the immobile frame. The enclosing area, the ground, seems to stand still and the figure appears to move within it. The concept of variability states that in cases where one object changes in reference to another, the changing object will be seen as the one in motion. In the example of "a line 'growing out of' a square, the variable object assumes the motion. The observer sees the line

stretching away from the square, rather than the square withdrawing from an immobile line" (Arnheim, 1974, p. 380).

Another way to frame motion, "Angular Displacement" refers to the "displacement of an object seen in relation to the observer" (Kepes, 1965, p. 53). In this case, the observer becomes the framework against which the motion is perceived. Often, an object being displaced in relation to the observer is also being displaced against other objects in the visual field.

In cases where there are no dependencies or frames for the motion of two objects, both motions may be perceived as being symmetrical, "approaching or withdrawing from each other" (Arnheim, 1974, p. 380).

Time, sequence and phase

Rudolph Arnheim (1974) identifies the ideas of "objects and happenings" (p. 372). Predominantly, objects persist in our awareness; happenings, or actions, appear to be attributes of objects. An object is seen as being in existence. Actions (motions) are considered to be variable, or time-based, having an effect on an object.

From the human perspective, a setting exists outside of time. When motion happens we perceive it to happen within the unidirectional flow of time. Time, sequence and phase are elements important to create order out of chaos. Two-dimensional visual works are understood as objects in a simultaneous way. The order of taking-in the parts does not inhibit their appreciation. Arnheim believes it's not the passage of time that distinguishes perception of happenings from objects but that in happenings "organized sequences containing phases... follow one another in a meaningful, one-dimensional order" (Arnheim, 1974, p. 375).

The ordering of events into sequences creates the meaning of the work. In time-based media, (e.g., movies, plays, music) the order of events is critical to the aesthetic of the piece as well as the intended communication. A change in the sequence changes the work into a new piece, often destroying the natural balance its creator intended.

Sequence orders events in complex motion but, like in a static composition, all the phases of the work create its meaning. "In order to create or to understand the structure of a film or a symphony, one has to grasp it as a whole, exactly as one would the composition of a painting. [...] The whole work must be simultaneously present in the mind" (Arnheim, 1974, p. 374). The relationships between the parts happening across time create the experience of the piece.

Motion can be experienced as it happens in time or in space. A work will feel that it happens in space if the "physical setting of the piece provides the framework" (Arnheim, 1974, p. 374). If the work shows a tour through the rooms of a house, the experience will be that the house is revealed room by room, through space. The impression changes to an event happening in time when the framing of the motion is one of "time running out." In a movie

someone rushing to escape from an attack in the house before it's too late will be experienced as happening "in time" (Arnheim, 1974, p. 374).

Mapping the Visual Areas of the Brain

The human brain dedicates a large area to processing visual information. The visual cortex is the organ's most massive and most well studied system. Located in the Occipital Lobe of each hemisphere, near the bottom of the back of the head, between the Parietal Lobe and the Cerebellum, it lies on either side of the Calcarine Fissure, a deep fold that bisects the brain at the back of the head.

The primary role of the visual brain is "acquisition of knowledge" (Zeki, 1999, p. 58). At one time scientists expected that seeing and understanding happened in different areas of the brain. Their search for "comparative mechanisms" (Zeki, 1999, p. 191), cells that combine the input of the highly specialized processing areas of the visual cortex into one complete image, has not been found in any area of the brain. While each area of the Visual Cortex does its job receiving and processing visual information, no separate area in the brain where understanding happens separately from seeing has been found.

When "seeing" the brain engages in an active, creative task following its own rules. It actively dismantles visual signals and routs them to highly specialized cells waiting for precise attributes to trigger their responses. Those cells construct the image from many small parts processed in different areas at the same time. All of the areas of the visual cortex both receive and send signals. They execute a series of specific functions performed for the parameters of color, form, movement and depth at precise locations in the visual field (Zeki, 1999, p. 58). The signals are processed and reintegrated as recognizable, understandable things. The experience of a healthy brain is that attributes like the color, shape, position, speed and direction of movement of an object are assessed and analyzed in different visual processing areas in a fraction of a second. In some parts of the brain, processes that recognize these attributes have been identified down to the cellular level. These mappings of function allow researchers to understand how visual signals are being interpreted in very specific ways.

Connection of the eyes to the brain

Our eyes connect to the visual processing center of our brains via the Optic Nerve. The Optic Nerve is a rope-like collection of nerve cells that transmit signals recorded in the retina to the visual processing areas of the brain via the Optic Pathway (Zeki, 1999, p. 81).

The Optic Nerves cross inside the skull at the Optic Chiasma to connect each side of the visual field to the opposite hemisphere of the brain (Zeki, 1993, p. 25). Things to the left of center of the visual field register in the right side of each eye and the right sides of the eyes connect to the right side of the brain to be processed. Things in the center are registered in both eyes and are processed in both hemispheres. Things to the right of center in the visual

field are recorded on the left side of each eye and are processed in the left hemisphere (Zeki, 1999, pp. 24–25).

Visual signals pass directly from the Optic Nerve through a structure at the bottom of the brain called the Lateral Genticulate Nucleus to the Primary visual cortex. The Lateral Genticulate Nucleus is separated into layers of Parvocellular Ganglion Cells (P-layers) and Magnocellular Ganglion Cells (M-layers). The P-cell layers transmit signals that relate to form and the M-cell layers transmit those related to motion (Zeki, 1993, pp. 25–26).

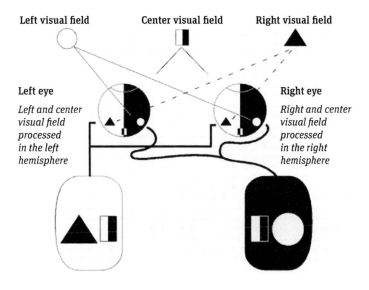

Left visual field **Center visual field** **Right visual field**

Left eye **Right eye**

Left and center visual field processed in the left hemisphere

Right and center visual field processed in the right hemisphere

Figure 2
Objects in the center of the visual field are processed in both hemispheres of the brain. Objects captured from the left of center of the visual field onto the right side of each eye are processed only in the right hemisphere, as those from the right visual field onto the left side of the eye are processed only in the left hemisphere.

Source: Copyright 2017 by Elaine Froehlich.

It takes from .5 to 1 millisecond for a visual signal to cross a synaptic barrier. A signal reaches the visual cortex from the eye in about 35 milliseconds at its quickest (Zeki, 1999, p. 66). Not all visual information travels at the same speed. Color information reaches the visual cortex first with the information for motion arriving 60 to 80 milliseconds later (Zeki, 1999, p. 66). The brain practices a sort of parallel processing, deciphering "different attributes of the visual scene in different areas of the brain simultaneously and in parallel" (Zeki, 1999, p. 62).

The parts of the visual cortex
Our eyes connect to the visual processing center of our brains via the Optic Nerve. The Optic Nerve is a rope-like collection of nerve cells that transmit signals recorded in the retina to the visual processing areas of the brain via the Optic Pathway (Zeki, 1999, p. 81).

The term visual cortex refers to the entire area of the brain devoted to processing visual information. It contains two main sections, known as the Primary or Striate visual cortex and the Prestriate visual cortex. The areas of the visual cortex have been identified based on the kinds of information known to be processed in them (Zeki, 1993, p. 60). These areas can also be referred to by their alternate names: the Primary visual cortex is called V1 and the Prestriate visual cortex can be referred to by the separate processing areas

it contains known as V2, V3, V4, V5 and V6. All visual areas both send and receive signals. The specialized areas act autonomously (Zeki, 1999, p. 68).

Sorting areas

Science understands many things about the ways visual information is delivered and processed in the visual cortex. In some cases, the function of single cells has been identified. Each cell in the visual brain has a single, highly specified job to do. Each cell selects for a single attribute. Cells ignore all other attributes except the one they select for (Zeki, 1999, p. 60).

Areas V1 and V2 of the visual cortex are two of the most highly understood areas of the brain. Area V1 sits at the back of the head in the Occipital Lobe (Zeki, 1993, p. 96). If you put your fingers together on the back of your head near the bottom of the skull, above the bony lump of the occipital ridge, you will be touching the area outside of the visual cortex.

Figure 3
Location of the visual cortex at the bottom, back of the brain.

Source: Copyright 2017 by Elaine Froehlich.

Signals from the retina pass through the Lateral Genticulate Nucleus to V1 where two kinds of cells, called the blobs and interblobs, process those signals. Named for the way they show up when magnified on a slide, the blobs transmit information dealing with form and color and the interblobs transmit signals dealing with motion (Zeki, 1993 p. 100).

Once a visual signal reaches area V1 two things happen. Evidence shows some visual processing happening immediately as signals enter V1 but predominantly it acts as a sorting area, sending signals off to be interpreted by the more specialized areas of the Prestriate Cortex (Zeki, 1993, p. 177).

The area nearest V1 in the brain is V2. It surrounds V1 and receives signals directly from V1. Like V1, it both processes the visual signals and passes them along to the other areas of the visual cortex. Area V2 cells contain larger receptive fields and perform more analytic functions than V1. V1 maps precisely to the retina, allowing for precision in locating visual sensations. The cells of both areas are selective for all of the features of sight: "motion, orientation, wavelength [color] and depth" (Zeki, 1993, pp. 177–178).

V2 has layers of cells in stripes called thick, thin and interstripes. They connect to the blobs and interblobs of area V1. The thick stripes of V2 connect with the motion-sensing interblobs of V1, continuing the chain of connected anatomy that processes motion (Zeki, 1993, p. 99).

Details of the subordinate parts of the visual cortex

Form is recognized in many areas of the brain. "Orientation selective" cells are dispersed throughout the visual cortex. They respond to "lines of specific orientation or motion in a specific direction" (Zeki, 1999, p. 113). Orientation-sensitive cells are arranged in a precise order. Each cell responds to a line or edge within their receptive field at the angle they are tuned to. They have "precision, regularity and predictability" (Zeki, 1999, p. 113).

In V3, cells that respond to similar orientations are aligned adjacent to each other. A single cell from among the billions that comprise the visual cortex waits for a signal from an edge at a precise angle. As the angle of an edge within its receptive field changes away from its orientation preference, it responds less and less. When the deviation of the edge becomes perpendicular to the angle the cell selects for, "they cease to respond" (Zeki, 1999, p. 102).

The cells in area V3 interpret form and dynamic form. Cells activate only when presented with lines oriented at precise angles (Zeki, 1999, p. 102). It's as though each cell is waiting for input to be received at a single, well-defined angle. When a cell recognizes a signal, that cell sends a response to area V1 that it is reading an input for its angle (Zeki, 1993, p. 125).

Special cells in area V3 recognize dynamic form or the motion of edges at specific angles of orientation. They differentiate between the motion of an object and motion created by movement of the eye. For forms in motion the brain must recognize both the form and the motion (Zeki, 1999, p. 131). While these are orientation-specific cells, this ability of some cells to perceive the motion of lines and edges augments the motion processed in area V5 to build complex understandings of moving objects (Zeki, 1999, p. 194).

Area V6 borders V3 and takes input from V2. Not much is clear about the function of V6 though indications show one of its abilities may relate to an understanding of space (Zeki, 1993, p. 105).

Area V4 is the primary color area, though it also processes some kinds of "form in association with colour." The cells of V4 " are indifferent to form. That is to say they will respond if a stimulus of the appropriate color is a vertical or horizontal bar, or if it is a rectangle, circle or square" (Zeki, 1999, p. 60).

The receptive fields of V4 cells are very large and either square or rectangular. The trigger that causes a V4 cell to respond generally is "some kind of transformation between what is in the receptive field and what is in the surround" (Zeki, 1999, p. 119). The cell responds to the difference between a color located within the receptive field and a different color adjacent to it. One cell might be activated by "a blue square on a white background" but have no response to the same "blue square on a black background" (Zeki, 1999, p. 120).

The motion specific area of the brain

Buried in the Superior Temporal Sulcus, area V5 responds to motion. Motion is directed from the retina through the M-layers of the Lateral Genticulate Nucleus through the interblobs of V1 and the thick stripes of V2 to be further

broken down in area V5. In addition, the study of brain anatomy shows direct neural connections from the retina to areas of V5, allowing V5 to register things moving at high speed (Zeki, 1999, p. 144). This example of a variation of the route visual signals take to reach their processing area shows that the areas work autonomously as well as cooperatively.

Area V5 receives input directly from V1. The majority of the cells, about 90%, are sensitive to orientation. The mapping here is less precise to the retina than in other areas of the visual cortex. They respond to any motion aligned in the appropriate direction at any point in the visual field. It's not a map of the retina, but rather a map of the activity of motion. Zeki clarifies his explanation by saying: "perhaps we should think of these areas as labeling a particular kind of activity in a region of visual space" (1993, p. 155).

Cells in V5 have large receptive fields. They are imprecise, only responding to movement in specific directions. Rather than being mapped to exact areas of the visual field, most cells of V5 sense motion in a single direction. A few cells are sensitive to motion in any direction but do not respond to unmoving signals. Cells of V5 respond regardless of the color of an input (Zeki, 1999, p. 143).

Other directionally oriented cells in V5 respond when a line of the correct orientation is recognized. They "respond better" when the line "displaces back and forth" across the receptive field in the opposite direction to the angle of orientation the cell prefers. A small number of cells only respond when the stimulus moves in one direction, toward or away from that cell's angle of orientation (Zeki, 1999, p. 133).

More motion-specific areas are known to surround V5 that are not well understood. Based on cells found in the Superior Temporal Sulcus of monkeys, research indicates that the brain processes motion in other areas. Those newly identified areas register "patterns of motion characteristic of biological motion" (Zeki, 1993, p. 193).

Motion in communication design

For designers, how does knowing how the brain works make a difference? Metaphorically, motion indicates life. The interrelationship between motion and life forms a natural, human connection. When I first researched the brain, learning that an area dedicates all its attention to processing motion surprised me. I always imagined a mental version of a movie screen tucked off in some neural corner projecting a continuous image coming in from the world. Instead, organic structures, billions of cells, exist within the visual cortex whose only job is to respond to motion. Speaking to this system of coordinated cells changes the way designers think about constructing messages.

Just as visual elements in design work best when they support the underlying message, moving elements designed to support the message and speak in a voice the brain understands will create more effective communication. The job for designers engaged with motion will be to incorporate the language of motion with the existing languages of design. Speaking to those billions of cells, ideas for messages that include motion will open new forms: branding

via motion, motion as a component in identity design, interface design further exploiting motion as communication and more investigation of the interrelationship between motion and gesture in interaction design.

Traditional fields like animation or film use motion as language. They work with highly structured motion hierarchies in their storytelling. Techniques such as the cut, the shot, pacing, narrative form and the use of sound comprise the building blocks that augment the movement of elements in a composition. Designers' roles in understanding these techniques will change their approaches to telling stories, adopting and developing a designer's vocabulary of motion to conveying messages. Learning the basic elements of motion and combining them with the distinct processes of visual communication design will create new pathways to making meaning.

Many early 20th century designers explored their fascination with motion in images. Designers and artists obsessed over the role of motion in two-dimensional design. Numerous books were dedicated to the new ideas motion brought into design. Some of the deepest thinking can be found in the writings of these designers. In the posthumously published book of his pedagogical studies of motion, *The Thinking Eye*, Paul Klee (1964) declared, "I should like to create an order from feeling and, going still further, from motion" (p. 5).

Laszlo Moholy-Nagy (1947) defines "*vision in motion*" as "creative performance–seeing, feeling and thinking in relationship and not as a series of isolated phenomena. It instantaneously integrates [...] single elements into a coherent whole" (p. 12). His description mirrors the description of the brain processing visual signals outlined earlier.

Motion has the capacity to inform or distract. It quickly rises to our foremost attention when indicating a threat. In extreme cases, it attracts our attention relentlessly. The way motion is articulated in its environment will determine how effectively it communicates. Within a composition, motion can be used

> to show: direct attention;
>
> to tell: impart, express thoughts or give an account of;
>
> to warn: give notice of danger;
>
> to acquaint: introduce, make familiar;
>
> to orient: set context;
>
> or to delight: give a high degree of gratification, extreme satisfaction or pleasure ("Motion," n.d.).

In his talk, "Fundamental Philosophy of New Media," Jan Kubasiewicz (2016) quoted Chris Pullman's (2014) observation that in a new, universal language of communication as it relates to designing interactive media, the fixed becomes fluid; passive changes to responsive, composition transforms into choreography and object turns into experience. In new media environments, motion combined with interaction reshapes the basic forms of communication. He finds that "the dynamic vocabulary of motion and gesture must contribute to a universal language of communication" (Kubasiewicz, 2008, p. 202).

It will help designers to get interested in languages of movement and gesture, of dance and the process of choreography; of physics and the behavior of objects ruled by mass and gravity; to observe the way lighting relates to ambiance and meaning in moving environments. Learning and using these techniques to deepen engagement for design purposes will by definition bring a new way of communicating design messages in the emerging contexts of technology and interconnected communication.

The gentle flutter of Elmar's muscles spoke to me of immediacy and danger faster than my cognitive brain could process, resulting in my great leap to safety. This experience suggests access to forms of communication through motion that go beyond those we commonly use today. The power to communicate in this way produces new opportunities in communication design.

Elaine Froehlich, MFA, Adjunct Professor Graphic Design,
Roger Williams University

References
Arnheim, R. (1974). *Art and visual perception: A psychology of the creative eye.* Berkeley: University of California Press.

Kepes, G. (1965). *The nature and art of motion.* New York: G. Braziller, Inc.

Klee, P. (1964). *The thinking eye* (2nd rev. ed.). J. Spiller (Ed.). New York: G. Wittenborn.

Kubasiewicz, J. (2008). The language of motion in communication design. Presented at the *11th Generative Art Conference.* Retrieved from http://www.generativeart.com/on/cic/papersGA2008/17.pdf

Kubasiewicz, J. (2016). The education of dynamic media: DMI concept,experience, community [Keynote presentation]. In *Retrospective: 15 Years of the Dynamic Media Institute at MassArt.* Symposium conducted at the Atrium of the Design and Media Center, Boston, Massachusetts.

Moholy-Nagy, L, (1947). *Vision in motion.* Chicago: P. Theobold.

Motion [Def. 2]. (n.d.). In *Merriam Webster Online,* Retrieved November 28, 2008, from https://www.merriam-webster.com/dictionary/motion.

Pullman, C. (2014). Some things change, some things stay the same [Personal web site]. *Design, Writing.* Retrieved October 7, 2016. Retrieved from: http://christopherpullman.com/home/some-things-change-some-things-stay-the-same/

Zeki, S. (1993). *A vision of the brain.* Oxford, Boston: Blackwell Scientific Publications.

Zeki, S. (1999). *Inner vision: An exploration of art and the brain.* Oxford, New York: Oxford University Press.

Zettl, H. (2008). *Sight, sound, motion: Applied media aesthetics* (5th ed.). Belmont, California: Thompson/Wadsworth.

"Games and movies have the ability to let us engage and feel immersed in experiences, both realistic and fantastic. Motion, as one of the many elements of this puzzle, should be as realistic or as farfetched as the whole experience is designed to be."

A conversation with
Daniel Alenquer, *Playerium*

Daniel is the Co-founder and Creative Director at Playerium, an international game studio based in Taipei, Taiwan. He is responsible for inspiring and informing all creative aspects of the work developed by the studio and is focused on designing immersive gaming experiences while exploring the intersection between creativity and technology.

Early Influences from the Entertainment Industry

The first time I worked on a motion design project happened around 1992. I was editing a documentary and the script required a static map showing two different roads leading to the same destination. Even though route A was much longer than route B, it was slightly shorter in terms of time travel because you could drive at a higher speed. I decided to use a sequence of images to communicate the difference in average speed—and as you can imagine the animation was much more successful than the static image.

Later, as I started working in different industries, from interaction design to gaming, I kept the same basic principle learned during that first map animation: if motion design is used with specific purpose—and clear intention—it can deeply impact how we communicate stories and concepts.

I've always been fascinated by how the entertainment industry experimented with motion design early on and influenced how other industries used it as an instrument to multiply meaning. Even from an early age I was constantly trying to figure out how movies, TV shows and games managed to create these amazing, exciting worlds that were heavily based on moving visual stimuli.

From Reproduction to Recreation

When I first started most of my efforts were guided towards observing how things moved. I believed that by analyzing speed, trajectory and acceleration, for example, I would be able to get most of the information necessary to create great motion design solutions. In a way, I was just mimicking what I saw around me—I would look at different objects in motion and try to analyze every single aspect of the movement. I tried to copy those elements and reproduce them as precisely as I could. That was a critical part of my learning process, but it wasn't until much later when I went to [graduate school at] Ohio State that I started to think about the relationship between motion and cognition. It became clear to me that being able to precisely replicate specific aspects of motion was only half of the work. It was equally important to be able understand how people perceive, process and respond to different animations.

Conveying Powerful Information Through Motion

Most animals use motion to collect information about other animals, objects and the environment. Some predators are known to select their prey by observing how they move: after collecting cues on which animals may be injured, or less capable of escaping, lions and tigers, for example, seek out and attack the weakest of the group.

Humans can make relatively accurate inferences about a wide variety of topics within a short amount of time: Thin-slicing is an evolutionary skill that helps us to take in large amounts of information by just observing how, for example, people, animals and objects move. We are capable of estimating how heavy or lightweight an object is based on how it rolls down a hill. We can even imagine how fragile it may be, or what kind of material it is made of by just looking at how it bounces down the same hill. Our ability to form abstract concepts allows us to go as far as imagining what someone else may be thinking, or feeling, by just observing how they walk. No matter how right or wrong our inferences may be, we are hardwired to look at things, observe how they move and draw conclusions constantly.

For [game designers], using motion to trigger players' thin-slicing capability is a powerful way of communicating a multitude of concepts within a short window of time. Embedding additional information about the environment, character and objects in the game is a key part of developing deeper, more meaningful and engaging experiences.

Part of the puzzle

When we watch movies, or play games, we observe each character and subconsciously collect information about what they do, what they say, how they say things, what they are wearing, what decisions they make, how they walk, everything. Meanwhile, our minds are quietly putting together a puzzle and trying to connect all these different pieces. These different bits of information help us make inferences about the character's personality, needs and desires. It helps us imagine what the character would do if something specific happened, or what they are capable of doing if you are in fact controlling this character in a game. All these subtle but important ingredients merge together to create the overall experience–and motion is an important part of this puzzle.

Figure 1
Different animations are used to test and highlight specific personalities through different walking cycles.

Copyright 2017 by Playerium. Reproduced with permission.

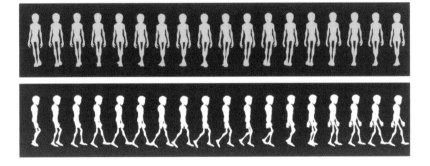

Because our brains are so quick to thin-slice everything, when any of the character's qualities is in dissonance with the way it moves, for example, it is harder for us to add things together. It becomes a distraction, as opposed to adding to the whole. Instead of paying attention to the story and enjoying the experience, we spend time trying to figure out what is wrong.

Rules of the game

Motion design also helps to inform players about how to interact with the game. Just like many other interactive media, games require users [players] to go through short cycles between action [on the user side] and reaction [from the game or system]. Players must rely on a variety of clues to interact with the in-game environment to achieve specific objectives. For instance, when a player sees an obstacle they must consider at least two out of many possibilities: should they jump over the obstacle, or should they try to destroy the obstacle? Players take the character's properties into consideration when making this not just this decision, but all other decisions in the game. Is this character fast? Can the character generate enough momentum to jump over the obstacle? By looking at the way the character moves, is it strong enough to destroy the obstacle?

Figure 2
Physical properties communicate to players how different characters may react to specific controls.

Copyright 2017 by Playerium. Reproduced with permission.

It's about consistency

Games and movies have the ability to let us engage and feel immersed in experiences, both realistic and fantastic. Motion, as one of the many elements of this puzzle, should be as realistic or as farfetched as the whole experience is designed to be.

Independently of what any motion design solution is trying to communicate, I believe that it is important to observe and understand the physical properties that dictate how objects move in our world. I believe that by analyzing features like speed, trajectory and acceleration we become better prepared to do so. But I also believe that it is more important for motion design elements to be consistent with the all the other elements in the game. Consistency is what makes the whole experience believable—real or imaginary.

Practice & Application

SECTION 1

Brand Building and Identities

Guy Wolstenholme & Jon Hewitt

David Peacock

Jakob Trollbäck

SECTION 2

Interface and Interaction Design

Andre Murnieks

Jeff Arnold

Gretchen C. Rinnert, Aoife Mooney, & Marianne Martens

SECTION 3

Narrative and Storytelling

Kyle Cooper

Adam Osgood

Karin Fong

SECTION 4

Space and Environment

Cotter Christian & Catherine Normoyle

Christina Lyons

SECTION 5

Experimental Visualizations & New Applications

Steven Hoskins

Isabel Meirelles

Matt Pasternack

SECTION 6

Educating Motion Designers

R. Brian Stone

Heather Shaw

Kyle Cooper

Daniel Alenquer

Karin Fong

Guy Wolstenholme & Jon Hewitt

Isabel Meirelles

Jakob Trollbäck

Section 1

Brand Building and Identities

A conversation with
Guy Wolstenholme and Jon Hewitt,
Moving Brands

Guy and Jon are agents of transformation. They operate out of Moving Brands, a London-based firm where both are Creative Directors. Their works focuses on developing new opportunities for their clients' brands, products, communication, and culture. Their goal is to connect people to brands through interactive environments and digital products, services, and experiences.

Here they share with us their ideas on how to best engage the people you need to reach through content, strategy, brand building, and moving messages.

Where Moving Brands started

As a company, Moving Brands has been been going now for nearly 19 years. We [the founders including Guy Wolstenholme, Ben Wolstenholme, and James Bull] started straight out of Saint Martin's College in England with degrees in graphic design but we focused mainly on film and animation because that's something we all enjoyed.

It began when we were approached by someone who wanted to start an ice hockey program—they needed everything from identity and branding to programming. The scope of the project was a huge leap forward for us and a huge year-long learning process. We realized that we worked very well together as a team and wanted to extend our offerings. We named our new group "Moving Brands."

We initially partnered with some of the bigger branding agencies because it felt like they didn't have any sort of motion design capabilities. It was great for us in this role because we worked on big brands doing end frames for advertisements or corporate films.

I think we were quite niche back then, although we got busy very quickly. What we found interesting were the conversations we had with clients regarding their brands. We would get questions like, "Can you just make it [the brand/logo] move at the end of the advertisement?" And we'd reply by saying, "Of course we can, but how should it move and how should it behave or what does it sound like or what sort of behaviors does it have?" 99 percent of the time the answers were "we don't know... none of that is in the guidelines."

From these experiences, we realized that no one (or very few) were thinking about motion and behaviors at the ideation of the brand. It seemed like a huge gap. There is the logo, the fonts, and the colors, but very limited consideration for understanding the brand in a more behavioral sense. We believe the

behavior of a brand in different scenarios is a lot more valuable because, as new media and new platforms appear, you have an understanding of how elements may behave rather than just building on texture as an afterthought.

Our clients started to ask us if we could do the static versions of a their brand marks. Honestly, it was a bit weird because we were defining ourselves as making things move, but we were trained in graphic design. The static elements felt like moments within a movement and it enabled us to think in a broader, more behavioral sense. We discovered that you can come to moments that you would never be able to design in a static sense. You're given the brand mark parameters and rules and you let it live in motion. With this approach, you get moments that you just can't design, which is where it starts to get really interesting. So we began to explore what we believed to be this natural progression and new way of branding.

An example of this is the rebrand we designed for Swisscom, a major telecommunications provider in Switzerland. The first thing we did was animate the brand mark. From there we looked for those static moments from within the animation. We looked at taking a moment from the animated sequence and made that the static version of the brand mark. It sounds very straightforward but it required weeks and weeks of work because it's not always easy to find a moment that looks elegant as a stand-alone graphic and works in a moving image sequence. There was a lot of back and forth in that process with our animators *and* designers.

Figure 1
Moving Brands created a kinetic identity for Swisscom that brings together their business offerings in one unified mark.

Figure 2
Motion based studies for the Swisscom mark.

Figure 3
Different instances of the Swisscom mark designed to move and act natively across all current and future touch-points.

Exploration process grounded in motion studies
At Moving Brands, motion design is part of the exploration process. It's not just for a piece of animation or filmmaking, but serves as source material for our designers and art directors who might be working on producing advertisements or posters or building signage. Through motion design exploration we are able to create different expressions of a brand, which can communicate a lot about the character of a business.

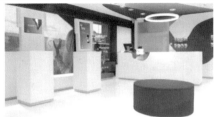

Figure 4
Swisscom's identity expressed through several different channels.

A project we believe that exemplifies this process is the system we developed for an Irish telecom business called Eir. Very early on in the design exploration, when we were sketching logo ideas on paper, we started to "sketch" in motion as well. So the two processes were running in parallel with ideas being sketched on paper and ideas being sketched in After Effects, then being reviewed by the creative team together. This allowed ideas to be explored quickly—for us to consider motion from the outset of the creative process and for the two mediums to cross-pollinate.

Figure 5
Simple but bold, the Eir identity animates in a psuedo cursive style.

Figure 6
A vibrant range of applications express Eir's current shift in business.

The Flipboard project, even though it's a few years old now, is still a good example of the results of our process. Flipboard is a news aggregator originally designed for the iPad. Our early explorations centered on sort of a flipping or unpacking aesthetic. The client really loved our motion studies to the point where it the "flipping" became the way you navigate through the app, so it ultimately felt like you were interacting with the brand as you're navigating through their product.

The properties of sound were also an integral part of the the Flipboard brand. We experimented with different sounds that occur when you flip physical pages. We consider the sounds that are made by books, magazines, and even a rolodex. The layer of sound further amplifies the behavior of the logo mark.

Figure 7
Moving Brands leveraged the gestural essence of "flipping" as a core element of the Flipboard user experience.

Figure 8
Analogue studies for Flipboard.

Figure 9
The Flipboard logotype dynamically unfolds to reveal itself.

Finding inspiration in real-world movement

We tend to create evocative films early on in the design process. We cast the net quite wide and draw references from macro photography or from nature. We'll look very closely at the wings of a butterfly and the way they move when you slow it down or the way bubbles form and burst in slow motion. We'll film our kids on swings or at the playground, for instance. You get these incredibly rich images and start to notice the nuances of the motion that you might not otherwise see. Having actual moving references show dynamics and gravity in the way things behave. These are invaluable when it comes to applying certain properties to objects or to brands.

When we show concepts, although our clients may not realize it, they have a feeling of familiarity because it comes from a real movement or a real property. Using real world references definitely helps our process. Stepping away from the screen, having a look around you, going for a walk in the woods, and being inspired by what's out in the world makes the difference.

On the future of motion design

Over the last couple of years we've seen a huge ramp up in the appreciation of motion design. This is linked to the processing power of our devices which allows for richer, more complex animations. Any content presented through a

screen becomes a canvas for the motion designer. It is integral to any business with a digital product offering, service, website, or app.

Because of this proliferation, there is a need for motion designers. Every screen that we interact with in the future will have to have some consideration of motion design. Therefore, this really rich discipline is emerging that isn't about traditional animation, but about the design and choreography of a UI [user interface], requiring the special skills of the motion designer.

Another area to think about is our real world physical stuff that we see all around us coming together with the digital augmented world. Right now a lot of the things being visualized feel a bit messy. The real world already feels pretty populated even before adding another digital layer. The challenge will be getting those two things to work better together. Going forward, rather than just layering and adding, it will be more about being selective. And maybe even gesture and physical movements to help people navigate, but it's about the skinning of the digital layers with the real layers that feels like the space to be thinking about.

Motion designers should take the lead in this space as things come together in this new area of augmented reality because it's everything they should already be and have been exploring.

Note

All images in the chapter are courtesy of Moving Brands (copyright Moving Brands) and reproduced with permission. These and more examples of their work can be viewed at movingbrands.com.

"Motion-based narratives reach wide audiences, tell brand stories, and promote dialog. For all of the following companies, motion was treated not as merely a delivery method, but rather as a core component of each brand's new identity."

David Peacock
Identities in Motion: Logo Introductions as Brand-Building Narratives

The Power of Motion-Based Storytelling

Author and digital marketing authority Mitch Joel (2009) describes video as "probably the most popular type of online content" (p. 146). Communicating with audiences through digital channels is increasingly important for brands that want to deliver relevant, meaningful communication (Adamson, 2009; Ahmed & Olander, 2012). With the rise of blogs, YouTube, Instagram, and other online video-sharing platforms, the communication barriers between consumers and brands are quickly disappearing. Fisher and Vallaster (2008) describe the notion of "connective branding," suggesting that companies are no longer the sole creator of their brands, disseminating information outwards to a passive audience, but rather must consider their customers as brand co-creators and engage with them in a two-way conversation.

In this environment, motion-based storytelling is emerging as one of the most compelling ways for companies to connect with their audiences. This study focuses on a particular area of contemporary brand communication—the use of video to introduce brand identity updates to the public. Companies across sectors have introduced new identities in the past decade (Gotsi & Andriopoulos, 2007), and this proliferation of identity updates speaks to today's dynamic marketplace (da Silveira, Lages, & Simões, 2013). Through the use of video, companies are able to communicate brand updates to a wide audience, describe their evolution or shift in focus, and ultimately, reveal the brand's values and purpose.

Once communicated by a press release at best, today's brand update announcements are likely to involve dedicated websites, in-depth blog posts, social media content, and the use of professionally-produced video and motion graphics. Far from the static text of a press release, identity introduction videos incorporate motion, animation, typography, editing, music, and voiceover to create dynamic brand narratives. Motion-based pieces give companies an opportunity to present a brand story in an appealing, consumer-friendly format. As Alina Wheeler (2013) notes in *Designing Brand Identity*, "The best videos tell stories, embody a brand's voice, engage customers, build communities, and unify a company—all in two minutes" (p. 78). The sheer volume of public and press reaction that brand updates receive today suggests that audiences are interested in the stories behind the updates—why the change was needed, how the creative process unfolded,

what the new symbol and colors mean, what others think of the new design, and how the new identity speaks to the company's future outlook. Brands that want to connect with today's audiences must take into account these emerging customer expectations, and video presents an opportunity for brands to build on public interest and tell their stories through an emotional and immersive form of communication.

Why should brands think about motion? What is it that makes motion-based video narratives compelling for consumers, and what is the best way to talk about the medium? Hillner's (2005) study into the perception of motion argues that motion is inherently exciting, even seductive, in that it has, above all, the benefit of surprise. It is the moment of surprise—and the sensation of not knowing what is coming next—that supports our ongoing interest in film, TV, and other movement-based forms of information. Further, kinetic motion directs our attention and draws us into the experience, and forces us to slow down as we attempt to take in and make sense of the information (Hillner, 2005). Recent scholarship on film title design suggests that motion can establish tone and set expectations within a particular category or genre (Krasner, 2013). In their study of the semiotics of motion, van Leeuwen and Djonov (2015) suggest that motion has a language and grammar of its own and has the potential to convey meaning beyond what the text reads. Krasner (2013) mapped the history of motion graphics and detailed the discipline's key concepts. Of particular use for this study is the idea that motion-based narratives unfold as a sequence of events, and, for the motion designer, motion graphics is the orchestration of these events and "the manner in which images and type move and change over time" (p. 244). Additionally, Krasner also identifies various aesthetic forms available to motion designers, such as live action, illustration (hand-rendered or vector-based), and typography.

Brownie (2015) further extends the scholarship on motion design by offering a precise vocabulary for the analysis of type in motion. For example, while kinetic type tends to be used by designers as a general term for motion-based text, she makes a distinction between kinetic motion, type that moves in relation to the frame, versus temporal motion, type that has a static position but transitions to the next sequence through a quick cut, dissolve, or other effect. Terminology from film studies is also useful for discussing motion graphics. Giannetti's (2016) examination of filmmaking offers an overview of narrative styles (realistic versus formalistic), editing techniques (such as 'cutting' a sequence of images together), and types of shots (including establishing, close-up, medium, and long shots). As motion design continues to evolve as an established discipline with its own terminology and corpus of knowledge, there is increased opportunity for it to play an important role as part of brand-building efforts. As Paul Pierson of the Carbone Smolan Agency describes, "Video brings dramatic new depth to how brands can express themselves" (Wheeler, 2013, p. 78).

The following examples represent brands that tapped into the potential of motion-based storytelling as part of their recent identity updates. Through

motion design, these brands explored the intersection of collaboration, creative process, and audience engagement. These particular examples are significant for several reasons. First, they offer a snapshot of the range of approaches and visual techniques available to brands working in motion, including live-action filmmaking, montage, illustration, and graphic minimalism.

Further, all of the rebrands discussed here, along with their accompanying introduction videos, received considerable attention from the press. Rebrands are now routinely covered by a range of media outlets, from mainstream publications such as *The New York Times* and *Wired* to business-focused titles such as *Inc.* and *Fast Company*. Creative professionals and non-professionals alike now flock to online message boards to offer opinions on the relative merits of new identities. All of this increased attention speaks to the importance of brand identity in contemporary culture, and the power of motion-based narratives to reach wide audiences, tell brand stories and promote dialog. For all of the following companies, motion was treated not as merely a delivery method, but rather as a core component of each brand's new identity.

Instagram: From Photo Filters to Lifestyle App

Instagram is an online image- and video-sharing platform, founded in 2010 by Kevin Systrom and Mike Krieger. The popular service allows users to take and share images and video through the Instagram app or through social platforms such as Facebook (who acquired the company in 2012), Twitter, and Tumblr. The company has grown rapidly and currently boasts more than 500 million monthly users. The company's 2016 rebrand, led by the internal Instagram creative team, was prompted by a desire to visually reflect its growth from a company that offers a photo-filtering app to one that has inspired a global community of photo and video enthusiasts "sharing more than 80 million photos and videos every day" (Instagram 2016a). The previous logo, a skeuomorphic, retro-style icon inspired by a vintage Polaroid camera, did not reflect the company's growing audience and needed an update that would represent the community "past, present, and future" (Spalter 2016). In practical terms, the move from a skeuomorphic to an iconic logo meant that it would be much more scalable and would create a better experience across a range of device sizes (Spalter 2016). The visual update also extended to Instagram's other services—Boomerang, Layout, and Hyperlapse—with the family of logos sharing common visual attributes.

Instagram's identity redesign was announced through a traditional press release, as well as social media, blog posts, and, most notably, "A new look for Instagram," a short making-of video that introduced the brand update through visuals and music. The video featured prominently in two blog posts that were central to the announcement. The first, published on the official Instagram blog, focused on the strategic vision of the company and the business case for the rebrand (Instagram, 2016a). The second, a post on the Medium blog site by Instagram Head of Design Ian Spalter, described the design rationale

behind the update (Spalter, 2016). "A new look for Instagram," a collaboration between the Instagram creative team and production studio Buck, focused on the creative process behind the logo's development. The bright, lively piece brings the logo's visual transformation to life by featuring the many iterations, sketches, and color changes that occurred throughout the process.

The video opens with the old logo shown on a mobile device. A finger taps the icon, and the logo transforms into dimensional wood shapes, which are then taken apart by hands entering the picture frame (Figure 1), an action that suggests that the logo is being taken apart and scrutinized. A series of different camera bodies are shown on white sheets of paper in quick succession, a visual cue that various camera designs were studied as part of the research process. Then, a series of hand-drawn sketches are posted to a wall on sticky notes, to visualize the exploratory design process (Figure 2). The narrative continues as icon sketches in a notebook are crossed out, an empty chair rotates forlornly, and a crumpled paper is tossed into a wastebasket. These representations of the creative process effectively describe design as an iterative, collaborative, and sometimes frustrating process. Conceptually, what is notable in this piece is the degree to which the design process itself is presented as a way to allow viewers to share in the creation of the new brand. As we watch the video, it is as if we are creating the logo alongside the Instagram team. The piece suggests a degree of transparency and a willingness

Figure 1

Frame from "A new look for Instagram." Over an upbeat soundtrack, a woodblock version of the old logo is taken apart.

Source: Instagram, 2016b. Copyright by Instagram.

Figure 2

Frame from "A new look for Instagram." Design sketches are posted to a wall, suggesting brainstorming and iteration.

Source: Instagram, 2016b. Copyright by Instagram.

to share the brand with its audience. What would have once been a secretive process—the public would only see the finished design—is now offered as part of the overall story.

One of the primary goals of the rebrand, according to Spalter, was to honor the existing logo and retain the elements that people loved most about it: the rainbow, lens, and viewfinder (Spalter, 2016). To articulate that idea, "A new look for Instagram" references the relationship between the old and new logos throughout the video. Indicative of this strategy is a series of vignettes that make up the middle portion of the video. Color chips, design software, watercolor paint, swatches, and finally a rainbow gradient are all shown to illustrate the color selection process. One sequence shows an eyedropper tool (most designers will recognize the Photoshop software interface) selecting the colors from the previous logo (Figure 3). The relationship between the old and new logo is visualized again near the end of the video, as a diagram-like overlay illustrates the transition from a realistic, skeuomorphic logo to a simplified, iconic form (Figure 4). The new logo, Spalter notes, may look like a radical departure but is actually "tied to the history and soul of Instagram" (Spalter, 2016). Telling a story about the lineage of the new (and, based on public reaction, controversial) logo was a smart strategic move. The video played a crucial role in explaining the new identity to an audience that felt very connected to the old logo (Vit, 2016) and gave viewers—especially those who were skeptical—insight into the creative process and thinking behind the work.

Figure 3
Frame from "A new look for Instagram." Photoshop's eyedropper tool is used to select colors from the old logo.

Source: Instagram, 2016b. Copyright by Instagram.

Figure 4
Frame from "A new look for Instagram." A diagrammatic style illustrates the logo's transition to a simpler, iconic form.

Source: Instagram, 2016b. Copyright by Instagram.

"A new look for Instagram" exemplifies a high degree of professional polish and reflects a youthful, contemporary brand persona. While not effects-laden, the work is notable for its seamless integration of in-studio photography, computer-generated graphics, and illustration. The various segments of the video are tied together through color (inspired by the brand's new rainbow palette), predominantly centered compositions, and the use of visual metaphor. Although the approach is upbeat and playful, there is a seriousness to the branding endeavor that the video strives to communicate. The video sends a clear message that the logo change was not arbitrary, but rather the result of a thoughtful, considered process. Most importantly, the rebrand and video rollout represents a growing-up for the brand, and marked the transition from a photo-filtering app with a retro logo to a globally-minded company that is aware of its importance for millions of users. With more than five million views since its launch, "A new look for Instagram" demonstrates the value in using motion-based storytelling to capture audience interest and attention.

Southwest Airlines: A Company Shows Its Heart

From its start in 1971, Southwest Airlines carved out a niche as a regional carrier known for its funky, upbeat personality and "entertaining service experience" (Hatch & Schultz, 2008). In a delicate balancing act, it was among the first airlines to adopt a no-frills approach while also maintaining a customer-centric brand philosophy. The company underwent a series of significant changes in 2013. The company's merger with AirTran Airways was nearing completion, a development that would add 5,000 new employees, along with the ability to offer international flights for the first time. Additionally, restrictions would soon lift that would allow Southwest to offer more direct flights from its home base at Dallas Love Field.

With these changes, it felt like the right time to update the brand and signal an evolution for the company (Kelly, 2014). Southwest enlisted highly regarded branding consultancy Lippincott, based in New York City. Lippincott Creative Director Rodney Abbot notes that one of their goals was to "remain true to the brand" that had a committed base of loyal customers (Abbot, 2015). From early on, the Lippincott team felt that the heart, a symbol that had appeared in Southwest marketing over the years in different guises, would be the right symbol to tie the past to the present. "The Heart is who we are," Southwest's Director of Brand Communications, Helen Limpitlaw, explains, "It encapsulates what we offer as a company. It's symbolic of our care, our trust, and our belief in providing exceptional hospitality" (Southwest Airlines, n.d.).

The Southwest rebrand required collaboration among several agency partners and internal stakeholders. In a multi-team effort, Lippincott handled the identity redesign, livery, and in-airport experience; longtime agency GSD&M handled the advertising, and digital agency Razorfish created the announcement website. In the fall of 2014, GSD&M launched the marketing campaign with *Machine*, a 30-second spot that appeared on TV and online, presenting the new identity as not merely updated graphics but as part of a bold vision for the future (Morrison, 2014). *Machine* builds an emotional

story through striking airplane imagery, a casual, conversational voiceover (supplied by actress Rashida Jones) and the use of Southwest Airlines employees instead of paid actors.

While the previous Instagram example is formalistic and stylized in its visual execution, *Machine* is more traditionally realistic and utilizes live-action camerawork (Southwest Airlines, 2014b). The video opens with a close-up shot of the plane nose entering the frame from the bottom, and with a quick edit transitions to a side view as the plane enters the frame from the right. These unconventional compositions complement the narrator, who explains, "This is a different kind of airline. One that invented low fares so everyone could fly." Next, the plane tail is shown in extreme close-up, to accentuate the brand's distinctive color palette (Figure 5). Then, from a bird's eye view, a pilot, flight attendant, and mechanic are shown walking toward the plane (Figure 6). The pilot inspects the plane with an outreached hand, adding a humanizing moment and supporting the line, "Some say we do things differently. We say, why would we do things any other way?" (Figure 7). This is an effective setup for one of the most important shots, a close-up of the heart logo on the plane's belly (Figure 8). The camera angle accentuates the logo's unconventional placement on the underside of the plane, meant to be visible while the aircraft is in flight. Throughout the video, there is a clear attempt to accentuate the

Figure 5
Frame from "Machine." The tail of the plane is shown in extreme close-up, foregrounding the brand color palette.

Source: Southwest Airlines, 2014b. Copyright by Southwest Airlines.

Figure 6
Frame from "Machine." Shown from above, Southwest employees approach an airplane.

Source: Southwest Airlines, 2014b. Copyright by Southwest Airlines.

identity through close-up images and tight cropping that bring the logo and color palette forward. This approach has an additional advantage in that many of the shots are from a human vantage point. The camera takes us up close, to see details from just a few feet away. When human figures are in the frame, they become the centerpiece, with the plane serving as a dynamic backdrop. These compositions artfully reinforce Southwest's customer- and employee-centered brand language.

Figure 7
Frame from "Machine." A Southwest pilot appraises the new design.

Source: Southwest Airlines, 2014b. Copyright by Southwest Airlines.

Figure 8
Frame from "Machine." A close-up of the new Heart logo, located on the airplane's underside.

Source: Southwest Airlines, 2014b. Copyright by Southwest Airlines.

Figure 9
Frame from "Southwest employees react to our bold, new look." Southwest employees enjoy a firsthand look at the new livery graphics.

Source: Southwest Airlines, 2014a. Copyright by Southwest Airlines.

As part of a major advertising campaign, *Machine* was conceived to exist as both a TV commercial and web content. While the TV spot saw wide media distribution, its role as a web video gave it increased importance as part of the rebranding rollout. In addition to the television campaign and an official press release, Southwest devoted a dedicated website to the brand update project. The website, Southwest-heart.com, included in-depth information about the rebrand as well as a number of videos. Along with *Machine*, the site includes *Bold*, a second commercial created for the launch campaign, "Love at first sight," a time-lapse video of new signage and wayfinding installation at Dallas Love Field, and *Southwest employees react to our bold, new look*, a video piece that captured the brand unveiling from an employee perspective (Figure 9). These videos also found additional viewers through the Southwest YouTube channel, where "Southwest employees react" and a series of similar employee-focused videos have received thousands of views.

Machine ends with an aspirational message, the tagline "Without a heart, it's just a machine." For Southwest, the *Machine* piece was an effective way to tell their brand story, as it illustrated how the various piece of the new campaign—the heart, the tagline, the bold color palette—all supported the people-first theme and humanized the air travel experience. The piece featured a cinematic style that brought gravitas to a message that could have easily become saccharine. Wrapping brand messages in the rhetoric of 'love' and 'heart' is a bold move for an airline, but Southwest was able to rely on their long-standing reputation as a customer-focused company. The rich content they produced as part of the brand update rollout gave customers an opportunity to connect with the brand on an emotional level.

For Southwest, video presented a medium to inform the public about their identity update, as well as express the company's values, purpose, and goals for the future.

Airbnb: The Story of a Symbol

Airbnb is an online marketplace, where travelers search for vacation properties (everything from apartments to high-end villas) from around the world and deal directly with the property owners, some of whom act as hosts and travel guides. Airbnb fits squarely into the sharing economy, as travelers bypass traditional hotels in search of unique travel experiences (Sundararajan, 2016). Founded in 2008 by Brian Chesky, Joe Gebbia, and Nathan Blecharczyk, the company has grown rapidly since its early days as a startup run out of a San Francisco apartment.

After six years of accelerated growth, the company decided the time was right for a rebrand. There were a number of factors that led Airbnb leadership to consider a brand update. One primary driver was the tension between how the world saw Airbnb and how Airbnb saw themselves. While the typical user thought of Airbnb as an online booking platform, the company felt there was an opportunity to express the brand as something more aspirational, reflecting what they saw as a global community of users who were creating "a network based on trust" (Schapiro, 2014). After a rigorous vetting process, Airbnb chose London-based DesignStudio as their design partner. The DesignStudio

team, led by founder Paul Stafford and Creative Director James Greenfield, worked onsite in close collaboration with Airbnb throughout the project. In June 2014, after an intensive nine-week collaborative effort, Airbnb launched a new identity and brand positioning campaign founded on the core idea of "Belong Anywhere" (Chesky, 2014). The introduction of the brand update featured a live video feed to more than 10,000 Airbnb employees, hosts, and customers. A central piece of the event was "Airbnb introduces the Bélo: The story of a symbol of belonging," a two-minute animated video that explained the Belong Anywhere concept and the development of the new brand identity. Airbnb's Creative Director Andrew Schapiro notes that the video functioned as "the most succinct way to tell the story" (personal communication, August 19, 2016).

The opening sequence establishes the tone of the piece, with bold sans-serif typography placed over, and sometimes interacting with, bright and upbeat illustrations. The opening text reads:

The world is full of cities and towns.

Constantly growing larger.

But the people within them are less connected.

Yet we are all yearning for a sense of place.

We are all seeking to Belong. (Airbnb, 2014)

Throughout the piece, the illustrations and typography are both imbued with personality. Significant words (connect, place, safe, share) are emphasized through color (Figure 10). The text transitions through kinetic movement and smooth dissolves. After the introductory sequence, a paper airplane interacts with the text, "Airbnb stands for something much bigger than travel." The scene then transitions to a postcard illustration, with text that reads, "We imagine a world where you can Belong Anywhere" (Figure 11). Postcards from around the world, representing Airbnb's growing global community, slide into the frame. The next sequence features one of the piece's most memorable illustrations. To emphasize the idea that the new logo should be "recognized anywhere," the Airbnb flag is shown, in a lighthearted gesture, planted on the moon (Figure 12). Next, the logo's primary inspirations—people, places, and

Figure 10

Frame from "Airbnb introduces the Bélo, a story of a symbol of belonging." Key words are accentuated through color.

Source: Airbnb, 2014. Copyright by Airbnb.

To feel accepted and feel **safe.**

Figure 11
Frame from "Airbnb introduces the Bélo, a story of a symbol of belonging." A series of postcards illustrate the company's global reach.

Source: Airbnb, 2014. Copyright by Airbnb.

Figure 12
Frame from "Airbnb introduces the Bélo, a story of a symbol of belonging." The Airbnb flag on the moon illustrates the 'Belong Anywhere' concept.

Source: Airbnb, 2014. Copyright by Airbnb.

Figure 13
Frame from "Airbnb introduces the Bélo, a story of a symbol of belonging." Typography and graphic elements illustrate the company's brand values.

Source: Airbnb, 2014. Copyright by Airbnb.

love—are illustrated through icons and text. The words and icons animate and interact with each other (Figure 13) before transitioning to the final symbol, known as the Bélo. This is a particularly effective use of motion design, as the otherwise abstract logo takes on new meaning as the viewer learns more about the brand values that influenced its design. Like the earlier Instagram

example, there is an interest in making the creative process visual, as a way to explain the story behind the logo and bring viewers into the creative process. In this instance, the identity creation process itself becomes part of the brand story.

The video reaches its emotional peak with the phrase, "Wherever you see it, you'll know you belong" (Figure 14), followed by a rapid succession of city names from around the world (again highlighting Airbnb's global community) and then finishing on the new Airbnb logo (Figure 15). The piece deftly combines information delivery and aspirational brand language, and helped Airbnb evolve from their public perception as a transactional website to a company guided by ideas of community and togetherness. While the other examples in this study are primarily pictorial, this work represents an effective combination of type and image. As the typography interacts with the graphics it takes on a life of its own and helps establish tone and style. Further, the typography, illustrations, and color palette align effectively with other brand elements in the new system; the piece feels integrated and central to rather than outside the brand.

Figure 14

Frame from "Airbnb introduces the Bélo, a story of a symbol of belonging." A key brand message is illustrated with typography and a dynamic graphic element.

Source: Airbnb, 2014. Copyright by Airbnb.

Figure 15

Frame from "Airbnb introduces the Bélo, a story of a symbol of belonging." The new logo design completes the story.

Source: Airbnb, 2014. Copyright by Airbnb.

Following the initial live event for employees and core customers, cofounder Brian Chesky announced the rebrand to the general public through a blog post on the Airbnb website. The "Airbnb introduces the Bélo" video featured prominently as part of the article, and, after the launch, continued as featured content on the Airbnb website, the company's YouTube channel, and press pieces about the rebrand. The video, created by DesignStudio in close collaboration with Airbnb's creative team, went from storyboard to script to final piece in only a few weeks. With a charming illustration style, subtle typographic transitions, and an upbeat soundtrack, the video brought the company to life from a positive, customer-centric point of view. Through the use of motion, the company was able to express its brand personality and share its core values in a way that felt more like storytelling and less like traditional marketing. Rather than focusing on particular services or features of the Airbnb website, the company instead focused on brand story, thereby presenting an identity update that felt personal, approachable, and authentic. With more than one million views since the brand update launch, the video has proven to be an effective way to engage the public and present Airbnb as a legitimate travel option while also speaking to its particular ethos as a community-centered company.

Google: The Evolution of an Internet Giant

Since its founding in 1998, Google has "evolved from a search engine to become a genuine leader of the technology age" (Lee, Yao, Mizerski, & Lambert, 2015, p. 24). During this span Google has undergone several identity updates, but none as dramatic as their 2015 brand refresh, which featured the transition of the classic Google logotype from a thin serif font to a modern sans-serif style. From a business perspective, the update coincided with the creation of Alphabet, a holding company of which Google is the main subsidiary (Page, 2015). With this change Google could return to its focus on Internet services.

As a design consideration, one of the most crucial reasons to rebrand was to optimize the mobile experience, which has gained rapidly in importance since Google's early days as a desktop browser interface (Page, 2015). There was further need, as described by design lead Jonathan Lee, to "future proof" the identity for on-the-horizon technologies like wearables and Android Auto interfaces (Wilson, 2016b). This meant creating a logo and supporting elements that would scale easily across devices "so users would know they are using Google, even on the smallest screen" (Cook, Jarvis, & Lee, 2015). Motion was an emphasis from the beginning, as Lee and team sought for "a new level of expression in our interface and for our brand" (Wilson, 2016b).

Google announced the updated identity on September 1, 2015. Many people likely discovered the update through an animation that appeared that day on Google's homepage. The animation, part of the Google Doodles series of homepage logos that mark special occasions, starts with an illustration of a child's hand wiping away the previous Google logo. The hand then draws the forms of the new Google logo with rough chalk-like strokes (Figure 16), finally

dissolving to an image of the new logo. The primary colors and child-like approach perfectly captures Google's personality and introduced the new logo in a way that inspired substantial press coverage and user reaction.

A primary means of delivering information about the new brand was "Evolving the Google identity," a blog post written by Alex Cook, Jonathan Jarvis, and Jonathan Lee, the brand update project leads. The post features an in-depth discussion about the rebrand and the reasoning behind the various design decisions. For the designers, a core idea behind the identity update was the development of a system of interrelated elements that could be used across different product platforms and marketing materials (Cook et al., 2015). Says Lee, "as a company we needed to become simpler so we can handle more complex problems" (Design Indaba, 2015). Motion graphics played a prominent role on the page, as a series of short videos illustrated each part of the system. "Google Logotype" is a short video that visually describes the Google logo update. In the opening sequence, a gray outline of the Google logo animates over a lined paper motif. With an overlay of thin directional arrows, the outline transitions to the full-color logo (Figure 17), a representation that "combines the mathematical purity of geometric forms with the childlike simplicity of schoolbook letter printing" (Cook et al., 2015). The full-color logo then transitions to a sizing chart that highlights its readability at small sizes, and then transitions to a logo lockup for Google Maps, as an example of how the system extends to Google sub-brands. Although short and relatively straightforward, the video represents an effective approach to supplying information in a way that is compelling and interesting for a general audience.

"Google G" highlights Google's new G icon meant for apps and other small display areas. Created in a similar aesthetic style as "Logotype," the animation focuses on the construction of the G form, and the subtle shifts that were introduced for optical alignment (Figure 18). "Colors" is a short animation that highlights the shift in the color system to a slightly brighter palette. Through motion, the subtle change is made clear as a radial transition reveals the brighter colors (Figure 19). Like "Google Logotype," both of these videos use diagrammatic graphic elements and smooth animations to highlight new brand components. For the Google design team, one of the most important tasks was to introduce expressive motion into the system and bring the Google experience to life through "dynamic, intelligent motion that responded to users at all stages of an interaction" (Cook et al., 2015). The team developed a series of dots animations that reflect different stages of interaction: listening, speaking, replying, incomprehension, and confirmation. For each interaction, the dots have a distinct motion that acts as a visual cue for the user, such as graphic equalizer lines for speaking (Figure 20), a subtle bounce for listening, and a side-to-side shake for incomprehension. One reviewer described these interactions as "Pixar-esque" in how much personality each small movement contains (Evamy, 2015, p. 14), and design critic Steven Heller called them "an evocation of contemporary media" (Wilson, 2016a).

Figure 18
Frame from "Google G Construction." A graphic overlay highlights the carefully considered Google G icon.

Source: Cook, et al., 2015. Copyright by Google Design.

Figure 19
Frame from "Google Colors." A radial transition illustrates the updated color palette.

Source: Cook, et al., 2015. Copyright by Google Design.

Figure 20
Frame from "Google Dots in Motion." Various user interactions are supported through subtle, intuitive animations.

Source: Cook, et al., 2015. Copyright by Google Design.

User Speaks

As a design goal, the creative team wanted the three elements—the logotype, and the G icon, and the Dots—to feel systematic, as if they were separate states of the logo (Cook et al., 2015). The videos demonstrate the team's systematic approach through subtle overlays that reference a common, underlying grid structure. A detailed look at the reasoning and process behind an identity update may have at one time been considered esoteric content of interest only to other designers. Today, though, that kind of material is of interest to a wide contingent of users. For Google's audience, it was an opportunity to learn about the design process and collaborative effort behind the update and get to know a company that has become, for many of us, a part of our everyday lives. It was important for Google to take a thoughtful approach and carefully explain the new logo and why the various changes were made, and ultimately how these changes will benefit users. Motion graphics offered an informative and entertaining way to express the company's dedication to simplicity and clarity, and demonstrated that motion design will play an important role for the brand going forward.

Motion-Based Narratives as Opportunities for Brand Engagement

This chapter attempts to address the increased importance of motion design as part of rebranding efforts, and in particular, the role of video in introducing brand identity updates to the public. The study focused on a series of high-profile updates that are indicative of the increasing importance of video as a medium for brand engagement. When today's brands launch a new identity they are often doing more than introducing a new logo: they are using the occasion as an opportunity to offer a narrative, establish relevance, and foster audience connection. The examples discussed here demonstrate that in today's dynamic, digitally-focused market environment, online motion-based narratives are valuable content pieces that start dialog, circulate through social media, and generate press coverage.

While these examples vary in tone, style, and execution, they all captured their brand's voice and personality. All four companies shared a common goal of offering viewers meaningful brand content, what brand consultant Allen Adamson (2008) defines as "entertaining, engaging and worth sharing" (p.

104). Southwest Airlines expressed their commitment to customer service through "Machine," a cinematic live-action identity introduction that centered the story on customers and employees as the company's "most valuable fuel" (Southwest Airlines, n.d.). Instagram expressed their goal of a connected, global community through "A New Look for Instagram," a vibrant piece that gave users a glimpse into their creative process. Airbnb expressed their mantra of Belong Anywhere through "Airbnb introduces the Bélo: The story of a symbol of belonging," an arresting combination of illustration and typography that carries an emotional impact. For Google, a series of short, informative videos brought audiences into the design process and turned a straightforward blog piece into a dynamic storytelling experience.

For these companies, the creation and introduction of the videos were also an opportunity to bring employees into the brand update project, through employee input (Instagram), cross-team collaboration (Google), viewing events (Airbnb), and employee reaction videos (Southwest). Olins (1990) noted the importance of making employees feel connected to a brand's identity so they "feel that it is really theirs" (p. 140). While this study focused on visual identity updates, there is an opportunity for further avenues that examines the use of video to address the challenge of introducing a name change along with a new identity—what is essentially a new company in the minds of consumers. Further research possibilities also exist for the examination of motion-based storytelling from a long-term perspective, and the ways in which motion-based storytelling gives brands a digital presence and supports their market positioning over the course of several years.

The various works discussed in this study suggest new ways of thinking about brand identity and the expansion of the core components of brand toolkits. Once peripheral notions such as animation, kinetic typography, and time-based narrative are increasingly central to how brands communicate with their audiences and are becoming as important as logo, typeface, and other common brand elements. Brand updates are time-consuming and expensive endeavors (Stuart & Muzellec, 2004), and companies face the challenge of adapting to changes in market conditions while keeping their values consistent and recognizable (da Silveira et al., 2013). Videos that introduce new identities have a functional purpose, but they also provide an opportunity to reveal what former P&G marketing executive Jim Stengel describes as "brand ideals"—what the company stands for at its core and its "essential reason for being" (Stengel, 2011, p. 3). While consumers may not have financial stakes in the companies whose products they use, they do have "emotional ownership" (Balmer & Greyser, 2006, p. 737) and often feel strongly connected to the brands in their lives. For companies involved in updating their corporate identity, motion-based narratives can help stakeholders—employees, investors, customers, the press—understand why the change took place and what it means for the future. As video-sharing platforms continue to play a prominent role in how brands connect with audiences, motion will continue to develop as a key concern for brands seeking to create strong narratives and represent who they are, what they believe, and where they are going.

David Peacock, Faculty, Vermont College of Fine Arts

References

Abbot, R. (2015). *Designing with purpose* [Video file]. Retrieved from http://www.
 underconsideration.com/brandnewconference/video/downloads/rodney-abbot-15-
 mins/

Adamson, A. (2009). *BrandDigital: Simple ways top brands succeed in the digital world.*
 New York: Palgrave Macmillan.

Ahmed, A., & Olander, S. (2012). *Velocity: The seven new laws for a world gone digital.*
 London: Vermilion.

Airbnb. (2014). *Airbnb introduces the Bélo: The story of a symbol of belonging* [Video
 file]. Retrieved from https://www.youtube.com/watch?v=nMITXMrrVQU.

Balmer, J. M., & Greyser, S. A. (2006). Corporate marketing: Integrating corporate
 identity, corporate branding, corporate communications, corporate image and
 corporate reputation. *European Journal of Marketing, 40(7/8),* 730–741.

Brownie, B. (2015). *Transforming type: new directions in kinetic typography.* London:
 Bloomsbury.

Chesky, B. (2014, July 16). Belong Anywhere–Airbnb's new mark and identity [Web log
 post]. Retrieved from http://blog.airbnb.com/belong-anywhere/

Cook, A., Jarvis, J., & Lee, J. (2015, September 1). Evolving the Google identity [Web log
 post]. Retrieved from https://design.google.com/articles /evolving-the-google-
 identity/

da Silveira, C., Lages, C., & Simões, C. U. (2013). Reconceptualizing brand
 identity in a dynamic environment. *Journal of Business Research, 66, 1.*

Design Indaba. (2015, October 28). *Jonathan Lee gives us insight into Google's
 rebranding* [Video file]. Retrieved from https://www.youtube.com/
 watch?v=nyS5Ug3dws4

Evamy, M. (2015). Word search. *Creative Review, 35, 10,* 14–16.

Fisher, C., & Vallaster, C. (2008). *Connective branding: Building brand equity in a
 demanding world.* Chichester, England: Wiley.

Giannetti, L. (2016). *Understanding movies.* Boston: Pearson.

Google. (2015). *Google's New Logo* [Animated graphic]. Retrieved from https://www.
 google.com/doodles/googles-new-logo

Gotsi, M., & Andriopoulos, C. (2007). Understanding the pitfalls in the corporate
 rebranding process. *Corporate Communications: An International Journal, 12, 4,*
 341–355.

Hatch, M. J., & Schultz, M. (2008). *Taking brand initiative: How companies can align
 strategy, culture, and identity through corporate branding.* San Francisco: Jossey-
 Bass.

Hillner, M. (2005). Text in (e)motion. *Visual Communication, 4, 2,* 165–171.

Instagram. (2016a, May 11). A new look for Instagram [Web log post]. Retrieved from
 http://blog.instagram.com/post/144198429587/160511-a-new-look

Instagram. (2016b). *A new look for Instagram* [Video file]. Retrieved from https://
 vimeo.com/166138104

Joel, M. (2009). *Six pixels of separation: Everyone is connected: Connect your business
 to everyone.* New York: Business Plus.

Kelly, G. (2014). A new look, the same heart. Retrieved from http://www.southwest-heart.com/#swa_gary

Krasner, J. (2013). *Motion graphic design: Applied history and aesthetics* (3rd ed.). Boston: Focal Press.

Lee, A., Yao, J., Mizerski, R., & Lambert, C. (2015). *The strategy of global branding and brand equity.* London: Routledge.

Morrison, M. (2014, September 8). Southwest lets fly massive brand refresh. *Adage.* Retrieved from http://adage.com/article/cmo-strategy/southwest-launches-massive-brand-refresh/294861/

Olins, W. (1990, January 1). How a corporation reveals itself. (an organization's corporate identity can inspire loyalty, shape decisions, aid recognition and attract customers). *The New York Times.* 140.

Page, L. (2015, August 10). G is for Google [Web log post]. Retrieved from https://googleblog.blogspot.com/2015/08/google-alphabet.html

Schapiro, A. (2014). *What's mine is yours* [Video file]. Retrieved from http://www.underconsideration.com/brandnewconference/video/downloads/andrew-schapiro/

Southwest Airlines. (2014a, September 8). *Southwest employees react to our bold, new look.* [Video file]. Retrieved from https://www.youtube.com/watch?v=rFbe5MI5y-w

Southwest Airlines. (2014b). *Southwest heart: TV commercial – Machine* [Video file]. Retrieved from https://www.youtube.com/watch?v=y4j1mV5e-6A

Southwest Airlines. (n.d.). Straight from the heart. Retrieved from http://www.southwest-heart.com/#spirit_article

Spalter, I. (2016, May 11). Designing a New Look for Instagram, Inspired by the Community [Web log post]. Retrieved from https://medium.com/@ianspalter/designing-a-new-look-for-instagram-inspired-by-the-community-84530eb355e3#.m2jwww9xh

Stengel, J. (2011). *Grow: How ideals power growth and profit at the world's greatest companies.* New York: Crown Business.

Stuart, H., & Muzellec, L. (2004). Corporate makeovers: Can a hyena be rebranded?. *The Journal of Brand Management, 11, 6,* 472–482.

Sundararajan, A. (2016). *The sharing economy: The end of employment and the rise of crowd-based capitalism.* Cambridge, Massachusetts: MIT Press.

Van Leeuwen, T., & Djonov, E. (2015). Notes towards a semiotics of kinetic typography. *Social Semiotics, 25, 2,* 244–253.

Vit, A. (2016, May 11). New icon for Instagram done in-house. *Brand New.* Retrieved from http://www.underconsideration.com/brandnew/archives/new_icon_for_instagram_done_in_house.php#.V_05dbQ5n3s

Wheeler, A. (2013). *Designing brand identity: A complete guide to creating, building, and maintaining strong brands.* Hoboken, NJ: John Wiley.

Wilson, M. (2016a, September 2). The branding gods (mostly) love Google's new logo. Retrieved from https://www.fastcodesign.com/3050638/the-branding-gods-mostly-love-googles-new-logo

Wilson, M. (2016b, September 21). Why Google changed the most recognizable logo on the web. Retrieved from https://www.fastcodesign.com/3063003/innovation-by-design/how-and-why-google-revamped-its-logo

A conversation with
Jakob Trollbäck, *Trollbäck+Company*

Jakob is a creative thinker and founder of Trollbäck+Company. His versatility as a designer is exhibited by his use of rhythm, form and detail in the motion graphics that he creates. He has developed notable film titles, television commercials, interactive displays, and identity design.

Jakob was among the earliest group of designers to understand and embrace the importance of digital media and the effect it would have on culture at large. Here he discusses the importance of having good ideas and creating experiences through motion.

How it all started—parallels between motion design and music

While living in Stockholm, I was a DJ and had a club and record store. I started to design flyers and things for the club. My transition into motion design mostly started by accident. I decided that I wanted to move to New York in the early 90s and landed a job at R/Greenberg Associates (now R/GA). They did feature film titles and TV commercials. At that time, I was just starting to do work on the computer, so it was somewhat natural to think about film editing in the same way I was thinking about design, while also leveraging all the things from my experience as a DJ.

When I started to work with editors, I realized very quickly that motion design has many parallels to music. If done right, it has a sense of rhythm and a sense of progress. You can take your viewer from one place to another. And I believe there should always be some kind of a "build" when you're working with motion design. I always think about it in the sense of a rhythmic mix. Music is fed by the same observations as good motion design because it's about creating drama and creating a crescendo to something. As with music, motion design should release energy or create a sense of surprise.

For me, personally, motion design has a very strong connection with music. People have said for years that motion design is about storytelling, but in reality you don't always have time to tell the whole story. What you have time for is to deliver a setup—that is something that can be learned from music. With music you can understand how things can change very quickly in tempo, or harmony, or structure. So, to me, the two are connected, but it's much more about how you want to make people feel or react. I use the same ideas working with music as I do when I'm thinking about motion graphics.

A watershed moment in my career

When I came to R/GA, I started to work with the openings for the TED conferences. Year after year, they became my own explorations in how to animate type. Many of those titles were highly regarded and appreciated by my peers. This work started opening things up for me about how I was thinking about motion design. More than anything, I was constantly experimenting and trying to find different ways to move type. That was an important phase for me as I had considered becoming an architect before I became a designer. I've always looked at design as something that's poly-metric so it became very natural to think about volume and space and time together.

Figure 1
Trollbäck's TED conference opening sequence uses a series of animated ticker tapes to promote the theme of the conference, "The Great Unveiling."

Copyright 2014 Trollbäck +Company. Reproduced with permission.

Moving on from that work, one piece that I still feel today was important was the opening I did for *Night Falls on Manhattan*. I credit this to the title's simplicity of the form and because I spent so much time thinking about the difference between art and design. I wondered to what extent could I make design look like a piece artwork. And that's exactly what that opening is—a sort of watercolor animation piece.

Figure 2
Trollbäck blurs the lines between abstract art and motion design in the title sequence for Night Falls on Manhattan.

Copyright 2014 Trollbäck +Company. Reproduced with permission.

Since 1999, my team and I have done interesting work year by year. The openings for the TED Conference and also the openings for the PopTech Conference are fine pieces. Some of our best work actually comes from work that was done pro bono or very low budget. The important thing though is all the baby steps of learning that come in between each project.

Figure 3
Opening sequence for the 2012 PopTech Conference held Reykjavík, Iceland.

Source: sacrednoise, 2012.

The unique benefits of motion design

One of the advantages I see in motion design is that the designer has complete control over the sequence of the experience that you provide for people. To the contrary, when you design a printed piece, and assuming you're in the western world, people are going to start reading on the top left, unless you have type that is much bigger that is somewhere else on the page. You can attempt to guide the viewer in a sequence that you believe is best for people to take in the information. This is a crude way to guide how people get information because you don't necessarily have control.

When working with motion design, regardless if you're working with just type or with other elements, you can decide that you want to put the viewer in a particular mood by showing something that's very dark. Then, after a certain amount of time, you can decide to let a little light in and then give it color. It's a very controlled way of communicating in that you can direct how people react to the work.

It's the opposite of working as an artist and doing a piece of work and hoping that people get some kind of a reaction from it. Again, it's akin to what a DJ does when mixing music. You pick your tracks, you decide when you want to mix it in, and dictate when you want the dance floor to go into a frenzy.

Looking to the future

I think an area that's going to be interesting is how we become more tactile in animating things. I think virtual reality is going to play a big role here. I can see us very easily working in a creative environment where you could create

motion and motion sequences by just using your hands in a poly-metric place. One way or another, virtual reality and augmented reality are going to be huge pieces of the puzzle. The question then becomes, how "new" are things going to be or how much they will be extensions of what we've done before, but in a new medium.

Figure 4
Motion design plays a part in maximizing the user experience at this Apple retail store. Interactive displays and video walls promote Apple's latest capabilities and product offerings.

Copyright Trollbäck +Company. Reproduced with permission.

Figure 5
Leveraging the iconic MTV logo, T+Co. extended the kinetic language to audiences across 45 countries and 13 language markets.

Copyright Trollbäck +Company. Reproduced with permission.

References

Sacrednoise. (2012). *Poptech 2012* [Video]. Retrieved from https://www.youtube.com/watch?v=d3OpdgEZsqE

Other images from videos retrieved from http://trollback.com/ and https://vimeo.com/trollback.

Section 2

Interface and
Interaction Design

"Animated visual feedback and dynamic,
interactive visualization of data are obvious

areas in which motion provides clarity and
context to complex information."

Andre Murnieks

Navigating VOX/UI: The Integration of Motion in a Voice-Controlled Information System

Moving on to the Next Revolution of Information Access

Why aren't we talking to computers? Or maybe the question today should be, why aren't we talking to computers more? They can talk back—sort of. Perhaps this is the stuff of science fiction, or maybe science fiction is exploring possible user interface permutations of the inevitable future of voice interaction with computer information systems. Having interviewed experts in computer science, human computer interaction, and psychology (S. D'Mello, R. Metoyer, & C. Poellabauer, personal communication, September 2016), the consensus is that having a conversation with a computer (beyond rote commands) depends on advances in natural language processing (NLP), defined here:

> Natural Language Processing (NLP) is an area of research and application that explores how computers can be used to understand and manipulate natural language text or speech to do useful things. NLP researchers aim to gather knowledge on how human beings understand and use language so that appropriate tools and techniques can be developed to make computer systems understand and manipulate natural languages to perform the desired tasks. (Chowdhury, 2003)

Assuming natural language processing is not a matter of "if" but rather "when," what will that interaction look like? The role of the interaction designer will have to evolve beyond a graphical user interface (GUI) if input commands are largely spoken. Designers are becoming more adept at going beyond just the visual affectations of human-to-computer interactions. A graphical user interface implies that all communication is text and image-based, but any designer working in this area must also integrate the aural and tactile input and feedback mechanisms of a digital interactive experience. Together these visual, aural, and tactile interface elements form a communication environment between human and machine through elaborate hierarchies of signs, symbols, and metaphors to navigate to the desired information. If the interaction with the machine were more natural using oral commands, how would that affect the GUI? Would the GUI even be necessary if natural language processing allows the machine to speak in return?

However, is the best response to spoken command a verbal response? As a feedback response, the machine's vocalization of much more than a few words is at best tiresome, and more likely annoying. While visual information may be scanned, oral information is temporal and ephemeral. Certainly the machine can be asked to repeat itself, but vocalizing the current temperature is a much different query compared to the recitation of the Magna Carta. Other than text, oral feedback is not even possible for highly visual data like imagery. In fact, if the machine can package (design) the visual response using methods prescribed by the designer, then every bit of information delivered to the user is based on her unique query and context. The presentation of information is always personalized.

To further define the extents of this hypothetical concept, the second assumption made here is that the most likely response to a vocal query is a dynamic visualization of type, graphics, and motion. By envisioning a probable future where computers respond to natural voice, it is possible to explore the key interaction moments of a hypothetical voice-based interface system where motion is critical to the human-to-computer communication experience.

The dynamic display of graphic information is greatly enhanced by the thoughtful use of motion. The purpose here is to briefly outline several of the opportunities for motion design in a futuristic interface largely driven by voice input, but still relies primarily on dynamic visualization as a means to deliver information to the user. In addition to drastic changes to the visual and aural (now including speech) dimensions of user interaction, it is important to reflect on the tactile methods of input that are bound to the visual user interface elements. In effect, the manual actions of a mouse and keyboard, as well as the gestures in a touchdriven interface, are also choreographed motions that must be considered.

The promise of natural voice interaction with the machine could mean the end for keyboards and mice. While that may seem far-fetched, another way to illustrate the absurdity of the current means of computer interaction is to frame it as an elaborate substitution for vocal commands. Every GUI element is simply a constrained, manual method for executing a prescribed and anticipated user's desire.

The Manual Motions of the Digital User Experience

Consider the very first mechanism that allowed for user input which then triggered a response that performed some kind of work. It likely had a "button" that executed some mechanical, moving process. What if the button is not meant for a human? Now consider the mousetrap—a very simple machine with disastrous results (for the intended user anyway). But yet the mousetrap is a mechanism that requires a motion to activate it and another violent motion in response to complete its task.

With anything electrical, the power switch is the simplest of input mechanisms for controlling the device's state, and also very familiar to the human, although the unseeable electricity is a bit more mysterious than mechanisms of

machines. Both mechanical and electrical devices become increasingly more complex and hybridized over time. The computer mouse invented by Douglas Engelbart in 1963 is a simple mechanical switch that controls something far more electrically complex: a microprocessor, which is, essentially, a dense collection of close to a billion tiny electrical switches (Moggridge & Atkinson, 2007; Knight & Glass, 2013). Of course, the click of the mouse is not affecting the microprocessor's functions directly, but rather through some coded logic and layers of interface that presents graphic information on the screen.

It is through these graphic layers of interface that we communicate with the machine, and this primarily dexterous vehicle for communication is through the ubiquitous button.

Buttons rule the graphical user interface
This screen-based graphical user interface is a marvel but still makes heavy use of mechanical metaphors to function, mostly notably the button. The screen is littered with them or derivations of buttons: hyperlinks, menus, sliders, scrollbars, and icons. And while the touchbased interface has allowed us to touch these buttons more directly, the mouse's abstracted, indirect method of screen manipulation is simply a way to use a mechanical finger (mouse) to control a virtual one (pointer) for purpose of pushing those screen-based buttons.

Before touch-based and mouse-driven interfaces, the keyboard reigned, and it is another array of mechanical buttons. And before mice and keyboards, a punch card's holes could be considered a "button," but certainly the keypunch that made the punch card holes was also riddled with buttons. To sum up, human-to-computer communication has largely been a manual act (by hand) using physical and gestural motions to gain access to the machine ("Punched card," n.d.).

The end of GUI
With the exception of sign languages, most direct human-to-human communication is not manual. Language is oral and text is visual, and while computers are better-than-ever at *showing* information visually and *telling* by producing sound as feedback to the user, they have not been so adept at seeing or hearing. If an interface could reliably respond to vocal commands supplemented by visual gestures, facial expressions, and eye tracking, what would that mean for button-based, manual user interfaces?

If vocal interaction is more efficient, faster, less prone to error, and far easier to learn, many of the manual input tasks commonly associated with computers and mobile devices could be completely supplanted by a new human-computer interaction paradigm. What would it mean if an interface did not depend on manual buttons? It would mean that screen-based visual interface design is dead. Natural voice interaction (systems understanding speech and context) will replace what is typically visual and tactile input (i.e., graphics and buttons) (Sparandara, Chu, & Benson, 2015). Furthermore, the entire

landscape of the visual feedback system (i.e., the screen) is information rather than an inventory of commands.

Dynamic Visualizations Responding to Voice Input

Introducing "VOX/UI," or voice user interface, a new acronym coined here to describe a hypothetical, yet plausible, method for man-machine interaction. While VOX/UI will end much of the graphic *input* side of user experience, the system will still respond graphically relying heavily on motion in response to a verbal query. In other words, you will speak naturally to the system, but it will show a bevy of visual responses, and motion will be critical to the interaction. Animated visual feedback and dynamic, interactive visualization of data are obvious areas in which motion provides clarity and context to complex information, but the third category purports that this interface could respond to the gestures and actions of the *user*.

Quite simply, how do we know the system is listening? With other humans, there are so many visual cues to pick up on, and, in fact, we tend to forget that we may be shaping what we are saying in mid-sentence to accommodate the feedback: the smirk, the raised eyebrow, or the audacious rolling of the eyes. An information system that can see and hear as well as it can show and tell is the ultimate personal digital assistant. Here in this futuristic system, the motions are enablers of user *feedback, clarity,* and human *behavior*. When and how to use motion in VOX/UI is broken down into these three main areas.

Computer-to-human interface feedback responding to human speech

The fantastical VOX/UI starts with, and depends, on clear evidence that the interface is actively listening. This assumes that the system has been genuinely asked a directed question, perhaps activated through a trigger phrase (Eadicicco, 2015) and perhaps in combination with biometric recognition (Jain, Ross, & Prabhakar, 2004) or even a glance—more on that later. Once activated, animated awareness of a user's query may be handled in a number of ways, but subtlety should be stressed. There is a fine line between active listening and interrupting.

Animated awareness responses during vocal queries (active listening)

For example, Apple's Siri in iOS 10 now employs a beautiful, if not psychedelic, wavy animation, and it responds to the amplitude of the user's voice. While this may be helpful to an audio engineer getting sound levels, is it helpful or distracting? Does shouting or whispering carry significance? In fact, this motion effect replaces aural and haptic feedback letting the user know that Siri was "ready" to listen (see Figure 1) in previous versions due to latency (Moren, 2015). The flow of the conversation has been improved with less interruption.

In contrast, Amazon's Echo responds to the trigger phrase with a subtle light animation that is vaguely comparable to the opening of an eye (see Figure 2). During the actual query, Echo merely stays lit to show attentiveness, and then uses a flashing pattern to indicate that it is processing the question. Echo can only respond orally to a query, so the lighting cannot mean anything more, but it does convey patience and attentiveness.

Figure 1, 2
Siri's animated active listening. (left)

Source: Screen capture from iPhone 5s running iOS 10.

Echo's active listening light ring in motion. (right)

Source: Fernandes, 2016. Public domain.

Animated gestural responses: preloading, previewing, developing, and filtering query results

But is there a case for a good kind of interruption during a query from VOX/UI? When someone finishes your sentence, sometimes it is a good thing—sometimes it is not. Much like predictive search results such as Google search and predictive text in iOS Messages, this future interface could start delivering visual results in tandem with the user modifying her query in response to the results displayed. This method would allow for a more "conversational" approach to the search rather than a binary question and answer. The user would probe rather than command. Visually, motion would help discern the salient direction of the probe from the general to the specific. Effects like focus vs. blurring, morphing vs. splitting, and focal vs. peripheral can be used to compare and contrast many bits of information effecting helping the user filter results or "drill down." As long as the system is providing guidance rather than annoyance, the user will appreciate the assistance (Trafton, Jacobs, & Harrison, 2012).

Focusing the query and building a search narrative

The probing, conversational approach to a query would help maintain focus on the objective. As the search results begin to visually take shape into the accurate and desired form, irrelevant information can be put aside. Search engines are largely acts of defining and redefining the search terminology until perceived serendipity leads to useful information (André, Schraefel, Teevan, & Dumais, 2009). Certainly, outliers and related distractions can be useful, but motion could help maintain focus on a singular search narrative while also noting divergence on the path that could be pursued at a later time. Imagine if VOX/UI could recall the time you were looking for that thing, but you stumbled across something else and did not have the time to pursue it—but VOX/UI *does* remember it from a vague description. Maybe it could be the "remember when" command?

Google's latest voice-based assistant for the Pixel phone has an animated visualization similar to Siri to let the user know it is actively listening also akin to a stylized audio wave form (see Figure 3). Additionally, the assistant

Figure 3
*Pixel's active
listening animated
bar chart.*

*Source: Novet,
2016. Copyright
2016 by
VentureBeat.
Reproduced with
permission.*

exclusively on Google's Pixel, for now, can be more conversational since it treats each query as a thread. In fact, the conversation with the Google Assistant looks more like a texting session rather than discreet vocal interactions. While both Siri and Google Assistant can reply to followup questions using the context of the previous queries, Google Assistant presents it as a conversational thread allowing the user to scan the vocal queries and results visually (Droid Life, 2016).

While the Pixel presents results more conversationally, the data of each query are not compiling into an aggregated, focused set of data. The query is connected visually, but not building into a single topic of research with multiple sources. Both systems will need considerable maturation to become research assistants, but a side-by-side comparison reveals that Siri prefers showing dynamic visualizations of the requested data, and Google Assistant would rather do a lot of talking (Droid Life, 2016).

Overcoming system latency with motion

Reducing perceived wait time is an important sleight of hand that motion can provide. The dynamic visualization of data already implies that some computer intensive retrieval and processing is happening behind the scenes. Everything from progressive JPEG images to progress bars are motion graphics indicating that something is yet to come. Humans have their ways of buying time too: "err"s and "um"s, pregnant pauses, and gesticulation. Perhaps VOX/ UI cannot be as dramatic, but it can use the variable animation rate of screen states to mitigate a perceived lag or freeze much like the technique Microsoft employs in the Windows Phone to match the screen transition rate to the required background tasks (Arnold, 2015).

Computer-to-human interface feedback utilizing motion for the delivery, unveiling, and formatting of information

The above query phase of VOX/UI already suggests a busy search for information. Applied elegantly, effectively, and sparingly, motion should help

rather than hurt the process. Like many of the other techniques the designer uses, if the motion effect is distracts from the intended communication, then it is probably being applied too heavy handedly or inappropriately. But even as information from a voice query is being viewed or manipulated, motion can still help with management of the visual space.

Speaking of the visual space, its definition as a "screen" is purposely vague because motion may be applied differently depending on its size and the viewer's relation to it. The screen of the future VOX/UI may be very mobile and fit in pocket. It may also be very personal, augmenting only the individual user's visual field. But it may be also very social, shared, and public meaning that any display device or projection is a possible output device for anyone's personal VOX/UI assistant. Projected into nearby space or onto flat surface, the visual space could also be very large seemingly without bounds.

To make sense of this visual cacophony, the motions of the data elements can aid in the decoding of the information using movement for salience in a "temporal hierarchy." Every method used to create hierarchy and structure in traditional print design can incorporate motion to change over time: position, size, rotation, color, and texture. Perhaps just a plot device, the Iron Man movie makes use of floating, transparent, and animated visuals to investigate the problem (see Figure 4).

Figure 4
Iron Man's Tony Stark analyses data in space (still from Iron Man 2).

Source: Feige & Favreau, 2010.

Motion for attention (where to look)
Above all else motion is highly useful in directing a viewer gaze. In fact, of all the ways to draw attention, motion might be the most effective in a system that will present complex, dynamic visualizations streaming at the user. There are other design techniques for capturing the user's attention in the visual field, but motion is more effective in the periphery of our vision (Ware, 2008). In other words, if attention is going to shift from the current focal area (central fovea), even a slight movement can be detected at the far edges of the screen space. It is also important to note that if everything is moving similarly then nothing is really moving at all–at least when it comes to acquiring the user's attention.

Differentiation (comparison of choices and search results)
The saliency of more important, interesting, or desirable information can also be enhanced with motions that imitate or anthropomorphize meaningful

actions or emotions. While a screen element might wiggle for attention, it may also suggest meaning in its motions to illicit further scrutiny. This suggests that motion can provide another method for ordering and hierarchy that does not depend on traditional methods of ranking static screen elements. Once again, it may depend on conservative usage reserved for information with the highest probability of a desirability match—or perhaps information that might be easily overlooked. But it may also be useful for extraneous alerts and warnings, or simply a "poof" when something less desirable disappears.

Orientation, ordering, and layering in virtual space (depth cues using motion)

As it is implied, dynamic data visualization in VOX/UI is much more than pure text. If the interface depends almost entirely on speech, this may greatly affect the graphic methods with which elements are presented. In desktop interfaces, the windowing method is used to depict a virtual space that is not entirely 3D, and yet allows for perceived the layering of information in a perceived three-dimensional space (Staples, 1993). This window metaphor may still work with VOX/UI, but since VOX/UI should not require a mouse, the user is likely to direct her wishes to the content rather than the interface artifice that contains it.

This highlights the progress made in touch-based mobile devices: the user is directly manipulating the object of desire. And motion plays a large role in making sense of this virtual space with swipes, pinches, and zooms. More on user gestures for VOX/UI later, but the management of screen elements and visualized objects will depend on motion for spatial organization (Ware & Mitchell, 2005).

Transition (building from the general to the specific through progressive disclosure)

Animated screen state transitions have already been mentioned as a method of reducing perceived system lag time, but these animated interludes provide so much more. As the user drills down into information going from the general to the specific, the manual act of tapping with a finger dismisses the current information with deeper, more detailed information. This method of the progressive disclosure on mobile devices is particularly helpful in "seeing the whole in parts" (Buyukkokten, Garcia-Molina, & Paepcke, 2001).

Similarly, VOX/UI can do the same with a vocal command, however transitional animations may even be more important to add a sense of control to the information being manipulated. For a click or a touch, there is haptic and/or aural feedback, but an active visual response to an oral command is needed for VOX/UI. A good analogy comes from cinema (or maybe live television) where the user is like a director who cues cameras and controls the narrative with immediate visual feedback. For VOX/UI, "Your wish is my command."

Data visualization enhanced by time-based delivery

The search, acquisition, and delivery of information with VOX/UI can all be enhanced with motion as visual active feedback responses. Additionally, the

delivered content can also benefit by time-based delivery where appropriate. For example, even pure text can smoothly scroll by command or gesture, and this is technically a user initiated and controlled animation. Beyond pure text, VOX/UI assumes that information can be formatted, summarized, aggregated, or otherwise manipulated into dynamic visualizations. This, of course, is a whole other topic pertinent not only to this futuristic interface but also to the very core of visual communication design. It assumes that data can be polled, collected and presented to the user depending on the context of the query whether it concerns baseball box scores or killer bee migration patterns. While a graphic table would suffice for baseball, motion could greatly help create a more meaningful visualization about migration over time. Beyond creating a narrative around the information, animated data has shown to enhance understanding and increase engagement (Heer & Robertson, 2007).

Human-to-computer interface input from user's motions and behaviors
Before discussing the third area in which motion could benefit VOX/UI, note that the motions described here are not screenbased, designer-created animations acting as interface feedback for the user's benefit and delight. Quite literally, these are the movements, subtle and gross, that the user makes: looking, pointing, and even grimacing. Are human bodily kinetics apropos to a discussion about future opportunities for motion designers? Good motion design is noted for respecting, if not exaggerating, the physics of the real world and the gestures of human behavior. Human mimicry is a feature of animation.

Designers are already familiar with the gestures and movements of their users through imitation, but can these motions be used as a method of input for VOX/UI to supplement voice interaction? The Kinect gaming system from Microsoft provides a "natural" interface using gestures to control gameplay (Francese, Passero, & Tortora, 2012), but is it really natural?

Learning the prescribed gestures of a Kinect game may not be any more sophisticated than the rote commands for Siri. Instead of controlling an interface, VOX/UI will supplement natural voice interaction with gestural cues from the user. This may be treading too far into science fiction, but if the system can further understand the thing the user is interested in, then, "I want to know more about that," is greatly enhanced by a look and a point of the finger. Combing natural interface (gestures) with vocal command input has the potential to greatly improve the context of the interaction and more closely resemble human-to-human discourse.

Reading the motions of human gestures
As noted earlier, the manual movements of the mouse and companion screen-based pointer are abstractions of a human's natural desire to communicate through pointing—something learned at the very early age of 12 months. Pointing is a precursor to language, and there is evidence they are interrelated (Tomasello, Carpenter, & Liszkowski, 2007). Perhaps we have been pointing at computers far too long, and it is time to learn to speak to them? However

imprecise pointing may be by itself as a form of communication, add it to a verbal command, and now VOX/UI has another context in which to derive user intent.

The idea of a system responding to pointing is not so far-fetched as experimenters have already commanded robots with mere gestures, and concluded that, "for a human to interact with a system intuitively, the system should be able to understand human intention as in interpersonal communication" (Sato, Yamaguchi, & Harashima, 2007). Gone is the mouse pointer and the rollover animation, and in its place are screen elements that react with subtle motion to communicate they are the objects of the human-computer's joint attention (Moore & Dunham, 1995).

Reading the cues from the (e)motions of facial expressions

Since interaction with VOX/UI is intended to be more conversational with visualizations preloading eliciting continuous bilateral interaction with the user, the visual cacophony may be overwhelming. The tracking of the changes in facial expressions could act as a nonverbal method for determining the relevancy of the information presented to the user. The technology is maturing, and more importantly, even a webcam from 2007 is capable of capturing enough visual information to derive emotions from the subject (Cerezo et al., 2007).

Like gestures, changes in facial features would only supplement vocal interaction as a means to infer a user's satisfaction level with the presented information. As motions, rather than static states, facial expressions can be tracked and coded for potential meaning. After all, the raising of an eyebrow is only significant if the motion is recognized. The question remains: how should the interface react? Since emotions are tied with facial expressions, there may be some machine learning needed to develop a rapport with one's own personal VOX/UI and vice versa. Empathy towards your VOX/UI "agent" may be important to the human-machine relationship (Paiva et al., 2004).

Natural voice and natural interactions present a new level of communication with information systems beyond WIMP (windows, icons, menus, and pointer), but this relationship, which may be perceived as artificial intelligence, is far beyond the discussion of motion design. However, motion contributes to the perceived "character" of the AI though the anthropomorphizing of animated actions.

Tracking gaze and visual fixation (and Saccades)

In tandem with gestures like pointing and facial expressions, the movement of the user's eyes is another possible input to supplement a vocal command. Eye movement may be an improbable method for navigating a system since our eyes only maintain a fixation of between 200–600 milliseconds on any given stimulus before they dart at an incredible rate on to the next thing (Jacob, 1995). These movements are referred to as saccades, and even when fixating on a single point, the eyes are jittering about in microsaccades. In fact, the eyes only move smoothly when tracking an object in motion:

Smooth motion of the eye occurs only in response to a moving object in the visual field. This smooth pursuit motion follows the moving object and is much slower than a saccade. Despite the introspective sensation that the eye is moving smoothly, this motion does not occur when viewing a static scene (or computer screen); it requires a moving stimulus. (Jacob, 1995)

The reality is that eye movement and fixation may be, for now, very poor inputs for the navigation of VOX/UI not only because of the seemingly erratic behavior of the eyes, but also the lack of unobtrusive technology to track the eyes. Few things in the real world respond to a person's eye movement with the exception of other people returning a gaze or following another's fixation to a shared object of attention (Jacob, 1995). However, it may not be as critical to system performance to know *exactly* where a user is fixating, but that the user is at the very least looking in that general direction. For example, if the user initiates a verbal query, the potentially misunderstood trigger phrase can be confirmed because the user is looking towards the visual space where the information will be presented. During a search, VOX/UI generates a stunning dynamic visualization of the migration of killer bees, but if the user has looked away due to a distraction—perhaps she sneezed—does it matter how great the animation is if no one sees it?

Promoting Innovation Through Prototyping

Herein lies a new opportunity for the application of motion design and UI/UX research: the animated presentation of dynamically generated information based on voice command and queries. By combining motion effects in UI/UX and vocal queries with pointing, eye tracking, and facial features (among other possible biometrics), it should be possible to correct for recognition errors and improve performance. This is no small task requiring advances in artificial intelligence and machine learning. Computer scientists and engineers will evolve the natural speech technology, and when it is viable, it will no doubt lack usability or any consideration for a human-centered approach to design. New technologies, processes, and methodologies often debut as crude functional betas of what could be. Lack of good interaction design with respect to the needs, desires, and expectations of the user would impede adoption (Rogers & Shoemaker, 1971).

Rather than waiting on the future, designers can plan for the ideal interface and interactions with such a system. As a form of developmental research (Brown, Gough, & Roddis, 2004), prototyping a futurist vision for VOX/UI has the potential to encourage and accelerate development in natural language processing. Even as nonfunctioning mockups, the animated visual simulations of human-to-computer interactions are powerful drivers of collaboration, programming and development. Designers also have the opportunity to shape this method of communication with the system using type, graphics and motion to give the VOX/UI system perceived personality, character and empathy but also avoid contemptuous anthropomorphisms (HAL 9000) or ridiculous skeuomorphism (Microsoft's Bob and Clippy) or awkward

Figure 5, 6
HAL 9000's irreverent voice-only interface from 2001: A Space Odyssey (1968).

Source: Kubrick, 1968. Licensed By: Warner Bros. Entertainment Inc. All Rights Reserved.

socializations (Google Glass) or gratuitous animation (Adobe Flash). And there are many more examples from which designers can draw inspiration and guidance from both the fantasy of science fiction (see Figures 5 & 6) and the analysis of failed, but promising technologies. In the meantime, the research question can be summed up thusly for designers: is it possible to anticipate this next computing revolution and envision methods of human-computer interaction and dynamic information visualization and the necessity of motion as an integral component?

Andre C. Murnieks, M.F.A., Research Faculty and Senior Lecturer, Massey University

References

André, P., Schraefel, M. C., Teevan, J., & Dumais, S. T. (2009). Discovery is Never by Chance: Designing for (Un)Serendipity. In *Proceedings of the Seventh ACM Conference on Creativity and Cognition*, 305–314. New York, NY, USA: ACM.

Arnold, J. (2015). Designing Time. In A. Murnieks, G. Rinnert, B. Stone, and R. Tegtmeyer (Eds.), *Motion Design Education Summit 2015 Edited Conference Proceedings*, 149–152. Dublin, Ireland: Routledge.

Brown, B., Gough, P., & Roddis, J. (2004). Types of Research in the Creative Arts and Design. [online]. Bristol, UK: EPapers, University of Brighton.

Buyukkokten, O., Garcia-Molina, H., & Paepcke, A. (2001). Seeing the Whole in Parts: Text Summarization for Web Browsing on Handheld Devices. In *Proceedings of the 10th International Conference on World Wide Web*, 652–662. New York, NY, USA: ACM.

Cerezo, E., Hupont, I., Manresa-Yee, C., Varona, J., Baldassarri, S., Perales, F. J., & Seron, F. J. (2007). RealTime Facial Expression Recognition for Natural Interaction. In J. Martí, J. M. Benedí, A. M. Mendonça, & J. Serrat (Eds.), *Pattern Recognition and Image Analysis*, 40–47. Springer Berlin Heidelberg.

Chowdhury, G. G. (2003). Natural language processing. *Annual Review of Information Science and Technology, 37(1)*, 51–89.

Droid Life. (2016, October 18). *Google assistant tips and tricks!* [Video]. Retrieved from https://www.youtube.com/watch?v=YhRoFErVvzM.

Eadicicco, L. (2015, September 9). Siri is always listening. Are you OK with that? Retrieved October 22, 2016, from http://www.businessinsider.com/siri-new-always-on-feature-has-privacy-implications-2015-9

Feige, K. (Producer), & Favreau, J. (Director). (2010). *Iron Man 2* [Motion picture]. United States: Paramount Pictures.

Fernandes, G. (2016, March 17). Amazon echo dot [digital image]. Retrieved from https://www.flickr.com/photos/131292477@N08/25219116374

Francese, R., Passero, I., & Tortora, G. (2012). Wiimote and kinect: Gestural user interfaces add a natural third dimension to HCI. In *Proceedings of the International Working Conference on Advanced Visual Interfaces,* 116–123. New York, NY, USA: ACM.

Heer, J., & Robertson, G. (2007). Animated transitions in statistical data graphics. *IEEE Transactions on Visualization and Computer Graphics, 13(6),* 1240–1247.

Jacob, R. J. K. (1995). Eye tracking in advanced interface design. *Virtual Environments and Advanced Interface Design,* 258–288.

Jain, A. K., Ross, A., & Prabhakar, S. (2004). An introduction to biometric recognition. *IEEE Transactions on Circuits and Systems for Video Technology, 14(1),* 4–20.

Knight, B. M., & Nick Glass, C. (2013, September 2). Are computer chips on the verge of a quantum leap? CNN.com. Retrieved October 21, 2016, from http://www.cnn.com/2013/09/02/tech/innovation/are-computer-chips-verge-quantum/

Kubrick, S. (Producer & Director). (1968). *2001: A space odyssey* [Motion picture]. United States: Warner Bros.

Moggridge, B., & Atkinson, B. (2007). *Designing interactions (Vol. 14).* Cambridge, MA: MIT press

Moore, C., & Dunham, P. J. (Eds.). (1995). *Joint attention: Its origins and role in development.* New York, NY: Psychology Press.

Moren, D. (2015). Small Siri improvements from iPhone 6s and iOS 9. Retrieved from https://sixcolors.com/post/2015/09smallsiriimprovementsfromiphone6sandios9/

Novet, J. (2016, October 5). Google Pixel hands-on: Like the Nexus, but with bling. *VentureBeat.* Retrieved from https://venturebeat.com/2016/10/04/google-pixel-hands-on-nexus/

Paiva, A., Dias, J., Sobral, D., Aylett, R., Sobreperez, P., Woods, S., ... Hall, L. (2004). Caring for Agents and Agents That Care: Building Empathic Relations with Synthetic Agents. In *Proceedings of the Third International Joint Conference on Autonomous Agents and Multiagent Systems Volume 1,* 194–201. Washington, DC, USA: IEEE Computer Society.

Punched card. (n.d.). In *Wikipedia.* Retrieved October 21, 2016c, from https://en.wikipedia.org/w/index.php?title=Punched_card&oldid=745507700

Rogers, E. M., & Shoemaker, F. F. (1971). Communication of innovations; A Cross cultural approach. Retrieved from http://eric.ed.gov/?id=ED065999

Sato, E., Yamaguchi, T., & Harashima, F. (2007). Natural interface using pointing behavior for humanrobot gestural interaction. *IEEE Transactions on Industrial Electronics, 54(2),* 1105–1112.

Sparandara, M., Chu, L., & Benson, J. (2015, 29 June). Speaking in context: Designing voice interfaces. Retrieved October 21, 2016, from https://www.punchcut.com/perspectives/speaking-in-context-designing-voice-interfaces/

Staples, L. (1993). Representation in virtual space: Visual convention in the graphical user interface. In *Proceedings of the INTERACT '93 and CHI '93 Conference on Human Factors in Computing Systems,* 348–354. New York, NY, USA: ACM.

Tomasello, M., Carpenter, M., & Liszkowski, U. (2007). A new look at infant pointing. *Child Development, 78(3),* 705–722.

Trafton, J. G., Jacobs, A., & Harrison, A. M. (2012). Building and Verifying a Predictive Model of Interruption Resumption. *Proceedings of the IEEE, 100(3),* 648–659.

Ware, C. (2008). *Visual Thinking: for Design.* Burlington, MA: Morgan Kaufmann Publishers.

Ware, C., & Mitchell, P. (2005). Reevaluating stereo and motion cues for visualizing graphs in three dimensions. In *Proceedings of the 2nd Symposium on Applied perception in graphics and visualization,* 51–58. ACM.

A conversation with
Jeff Arnold, Microsoft

Jeff is a Principal User Experience Designer Lead at Microsoft. Jeff and his team conceived and implemented the Motion Design story of Windows Phone 7, which ultimately became Microsoft's Design Language. Prior to joining Microsoft, Jeff spent 12 years in broadcast design, and he offers insights about how the language of motion can be meaningful regardless of media.

He believes that UX Design is about solving real problems for real people in a way that is delightful and engaging. And while the use of motion in User Interface may not be new, Jeff tells us how the thoughtful injection of teaching moments and other concepts introduced in Windows Phone 7 make the difference between UI and UX.

Making motion design central to Windows Phone 7

I was the motion design lead for Microsoft's Windows Phone 7. I spearheaded the effort to integrate motion design into the core experience of the UI. At the time, it was something that Microsoft had never really engaged in before. A lot of effort was put in to the interface so it would work as smoothly as possible. One of the most important things when dealing with motion is to elevate the frame rates so you take full advantage of the the transitions and easing behaviors that really sell any particular motion that's happening.

One of the features of the new operating system was "Live Tiles," which gave Windows Phone 7 a unique appearance. It was also key in establishing and communicating the product's brand. At the time, everyone was trying to do their best to copy the iPhone but we wanted to do more than that. For Windows Phone we wanted to go beyond just having a simple launcher. We wanted to deliver something that felt more dynamic and had a design language that would carry through the rest of the device.

The motion of "Live Tiles" and "Turnstiles"

We started with a very flat visual style that would have these moments of surprise through motion. We developed this idea where the interface would have 3D "flips" happening drawing your attention to key content elements. We were trying to do better than just a simple icon that you'd tap to launch an application—we aspired to do something to help feed a little bit of information to the user while at the same time providing an iconic look and feel that would be fresh to the market. What we ended up with is a UI that tells a story in a very interesting way. The behavior of the interface gives you these moments of excitement and moments of surprise that tell the story of content that resides behind the scenes.

Content is previewed through the 'Live Tiles' as they flip at particular time intervals. To define this behavior, we created an algorithm that would account for the number of tiles on a given screen, along with the size of the device and the density of pixels. Based on the number of tiles present on the screen, we defined how many of the tiles would animate. For instance, if you had a screen with 15 tiles, we'd animate two or three to avoid creating a bunch of noise that may end up distracting the user. Through this algorithm, the system choreographed which tiles were animating, when they animated, and for how long.

Figure 1
App icons intermittently rotate on a horizontal axis providing previews of interesting content.

Another aspect of the design language is around the action of opening an application. We call that animated transition "turnstile." The idea behind this motion is when you tap on a tile, all objects on the page swing on a left-page mounted hinge—it swings 90 degrees off screen, then opens the application. Think of the entire system as this big wide open 3D space with all the application icons situated along this turnstile.

This also provides a nice layer of surprise where you get the sense of space that you wouldn't have if everything was presented on a flat layer. An elegant detail is that the icons don't all turn at once. There's a tiny little lag in how the icons swing out. For example, the first five swing out, then another five, then another five, and then the one you actually touched is the last one that transitions away.

Figure 2
*When opening an
application, the
entire home screen
rotates along a left
aligned vertical
axis, similar to a
revolving door or
turnstile.*

We thought of all the transitions as purpose built. The turnstile animation
was more of a signature catch-all. It provided delight and led the user. Other
transitions were there to drill deeper into or across experiences.

Motion studies and perceived device performance

In the early stages of the interface's development, we did a lot of motion
studies and established classes of animations to target. We knew we needed
some type of animation to launch applications, to transition to other areas
of the UI, return to the home screen, and those types of things. As we
experimented, we started forming this 3D world that all of the applications
played in. As we conceptualized this world inside of the phone, we looked
at real world examples involving physics. We would look at how things in
the physical world worked and behaved to inspire how we designed the
movements. For example, to explain how the UI should ease between key
frames, I would take my phone and slide it across the table, pointing out that
initial burst of energy as the phone first hits the table and then as friction takes
hold, slows the object down.

We wanted our animations to embody these kind of characteristics so we
established a set of rules for our interface behaviors based on these studies
and ideas.

Complementary to doing studies for the UI, we did additional motion studies
around the perceived performance of the interface. When we first started
Windows Phone 7 and were doing our first lab studies, we had another
transition we called "continuum." Let's say you are replying to an email from

a list. When you tap reply, the sender's name would detach from the list, and do this swoop. What was originally on screen goes away, the new screen comes in, and then that name becomes the header of the incoming page.

As we continued to build the design language, we applied extreme easing, where elements in the interface would start slowly and then reach a high velocity very quickly. Right before an element lands, we'd put on the brakes, easing to a soft pillow landing.

With that particular form of easing, we found that people who tested the device thought the performance was much faster. We'd simply ask them to do a specific task on a competitor's device then have them do the same task on a Windows phone. In some cases, although they completed a task a little bit faster on a competitor's device, when we asked which one seemed faster, they would always say the Windows Phone. Most of the competitor devices at the time were not doing a lot of easing—most of them had these linear movements. So we can conclude that the easing and animations we did translated to what felt like a faster user interface amongst our lab participants, changing their experience with the phone.

Influence on the marketplace
I'd like to think that Windows Phone has had an influence on motion design for mobile devices. Prior to the Windows Phone release, I don't think any of the other competitors were looking at UI and motion design to the level of depth that we were at the time. We've gotten a lot of notice and a lot of questions from designers and developers. People are definitely paying more attention to it and I think that's awesome.

There's a tremendous user benefit that came out of the work we did on Windows Phone because more and more consumers and companies are really paying attention to motion. All the refined easing and that type of interactions that came out of it really gives the users better experiences out of their devices than they've ever had in the past.

Gretchen C. Rinnert, Aoife Mooney, & Marianne Martens

Energetic Alpha: *A Design Continuum Created Through Collaboration*

In this paper we present our interdisciplinary collaboration, *Energetic Alpha*, an iPad app for preschoolers that teaches letterforms and letter writing through interactive learning elements and animations. The project brought together experts in media mentorship, children's librarianship, children's publishing, usability, interaction design, motion graphics, typeface design, photography, videography, and iOS app development. Using a touch interface, the app integrates video and interactive elements that require users to practice writing letters in order to unlock animated sequences. Our primary audience are children between the ages of two and six years old, who are attending preschool or kindergarten, and are in the process of learning language and letterforms. Our secondary audience are those interacting with such children, including early childhood educators, parents, child care providers, youth services librarians, and media mentors. Inspired by popular educational television programs like *Sesame Street* and inventive and memorable children's books, like those by Dr. Seuss, we set out to advance children's app development by exploring motion and interaction design as a means to teach young learners in a fun and interactive manner.

Apple's App Store launched on July 10, 2008 and since then we have seen an explosion of educational apps for children, from games and interactive storybooks, to coloring and early learning tools. Many are free for download, others charge a nominal fee, but the design of many of these new technologies remains an afterthought, focused monetary rewards. Any parent of a young child knows there is an abundance of alphabet books on the market, and is likely to spend hours reading alphabet books to help children memorize. These devices work well to help children to learn the letters and identify the shape that matches the name. One such example is *Dr. Seuss's* (1996; originally published in 1963) *ABCs: An Amazing Alphabet Book!* Of all authors on Amazon.com, Dr. Seuss (aka Theodore Geisel) ranks at number 62 in popularity, and this title is number five of all books published by Dr. Seuss. Many American parents only need to hear the infectious beginning: "Big A, little a, what begins with a? Aunt Annie's alligator, A, A, A..." to begin reciting the rest of the narrative. First published over 50 years ago, the book is a classic, with over 32,000 reviews on goodreads.com. This book includes rhyming, repetition, easy to memorize

phrases, and fun illustrations. As a traditional alphabet print book it teaches identifying letters, but does not teach the early learner how to write.

As of this writing, a search for alphabet books on Amazon.com retrieves 619 results. In contrast, the Apple's App Store hosts close to 100,000 apps under the "educational" category, and 216 alphabet apps demonstrating the abundance of new media products targeted at young children. Subsequently, it is really difficult for parents, caregivers, and educators to find the best apps for young children.

With so much digital content to sift through, librarians are required to be media mentors. According to Claudia Haines and Cen Campbell (2016), a media mentor "supports children, teens, and families in their media decisions and practices relating to media use" and "has access to and shares recommendations for and research on children's and teens' media use" (p. 6). Upon evaluating several of the top selling educational apps it is easy to identify problems with existing apps. One such problem, is that solid design is absent from most of the offerings on the market. With so many alphabet learning products, what would make a new app unique? Guernsey (2012) recommends looking for the three C's: content, context, and the individual child, and librarians Claudia Haines and Cen Campbell (2016) have designed rubrics for evaluating toy and story apps for children. This rubric acted as a framework to follow. We designed *Energetic Alpha* to fit the requirements they outline.

Based on our initial research and literature review, our team had four goals:

1. To create an app that meets the needs of a young learner by integrating interactive tools.

2. To incorporate motion design to be a motivational element.

3. To design an app that had the ability to engage and teach young learners.

4. To build an app that incorporates diversity and focuses on inclusion.

We created a simple structure that allowed letter writing to be gamified and focused solely on the child's learning experience and engagement. The app hosts a playful environment that rewards the user with animated sequences.

All too often a designer is brought into a project half-way through the development process, or worse, at the end, as the product is about to launch. Business managers and project leaders sometimes see design as the icing on the cake, the finishing touches that make the product look good. In the case of *Energetic Alpha*, we began the product with research-informed design. With design in the driver's seat, our team was able to fully investigate design processes, ideas, and concepts. This gave the team freedom to explore the navigation, the role of typography, the integration of sound, and the way motion could function as part of the letterform-learning curriculum.

Design at the Inception

Energetic Alpha began as a response to current educational technology on the market. As parents and professional designers and media experts, we had been disappointed with learning technology directed at toddlers and preschoolers. Many have poor navigation, and lacked educational value. Together our team of experts (Gretchen Rinnert, Marianne Martens, Aoife Mooney, and Bryan Rinnert) were awarded a $10,000 seed grant from Kent State University's College of Communication and Information to create the *Energetic Alpha* iPad application, which, as of this writing, is in development. The seed grant helped support the app's prototyping, pilot testing, and the production of eleven unique animations. *Energetic Alpha* began as a project led by design and research, not by financial factors, business goals, or development. Contrary to most design artifacts on the market, the project started by focusing on the problem and on the users.

During our initial research phase, the team profiled current competitors to understand current children's apps. What we discovered was that there are many poor quality apps with high reviews in Apple's App Store. In spite of their good standing many of these apps break design principles and conventions. We catalogued the problems we frequently encountered:

- Have a lack of hierarchy and lacking negative space

- Use a vibrating or neon color palette

- Inconsistent use of typography

- Typefaces that are difficult to read, or have poor visual spacing between letterforms (i.e. kerning)

- Contain motion and interaction that is contextually void of meaning

- Have poor or confusing navigation that even adults had difficulty navigating

- Are missing feedback scenarios or error prevention

- Over-use of motion or animation that may distract the user

In addition, we based our overall assessment on an app rubric published in Haines and Campbell's (2016) *Becoming a Media Mentor: A Guide for Working with Children and Families.* We found that many of the existing (and popular) apps were breaking Haines and Campbell's recommendations for a high quality story app. For example, one app we reviewed is well rated with an aesthetically pleasing color palette, but it had confusing navigation that was difficult even for adults to operate, with similar buttons and functions. To quote Jakob Nielsen (1995), "The system should always keep users informed about what is going on, through appropriate feedback within reasonable time." When one becomes lost within digital space it is hard to get into the flow of content. Instead a person wanders and eventually gets frustrated and leaves.

Many apps use ads to drive revenue and offset the cost of a "free" download. Other apps have distracting sound effects or music. This could interfere with the child's attention, or bother other people around the child. While not that important, a product that annoys parents may not last long in the hands of children. According to Apple's iOS Human Interface Guidelines, designers should sensibly employ animation (Apple Developer, 2016). Trite animations and motion design elements may distract or disconnect users from the app's intended experience which is especially problematic with young children who are easy distracted.

Free apps tend to include in-app advertising and gated content. One app studied offered a single free item. All other activities required an in-app purchase. There are also privacy concerns with apps that link to the internet. And finally, but extremely important, many apps reviewed included text-based instructions that would not work for preliterate children (Haines & Campbell, 2016).

Once the team understood the current terrain of the app market, we moved forward by developing the concept for a new and strategically different alphabet app, that relied on research, design methods, and motion design to create a new learning experience.

Research methods and process
Energetic Alpha has three distinct areas of design focus:

1) Type Design

2) UI and User Experience Design

3) Animation / Motion Design

Within those areas we used the following methods of research collection:

1. Design and development of low-fi and fully functioning prototypes, that are fully responsive to users' interactions and include animations.

2. Co-design user testing conducted as part of one-on-one interview sessions.

Working in a small team, we wanted to remain flexible to change and iterative in our designs. All three areas of focus, the type design; the interface; and the animations were developed simultaneously—all while the developer was testing out the best options for coding the app. Each team member had a voice and expressed their ideas on the interface and interaction. If a team member did not approve of a design decision we worked together to find a compromise. One team member was very dedicated to integrating diversity into the app. Upon viewing the first animation which showcased the hand of a white child, she asked us to reflect multiple ethnicities. Her insightful recommendation helped shape the design to include diverse models, voice talent, and actors.

Our design process was infused with discussion, and collaboration:

1. Concept Development: definition, research, and literature review

2. Ideation: sketching, wireframing, and CSS / HTML prototyping

3. Design Exploration: typeface development, style tiles, interface designs, interactive prototyping using InVision and Adobe XD

4. Pilot Testing: a small sample user testing (10 children)

5. Revise: developing a plan of action that responds to feedback

6. Development: working with an iOS developer to program a working prototype

7. Pilot testing: pre-user testing to vet the system as it stands

8. Revision: developing a plan of action that responds to feedback

9. User Testing Group #1: testing and co-designing with children

10. User Testing Group #2: testing with parents, teachers, and caregivers

11. Revision: respond to user feedback

12. Roll out and Release: begin offering *Energetic Alpha* on Apple's App Store

13. Track feedback and errors: through continued product testing and from user feedback update design and backend

14. Disseminate research findings: evaluate, assess, and share

Motion Design

A driving force in this project was to explore motion design processes and strategies. Our aim was to make an eclectic catalogue of animations that used not one single style but instead a multitude of visual solutions. Our team consisted of one motion designer and one photographer.

We began by charting all possible motion design outcomes. We were able to generate a list of 20 unique concepts, but all fell into 7 categories. We defined these categories as the following:

1. Stop Motion / Still Motion: Using still photography to record a single frames in a sequence to simulate movement or to record movement.

2. Video: Recorded video images using digital technology.

3. Time Lapse or Slow Motion: Similar to stop motion these strategies use still photography to capture time, although they alter time to either speed up or slow down moments in time.

4. Traditional or Hand Drawn Animation: Traditional Disney animations from the past used art work placed in a sequence to demonstrate movement. Every element had to be drawn by the artist.

5. 2D / Vector Based: Graphic elements including characters, letters, and objects are drawn on the computer using programs like Adobe Illustrator and animated in another program.

6. 3D / Computer Animation: 3D models and animations that fall into the category of CGI.

7. Mixed Media Motion: This includes combinedelements from those the six previous categories.

Based on these definitions the team created animations for five letters that could be used within the prototype to demonstrate the first five categories. Computer generated and mixed media were saved for later prototypes. The prototype established a plan, as each letter was assigned a verb, a method of visualizing that letter (or word), and ways to incorporate sound, voiceover, or music.

The first set of animations included:

Letter	Verb	Strategy	Sound
A	Abstract	Stop Motion	Classical Instrumental music
D	Drumming	Video	Drum Beats Played in the Animation
H	Hugging	Vector Animation	American Folk Instrumental music
K	Kick	Hand drawn pose to pose	Classical Instrumental music
M	Melting	Time Lapse	Classical Instrumental music

Table 1
Animation Production Table #1.

By using only verbs the animations were framed to focus on *motion and action* to demonstrate the word's definition. Nouns would have been visually interesting, but we wanted to focus on the kinetic qualities. Whenever possible the real elements were incorporated to give a tangible and concrete representation for our young audience. Instead of creating vector art to simulate melting we created a physical "m" and applied heat to record it actually happening.

Each animation began as rough thumbnail sketches, and then we designed style frames and storyboards. Depending on the strategy being used, the team would move into trial and testing phase, ideating by creating physical objects and recording. If the strategy was to create a vector animation, artwork was developed in Adobe Illustrator or Photoshop (if on the desktop computer) or in

Procreate, if working on the iPad. Artwork then moved into Adobe After Effects. The second set of animations included the letters C, F, P, S, X, and G (Table 2).

Table 2
*Animation
Production
Table #2.*

Letter	Verb	Strategy	Sound
C	Camouflage	Vector Animation	Classical Instrumental music
F	Falling	Mixed Media Animation	Classical Instrumental music
P	Popped	Vector Animation	American Folk Instrumental music
S	Slither	Computer Generated Animation through AE Expressions	South American Folk music
X	X-Ray	Vector Animation	Classical Instrumental music
G	Grow	Time Lapse	American Folk Instrumental music

As the project has continued we have incorporated new technology to test out classical styles of animation, like traditional approaches that were frequently used by Disney and other early animation studios. For instance the animation for the letter F, F is for Falling, uses a hand drawn technique that is reminiscent of traditional cel animation (see Figure 1). The motion designer used an iPad Pro with an Apple pencil to draw each image on separate layers using the software program Procreate. The file was then imported into After Effects and sequenced to show only one image at a time. Each composition is a small animation project that usually takes between several days to several weeks to execute. The animations are between 8 seconds and 2 minutes in length.

Figure 1
*"F is for Falling"
animation process.*

*Copyright 2016 by
Gretchen Rinnert.*

As the team continues to produce the remaining fifteen animations, strategies are being reconsidered, utilizing scripting, nested components, and even more hand-rendered elements, such as watercolor, ink, flip-book, thaumatrope, and zoetrope. Photographic manipulation and three dimensional characters will be integrated to explore additional CGI strategies (see Figure 2).

Figure 2
*Final animation
stills.*

*Copyright 2016 by
Gretchen Rinnert.*

Type Design

Our project started with a relatively open scope, looking at motion design as educational entertainment with little to no interaction planned. With such an open framework, the typography followed suit. We were inspired by fun typefaces with large slabs and changing widths. We imagined playful animations using dynamic shapes and as designers we wanted to steer clear of reflecting a corporate attitude. BioRhyme, a new Google typeface designed by Aoife Mooney, seemed to be the perfect mix of whimsy and fun (see Figure 3).

Figure 3
*BioRhyme type
specimen.*

*Copyright 2016 by
Aoife Mooney.*

The project shifted scope after several team meetings. Our children's librarian directed us to the importance of letter writing so the project evolved to integrate a letter writing functionality, but we never realized how this additional function could affect every single aspect of the app, including the typeface we were using throughout the interface. The typeface would no longer be just for reading, but also for writing, an activity we had yet to fully explore completely. With this new consideration, we decided to investigate the possibility of using the app as a means to help our audience make connections between seriffed typographic forms, and more basic manual skeleton forms. Research into the relationship between typography and handwriting has traditionally focused on the influences of calligraphic models on the stress and formal properties of different typographic classifications. Research into typefaces designed for early learners has tended to focus more on the readability of the typeface, rather than on its relationship to the shapes the child is making when drawing

letterforms. A foundational text in the history of typographic discourse, that has dealt directly with this relationship is Gerrit Noordzij's (2005) *The Stroke: Theory of Writing*, and yet this theory has not seen much traction or extension in the development of typefaces for children learning to write. For this reason, we decided to test out the response of the child to the serifs, to see how this would impact their understanding of the shapes.

In "Serifs, sans serifs and infant characters in children's reading books," an article appearing in the *Information Design Journal*, the impacts of the serif on the recognizability of the letterforms and impact on the child's reading were investigated, and the conclusion supported our motivation to trial this approach (Walker & Reynolds, 2003). While the authors note that the children's preference for the Gill typefaces suggests that sans "serif types may have particular appeal for beginner readers," they conclude:

> Our study does not highlight any significant differences in reading performance between material set in Gill [sans] or Century [seriffed]... careful attention to line and word spacing is equally as important or more important than whether typefaces have serifs or not; and that attributes such as ascender and descender length of a typeface are as significant as absence or presence of serifs. (Walker & Reynolds, 2003, p. 26)

BioRhyme takes its shape language from a mixture of influences from the typographic landscape. It has a monoline, typewriter quality to it, with slab serifs and similar proportions to the Century Schoolbook typeface, which was at one time advocated as a standard typeface for children's reading (see Figure 4).

Figure 4
BioRhyme influences.

Copyright 2016 by Aoife Mooney.

It has open apertures (openings within the letters) and the letters are made of simple, geometric forms echoing the ball-and-stick Futura-style model of children's typography (see Figure 5). For the purposes of this project, we added single-storey a and g forms to more closely

align with the shapes the child will have been taught to write. Thus, the major difference between BioRhyme and some of the most popularly used typefaces for children's content lies in the slab serifs.

Figure 5
BioRhyme letterform construction.

Copyright 2016 by Aoife Mooney.

Interface Design and User Testing

Bringing motion and type together, the interface and user experience had to bring the elements into a complete and singular experience. The interface went through several iterations of wireframing, UI and UX design, menus, color palettes, and flow of information changed over time greatly. Eight months after beginning the project we conducted user testing using our prototype with 4–11 year olds. Individual interview sessions lasted 20–30 minutes as users tested the interface. We also included a simple co-creation activity to generate new ideas from participants. Children were asked to draw ideas on an iPad sketch pad of things they would want in an alphabet game app. Children were also provided markers, pens, crayons, and pencils and prompted with two questions:

1. "What would you want in future animations?"

2. "Please help us improve this game. What would you include?"

We found that the development method we used was far too complex and needed a complete overhaul. The flow of information was good as children understood how to navigate, but additional information was needed to help the audience understand progression and error correction. The motion sequences held the audience's attention, and even our older users were engaged. We also learned that our typographic approach was a leap too far for our young audience. The connections we were trying to prompt, between the typographic forms and the manual models, was too long of a bridge for our preschool audience. Since we knew before user testing began that this could be an issue, we prepared by bringing along paper prototype "screens" that used both a sans serif typeface and our current slab typeface, BioRhyme. Giving the children paper, pens, and a simple prompt stating "Please trace the letter" we were able to confirm that our core audience (users between 3 and

5) saw the slab letters as abstract shapes, unrelated to the letterforms they had learned. A slab "A" looked like something new and different. One young participant, a four-year-old boy, whose name included the letter "a" did not recognize the slab A, saying "That letter is not in my name." Other children, one aged five and another aged seven, understood that the characters were the same, but they were confused by the slab serifs and when asked to trace, they carefully filled in the entire shape—including the slab (see Figure 6).

Figure 6
User testing documentation.

Source: Copyright 2016 by Gretchen Rinnert.

This was a particularly interesting research outcome, as it demonstrated the disconnect between the teaching of writing and reading, and the role of typography in shaping the relationship for a young learner. It identified a hole in the research from the typographic domain into the design of typefaces for children learning to write, rather than for those further along in the process and learning to read.

Now halfway through the development process, we learned that our typeface needed to be replaced, we set to work researching a new solution for the more refined task at hand. No longer concerned with creating a bridge between typography and writing (saving that for another day), and aware of the dearth of typefaces designed for the purposes of reflecting the forms used in the teaching of handwriting, we searched simply for a typeface designed for reading, which was child friendly in the sense that it aligned more closely with the 'ball-and-stick' forms used in many of the more prominent models—Zaner-Blosser, Handwriting Without Tears™, and others— for the teaching of handwriting that would work on screen and provide wide range of widths (see Figure 7). We needed a bold weight for the larger letters to trace within and thinner weights throughout the interface. With Professor Mooney's guidance we found the perfect typeface family for our project, 'ABeZeh', designed by Anja Meiners and first published by Carrois. According to the font webpage, "ABeZeh was specifically designed for the learning environment. Unfortunately, publications within the field of learning are often set in typefaces which simply mirror b, d, p & q and hardly differentiate between capital I and small

Figure 7
Capital Formation Chart produced by Handwriting Without Tears.

Source: Handwriting Without Tears, 2008. Copyright by Handwriting Without Tears.

l. ABeZeh's distinguished, open and friendly shapes simplify the reading (and learning) process – for both adults and children." (ABeZeh, n.d.).

Several other important issues became apparent from the user testing. When the children selected a letter, they immediately needed direction about what to do next, and most relied on the verbal commands provided by the researchers. We found that additional system feedback was essential. The app's design complies with letter learning in the classroom and the stroke order is built into the interface. In order to open the letter animations, the user had to write the letter using the correct stroke order. Letters traced in the wrong order will not open the animations. The user would remain on those screens not knowing how to move forward.

We knew the users needed *feedback and error correction*. We developed a variety of possible solutions. Many used standard print-based ideas that utilized arrows, dotted lines, and numbers, very similar to workbook sheets many children use in school. The screen affords much more, our iterations moved to using motion, timing, and graphics of hands to represent the proper stroke order. We found in subsequent user testing that illustrated graphics were not enough, and they required interpretation. We know that early learners respond more quickly to concrete examples that do not call on indexical knowledge, but act as a direct model. In response, we decided to use the image of a hand, and, using animated GIFs, we moved the hand across the screen.

We call our solution "animated trace hints" that are timed to appear when the user either: 1) incorrectly marks on the letter; or 2) waits to do anything for a set amount of time. By providing a concrete example, a child's hand traces over the white letter form in the proper stroke order. The app provides

a clear and direct instruction. We avoided using numbers, text, or abstracted icons for our young users who cannot read. This new addition provided a step towards independent instruction for the child, so that they could play without an adult present. It also gave us an opportunity to be inclusive in our design, as we were able to use models of different ethnicities (see Figure 8).

Figure 8
System Feedback, Trace Hint Animations.

Source: Copyright 2016 by Gretchen Rinnert.

User testing also revealed that children were engaged and responsive to motion sequences. Many of the participants were happily engaged, and when they learned that tracing the letters could unlock animations they started to approach the interface as a game (see Figure 9). Many of the children figured out which letters led to the animations and continued to focus on those letters. This helped us determine that the motion graphic sequences were motivational to our young audience.

Figure 9
User testing documentation.

Source: Copyright 2016 by Gretchen Rinnert.

Conclusion

As of this writing, we have completed an extensive prototype and several revisions thereof, based on our initial round of user testing. Next, we will conduct additional user tests and a focus group study, the results of which will inform the design going forward. This iterative process has been insightful in various ways. In addition to creating a research and design driven product, we have brought this work into the interaction design classroom. It has

inspired new teaching methods and processes by allowing us to see the benefit in using several quick prototyping tools, like InVision and Adobe XD.

Energetic Alpha is an animation driven alphabet app; as such, motion design was key to our collaboration. It was not only central to our design artifact, but it was also a collaborative strategy. Conclusions from the typographic explorations we have undertaken have also prompted research into the design of typefaces specifically designed to support shape recognition and gestural control required for the learning of handwriting. Our interdisciplinary project informs teaching in the field of Design, but also in Library and Information Science, and we hope that what we learn will contribute to the dilemma of how to evaluate quality in app design, which in turn will aid the app selection process for those working with young children.

Figure 10
Final user interface for Energetic Alpha.

Copyright 2016 by Gretchen Rinnert.

In developing *Energetic Alpha* our team learned that preliterate learners require very specific interactive space. Language and symbol based prompts do communicate to young learners, but concrete examples, physical demonstrations, and motion design sequences are excellent solutions for this age group. Initially, our team saw motion design as an educational-entertainment tool, but we found it became a learning reward, a reminder, and design strategy to trigger letter recognition. *Energetic Alpha* has brought together many skill-sets, and part of the project was to work on an interdisciplinary basis. And while we are creative professionals who speak the same "design talk," we had to learn how to work together. Project management and communication became our biggest hurdle. We employed motion design as part of our iterative process. We shared prototypes, mock ups, and demos and we used motion design sequences to speak to our developer and explain our design vision for the interaction.

Energetic Alpha is scheduled to be released in Apple's App Store in 2018.

Gretchen Caldwell Rinnert, M.G.D. Associate Professor, Kent State University
Aoife Mooney, M.A. (Typeface Design), Assistant Professor, Kent State University
Marianne Martens, Ph.D., Assistant Professor, Kent State University

References
ABeZeh [webpage]. (n.d.). Retrieved May 11, 2018 from https://bboxtype.
com/typefaces/ABeZeh/#!layout=specimen

Apple Developer. (2016). Animation. iOS Human interface guidelines. Retrieved
October 14, 2016 from https://developer.apple.com/ios/human-interface-
guidelines/visual-design/animation/

Guernsey, L. (2012). *Screen Time: How electronic media – from baby videos
to education software – affects your child.* New York, NY: Basic Books.

Haines, C. & Campbell, C. (2016). *Becoming a media mentor.* Chicago, IL: American
Library Association.

Handwriting Without Tears. (2008). *Letter and number formation charts.* Retrieved
October 14, 2016 from https://www.lwtears.com/letter-number-formation-charts

Noordzij, G. (2005). *The Stroke: Theory of Writing.* London, UK: Hyphen Press.

Nielsen, J. (1995, January 1). 10 Usability heuristics for user interface design. Nielsen
Norman Group. Retrieved from https://www.nngroup.com/articles/ten-usability-
heuristics/

Seuss. (1996). *Dr. Seuss's ABC: an amazing alphabet book.* New York, NY:
Random House.

Walker, S. & Reynolds, L. (2003). Serifs, sans serifs and infant characters in children's
reading books. *Information Design Journal & Document Design, Vol. 11* (2/3),
106–122.

Acknowledgements
Bryan Rinnert, Photographer, Videographer and UX Designer
Josh Talbott, Application Developer
AnnMarie LeBlanc, Dean at Robert Morris University
Amy Reynolds, Dean, CCI, Kent State University,
Audrey Lingenfelter, Senior RCM Business Manager, CCI, Kent State University

Section 3

Narrative and Storytelling

A conversation with
Kyle Cooper, Prologue Films

The producer and director of hundreds of main title and visual effects sequences, Kyle has made an indelible mark on the area of Motion Design. He named and co-founded Imaginary Forces, as well as Spatialand, and Prologue Films, where he has created title sequences for Godzilla, American Horror Story, and The Walking Dead. He has earned nine Emmy Award nominations and two wins. In 2014 he was awarded the AIGA Medal and he's a member of the Academy of Motion Picture Arts and Sciences. He also holds the title of honorary Royal Designer for Industry from the Royal Society of Arts in London.

His past experience includes a tenure with R/Greenberg Associates as creative director and founder of Imaginary Forces in 1996. Kyle talks about his approach to main title design and captivating narratives born out of ideas and execution.

Early influences

After I graduated from the University of Massachusetts [Amherst with a degree in Interior Architecture], I got to do an internship at Wang Laboratories in North Chelmsford, Massachusetts. Hugh Dubberly, who had set up the corporate communications department, would regularly hold "show and tell" sessions with the staff. Once a week, someone would bring in examples of graphic design that they thought were noteworthy and worth discussion. They'd bring in Jan Tschichold's or Alexey Brodovitch's books or talk about Paul Rand. The intent was to inspire one another, and I was very inspired by it all. But I was most inspired when someone brought in a reel of film titles. I was only 21, but I saw *Take a Walk on the Wild Side* by Saul Bass and *The Man with a Golden Arm*. The ones that I gravitated towards were some of the work that R/Greenberg had done, which used minimalistic typography and music that really set a tone for the movie. I was fascinated with *The Dead Zone*, the David Cronenberg movie, and I loved the credits for *Alien* and *Altered States*. Those all came out of R/Greenberg Associates.

Figure 1
Designed by R/Greenberg Associates, slowly revealing counter forms set the tone and title for Cronenberg's Dead Zone.

Source: Hill & Cronenberg, 1983.

At that point in my life, I thought working on main titles was a "backdoor" into the film industry and that was my goal. At the same time, all the guys at Wang

[Laboratories] were telling me to go to graduate school at Yale and work with Paul Rand. They did a lot to encourage me and help me get into Yale.

Shifting focus to film titles

So I went to Yale and studied with Armin Hofmann, Wolfgang Weingart, Inge Druckery, and Philip Burton—they had all come from Basel [Switzerland]. While they were trying to get me to see, to train my eyes, I was wanting to talk to somebody about film. The people that I could eventually talk to about sequence, story, and sound were, surprisingly, Paul Rand and Chris Pullman.

Along with my design studies, I took film classes with this idea in the back of my mind that I would do film titles when I graduated from Yale. I did an independent study with Paul Rand. His work that I really gravitated towards was what I call a *moment in time*. I always felt some of his best posters—for instance, the William Tell poster with the apple on top of the A—and some of the book covers were like "a moment" or a freeze frame. It seemed to me that he had already made all the formal choices in the still frame and captured an animated moment in time, that he was thinking about motion. It seemed very simple to me that you could carry that thought through an entire sequence.

This is how I always approach things. I make choices about what the idea is and what the story is, and then figure out what it's going to look like in one frame. And then, when you work in motion, try to make every frame beautiful as if you were to freeze on it. Then the challenge is to make it visually interesting for the two and a half minutes of a title.

Alvin Eisenman once said to me, "The world needs more graphic designers than filmmakers." I don't know if he was trying to discourage me from being interested in film or if he was really saying, you need to be a graphic designer before you can be a filmmaker. On reflection, I think that was more his meaning—that you need to learn how to make beautiful compositions so that you can build form into your filmmaking.

Even though all the departments at Yale and most other schools were very separate at that time, Paul Rand and Chris Pullman were engaging me in conversations about motion and the marriage of graphic design and motion. Today if you take graphic design in any school it's sort of a given that you're going to take motion graphics. There's so much overlap now, people may take it for granted and forget that that wasn't always the case.

But, I still think Alvin Eisenman is right that if you don't learn how to be a graphic designer you're just going to be animating ugly things. Even though the choreography of the elements might be beautiful, you have to figure out how to make the elements themselves beautiful.

Evolution of and approaches to film titles

After I graduated from Yale, I got a job at R/Greenberg. I was inspired by the titles for *Altered States, The Dead Zone, Alien,* and *The Untouchables*. They're mysterious, slow, and haunting accompanied with music that set an emotional

Figure 2
Kyle has drawn inspiration from the poster designs of Paul Rand (1965) and others.

tone. The titles would build using graphic deconstructed abstractions. I would ask, "What are these abstractions? Something's building. What is it? Oh, it's the logo!" I was also intrigued by their idea behind *Superman* where the typographic pun was the letterforms streaking and that they could extend that same typographic treatment for 29 credits over and over again.

I began to do things like the remake of Abel Ferrara's *Body Snatchers* where the typographic pun is the use of shadowy letter forms overtaking the clean letterforms as if the bodies (letters) are being snatched. Or *Indecent Proposal*, where the words have the same number of letters and "indecent" is a shadow of the word "proposal." I wanted audiences to think, "What am I looking at? Oh, it's big letter forms. Oh, it becomes the logo." But, I was feeling like I wanted to make the type more expressive or more violent and make the edits faster and more intense. Then the emotional tone that is set could be more disturbing, or jarring, or celebratory, or fast. There was a lot happening editorially in music videos, which I wasn't directly influenced by, but I suspect that some of the directors that I worked with were.

I didn't want to just have this mysterious thing play out on screen, then have it turn into the logo, or repeat the same typographic metaphor 29 times. So with that I started moving away from what I was seeing and the work I was doing with R/Greenberg.

For example, while working on *The Island of Doctor Moreau*, it seemed to me that the process of a human body turning into an animal or creature would be a violent cellular process. I wanted to visually express this pain through a frenetic process of metamorphosis. I designed the type to behave in a fragmented, aggressive, disturbing way.

It's all about the tone you're trying to set. What do you want people to feel? That's the Holy Grail in any of these things. Through the emotional tone I set, I only have two and a half minutes to try to make somebody feel something.

The tone of *Alien* and *The Dead Zone* are fantastic. In these cases, the Greenberg methodology is appropriate and I'm delighted to let something play out over time if it works. But I'm always asking if that tone is appropriate for this particular movie. How do I want people to feel right out of the gate of this movie? That approach is at the core of my work.

It was the same process with the title for *Se7en*. I wanted to make it disturbing because it was a very disturbing movie. You have to do this kind of editorial dance, choreographing all of the elements that go into a title. It's not just about typography. It's a synchronization of all the different elements.

I once read that Saul Bass said, "The main title is like a poster for a movie." At one point, I was pitching the main title to Martin Scorsese's *Goodfellas*, keeping in mind that quote from Bass. I was thinking about a poster for the movie, but the reality was the assignment was more about the *beginning* of the movie. Scorsese had already envisioned the beginning of the movie where we see Ray Liotta's character in the car, then finding the guy in the trunk. He then had

the red gel and Liotta's character saying, "I always wanted to be a gangster." The challenge was to figure out how to get these credits into that opening that Scorsese already had in mind.

I actually lost that job to Saul Bass of Bass/Yager. What they did had nothing to do with a poster for the movie. It had to do with how they seamlessly integrated typography into a pre-existing opening. What I learned from that is it's not just coming up with a poster for the movie, and it's not even identifying only the emotional tone that you need to set at the open. It's also looking at the way the film begins, or looking at the entire film and realizing that there's a backstory that needs to be told. There's a feeling that people need to experience at the open and you can't just put a poster on the front of it. Sometimes the start of these movies has nothing to do with what ultimately happens. So you have to ask how you help the film begin or quietly and unassumingly integrate the utilitarian credits without disturbing an opening that's actually working pretty well. And, if you're lucky, how do you get a nice piece of graphic design in something that doesn't really need a beginning?

The best title sequences seamlessly dovetail into the beginning of the movie, and they're not some kind of disembodied expressive exercise.

Take *Se7en* for example. You don't see the killer until the third act of the movie. So how do you get a sense of the killer at the beginning so it's okay to wait for him? I felt like it was appropriate to introduce the killer's obsession at the outset and that comes from studying the whole film and its look rather than just making a poster. I go in thinking about how I can be of service to this filmmaker and this movie. How can I tell whatever backstory the movie needs without trying to be necessarily innovative? Paul Rand used to say, "Don't try to be original or innovative... just try to be good."

Figure 3
The dark and melancholy nature of Se7en *provides a look into the mind of a serial killer.*

Source: Kopelson, Carlyle, & Fincher, 1995.

Figure 4
Selected stills from Godzilla (2014), Feud: Bette and Joan (2017), The Walking Dead (2010), Flubber (1997), Donnie Brasco (1997), & Dawn of the Dead (2004).

See References.

References

Darabont, F. (Creator). (2010). *The Walking Dead* [Television series]. Georgia, United States: AMC Studios.

Hill, D. (Producer) & Cronenberg, D. (Director). (1983). *The Dead Zone* [Motion picture]. United States: Paramount Pictures.

Hughes, J., Mestres, R. (Producers), & Mayfield, L. (Director). (1997). *Flubber* [Motion picture]. United States: Walt Disney Pictures.

Johnson, M., Levinson, B., DiGiaimo, L., Mutrux, G. (Producers), & Newell, M. (Director). (1997). *Donnie Brasco* [Motion picture]. United States: TriStar Pictures.

Kopelson, A., Carlyle, P. (Producers), & Fincher, D. (Director). (1995). *Se7en* [Motion picture]. United States: New Line Cinema.

Murphy, R., Gardner, D., Minear, T., & Woodall, A.M. (Producers). (2017). *Feud: Bette and Joan* [Television series]. Los Angeles, CA: FX.

Rand, P. (1965). With the sense of sight, the idea communicates the emotion [Poster]. Retrieved from http://cprhw.tt/o/2Dwec/

Rubinstein, R.P., Abraham, M., Newman, E. (Producers), & Snyder, Z. (Director). (2004). *Dawn of the Dead* [Motion picture]. United States: Universal Pictures.

Tull, T., Jashni, J., Parent, M., Rogers, B. (Producers), & Edwards, G. (Director). (2014). *Godzilla* [Motion picture]. United States: Warner Bros. Pictures.

Adam Osgood
The Blurry Intersection of Illustration and Animation

The role of the illustrator is to communicate an idea visually. Historically, illustration has been a print-based field, and illustrators have traditionally been commissioned to create imagery for publications, advertisements, packaging, etc. In the past several years, however, the field has evolved dramatically with the growth of digital tools, digital viewing platforms, and the prevalence of social media. Over the past 20 years illustration has shifted from a vocation for the world's most skilled painters into a market best suited for digital artists who are passionate about experimenting with 4D tools and novel modes of presenting work. This chapter explores the intersection of illustration and animation through a survey of contemporary work by illustrators who design with motion.

Historical context

Throughout history, the illustrator has consistently had to find new outlets for illustration. Printed jobs like album art and gig posters, now viewed as typical illustration assignments, were new ideas in the 1960s. Today's illustrators and their clients have been working for over 20 years to discover how to best use the web as a platform for media consumption. As the web and digital technology have expanded to include apps, video-on-demand, and digital publications, so have illustration jobs expanded into these territories, demanding that illustrators incorporate animation techniques that exploit the dynamic qualities of screen-based viewing. In a statement as relevant today as it was at the time of the 2001 publication of *The Illustrator in America*, author Walter Reed questions the state of the illustration field:

> As print itself becomes a marginalized medium, the illustrator has had to explore little-charted territory as outlets for his talents. As early as the 1960s, illustrators had to profoundly adapt and were venturing into model and game box art, concert posters, or record album covers. Then came trading cards, graphic novels, action figurines, and the World Wide Web. Now some of the best illustration never gets seen, as it is movie or animation concept art, or electronic game character design. Is this even illustration at all? (p. 425)

Historically, it is worth noting that multi-disciplinary work is not necessarily a new thing for illustrators, who share an entangled history with the graphic arts and animation. For instance, Alphonse Mucha and A.M. Cassandre are celebrated as pioneers of modern illustration *and* graphic design dating back

to the late 1800s into the early 1900s. Likewise, children's book illustrator Gustaf Tenggren created concept art defining the look and feel of Disney's first animated feature, *Snow White and the Seven Dwarves* (Hand, 1937), a legacy continued by Eyvind Earle and Mary Blair who created concept and production artwork for Disney's mid-century features. Similarly, UPA's mid-century animated films, such as *Gerald McBoing-Boing* (Cannon, 1950), are so influenced by the look of period illustration that they appear as an illustration come-to-life.

As the areas that illustrators work in have expanded and tangled with related fields, so has the toolset the illustrator uses to create artwork. Once a profession dominated by some of the top painters in the country such as Charles Dana Gibson, J.C. Leyendecker, and Norman Rockwell; illustration has shifted to include artists who work in a variety of styles and mediums. As Laurence Zeegen (2010) notes, illustrators who have joined the field in the past 15 years might have only ever known it as a digital field. Today's illustrator can create artwork using software and e-mail the file directly to the client without ever touching a physical sheet of paper or visiting the post office.

The convergence of important trends in the commercial arts field and consumer marketplace explains why so many illustrators are venturing into animation. For instance, the prevalence of social media channels have created a vacuum for animated content, and the illustrator-friendly animated GIF has become the de-facto medium for this content. Meanwhile, commercial outlets are searching for ways to leverage social media to advertise their brands. Finally the tools to create digital media have become inexpensive and widely available to independent artists.

The GIF was introduced in 1987 as a compression method for transferring images over the web, but it has only been in the past several years that it has been adopted by the illustration community at large. The GIF format is special because it can be viewed by anyone with a web-browser and does not require programming skills to create (Krasner, 2013). Illustrator Robin Davey, whose work is surveyed later in the chapter, says, "My interest in GIF-making was mostly sparked by its accessibility. Anyone can make GIF art once they have the right programs to do so" (Carpenter, 2015).

While the availability and low-entry-cost of digital tools has democratized the field, it has also introduced new problems in the commercial arts. Zeegen (2010) points out that almost everyone has a computer and access to the same design software and now almost anyone can call him or herself an illustrator. This accessibility opens the field up to diverse talent with new points of view, however it also has great potential to devalue the work of experienced illustrators who might get lost in the flood of untrained artists who have access to professional digital tools. It is important to remember that illustration must *illustrate* a story or concept, otherwise it is simply decoration (p. 14). The illustrator must have a point of view and an idea to express.

This chapter highlights several contemporary revolutionaries of the illustration field who have embraced the integration of animation in their work, helping to define the future of what illustration will or might become as we explore the blurry intersection between illustration and animation. Their work is important because it carries on the tradition of illustration as a practice aimed at communicating ideas visually, while advancing the field by incorporating animation techniques.

The works surveyed in this chapter are described as "motion illustrations," because they don't follow the mold of cartoon animation, which traditionally uses performance and character acting to tell a story in a linear fashion over an extended period of time. Alternately motion illustration must communicate a story or idea immediately with a combination of visuals and animation. Unlike cartoon animation, which is typically meant to stand-alone as a singular piece of art, motion illustration is generally designed to exist with text and/or to live on a multimedia webpage in the context of an advertisement or written article. Additionally many projects implementing motion illustrations are often designed for mixed use (digital and print) and therefore must function with and without animation. Listed below are several motifs in visual design and animation that have emerged through this survey of motion illustration:

Visual design:

- Minimalist design: Motion illustrations often rely on clean, geometric, shape-based design.

- Hand-drawn: A noticeably hand-drawn or hand-made aesthetic permeates the illustration.

- Strong composition: Objects are arranged to intentionally direct the viewer's eye in dynamic compositions that maintain their integrity during motion.

- Limited color: Color palettes are minimal and help convey a mood or a feeling rather than representing the subject naturalistically.

Animation:

- Simple motions: Character animation is limited to simple gestural motions such as waving a hand, the rippling of a cape, or legs pedaling a bicycle.

- Scrolling backgrounds: The impression of a journey or time passing is conveyed with characters or vehicles placed over an infinitely scrolling background. Sometimes a parallax effect is used to add depth to the scene.

- Atmospheric effects: Often scenes are designed around environmental animations like falling rain, crackling fire, or sparkling magic.

- Metamorphosis: Objects and characters will transform into one another.

While the inclusion of these themes is not a hard rule for what motion illustration is or must be, they are recurring motifs in the works described

in this chapter. Whether static or in motion, the one universal quality that connects all illustration is the communication of a message or concept. Effective motion illustration transcends decoration with animation that highlights important symbols and ideas to convey its message.

This chapter is organized into three areas of historical importance to the illustrator: *advertising, editorial,* and *narrative.* These three areas were chosen because they represent the broad range of work an illustrator is commissioned to produce and because each area is aimed at a different audience and therefore requires a different way of thinking about image-making. Illustrations designed for advertising must sell a campaign's message; illustrations designed for editorial offer the illustrator an opportunity to comment on a newsworthy issue; and illustrations designed for narrative, such as those used in comics or films, will tell a story sequentially over a series of images. While most illustrators do not exclusively produce work in just one of these categories, organizing the work in this way showcases the different approaches these illustrators must take to create functional work for advertising, editorial, and narrative purposes.

Advertising

Although advertisers are still learning how to effectively use social media to promote brands and products, a trend has emerged in which illustrators are commissioned to create clever, silly, and transfixing looping animations to be shared across social media channels and engage potential consumers with brand messaging. Illustrators working on advertising and commercial projects are also growing into art direction roles where they use their ability to tell visual stories on team projects that might use photography, typography, or complex cartoon animation. Zeegen (2010) writes,

> There is a real sense of optimism in contemporary illustration, a feeling that the discipline hasn't just returned to form after its years in the wilderness during the 1990s, but has moved dramatically on...with big businesses harnessing the talents of illustrators to give their brands unique personalities, and ad agencies increasingly turning to illustrators when searching for 'cool' ways to promote their client's products, it is clear that illustration has much to offer again. (p. 240)

Cindy Suen, cargocollective.com/cindysuen

Cindy Suen is a fantastic example of an illustrator at the forefront of this new era in social media advertising. She has been commissioned by brands such as Subway, Google, Fox, and Kit Kat to create GIF loops that leverage her popularity as a contemporary digital artist to the benefit of the brand's message. For instance, content producer Giphy and digital shop 360i developed a mini-campaign for Subway with over 70 animated GIFs created by multiple artists to be delivered over Twitter and Facebook (Heine, 2014). The campaign does not directly ask consumers to buy their sandwiches, but instead encourages web users to share Subway's meme-inspired GIFs featuring sandwich-related imagery. Suen's cute and quirky style fits the needs of the

campaign, which is based on consumers emotionally connecting with the imagery and sharing on their own social channels. Per the animation themes outlined in the introduction, Suen's Subway GIFs feature simple, looping character animation with illustrated sandwiches as emoticon-like characters doing a variety of activities, from skiing to swimming. In one GIF, a meatball sub uses a hockey stick to shoot food into another sandwich's adorable mouth. The images are relatable, charming, and highly shareable.

In an interview with *Neon*, Suen says, "I'm so glad that animated gifs is a thing. Ever since I learned about them, I've always been thinking about things in loop form" (Han, 2015). Figure 1 showcases Suen's unique take on animated loops, and is also a strong example of her youthful aesthetic. The image begins with a white cat that lays down, turns over, and transforms into a sushi roll. The smooth metamorphosis is typical of Suen's work. She often uses animation to create magical effects that would difficult to achieve in another medium, such as photography.

Figure 1
Five frames extracted from one of Suen's GIFs show the animated metamorphosis from cat into sushi roll.

Source: Suen, 2015. Copyright by Cindy Suen. Reproduced with permission.

Stylistically Suen's work is minimalistic. She uses strong shapes and flat colors that have an appeal similar to the stylization found in children's cartoons. This is ideal for GIF animation because the format limits the number of colors that can be used, and also great for social media channels where the simplicity of the image can help make an immediate impact to grab viewers who are often surfing quickly and on small screens. Suen performs a complex feat in the apparent simplicity of her designs, which must simultaneously convey a mood or feeling while maintaining strong compositions as the elements in her images move and change.

Christina Lu, christinalu.com

Christina Lu is an illustrator and art director, whose work showcases her broad range of skills in design, concept development, and hand-drawn animation. For client projects like *Fast Company's* "Who's Next," her work veers in the direction of motion graphics with colorful geometric shapes animated into a visual symphony. Alternately, her work on Kohl's "Spring/Summer Look Book" shows her range as an art director in the way she fits together photography, film, and design into a single campaign.

A great example of Lu as a motion illustrator is her work for MTV's 2014 *Movie Brawl*. Like Cindy Suen, Lu creates GIFs with simple shape-based characters performing looping acts, such as Spiderman jumping into his trademark pose while shooting webs out of his hands. The design of these loops rely on compelling character designs and large blocks of vibrant color to draw the viewer's attention. As in Suen's work, Lu's minimalist design and simple animation allow her to convey an idea immediately with her work. In an

interview with *The Washington Post*, Lu describes the quality of a successful animated GIF, "It's just like one little detail. It's just a tiny dynamic element that makes it super fun. The GIF is a not a still — it tells its story in one second" (Carpenter, 2015).

Lu's skills as an illustrator are apparent in her design choices and ability to quickly convey a message with her imagery, even when it is not drawn. This is evident in the photography-based "Airheads 30th Birthday Announcement" by Agency Huge. In one GIF, a birthday cake is photographed in a cropped composition on a table littered with balloons and metallic tinsel. The framing is static as packaged Airheads candies are animated in stop-motion to emerge from a cake. Another image in the series shows three kids with guitars amidst a pile of Airheads. Again the background is stationary with the motion coming through the "simple character movements" of the three boys playing guitar with a choppy video-editing style that feels like stop-motion animation. The styling in each image uses a minimal palette featuring bright candy colors that evoke the product. Even in photography, the design and animation choices refer to this chapter's themes and showcase Lu's training as an illustrator. Her exuberant and fun work is designed to emotionally connect with the viewer and encourage sharing on social channels.

Rafael Varona, www.rafael-varona.com
Rafael Varona is an illustrator working in a broad range of fields from print to product to web, with clients including Adobe, Intel, and Yelp. His work translates seamlessly across multiple media platforms, as evidenced by his work with MYKITA, a Berlin-based eyewear manufacturer. Varona describes the project as requiring several large illustrations meant to be used in shop windows, cards, bags, and on MYKITA's website. He was also commissioned to make a series of animated loops that matched the campaign.

Like Suen and Lu, Varona's work relies on strong shape-based design and charmingly minimal color palettes that convey a mood. Unlike their work, however, Varona uses lush textures that give his work a hand-made aesthetic that almost feels as though it were painted in gouache.

Figure 2
Four frames extracted from this GIF made for MYKITA show how background movement creates the illusion that the character is traveling forward.

Source: Varona, 2016.

Figure 2 shows four frames from one of Varona's loops for MYKITA, all of which use simple yet effective animation techniques. This GIF portrays a girl who is perpetually riding her bicycle, indicated by the constant movement of the background to the right of the image. The other loops in the series also follow the noted animation motifs identified in this chapter: the second loop uses shows a dog interacting with falling snow (atmospheric effects), and the third shows a face with glasses appearing and disappearing (metamorphosis).

Editorial

Of all the markets in which an illustrator might work, the editorial illustrator is likely the hardest hit by the rise of web, digital tools, and social media. Historically, the editorial illustrator has been commissioned by newspapers and magazines to create an image to pair with a story. Although the decline of print publishing has diminished this field significantly, new possibilities for editorial work are growing as publications pivot to leverage the animated and interactive potential of smart devices. A growing list of contemporary illustrators have taken advantage of digital media to promote themselves as a new kind of motion illustrator. They still visualize concepts and ideas, but now use moving elements to capture the attention and imagination of the reader. While it is possible to add motion to an image designed to be static, the strongest illustrators creating animated editorial work develop concepts that rely on animation as an integral storytelling tool.

Rebecca Mock, rebeccamock.com

Rebecca Mock is one of these modern illustrators who creates editorial work for publications such as *The New Yorker, The New York Times,* and *The Walrus.* Figure 3 shows a favorite example from Mock's portfolio; a one-second loop depicting a sweltering New York City apartment in the summer, which includes a secondary animation of the window light subtly changing intensity. The illustration functions fine without motion, but the movement of the fan blades and visualization of the sun rays situates the viewer in the room and creates a visceral feeling of summer humidity. Critic Liv Siddall (2015) writes,

> When you find yourself scrolling cross-eyed through the internet and you come across GIFs with such delicate majesty such as these by Rebecca Mock, it hits you like a pixelated smack in the face...Her illustrations are subtle and somewhat tender moments represented in GIF form, un-showy and delicate.

A second example from Mock's portfolio showcases her sensitive handling of animation techniques in an illustration titled "The Party" which shows a desk piled with electronics and sketchbooks. The animation is reserved to a few lights blinking on the laptop and a smartphone screen lighting up with a new text-message. The subtlety places the viewer in familiar situations in which the pervasiveness of electronics is inescapable even in our most quiet moments. Mock's illustrations feature a lovely hand-made painterly quality and the bold graphic shapes immediately communicate the concept of the image to the reader.

Perhaps Mock's showiest piece is "The Aftershocks" for Medium.com, in which the whole image violently moves. Here she has drawn the interior of an apartment shaking as if an earthquake rumbles below. To produce this image, Mock separates the artwork for all of the items in the home (framed pictures, lamps, book shelves, potted plants) and moves them independently from one another to create the disturbing and transfixing effect. The result is an

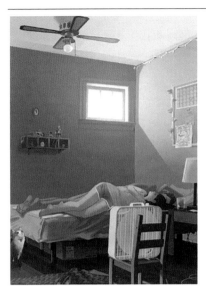

unsettling depiction of how it would feel for an earthquake to tear through a home. As with her other images, Mock forces the viewer to feel as though they are part of the illustration through clever depiction of the familiar.

Stephen Vuillemin, stephenvuillemin.com

Stephen Vuillemin is a French illustrator, animator, and comics artist working out of London. He has produced editorial work for publications including *GQ*, *The New York Times*, and *Bloomberg Business*, as well as non-editorial work such as the animated hallucination scene from Fox's *Deadpool* (Miller, 2016).

The "Artist of the Day" feature on *Cartoon Brew* describes how Vuillemin uses motion to enhance his illustration work, "Stephen has elevated the art of the animated GIF by producing work specifically for that format...When the same publications run static print versions of the GIF illustrations, Stephen's work flops the paradigm: the print version is the modified, adapted, and even inferior version when compared to the animated online version—but only because it lacks the motion" (McDonnell, 2013).

In describing his motion work, Vuillemin says, "It is a funny thing because most of the other GIFs that you can find on the internet are made with bits of video— they are a cheaper version of the original thing...But in the case of my illustration, the animated gif version is a more advanced version of them" (Stinson, 2013). As with the other illustrators described in this chapter, Vuillemin carefully designs his imagery with motion in mind to create compelling animations that immediately convey a story.

Per the chapter themes, Vuillemin's visual aesthetic leans on simplified solid shapes without defined outlines, but tends towards naturalistic proportions for figures and objects. Vuillemin dresses his imagery with minimalist and surprising color palettes that combine electric greens, pinks, and oranges with subdued blues and violets. His graphic framing choices direct the eye and aid the viewer to instantly understand the concept.

Unique from the design choices of the other illustrators highlighted in this chapter, many of Vuillemin's GIFs are rendered with very obvious ordered dithering patterns that achieve an intentionally retro look ("Dither," 2016). For instance, his commission for a *British GQ* article on sexting depicts a woman holding a hotdog while interacting with her phone. When we look very closely at her skirt, which appears as a solid shade of mint green, we can see that it is actually comprised of a pattern of discrete gray, yellow, and green tones that blend in the viewer's eye into a single hue. It seems as if Vuillemin chooses patterned dithering to pay homage to the low-fi qualities of GIFs and computer art in their infancy when the limited colors available on a computer monitor required artists to work this way.

Figure 4
Two frames extracted from Vuillemin's GIF for Bloomberg Business show the most extreme poses of the figure's pumping action.

Source: Vuillemin, 2016. Copyright by Stephen Vuillemin. Reproduced with permission.

In Figure 4 we can see the two most extreme frames from a GIF Vuillemin created for *Bloomberg Business*. The cleverness of the illustration functions with or without motion, depicting investors as a many-headed monster literally filling a balloon that represents the lending bubble (Robinson, 2015). Vuillemin actively engages his character with an infograph that he has wittily transformed into the balloon. In the animated version, the action is simple but effective in enhancing the editorial concept: the four-headed man pushes the bicycle pump up and down, slightly inflating and deflating the bar graph with each motion. Vuillemin adds supplementary animation to each head, including neck movements and eye blinks. The subtle motion is ideal for editorial work that lives next to large bodies of text, providing visual interest without distracting the viewer while they are reading. This GIF provides a strong example of the requirement for the editorial illustrator to create an image that will engage the reader on the printed page, but also give the electronic viewer a little something extra that takes advantage of the digital format.

Robin Davey, robindavey.co.uk

Robin Davey is a London-based illustrator who has worked for clients such as *Wired Italia, Time,* and *MacWorld.* Much like the work of Mock and Vuillemin, Davey's work has to function both as print and in electronic media, which poses the dual challenge of designing an immediately communicative 2D illustration and incorporating looping animation that enhances the storytelling.

In an interview with *The Verge*, Davey says, "If you'd told me five years ago that I'd be delivering work in GIF format, I'd have laughed…As an artist they're fun because you know they'll likely be viewed more than once through, so you can build in details and rhythms that might go unnoticed in a purely linear format like video" (Webster, 2014).

A strong example of Davey's skill as a motion illustrator, titled "Sci-Fi," (viewable on his representative's website at www.agentpekka.com), depicts a slender scientist posed in front of a chalkboard drawing of a hulk-like body. The juxtaposition of two figures is a classic illustration device that prompts the viewer to compare and contrast them. Davey pushes this device with animation that highlights the muscularity of the drawing with a flexing animation against the brainy heroism of the scientist symbolized with the animation of his labcoat flowing gently like Superman's cape. Davey's elegantly simple visual aesthetic and motion design fit the identified chapter themes.

Narrative

Illustrators are also using motion to extend a rich history of narrative storytelling in a variety of medium including sequential art, children's books, and animated short films. Kevin Dart and Nicolas Ménard, for instance, are both accomplished 2D illustrators who often tell animated stories with their sharp sense of visual design. The translation of their abilities from illustration to filmmaking is showcased in instantly readable compositions, use of minimalist color as a device to convey mood, and a hand-made aesthetic that permeates the designs of characters and sets.

Kevin Dart, kevindart.com

Kevin Dart is an art director working in animation, and the lead of studio Chromosphere. He is well known for his animated shorts that riff on 1960s spy films and top designers like Bob Peak and Saul Bass. In an interview with *Grain Edit*, Dart describes the birth of his signature character, Yuki 7:

> I was thinking a lot about this concept of a jet-setting spy girl with impeccable taste in fashion. I love 60's spy films like *Deadlier than the Male, Danger: Diabolik*, and of course the James Bond movies. So I wanted to create a fictional series of movies that, had they actually been made, would have been the greatest spy films ever made—filled with awesome chase scenes, amazing costumes and sets, and gorgeous ladies. (Danico, 2009)

Originally, Yuki 7 began as a series of posters for faux movies that are designed to look like they were released in the 1960s—an aesthetic style reliant on strong bold shapes and minimal color palettes. Dart and his animating partner Stéphane Coëdel then translated these posters into the spectacularly designed and animated shorts, *A Kiss From Tokyo* and *Looks That Kill* (both produced in 2011). While Dart's motion work lives in the field of animation, the visual and animation choices fit the themes identified in this chapter. In both Yuki 7

films Dart applies his retro inspiration to create illustration with bold shapes, a textural hand-drawn aesthetic, minimal color palettes, and illustrative framing that aids the viewer with understanding the scene. Coëdel in turn animates the artwork, implementing simple character motions and moving backgrounds that simulate travel.

More recently, the duo has teamed up for *Forms in Nature: Understanding Our Universe* (2016), a gorgeous two-minute animated film that cycles through a series of moving illustrations of natural wonders such as volcanoes erupting, an ant carrying a leaf, or day turning into night. Each illustrated composition is based around a circle in the center of the frame and the artwork recalls minimalist geometric qualities found in the nature illustrations of Charlie Harper. Dart's films are masterful and arguably different than most contemporary cartoon animation because his illustrative framing allows any moment from the video to function as a fully realized static illustration that immediately communicates an idea. His partnership with Coëdel adds complex and nuanced character animation; such as the scene with a monkey chewing on a twig, or bees collecting pollen in a field; but it is the strong composition and design of each frame that makes *Forms in Nature* unlike anything else.

Nicolas Ménard, www.nicolasmenard.com

Like Dart, Nicolas Ménard develops short animations with illustrative framing devices, bringing his skills as a printmaker to life with films that feel like moving prints. In an interview with *Skwigly*, an online animation magazine, Ménard says, "Printmaking came first, explaining my obsession for print aesthetics. I studied graphic design for 6 years in Montreal before my MA in Animation at the RCA. I used to do a lot of screen printing and experiments with my inkjet printer, and I wanted to merge these skills with my animation practice" (Cowley, 2015). Although Ménard describes himself as a "Graphic Artist & Animation Director" on his website, much of his work features illustration, and perhaps the tactile print-made quality in his animated work feels to the viewer much like a printed illustration come to life. His short film, *Somewhere* (2013), borrows the look of a two-color printing process while telling the story of an astronaut's journey. The images in Figures 5 and 6 show a frame from the film as well as a spread from the companion book,

Figure 5
A frame from Ménard's animated short, Somewhere, *shows its screen-print aesthetic.*

Source: Ménard, 2013. Copyright by Nicolas Ménard. Reproduced with permission.

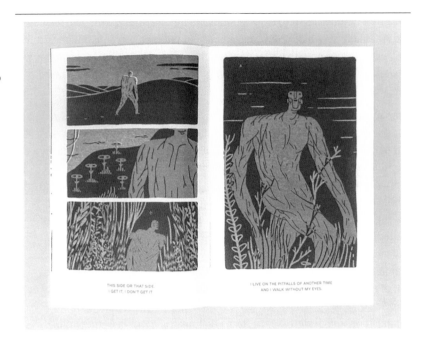

Elsewhere. Looking at the two samples next to each other makes it easy to see Menard's inspiration for the limited color palette as well as the slight offset in color registration, as can so easily happen when printing a multi-color image by hand. Ménard says, "There's two things in my practice that I find utterly satisfying...the feel and smell of ink on paper and the miracle of drawings moving" (Gorochow, 2013).

Jen Lee, thunderpaw.co

Jen Lee (2016) also creates illustrations within a narrative context, but rather than animating short films, she uses motion to enhance her web comic, *Thunderpaw: In the Ashes of Fire Mountain.* While *Thunderpaw* uses typical comic devices such as sequential panels and word bubbles to tell its story, it is unique because it includes looping GIF animation to bring the world and characters to life. Lee uses motion in several ways. As the reader first begins reading the comic, the animation isn't necessary to the storytelling; in one panel on the second page, a dog's tail wags, and in another panel his nose "sniffs." Both of these motions could have been illustrated plausibly without animation. As the reader continues through the story, the motion begins to add significant nuance to the storytelling, such as when an animated jitter is added to the character's word bubbles, affecting a different kind of speech, such as a shout or a scared whisper.

The animation Lee uses often falls under the motifs discussed in the introduction—atmospheric effects, simple character actions, and moving backgrounds that suggest the characters moving through an environment. These animations reinforce the narrative by causing the reader to "feel" the weather, or by suggesting a long passage of time indicated by a looping walk cycle. Both of these ambient animations would require additional panels in a static comic to convey the same message.

It is really towards the end of the first chapter, however, that Lee uses motion and the web platform to its full potential as she begins breaking the formal "page-size" dimensions of a printed comic with uniquely long horizontal and vertical page layouts that require the viewer to take an active role in "traveling" through the story with the characters by scrolling the browser window. A notable example from the beginning of Chapter Two features a vertical tunnel that the characters are moving down into, which is juxtaposed over a menacing looping background GIF depicting countless eyes opening and closing. The effect is jarring and surreal because Lee, until this point, has followed the conventions of the printed comic page. Unlike layouts earlier in the comic that fit traditional conventions for printed comics, this layout could not exist in its current construction without the jarring animated effect and reader interaction to "move" through the scene.

Are Illustration and Animation Becoming One Field?

These wonderful examples of illustrators working with animation techniques beg the question: where is the line drawn between illustrator and animator?

While both fields are charged with creating visuals that tell a story or communicate an idea, the motive of the illustrator and animator remains distinct. Illustrators must convey an idea immediately while the animator tells a story over a period of time. Additionally, the study of illustration often focuses on development of a unique visual aesthetic, while the study of animation might focus on refined motion, such as believable performance or expressive timing. The years of study and practice it takes to either master an illustrative style or master the art of animation or motion design is itself a great reason that the two fields should remain distinct. In a personal communication with Nicolas Ménard (2016), he writes, "I'm constantly finding my design skills lacking compared to some more focused illustrators, or my storytelling skills lacking compared to comic artists, or my animation skills lacking compared to animators who do just that as a living. It's a constant struggle, having to catch up with so many different things at the same time."

On the other hand, the prevalence and availability of inexpensive animation tools, such as the Timeline feature in Adobe Photoshop, combined with the needs of the market for moving illustrations, opens opportunities for the illustrator to add bits of animation to their work or even create work within the animation field. Likewise, jobs that were traditionally the territory of illustrators, like the aforementioned editorial, are now open to animators and designers who can create works in motion to visually explain a concept. Whether illustrators like it or not, the field is morphing into something new that may be slowly pushing out some very talented analog artists while opening the door for motion designers and animators to join. Modern illustrators must live on the edge of digital technology; animation keeps us relevant.

More motion illustrators

While this chapter discusses several talented pioneers of the illustration field who use animation as a storytelling device in the age of social media, it is by no means a complete or exhaustive list. Here are a few more artists of note that use motion to add meaning and complexity to their illustrations:

- Boulet, english.bouletcorp.com
- James Curran, www.slimjimstudios.com
- Zac Gorman, magicalgametime.com
- Markus Magnusson, markusmagnusson.tv
- Eran Mendel, www.eranmendel.com
- Chris Piascik, chrispiascik.com
- Oamul, www.oamul.com
- Otto Steininger, www.ottosteininger.com
- Sachin Teng, sachinteng.com
- Heidi Younger, www.heidiyounger.com

Adam Osgood, Associate Professor, University of the Arts

References

Cannon, R. (1950). *Gerald McBoing-Boing*. United Productions of America.

Carpenter, J. (2015). Meet the artists turning GIFs into legitimate careers - The Washington Post. Retrieved September 6, 2016, from https://www.washingtonpost.com/news/the-intersect/wp/2015/07/20/meet-the-artists-turning-gifs-into-legitimate-careers/

Cowley, L.-B. (2015). Interview with "Loop Ring Chop Drink" director Nicolas Ménard | Skwigly Animation Magazine. Retrieved September 8, 2016, from http://www.skwigly.co.uk/nicolas-menard/

Danico, G. (2009). Kevin Dart interview. Retrieved from https://www.grainedit.com/2009/06/03/kevin-dart-interview/

Dither. (2016). In *Wikipedia*. Retrieved from https://en.wikipedia.org/wiki/Dither#Algorithms

Gorochow, E. (2013). Get Lost In Somewhere, A Galactic Illustration-Based Animation With An 8-Bit Heart | The Creators Project. Retrieved September 8, 2016, from http://thecreatorsproject.vice.com/blog/get-lost-in-somewhere-a-galactic-illustration-based-animation-with-an-8-bit-heart

Han, S. (2015). Artist Interview: Cindy Suen on Why She Loves Animated Gifs, Pizza, and Cats — NEON. Retrieved September 6, 2016, from http://www.seeingneon.com/blog/artist-interview-cindy-suen-on-why-she-loves-animated-gifs-pizza-and-cats

Hand, D. (1937). *Snow White and the Seven Dwarves*. Walt Disney Productions.

Heine, C. (2014). Subway Unleashes 73 Gifs for #januANY Campaign | Adweek. Retrieved September 6, 2016, from http://www.adweek.com/news/technology/subway-unleashes-73-gifs-januany-campaign-154975

Krasner, J. (2013). *Motion Graphic Design* (3rd ed.). Burlington: Focal Press.

Lee, J. (2016). THUNDERPAW: IN THE ASHES OF FIRE MOUNTAIN. Retrieved September 6, 2016, from http://thunderpaw.co/

McDonnell, C. (2013). Artist of the Day: Stephen Vuillemin. Retrieved September 6, 2016, from http://www.cartoonbrew.com/artist-of-the-day/stephen-vuillemin-82039.html

Ménard, N. (2013). *Somewhere (2013)* [animated video]. Retrieved from https://vimeo.com/77703019

Miller, T. (2016). *Deadpool*. Twentieth Century Fox.

Mock, R. (2016). rebecca mock//rmmock@gmail.com - Home. Retrieved September 6, 2016, from http://rebeccamock.com/index.html

Reed, W. (2001). *The Illustrator in America*. New York: Watson-Guptill Publications.

Robinson, E. (2015). Wall Street Loves Peer-to-Peer Loans Despite Concerns of a Bubble – *Bloomberg*. Retrieved October 2, 2016, from http://www.bloomberg.com/news/articles/2015-05-14/wall-street-loves-peer-to-peer-loans-despite-concerns-of-a-bubble

Siddall, L. (2015). It's Nice That | Intricate GIFs depicting modern life from illustrator Rebecca Mock. Retrieved September 6, 2016, from http://www.itsnicethat.com/articles/rebecca-mock

Stinson, L. (2013). A Sweet Comic Book Made Entirely From GIFs | WIRED. Retrieved September 6, 2016, from https://www.wired.com/2013/09/a-clever-comic-book-made-entirely-from-gifs/

Suen, C. (2015). Cindy Suen | Motion, Illustrations, Graphics. Retrieved September 6, 2016, from http://cargocollective.com/cindysuen

Varona, R. (2016). Rafael B Varona /// Illustration - Animation - Webdesign. Retrieved September 6, 2016, from http://www.rafael-varona.com/

Vuillemin, S. (2016). Stephen Vuillemin. Retrieved September 6, 2016, from http://stephenvuillemin.com/

Webster, A. (2014). The whimsical animations of Robin Davey | The Verge. Retrieved September 6, 2016, from http://www.theverge.com/2014/10/24/7047747/robin-davey-gif-art

Zeegen, L. (2010). *Complete digital illustration: A master class in image making*. Mies, Switzerland: RotoVision SA.

"I'm always trying to think of what is going to give the emotional tone or the emotional resonance and help tell the story or help

communicate. Being concept based goes hand in hand with trying to find the emotional core."

A conversation with
Karin Fong, *Imaginary Forces*

Karin talks here about the ideas and skills that have inspired her to develop her critically acclaimed film and television titles, commercials, and gaming prologues during her career. She is an Emmy Award-winning designer and director and her work is conceptually driven through storytelling and image making.

Karin is a founding partner at Imaginary Forces. She previously worked at the west coast R/GA studio. Her work has appeared at the Wexner Center for the Arts, Cooper Hewitt National Design Museum, the Pasadena Museum of California Art, and the Walker Art Center.

Background and introduction to title design

For myself, I really love the conceptual aspects of motion design. I love shooting things live action. I love working in a hybrid medium, where you're not sure where one thing ends and another begins... where photography ends and animation or typography begin. It's a really interesting medium because you can collage so many things together.

I've always been making things. I was always the kid who could draw and when I was in elementary school I loved to make little books. I love narratives, I love stories, so, I would make little books and little newspapers. My mom is a third grade teacher, so I remember designing a way for her to do stop-motion film with her students. At the time it involved using an 8mm film camera and making little paper templates that you just move and snap a picture and you move and you snap a picture, and then sometimes you'd get your hand in the way, you know?

I should also mention that I've been incredibly influenced by *Sesame Street*. It was one of my favorite shows as a child. I just loved how it really took the language of advertising (I found this out later) and made it catchy for teaching kids numbers and letters. And, of course, what's wonderful about *Sesame Street* is the mixed media aspect of puppets in one segment and stop-motion animation and cell animations in another, plus combining those creatures and live action. It's a very rich and playful sort of experience. I think that has always stayed with me.

I remember even in high school, I asked the teacher if I could just make a stop-motion film instead of doing a paper. Unfortunately, or maybe fortunately, back in those days, I didn't have editing equipment, so it was just whatever I shot. But, from those experiences of making, I originally thought I wanted to be a children's book illustrator and designer, which there's still hopefully time in my life to do.

I eventually went to school at Yale, partially because I knew it had a very good art school, but it was also strong in many other departments, like English, history, literature, and art history. I knew I would be able to study a lot of things—I always felt that the writing and storytelling, and the content go hand-in-hand with all the things I wanted to make. I always knew I wanted to be an art major, but I also wanted to really know how to write and learn other things as well.

I had some really good experiences at Yale. I was there at the cresting of "interactive media" where everybody was talking about how all of our content was experienced on CD-ROM. That was the future!

My senior project was actually an animated alphabet book. I think that really pulled together a lot of the things I love. I love the idea of doing something for children, but there was also something about the medium where I recognized that sound and animation were this incredibly powerful tool. Like thinking about how you teach children to read—why not use those tools?

And so, when it all came together for my senior project and what I wanted to do, I thought, "Oh, well, I'm going to do this animated alphabet book." And I had a terrific time with it. I only managed to do like six letters, so it was more like a prototype. I did it in what was then MacroMind Director—that's how long ago it was. But it was wonderful, because I spent so much time as a child creating things with Super 8 and now I could draw a ball and make it bounce right on the screen. In just minutes you could see that happen, which seemed like this magical thing.

Another important influence that perhaps got me my job with R/Greenberg Associates [now R/GA] was that I was creating cinematic transitions in my senior project. My professor at the time, Michael Rock, looked at it and said, "You know, the way you think is very cinematic," and I didn't know what he was talking about, because to me cinematic meant *Lawrence of Arabia* with big shot sequences and gorgeous photography. But, cinematic thinking is really a language of film that is quite different in that you can zoom in and be immersed in the transitions. There's the cut and the dissolve yes, but there are new ways—you can have a mountain and turn it and it's the face of a woman. There are ways you get around a narrative without necessarily being linear or super literal.

And so I was doing those types of things in my senior project, and my professor said, "Maybe you would like a career in film titles." I had never heard of having a career in that or doing that as design work. He had me interview with Kyle

Figure 1, 2, 3
Karin Fong's Senior Project at Yale, an animated, interactive alphabet book.

Clicking on letters and pictures made them come to life.

Transitions made it playful. Here "opera" will soon become "octopus" (Watch the dress!).

Reproduced with permission.

Cooper, who eventually hired me as a designer at R/GA, and he became my mentor. There was a very direct, sort of linear progression from doing my senior project to actually working in the business.

Why motion is captivating

When I think about the advantages of motion design, one is that you can really drive the read. The wonderful thing in film is that you're holding the camera and you're directing people to look exactly where you want them to look and when. Whereas, if you're designing a book or a poster, people's eyes can dart to whatever. And, of course, you do things in the design hierarchy for the read to be right, but you really get to be a control freak in the motion department, which is a lot of fun.

I think a lot of us working in this field are perfectionists—we know that it's really important that something hits on the beat of the music or that the moment happens in a certain way. I think that kind of control is an appealing and powerful way of communicating.

Naturally, this isn't inherent in all motion because there isn't always audio, but you do have that partner in your audio much of the time. In fact, we're always joking that audio is 80% of it. It's a tool for emotional resonance, for energy or whatever you need—having audio as another layer. I especially love that sometimes the picture doesn't always say what the audio does, so you have some tension. There's a lot to play with and it's a very rich communication form.

A conceptual approach to motion design

I'm a very conceptual designer and I'm always trying to hone in on whatever the emotional message is. In the process, I'm always trying to think of what is going to give the emotional tone or the emotional resonance and help tell the story or help communicate. Being concept based goes hand-in-hand with trying to find the emotional core. I'd always try to think of something with an "ah-ha moment"—something where there's an element of surprise or delay or discovery or perhaps even mystery where something comes together.

When it comes to title design, I'm always looking for what's "ownable"—what is unique about this show or this product or this story that makes it special and its own thing? I would hate to do a title that you could just put on the front of another show. You want it to really resonate with the essence of whatever message or story you're telling.

A proud accomplishment

One of my favorite pieces of work was the title for *Boardwalk Empire*. It was fun because it combined so many different things. There was a live action shoot with Steve Buscemi wearing a three-piece vintage wool suit on the hottest day of the year in July. The show's production paid attention to every detail. All the costumes were original vintage fabrics. There were specific socks and shoes the actors had to wear. It was such a treat to work with their production team. It was visually amazing.

So the premise of the show is the character Nucky, who is sort of the center of this whole world. The first idea proposed was that the viewer didn't see him at all. Nucky would just walk and we'd see his point of view—the boardwalk which was a microcosm of American society with commerce, corn dogs, and hordes of the middle class. You also had the underbelly of gambling along with the glamour of show girls. Again, the goal was to see his point of view. But this idea was totally flipped, because in talking to the creators it became very apparent that the one thing that doesn't change in the show was Nucky. When you do a show you hope it lasts several seasons and this arc develops. Nucky, this Kingpin, was at the center of it all.

So, we have him literally being the center of a very specific storm. This was the element that was ownable. I'm always looking for what's ownable. Like, what is unique about this show, or this product, or this story that makes it its own thing?

There have been various mob shows, Godfather-like shows, and shows about the 1920s. But, what's different about *Boardwalk Empire*? One of the things that makes it different, besides its main character, is that it's in Atlantic City, a smuggling hub at the time. Prohibition really changed the fortune of that city, so the idea that Nucky is looking out to the horizon and seeing liquor bottles being the future coming towards him on the shore was a very powerful metaphor for the show.

So, with all of that there's a lot to consider being a live action shoot. We had to consider everything from managing talent to an effect shot with bottles. And I love it when we can do hybrid stuff where both real shots and photographic effects are combined and you don't know where one ends and the other begins.

So we put bottles on the shore and shot some of them, but a lot of them are effects work. We took stock footage of storms and composited them with a time lapse feel. And I think what is interesting is that HBO really wanted something metaphorical that would stand out. Not just a montage of life on the boardwalk but something that would make people sit up and take notice and wonder about the scenes of the show. It was fun to be able to do that.

On the future of motion

Now that you can literally make an animated film with your phone, I think there's going to be more makers and that's going to be very interesting. There'll be more spaces for that.

And the whole realm of virtual reality is exciting. It's truly a new media form. It's not like film-to-television, where it's basically the same medium but a different delivery device, but the way virtual reality and augmented reality are working, it's truly this new experience where you're in an immersive environment and working in dimensions. That's going to be really, really interesting.

I've heard it described like the birth of motion pictures because nobody knows how to use it yet. It's so interesting to think that in the beginning of film there wasn't montage. A new media always mimics the old one before it and so people would just film a piece of theater or something—they wouldn't think to cut or have ways of jumping through time. All these things people had to figure out with the medium of film. Imagining going back that far in the history of film, and now this is where we are with the development of VR and AR—right at the beginning where people don't quite know what to do with it yet.

The same can be said with gaming—gaming is great and it's really interesting. I think there are probably going to be breakthroughs in the way that it's integrated into our lives. So I think there's going to be a lot of exciting things that are different from what we have now as we think about how to integrate cinematic language into new forms of content. The opportunities for combining storytelling with interactivity are just going to grow.

Reference

Winter, T. (Creator & Executive Producer). (2010). *Boardwalk empire* [Television series]. New York City: HBO Entertainment.

Section 4
Space and Environment

"By identifying contextual considerations of place and reviewing the underlying variables found in motion design installations, practitioners are better equipped to create work that is impactful, meaningful, and creates a stronger sense of place."

Cotter Christian & Catherine Normoyle
Motion Design in the Context of Place

Technology has shifted the definition of motion design and what it means to practice in the field; these changes not only enable designers to explore new methods and outcomes for creating artifacts, but they also contribute to the capabilities of working in different contexts. By moving away from traditional digital devices, the field of motion design has the opportunity to explore more sophisticated technological systems, fostering state-of-the-art configurations realized as installations in place. Often allowing for new interpretations of scale, these types of motion graphics must consider concepts of place into the processes and outcomes of the work.

This chapter will discuss motion design in the context of place, addressing how each can reshape the way the other is perceived, generating meaning that creates more dynamic experiences between people and their environment. By identifying contextual considerations of place and reviewing the underlying variables found in motion design installations, practitioners are better equipped to create work that is impactful, meaningful, and creates a stronger sense of place. A review of select motion design work provides insights on how a place can affect the content and add value through goals that stretch beyond traditional principles of the practice. The examples also highlight a range of motion design methods used in various places that challenge the boundaries of the practice, revealing its interdisciplinary nature. We conclude on insights and findings from our analysis and expand on ways motion designers might consider place in their work.

Motion

As technology has enabled designers to create artifacts beyond the static page, the concept of motion has changed the visual landscape of design, altering methods and outcomes for communication, information visualization, and artistic expression. The element of time, which supports components of movement and sound in designed artifacts, expands the possibilities for the types of work that designers may create, and blurs the boundaries between traditional graphic, communication, or visual design with dynamic storytelling disciplines such as film, video, and animation. Technological advances also encourage more designers to experiment visually with programming methods that can add or alter the way artifacts are made, overlapping with interactive disciplines such as UI/UX (user-interface, user-experience), gaming, procedural art generation, and HCI (human-computer interaction). Meanwhile, dramatic shifts in the design field, considerably due to the wide availability of technology and open-source knowledge in general, support

engagement and experience as primary outcomes of design, not just the artifacts themselves.

These factors shift perceptions of what motion design is and how it should be defined. Also identified as motion graphics and motion media, motion design can be referred to as a field of study at the convergence of communication design and cinema; or a discipline for disseminating information and messages to an audience in a time-based, interactive, scripted, or other type of format. It combines principles of storytelling, design, audience, engagement, and experience through the manipulation of type, image, color, content, sound, and movement.

Most often, motion design is displayed on digital devices—televisions, computer screens, or mobile phones and tablets, for example. These devices, especially the latter, are transient, not necessarily reliant on a particular place. However, by considering how motion design impacts place as an integrated or applied part of an exterior of a building, an interior space, or other spatial environment, it becomes clear that the context of the work alters the perceived outcome. A solid understanding of what defines place and how it can play an important role in the practice of motion design can make the work more impactful to an audience, creating a stronger experience, and adding to a sense of place.

Place

The meaning of place has been thoroughly debated in the literature of architecture, interior design, geography, and environmental psychology, among others. Fostered by phenomenological inquiry, the study of place and meaning dates back to the middle of the last century and beyond, and we can look to authors such as Gaston Bachelard (1964) in *The Poetics of Space*, and Martin Heidegger to uncover how humans create meaning in and around the architecture they inhabit. This approach was revolutionary at the time, as it was an early rejection of the modernist, positivist philosophy that the problems of the world could be solved with universal design solutions. With the postmodern movement, this rejection of a one-size-fits all solution emboldened designers and theorists to heavily consider the merits of individual and cultural meaning in the built environment. Kevin Lynch in *Image of the City* (1960) and *What Time is this Place* (1976), *Learning from Las Vegas* (Brown, Izenour, & Venturi, 1977), Yi-Fu Tuan's (1977) *Space and Place*, Jane Jacobs, Christopher Alexander, and many others, have reinforced the importance of a connection between architecture, cities, and a sense of place. It can be generally agreed that the built environment should be designed for the people who inhabit it, recognizing its capacity to create and carry meaning not only through its formal semiotic language, but in the way that it promotes interactivity, references socio-cultural and historical meaning, and connects people to each other and the world around them.

Place can be defined as space with an added layer of meaning. Yi-Fu Tuan, in his 1977 book on the topic, *Space and Place: The Perspective of Experience*, states: "Space is transformed into place as it acquires definition and meaning"

(p. 136). A sense of place also emerges when a space is activated through personal and shared connections. Sime (1986) summarizes this idea by suggesting that place, "as opposed to space, implies a strong emotional tie, temporary or more long lasting, between a person and a particular physical location" (p. 50). The relationship between people and place is highly subjective, yet there are certain physiological and cultural factors which can contribute to associations with the environment. According to Heerwagen (2008), "Buildings with high psychosocial value are designed around basic human needs, ancient preferences, and connections to the patterns of nature and the mind." So while we may all have different associations to our physical surroundings, there are some agreed upon sensory experiences dominant to certain socio-cultural groups as well as shared human responses to color, light, access to nature, territoriality, proxemics, and a sense of refuge. These factors can be influenced by the architect and designer but only to a point. It is the architect and designer's responsibility to create environments that present a willingness for a sense of place to be bestowed upon them. People create the place; architects and designers provide the opportunity for a sense of place to occur.

The Intersection of Motion and Place

When motion design is included in the built environment, it becomes part of the myriad of materials, finishes, and formal language that contribute to the space's meaning, yet is subjected to the same challenges in creating a sense of place. Often bright in contrast to their surroundings and visually captivating, these motion design installations may become focal points in the environment, having a tremendous impact on how users create a sense of place. The messages they communicate, the level of their integration or application, the colors used, their scale, and their intention can either support the meaning generated by the space or be in contrast to that environment. Whether atmospheric or informative, screens, projections, or other motion design display systems fundamentally contribute to the ability for a space to foster a sense of place by its inhabitants. This is crucial, as meaning enriched environments are fragile and transitory, and our modern condition presents many challenges to this proposition.

Contextual considerations of place

There are many ways that meaning can be associated with a place, and so much of this meaning-making depends on a vast array of subjective interpretations ranging from one's immediate past experience to deeply ingrained memories and associations with particular building types and environments. Any effort to categorize the characteristics of place will draw upon the researcher's perspective and experience, but can be used as a necessary guidepost for foregrounding a conversation on the relevance of place in motion design.

There are four distinct lenses that may be considered while examining motion design and its relationship to place: the sensory and aesthetic experience; scale and proximity; the activity, audience, and intended architectural program ; and the narrative that is communicated by both the motion design

and the space itself. The sensory and aesthetic experience communicated by the motion design installation will consider the formal characteristics of what is displayed, but also how it is displayed, taking into account illusion, texture, color, sound, and other primarily visual stimuli. Scale has tremendous impact on the character of space and must be evaluated by the motion designer for it will alter the way that people view and interact with the work. The happenings in a space, including the activities, audience, and program, reveal another layer of complexity as we assess how motion design relates to the use of the space as well as how different audiences interact (or not) with the work. And finally, the narrative expressed by the design affords consideration of permanence and history—both a shared cultural history and a site-specific history of the place, which may inform a sense of subconscious rootedness as described by Tuan (1977) and another component to attaching meaning to environments.

Underlying variables of motion in place

A range of motion design installations in a variety of place-based contexts were analyzed to understand the underlying variables considered in these works including audiences, locations, intents, methods, and mediums. Each variable is described as a continuum with two categorical ends identified as variable types. It is important to note that these categories are not stable, and most examples can appear in multiple places at varying degrees. The goal behind this categorization is to develop a framework to analyze the place-supporting efficacy of motion design projects through a contextually and intentionally adjusted lens (Figure 1).

AUDIENCE
Repeat — First-time

LOCATION
Interior — Exterior

INTENT
Informative — Atmospheric

METHOD
Algorithmic — Scripted

MEDIUM
Applied — Integrated

Figure 1
Variables of Motion in Place.

Copyright 2016 by Catherine Normoyle.

Motion design can play a unique role in connecting an audience to their surroundings; a repeat audience will have a different relationship to a work of motion design than someone visiting the space for the first time. When we are unfamiliar with a space, we tend to more acutely notice its characteristics, but over time and repeated visits, those things may become repetitive, falling into an overall landscape of familiarity. Also, buildings communicate a series of unspoken behavioral recommendations and responses, and motion design has agency in this dialogue by reinforcing or confronting these intentions. For

example, we behave much differently in a library than a coffee shop despite the fact that one could study in either location. If motion design impacts how people use a particular space, then its location in the built environment and where it confronts the visitor, whether exterior, interior, or a transitional space, is also an important consideration.

Most motion design installations lean toward one of two purposes— information communications or supporting atmospheric environments. Motion design that falls within the information communications category intends to disseminate information, messaging, and data in and, in some cases, about a place. It may be a literal representation or a more abstract representation, but often it transmits informative knowledge to an audience. Such work may fall into sub-disciplines of branding, advertising, information design, signage, or data-visualizations and mapping. Motion design that falls within the atmospheric environments category often attempts to evoke a feeling or mood in its environmental context. It is less informative than its counterpart and more expressive. Such work may fall into sub-disciplines of art, exhibition, theatre, performance, film, video, or animation. In both, there is overlap, and sometimes a sub-discipline may fall within both categories or align more with one, based on the specific installation's intent.

Implementation methods and medium typically include either algorithmic or scripted strategies , or a combination of both, to visualize the designs in place. Both methods are considered agents of motion design and may be applied to the built environment through applied projections or integrated directly in and on the building as screens and other motion design display systems. All of these variables should be considered in contemporary practices as they shift traditional processes of motion design.

Contemporary Practices

The following presents a range of motion design installations, either integrated or applied, that contribute to a sense of place. Projects have been divided into four different groupings based on their perceived intent and/or content: commercial applications, outdoor artistic pursuits, information systems, and interactive data-visualizations. Commercial applications represent work that, from our analysis, has a primary intention of selling a brand, service, or good. Large format architectural projections, reviewed as outdoor artistic pursuits (although they may be applied indoors as well), include work where the primary intention is expressive, revealed through event-like, theatrical methods. The information systems category includes work that communicates information-based content, sometimes about the building itself, to the occupants. And, finally, interactive data-visualizations examine work that displays live data in an abstract, constantly changing manner, which in the provided examples tend to be atmospheric in nature.

Commercial applications

For decades, advertisers have clamored to emblazon the urban canyon surrounding Times Square with their brands. It seems with every new building or technological advance, the signage becomes brighter, crisper, and more dynamic, leading to a competition for the next bigger and better screen to grab

the attention of television cameras and the 1.5 million tourists, residents, and office workers who pass through every day (Times Square, n.d.). One could deconstruct the individual motion installations throughout Times Square and its periphery; but, a more compelling argument for the creation of place, in this context, is to consider the cumulative effect of combining all the billboards collectively (Figure 2). So, while the intent of these screens is to communicate discreet information (advertising), in totality, they form a distinct, immersive urban space (not unlike Tokyo's Shibuya or Piccadilly Circus in London) that takes on a unique sense of place due to the sheer size and number of digital billboards. While the content on the screens is constantly changing, the combination of all the screens projecting 24/7 suggests a quasi-permanence for the overall space, thus creating a specific and culturally shared sense of place.

Figure 2
*Advertising &
Branding Motion
Design Displays
in Time Square,
Manhattan.*

*Copyright 2016 by
Cotter Christian.*

Built on the northern edge of Times Square, acting as a transition to the fully immersive visual cacophony that occurs at the intersection of 7th Avenue and Broadway, is 745 7th Avenue. Completed for Morgan Stanley in 2000, sold to Lehman Brothers in 2002, and now occupied by Barclays Bank, the building consists of multiple bands of screens integrated in the spandrel area of the curtain wall between its lower level floors (Emporis, n.d.). The designers for this project recognized the original building site's occupants—a financial investment firm—and attempted to create a unique sense of place around, and potentially in, the building by changing the content of the displays away from pure advertising and toward more atmospheric content. The screens and accompanying graphics were designed by Imaginary Forces (n.d.) who claim that "[t]he integrated signage and its cinematic content counter the overtly commercial nature of Times Square." The original intent for 745 7th Avenue, according to Matt Checkowski (n.d.), one of the designers on the project, was that the signage "combines live data simulations, weather maps, and designed scenes to provide 24 hour content that creates a [...] continually evolving branded surface." Where the displays in Times Square demand attention for their advertising, these displays were intended to take the viewer on a journey over bridges, across global markets, and expose the inner workings of the building itself (Checkowski, n.d.). The original graphics make reference to far off places, and although the intention was to have the displays alter based on weather, traffic, and building usage, because of the overwhelming visual stimulus in the area, this effect was greatly challenged.

The screens, integrated into the architecture in bands, allow the life within the building to be revealed through the clear glass between, becoming a part of the larger composition. Like many of the displays used in Times Square, the screens are high-resolution panels attached to the exterior of the building and are similar to the NASDAQ building as well as the ABC Good Morning America studios in how they articulate the building architecture, the screens themselves taking on a unique, formal quality. In the end, scale and proximity are important, and in this example, the association to Times Square is unavoidable. It is difficult for the building to create a discreet sense of place among the visual chaos of this unique neighborhood. Ultimately, an important issue that is raised by this project is the continuity of content. On a recent visit to the site, it should be noted that the motion design for the screens no longer displays real time data-driven information; what was an attempt by the original design team to create a different kind of motion design, has since been changed by the current tenant, as the displays do little more than showcase the brand identity of Barclays (Figure 3).

Motion design, when thoughtfully imagined, has the opportunity to capitalize on their ephemeral and immersive nature to project a business's brand identity, beyond a simple logo in otherwise traditional architectural typologies. At a relatively new Capital One bank location near New York City's Union Square Park, the branch merges a coffee shop with less formal tellers whose role is primarily to assist customers with online transactions. In contrast to the historically proverbial temples to security and finance that often employ classical architectural motifs, which suggest a particular experience and relationship between business and customer, this Capital One branch has a number of architectural, digital display panels extending from the exterior of the building to the interior. Thin bands of displays pierce the glass storefront and become the ceiling of the upper floor, while large, full height panels flank the ATM vestibules. The digital screens also serve to connect the two floors, the upper containing a more traditional banking environment with the lower, nontraditional cafe space. The digital screens are functional, supplementing natural and artificial lighting. All of the screens at the branch display the same graphic program simultaneously: bright colorful, liquid patterns, somewhat reminiscent of a lava lamp, are dispersed with abstractions of their logo. Ironic nods to traditional architecture by superimposing classical pediments above the ATMs and seasonal programming add to the mixed atmosphere of this hybrid space. The fluid shapes move from screen to screen throughout the

interior and exterior of the space, offering a visual connection between the two and drawing attention from the passersby. It would be difficult to discern that this shop was in fact a bank branch, the motion graphics metaphorically reinforce the evolving nature of this building typology. Further, by integrating full height displays with fluid and dynamic motion graphics as walls, the notion of a typical enclosure becomes something more ephemeral, perhaps reinforcing the relationship between the virtual and physical banking presence (Figure 4).

In this example, Capital One has continued the trend of moving the bank branch architectural standard from one of traditional stability and security to something that mirrors a virtual experience, and this is reinforced by the extensive use of motion graphics. The graphics and digital displays in this location stand out in contrast with the New York City streets while simultaneously drawing in customers and identifying this bank branch as someplace different from a typical banking experience, and that the previously understood "place" of banking has evolved. The abstract motion graphics in the space reinforce this idea by suggesting that there is a connection between inside and outside, a fluidity among physical space, and ultimately, that technology is the new interface for banking.

Outdoor artistic pursuits

While designers may recognize the heightened scale, quantity, and volume of advertising and branding possibilities in the industry, other opportunities in the public sphere have emerged, like atmospheric artistic approaches in motion design, particularly since the 90s. Often explored as projected installations on the built environment, these instances of art have been taken out of their original, gallery context and inserted into public space, sometimes to disrupt the social contexts of a place or contrast the built environment itself. The work engages a different audience than the typical gallery visitor or critic. While these outdoor motion design approaches intersect aspects of theatre performance, cinema, film, and video, the content of the work is commonly communicated through scripted methods where it is less about interaction and more about engagement with a cross-cultural, macro audience at impressive scale.

Urbanscreen, an artist collective and creative company based in Germany, focuses on the intersections of art and technology as it applies to site-specific architectural projection, sculptural augmentation, and virtual theatre. Their

interdisciplinary team, made up of architects, artists, and technical specialists, create compelling projections that augment the physical form of exterior surfaces and challenge the structural elements (by way of formal aesthetics) of the built environment (Urbanscreen, n.d.-a). They describe this as "seizing the inherent structures of the given architecture as a conceptual starting point, [their] works form an aesthetic symbiosis with the façade and bring forth coherent and stunning sensual impressions" (Urbanscreen, n.d.-b). An example of this is "Lighting the Sails," which was projected on The Sydney Opera House in Australia in 2012. It is one of the many works by the collective that visualize this reinterpretation of form through motion design. The content supports the original vision of the architect, Jorn Utzon to "create a human expression in the architecture" (Urbanscreen, n.d.-c), which he realized through the curvature and contours of the rooftop shells of the Opera House. Applied to the surface, the projection enhances the expressionist style of the building, creating a virtual illusion of soft, organic forms, and transforming the exteriors of the building into a sensual landscape. The reinterpretation of the building feels light as air, fabric-like, a stark contradiction to the architectural solidness and weight that usually describes the physicality of the built environment. Human elements of the figure, represented through shadow, and hands pressing up against the seemingly malleable surface, challenge definitions of depth and form in the structure, while directly referencing humanistic qualities (Figure 5).

Figure 5
The architectural projection of "Lighting the Sails" on The Sydney Opera House.

Copyright 2012 by URBANSCREEN. Reproduced with permission.

The Sydney Opera House is reimagined through highly technical 3D-video mapping techniques at massive scale to create illusions of form. The work, described as "audio/visual stagings on the fluctuating cusp between virtual and real spaces" (Urbanscreen, n.d.-b), challenges the solidness and structure of the facade while literally, turning the three-dimensional, rounded exterior surfaces into screens. However, what is not inherent in the projection itself is the sense of place created through audience engagement. People gather to view the massive display, which in turn, creates a revitalized sense of place through the event of the production itself, similarly to a theatre performance experience.

In similar technical and conceptual approaches, a recent 2016 Urbanscreen projected installation piece called "Kubus" was created for the opening of the Weißer Kubus education center and exhibition space in Weißenstadt,

Germany. The projection considered definitions of the white cube as "a neutral architectural space for the presentation of artworks" (Urbanscreen, n.d.-d), and is almost exclusively expressed through formalist concepts. Deconstructing the architectural form of the cube, the motion work is a geometric, graphical visualization of the building itself. It responds to, exaggerates, and exemplifies the building's structural components by formally investigating its spatiality (Figure 6). Both of these examples consider place by directly responding to the characteristics of the architecture. Perhaps similar in method and intent, the audiences can expect very different performances from each building.

Figure 6
The architectural projection of "Kubus "on Weißer Kubus in Germany.

Copyright 2016 by URBANSCREEN. Reproduced with permission.

Another example of an artistic approach to motion design in place includes Jill Wissmiller's multichannel video installation, "Omelet and a Lemonade," which responds to a financial exigency during Memphis College of Art's Premier Selection Auction at the Hyde Gallery in Memphis, Tennessee. The projection was a response to the remittance of the college's artworks for auction and was hotly debated in the city. Wissmiller's work references Roy Lichtenstein's print, "Sandwich and a Coke," and as she states: "While it is never easy to let go of treasured works, you got to break some eggs to make an omelet; when life gives you lemons" (personal communication, September 1, 2016). The visual metaphor explores themes of people and their relationship to the gallery and art. The work, a cinematic, image montage, communicates a narrative that challenges the viewer to think internal about one's self and place through a public art experience. It challenges the social contexts of the gallery space by overtly placing these massive scale, continuous film sequences on the museum and its window facades, opening the gallery experience to the passerby and ultimately making them more aware of the college itself (Figure 7).

These projected installations challenge permanence in the built environment, as they are all temporary, ephemeral productions that live in a place for a finite, and usually limited, amount of time. As they are only recorded in video and photo formats, the implications of the installations may vary if they were applied to the environment for longer durations or at different times and intervals. As they rely on place to exist, they will also communicate differently taken out of their contexts and viewed as recorded formats. The very nature of a fleeting performance, as reviewed in the Urbanscreen examples and Wissmiller's artwork, that intends to surprise, delight, challenge, or inspire creates an unexpected sense of awe through shared connections with people

and places; and it is this unexpectedness that helps create a renewed sense of place by instilling moments of pause in and around the built environment.

Information systems

Motion design can serve an important role in distilling and communicating vital information about a building, using the wealth of data generated by building systems to bring to life otherwise invisible aspects of the built environment. Much effort is spent designing buildings for optimal sustainable performance, and besides well-documented improvements in human health and performance; many of these environmentally beneficial improvements are invisible to the everyday user. In the following examples, we can see how motion design can be used to both abstractly and concretely inform users of the sustainable efforts achieved by a building while at the same time, providing a feedback loop that encourages real-time behavioral modifications to further improve sustainable performance.

The Beacon occupies a prominent location in the Tower at PNC Plaza in Pittsburgh, Pennsylvania. The building, designed by Gensler (n.d.), and opened in 2015, earned the highest (platinum) level of certification offered by the LEED (Leadership in Energy and Environmental Design) program for its sustainable systems and commitment to a healthy workplace. The Beacon, designed by Manhattan-based experiential design firm, ESI Design, "interprets data from the building's advanced green systems and the external environment" and "translates this data into ever-changing patterns of light, color, and sound" (Business Wire, 2015). The systems measure things like ventilation, energy usage, and temperature, and then, using rows of liquid crystal film coated panels containing LEDs, display this information in abstract graphics (PNC, n.d.). When not visualizing the system data, the Beacon "plays artistic animations for visitors in the lobby" (PNC, n.d.).

Also communicating information about a building's environmental performance, the LEED Dynamic Plaque evaluates data that has been automatically or manually entered into the system and generates an overall environmental score based on the LEED System. The actual display unit (Figure 8) is only one part of a larger system aimed at continued performance and existing building certification. This system "enables building owners, property managers, and other stakeholders to track historic and ongoing performance" (Bessoudo, 2016). The digital display unit shows the building's "performance score in a visually engaging manner for building occupants,

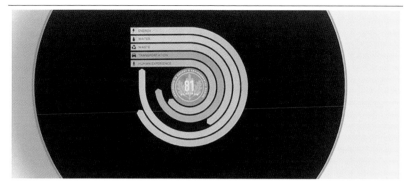

tenants, and visitors" (United States Green Building Council, n.d.) but may or may not be updated in real time, as it relies on data entry by the building owner to supply crucial feedback. The Dynamic Plaque display can show building performance in sustainable criteria such as energy consumption, water use, and others in real time, but that would require installation of smart sensors and a willingness of the building owner to display information that might negatively represent the sustainable efforts of the project.

While both of these systems expose the sustainable criteria of their respective buildings, making invisible data available to users, they do so in very different ways, and because of this, possess different potential for creating a sense of place. Both examples represent a hybrid between purely scripted content and visuals algorithmically derived from data; the Beacon has animated shows in between the data-visualizations, and the LEED Dynamic Plaque display system can either draw data from sensors or is manually entered. The Beacon, acting as a landmark within and from the exterior of the building, along with its colors, movement, and light impacts the user experience in the space regardless of their understanding of the visuals. The scale of the installation allows it to visually dominate the lobby, creating a dynamic sense of place and potentially fostering a deeper level of inquiry by both the everyday user and the infrequent visitor. The LEED Dynamic Plaque visual display, however, can be placed anywhere within the building, its motion graphics align with the branding of the program it represents, effectively disconnecting it visually from the place it inhabits. Both of these examples have the potential to connect users with their built environment, and this is the most important way that these motion design systems have for potentially fostering place attachment. They reveal the narrative of the building in different ways, animating it as an ever-changing constructed organism and reinforcing the connection between users and their environment, while showing that buildings and humans have a symbiotic relationship when it comes to sustainability. They create a sense of connection, and through that connection offer an opportunity for added meaning to be instilled.

Interactive data-visualizations
While motion design can provide a medium for buildings to communicate information about the workings of an environment, it can also provide atmospheric expressions of information that respond to interactive variables like movement and activity in and around a building through sensory

recognition. These types of interactive media displays can create immersive experiences that intersect components of motion graphics, interaction, data-visualization, and the architecture itself, fostering a strong sense of place by inviting variables into the work through algorithmic means. The results become a co-creation of narrative envisioned by designers and the influences of the activities in the space.

In the following example, an immersive experience is created through the integration of motion design in the workplace. Beacon Capital Partners is a real estate investment company that transforms office properties into distinctive workplaces through art. Owners of the Washington DC property, Terrell Place, they recently worked with ESI Design to create a reactive motion design installation that integrates "1,700-square-feet of motion-activated LED displays into the architectural surfaces" of the interior (ESI Design, n.d.). The renovation created a connected virtual canvas across the walls of the office lobby of Terrell Place, producing a cohesive atmosphere as it displays one of three rotating content modes—"Seasons," "Color Play," and "Cityscape," which have multiple scenes. The digital displays can be recoded to include new scenes; the scenes change at different times of day to keep a recurring audience of visitors and tenants engaged with the space. The results are distinctly visual, narrated by evocative, collage-like imagery that add form, color, depth, texture, and movement to the space like a digital, time-based mural. Additionally, sound and ambient lighting contribute to the mood of the space, creating a multi-sensorial immersive experience for its audience.

Some of the imagery is informed by the city itself—DC architecture and Cherry Blossoms—while others are more abstract, possibly reflecting on the desired tone of the building, the workplace as a stimulating and inspiring environment. The addition of formal aesthetics at an architectural scale add to the many finishes that set the tone for this building, creating a stronger sense of place for its inhabitants. It's striking at its scale, and can be seen both inside and outside of the building, creating engagement with street-side pedestrians as well. But possibly most intriguing is its motion-activated features that make the virtual walls react and respond to the movement in the space. As visitors navigate the lobby, algorithmic methods interpret the activity and movement into each scene, creating another layer of visual complexity. Michael Schneider, Senior Creative Technology Designer at ESI Design states, "[e]ach of the media scenes reflects the time of day and the movement of people through the lobby, acting almost as a large abstract data-visualization of the ebb and flow of Terrell Place" (ESI Design, n.d.). The activity of the place is interpreted through the user's movement and engagement with the environment, making the experience unique every time a person walks through the space. Through the consideration of the audience's activities in the space, the final work expands beyond scripted content, and not only can be viewed, but also directly interacts with the audience, creating an experience that is dynamic and evolving (Figure 9).

Activity can also be understood through other types of environmental, sensory-based information. In another example, the glass storefront, entrance

lobby of 605 3rd Avenue in Manhattan, recently renovated by the architecture and design firm, Rockwell Group, is activated by interactive motion design that responds to environmental changes in the weather, among other stimuli (Figure 10). This installation, comprised of two 15-foot square panels made up of a series of LCD tiles, showcases six different geometric motifs, including data-visualizations generated by an outdoor wind sensor (Morris, 2016). According to Rockwell Group (n.d.), "Each tile can be programmed to be opaque, clear, or one of 254 monochromatic shades in between." Adjusting this transparency allows for differing, and constantly changing views from the street to inside the lobby as well as framing the passing cars and pedestrians in a new way from the interior.

Similar to the Terrell Place example, this motion piece addresses the transitional space between interior and exterior capturing, as designer David Rockwell states, "a moment of reflection as visitors or tenants move from the street to the office" (Morris, 2016). Combined with the consistent and complementary material and color palette of the overall lobby renovation, this installation introduces the user to the space, setting up an environment conducive to inquiry and creating a unique sense of place. The installation fosters an experience that is subtle with the intent of creating a tranquil space. The display program motifs provide a constantly changing variety of imagery by adjusting the transparency of the LCD panels, with the intention "to keep the images and installations unpredictable" (Morris, 2016). The installation may capture the attention of a passerby or building tenant, causing them to reflect and be connected to the physical space in that moment, or they may simply pass by as witnessed on a recent visit to the building, only experiencing the motion design as another material component in the overall design of

the building. Where this installation is highly successful is in relating the movement of the streets created by the constant flow of pedestrians, traffic, and weather, and transitioning those dynamic qualities into what would otherwise be a very static lobby space.

The impact these installations may have on creating a sense of place is strongly connected with the designer's ability to incorporate elements of spontaneity in the work, making it appealing to both every day and infrequent visitors. The balance between communicating an evocative expression and avoiding repetitive visuals or audio cues that may become redundant after many viewings, by including moments of surprise or unexpectedness add aspects of variation to the work. Another consideration for the designer may be to reflect on the needs of the audience and recognize the intent of the building itself. Both Terrell Place and 605 3rd Avenue visualize information from their respective places to create an abstract, artistic solution that communicates a message full of evocative expression. They also add to the identity of the place, creating a unique experience for the user and ultimately benefiting the developer, owners, or others who may want to showcase the property for its design characteristics. The work manipulates motion design elements of movement, sound, imagery, and color to evoke a spirit and expression that is innately intertwined with the building to improve or impact the livability of the work place and its inhabitants.

Insights and Findings

A sense of place, often ephemeral and subjective, is perceived and created by users through the combination of all the material and immaterial aspects of the environment. When occupying space, motion design installations play a role in the generation of place. They can reinforce existing features of place, or stand in contrast to their host. They can be fully integrated into the physical architecture or applied in a superficial manner. Regardless of where, how, and for what intention these installations occur, their designers must be sensitive to features that allow for meaning-making to occur in the environment. Additionally, motion designers need to think beyond the traditional design process to include the context of place in their design investigations and practices. Place should be considered in the work through all phases of the design process of research, design, planning, and execution.

The role of the audience is a universal concern in motion design, as it is in many fields. Designers must consider the user, whether it is to provoke action, communicate information, evoke a sensory response, or interact with the audience. In all the examples discussed, people play an important part in the design, not only in the developmental process, but also in its outcome. While the Terrell Place installation is audience-activated in its conception and implementation, it is also audience-driven as it attempts to create an experiential and immersive environment for its inhabitants. Businesses also try to create better experiences for consumers as we saw in the experiential branding for Capital One Bank Branch. Motion design plays a crucial role in reinforcing their identity system. Perhaps most importantly, the user (or

audience) is ultimately who defines a sense of place through their shared experience.

A number of the examples discussed here present unconventional storytelling strategy as a means of connecting to place. We see how data, including weather, building information, user behavior, and more, is used by some motion design installations like the LEED Dynamic Plaque to tell visually captivating stories about the environment. The motion graphics reveal the story of a place by visualizing invisible data and layering information about the built environment. Even though a space's occupant may be unaware of the algorithmic narrative produced in a motion design, the potential exists for deeper inquiry to occur, fostering a more engaging sense of place.

Advances in technology offer new possibilities in the mediums that motion design may exist. Screens are thinner and brighter, LEDs more flexible allowing the screens themselves to become part of the architecture. This relationship, as seen in examples like the Barclay Building, between the form of the screen and the architecture, stands out as a unique way in which motion design can relate to place. Additionally, advanced technological projector systems, as seen in installations created by collectives like Urbanscreen and independent artists like Wissmiller, offer opportunities to apply motion design to place at impressive scales. Whether it is a projection on architecture or if the screen is designed into the architecture should be a fundamental consideration in how the work considers place.

Digital display systems, by their very nature, have an ephemeral quality, at the mercy of a fully charged battery, a necessary update, or changing tenants and owners. Motion design, relying on technology, must balance its inherent ephemerality with the relative permanence of the architecture. Permanence and a sense of existing beyond the immediate encounter are important aspects of an environment that has a strong sense of place. An ephemeral environment, reinforced by motion design that is constantly changing without a strong sense of permanence, will make it difficult for users to develop a stable and rich sense of place. On the other hand, if the installation reveals more about the building, like we see with the Beacon in the Tower at PNC Plaza, it has the potential to provide deeper meaning about the environment, potentially creating a grander sense of permanence for the user.

Successful consideration of place in the built environment requires a rigorous effort to understand the physiological, psychological, and sociological filters through which one is impacted in their placing meaning on their surroundings. It is an interdisciplinary endeavor, blurring the boundary between many fields and modes of interpretation. Likewise, motion design itself is in a unique position that also blurs boundaries of different disciplines. The screens and projections become architecture, while the content often exists on a continuum including information delivery, artistic interpretation, and commercial branding. The mixture of these influences may make interpreting the meaning of the motion design difficult, reinforcing the need for place and context to be considered to frame the visual content.

As we have seen from the examples, scale exists at multiple levels in motion design, from size to complexity. Technology has afforded a relentless quest for bigger, sharper, and brighter, resulting in the rise of the "Spectacular" billboard, which competes with the multitude of other signage and motion graphics in our built environment. But scale can also exist in the complexity of or how the information is delivered. The lobby at 605 3rd Avenue uses complex algorithms to generate what appears as a somewhat pixelated and low-tech design. But, this design invites the user in, offering exploration and creating connection to the physical space. So while the Spectaculars of Times Square create an immersive sense of place due to their excessive scale, complexity of meaning on a smaller physical scale can create similar user attachment.

Conclusions

Through the consideration of motion design principles and concepts of place, the interdisciplinary pursuit of motion installations in and around built environments implies a revised set of affordances and challenges. Based on new contextual considerations, place may influence work through sensory and aesthetic experiences, scale and proximity, activity, audience, and intended architectural program, and narratives communicated both by the space itself and the motion integrated or applied. Underlying variables of audience, location, intent, method, and medium are explored to help motion designers identify relevant needs that affect the design process. From contemporary practices of motion installations in place, we identify four applied usages, commercial applications, outdoor artistic pursuits, information systems, and interactive data-visualizations. Through the combination of architectural structure and the fluid, technological advances in motion design, new immersive environments and narratives are at play, creating a renewed sense of place. These examples also provide insight on how academics and practitioners may find areas to expand on this discourse and dialogue. Finally, new methods for evaluation of these immersive environments should be considered as these practices are expanded on in global contexts and multi-faceted perspectives.

Cotter Christian, Assistant Professor of Interior Design, Parsons School of Design, The New School University

Catherine Normoyle, Assistant Professor of Graphic Design, School of Art & Design, East Carolina University

References

Bachelard, G. (1964). *The poetics of space.* (M. Jolas, Trans.). Boston, MA: Beacon Press. (Original work published 1958)

Bessoudo, M. (2016, June 26). LEED dynamic plaque: Providing a new direction for green building certification and benchmarking at scale. Retrieved from https://www.gresb.com/insights/2016/06/leed-dynamic-plaque-providing-a-new-direction-for-green-building-certification-and-benchmarking-at-scale/

Brown, D. S., Izenour, S., & Venturi, R. (1977). *Learning from Las Vegas*. Cambridge, MA: The MIT Press.

Business Wire. (2015, October 9). First-of-its-kind light-and-sound Installation created by ESI Design expresses Real-time Building and Environmental data from world's Greenest Skyscraper [press release]. Retrieved from http://www.businesswire.com/news/home/20151009005612/en/First-of-Its-Kind-Light-and-Sound-Installation-Created-ESI-Design-Expresses#.VhfnD3gii-J

Checkowski, M. (n.d.). 745 7th Avenue [personal portfolio]. Retrieved from http://checkowski.com/745-7th-avenue/

Emporis. (n.d.). Lehman Brothers building [catalog site]. Retrieved from https://www.emporis.com/buildings/100398/lehman-brothers-building-new-york-city-ny-usa

ESI Design. (n.d.). ESI design transforms Terrell Place in Washington, DC, with 1,700 square feet of motion-activated media displays [press release]. Retrieved from http://www.esidesign.com/press/7194

Gensler. (n.d.). The Tower at PNC Plaza. Retrieved from http://www.gensler.com/projects/the-tower-at-pnc-plaza

Heerwagen, J. (2008, May 23). Psychosocial value of space. Retrieved from https://www.wbdg.org/resources/psychspace_value.php

Imaginary Forces. (n.d.). 745 7th Avenue [project portfolio]. Retrieved from https://www.imaginaryforces.com/work/745-7th-avenue

Lynch, K. (1960). *The image of the city*. Cambridge, MA: The MIT Press.

Lynch, K. (1976.) *What time is this place*. Cambridge, MA: The MIT Press.

Morris, K. (2016, April 20). A new take on lobby art. *The Wall Street Journal*. Retrieved from http://www.wsj.com/articles/a-new-take-on-lobby-art-1461200071

PNC. (n.d.). The Tower at PNC Plaza live view [microsite]. Retrieved from http://www.pncbeacon.com/

Rockwell Group. (n.d.). 605 Third Avenue [project portfolio]. Retrieved from http://www.rockwellgroup.com/projects/605-third-avenue

Sime, J. D. (1986). Creating places or designing spaces. *Journal of Environmental Psychology, 6,* 49–63.

Times Square. (n.d.). Digital screens and billboards. Retrieved from http://www.timessquarenyc.org/advertising-sponsorships/digital-screens-billboards/index.aspx#.WF13W7YrIht

Tuan, Y. (1977). *Space and place: The perspective of experience*. Minneapolis, MN: University of Minnesota Press.

United States Green Building Council. (n.d.). LEED dynamic plaque. Retrieved from https://www.leedon.io/

Urbanscreen. (n.d.-a). Insight. Retrieved from http://www.urbanscreen.com/insight/

Urbanscreen. (n.d.-b). Facts. Retrieved from http://www.urbanscreen.com/facts/

Urbanscreen. (n.d.-c). Lighting the sails. Retrieved from http://www.urbanscreen.com/lightning-the-sails/

Urbanscreen. (n.d.-d). Kubus. Retrieved from http://www.urbanscreen.com/kubus-2/

Christina Lyons
Motion Design: Application and Impact on the Exhibition Experience— from Theory to Practice

Exhibition experiences have come a long way from that of static content directed to an anonymous public, to a place of visitor participation and dynamic experiences; where one has a personalized experience rather than a passive viewing of content. The modern visitor to a museum, science center, historical site, retail space, trade show, or the like, expects an *experience*.

Today, that experience is often participatory and collaborative at various levels, enabling personal interaction with content and other visitors. Concurrent with this shift in the landscape of exhibition and experience design, and perhaps its catalyst, is the incorporation of digital media and motion design in how content is both presented and experienced by visitors— extending its reach while personalizing it.

In contrast to the way the public was designed for in the past, motion design in digital media has transformed how exhibitions relay content and to whom. When employed successfully, digital media allows for a spectrum of visitor types with varied learning styles to comprehend complex data efficiently and give important cues for how to engage with the rest of the physical experience. It allows for multiple entry points while fostering participation in multifaceted activities that may have otherwise been static.

How this rapidly evolving tool is used to enhance visitors' emotional engagement, can perhaps be best understood by tracing motion design from academic analysis to practical applications. This chapter will explore various levels of motion design in exhibition and experience design and its impact on audience types, from ambient immersive digital media that simply and immediately conveys content cues, to large scale interactive walls that require body movements, to digital interactive stations in which one can drill down and discover layers of content.

Audience
In the industry, exhibition visitors are often classified as *Streakers, Strollers,* and *Studiers. Streakers*, move quickly through exhibition experiences. They are attracted to images, particularly moving ones, and require immediate content cues, while *Strollers* take their time and look for key elements that are of particular interest to them, and *Studiers* stay the longest and want learn as much as possible. An effective exhibition experience must account for all three types while seeing these audiences as individuals with unique needs.

The understanding of visitors' motivations and desires is crucial in crafting an experience with reach. Exhibition and experience designers, curators, and content specialists analyze extensive audience studies and user experience evaluations to strive for the most authentic and meaningful experience for each visitor. Conceiving and designing an exhibition experience is a complex process. The exhibition designers, curators, and content developers work to uncover and reveal stories through research and then interpret those stories in a way that can educate and evoke curiosity. The visitor experience is paramount and each element of an exhibition experience relies on the other. Everything is carefully choreographed—content is layered and designed within a hierarchical structure and all the parts are integral to the whole.

Analysis

Various types of digital media are used for specific purposes within the content hierarchy of an exhibition narrative and each can be employed to reach specific audience types. Analyzing the type of digital media alongside the exhibition storyline and audience type can be instrumental in achieving a meaningful visitor experience.

The following matrix (see Figure 1) is a process tool that can be used in both practice and the classroom that analyzes motion design types in an exhibition experience for an assessment of the amount, types, and purpose of digital media in an exhibition experience. This tool allows designers, curators, and content developers to have a glance at all the digital media pieces proposed in an experience and ensure that each is relevant and targeting a specific audience and learning style. It also allows the design team to review the flow and circulation, allowing for a variation of experiences throughout. This information, viewed together and contemplated, helps to ensure that a full spectrum of the audience is engaged, in effect creating a more powerful experience for each individual.

An exhibition digital media plan locates all the types of digital media in an experience, such as ambient media, films, animations, or digital interactive systems of all types. Pulling from the exhibition's digital media location plan and script or content outline, a matrix is created that connects the storyline with the media type, and the audience with a learning style to help ensure all visitors are captured. The matrix outlines motion design types within a particular exhibition experience and the three basic audience types (as mentioned above), alongside Howard Gardner's (2011) *Multiple Intelligences*, first published in 1983.

In addition to ensuring that a spectrum of audiences are captured in the experience, the location plan and matrix also can reveal a varied flow of media types for circulation, timing, interest level, and a sensitivity to sensory overload. The matrix is customized for each exhibition project by inputting the elements of the storyline—the Key and Supporting Concepts. This analysis simply allows for an alternate view of all digital media elements that are sometimes difficult to see while designing and writing. After this analysis, elements are shifted or altered to enhance the experience and determine the best solution to enhance and deliver content and convey the storyline.

STORYLINE*

Key Concept Area 1... | Supporting Concept 1a... | Supporting Concept 1b... | Key Concept Area 2... | Supporting Concept 2a... | Supporting Concept 2b... | Supporting Concept 2c... | Key Concept Area 3... | Supporting Concept 3a... | Supporting Concept 3b... | Supporting Concept 3c... | etc...

MOTION DESIGN TYPE*

Ambient
GOBO
Film
Digital Interactive (drill down, 1 person)
Digital Interactive (large scale, 2+ people)
Spacial Projection
Body Kinesthetic
Infographic
Real-time Data
etc...

EXHIBIT TYPE*

Individual Experience
Collaborative Experience
Visitor Feedback/Input
"Smart Badge" RFID
Contains Audio
Contains Tactile Elements
Contains Objects
etc...

AUDIENCE TYPE

Streaker ★
Stroller ●
Studier ■

LEARNING TYPE (Gardner)

Visual (spatial)
Verbal (linguistic)
Logical (mathematical)
Bodily (kinesthetic)
Interpersonal
Intrapersonal
Naturalistic
Existential

customize per exhibition experience
figure 1

Interpersonal
Intrapersonal
Naturalistic
Existential

customize per exhibition experience
figure 1

Howard Gardner's multiple intelligences is one example that can be used to categorize visitors beyond basic demographics, which was historically how many museums thought of their visitors. Grouping visvitors based on a unique set of learning styles, Gardner identifies nine capabilities and ways people may prefer to learn; as described by WNET Education (2004), these are:

1. Verbal-linguistic intelligence – well-developed verbal skills and sensitivity to the sounds, meanings, and rhythms of words

2. Logical-mathematical intelligence – ability to think conceptually and abstractly, and capacity to discern logical and numerical patterns

3. Musical Intelligence – ability to produce and appreciate rhythm, pitch, and [timbre]

4. Visual-spatial intelligence – capacity to think in images and pictures, to visualize accurately and abstractly

5. Bodily-kinesthetic intelligence – ability to control one's body movements and to handle objects skillfully

6. Interpersonal intelligence – capacity to detect and respond appropriately to the moods, motivations, and desires of others

7. Intrapersonal – capacity to be self-aware and in tune with inner feelings, values, beliefs, and thinking processes

8. Naturalist intelligence – ability to recognize and categorize plants, animals, and other objects in nature

9. Existential intelligence – sensitivity and capacity to tackle deep questions about human existence such as, the meaning of life, why do we die, and how did we get here.

By including Gardner's "intelligences" within the matrix, one is able to quickly categorize visitors' unique blend of capabilities and learning preferences. When looking at these preferences alongside the three main visitor types and types of motion design within digital media, one can achieve a view of the spectrum of visitors being captured and engaged in a proposed exhibition.

The matrix is customized per exhibition experience and can work for designers in varying degrees. The storyline and media types will all vary per exhibition, but also audience types can be customized based on the institution and content. This tool is a way to have a glance at the variety and needs for all digital media in an exhibition. Evaluation and prototyping throughout the design process are crucial steps and this tool can be used in conjunction to these important steps. Content developers, curators, and designers can and should go far beyond this matrix to analyze audience needs in a much deeper way. However, as it is married to the storyline, this matrix is a simple and helpful way for designers to confirm the need and relevance of each digital media element in an experience.

Application

The following three exhibitions explore the levels of motion design in exhibition experiences and their ability to reach in varying degrees the three main audience types, *streaker, stroller,* and *studier*—exposing the power of the medium to rapidly connect with and capture a variety of audience types and learning styles and allow for various levels of engagement.

Vertical Wilderness

Vertical Wilderness is an exhibition in the Haus der Berge visitor center in the German Bavarian Alps, at the entry to the Berchtesgaden National Park in southeast Bavaria. Haus der Berge, pictured in Figure 2, was conceived and designed by Atelier Brückner of Stuttgart, Germany and the motion design and digital media is by Tamschick Media+Space of Berlin. The title Vertical Wilderness represents the space between the Königssee (a lake) and the summit of the Watzmann (a mountain) in the Berchtesgaden National Park.

Figure 2
Exterior view of the Haus der Berge entry set against the Watzmann mountains.

Copyright ATELIER BRÜCKNER / Michael Jungblut. Reproduced with permission.

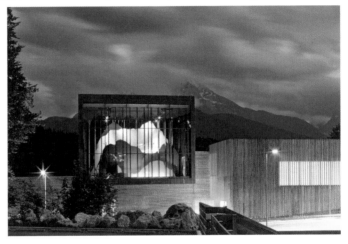

A broad audience of tourists and school groups of all ages are completely immersed in ambient projection mapping techniques used in a collage of changing light, moving image, and sound installations representing the changing four seasons. These techniques are particularly successful in capturing visitors that move quickly through exhibition experiences, perhaps only gleaning obvious content cues. Content is received immediately through immersive moving projections of spring, summer, autumn, and winter cast on die cut landscape shapes creating backdrops representing four alpine habitats of the National Park, giving each season a three-minute interval (see Figure 3). This dramatic focal point to the exhibition narrative is immediately engaging yet allows for lasting impressions for visitors as they experience the exhibition and the national park beyond the walls of the visitor center.

Charlotte Tamschick of Tamschick Media+Space describes the design team's concept and inspiration for the project narrative, "We were inspired by the dramaturgy of Richard Strauss' Alpine Symphony and integrated this as the general approach for designing the experiences of the different themes. We wanted to capture the influence of the four seasons on the flora and fauna of the Alps, and show the erratic power of nature. We filmed all seasons in

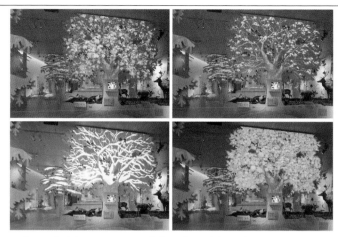

a variety of speeds (slow-motion and time-lapse) in order to create our very own visual Alpine Symphony." Charlotte continues, "Nature isn't static, it is constantly changing and that was the core idea behind all the media stations in the exhibition. Our goal was to create an exhibition that changed according to the four seasons using audio-visual tools to create this immersive experience" (personal communication, August 15, 2016).

Visitors of all types, especially the *Streakers*, are immediately captivated and engaged with the content through motion design within these immersive techniques. Atelier Brückner explains the experience, "This animation accompanied with the specific sound, works and fascinates with an appealing visual presentation of the natural processes. These can be realized very quickly and create a lasting impression" (personal communication, September 1, 2016). The moving projections are enhanced because of the rather stark and uniform color of the static exhibition structures, which are a neutral lightwood. All color in this area is a result of the motion graphics. This technique allows visitors to have an extremely focused immersion into the moving image, sound, and light collage. Forty-eight loudspeakers are distributed throughout the exhibition space, each playing unique sounds of nature that correspond with the season.

The design team's intent was to never replicate nature but to simply offer perspectives and compel visitors to become curious and explore not just the exhibition content but also the national park. The goal was to address and engage all the senses and offer diverse and unexpected approaches to nature, while never replicating that which is right outside. Atelier Brückner (personal communication Sept 1, 2016) explains,

> This exhibition at Haus der Berge does not pretend to be real nature but conveys natural processes in a sensitive way. As our slogan is "form follows content," our exhibitions are derived from the content and for the people. We arouse the visitor's curiosity by playing with the scenographic tools, implementing them in the appropriate, best-to-serve way. There are no tools used just for using it, but every tool is used to be an indispensable

part of the "Gesamtkunstwerk" (artwork). This is our aim in designing exhibitions.

While this focal point certainly engages a broad audience, the design team also carefully guides visitors through a choreographed hierarchy of both immersive content (Figure 4) and over thirty digital media stations which range from interactive touch screens (Figure 5) to documentary films. The variety and levels of digital media are designed to engage all audiences and various learning styles, from those who streak through the exhibition to those that want to examine and study the content.

Figure 4
Alluring projections animate the floors and ceilings.

Copyright ATELIER BRÜCKNER / Michael Jungblut. Reproduced with permission.

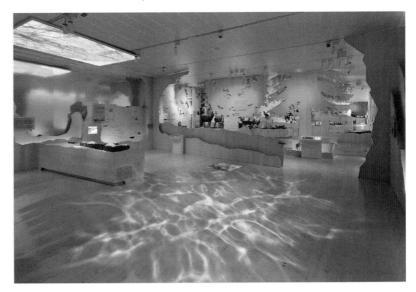

Figure 5
Visitors explore detailed content in the digital interactive stations throughout the experience.

Copyright ATELIER BRÜCKNER / Michael Jungblut. Reproduced with permission.

Visitors of all types can pace themselves and engage in both playful and scientific content for Logical-Mathematical, Visual-Spatial, and of course the Naturalist and even Existential learning styles. When deciding which type of digital media is more appropriate for a specific experience,

Charlotte Tamschick (personal communication, Aug 15, 2016) of Tamschick Media+Space states,

> The type of media was naturally strongly connected to the content. There were clear requirements for what type of content could be more playful and what other topics had to be handled on a more scientific level. For example, there's one station where visitors can interactively puzzle together the right kind of bird. There's another one where they discover microscopic details of minuscule creatures. We felt portraying the life of a mountain farmer was best told in a documentary format, which gave viewers the feeling of being close to the story.

The exhibition culminates with a captivating and immersive spatial projection installation. After a twelve-minute collage of moving imagery the projection screen literally opens up with glass windows to the real life panoramic view of the national park's famous Watzmann mountains. This innovation is most intriguing as it juxtaposes reality with a digital moving verisimilitude—blurring the line between the two and offering the audience a new way to see, engage and ultimately become emotionally invested in the subject (Figure 6).

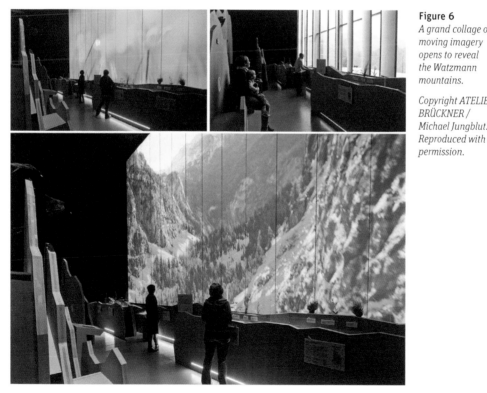

Figure 6
A grand collage of moving imagery opens to reveal the Watzmann mountains.

Copyright ATELIER BRÜCKNER / Michael Jungblut. Reproduced with permission.

Charlotte Tamschick (personal communication, Aug 15, 2016) of Tamschick Media+Space explains, "We wanted to show details you rarely see with the bare eye and focus on unexpected perspectives: like making visitors feel like an insect surrounded by tall blades of grass or twirl around a flower like a bee

or dive into the crystal clear mountain lake or experience a midnight storm on a mountain peak."

This animated display on a grand scale allows the audience to enjoy various points of view—a new way to view nature that ultimately evokes curiosity to wander the national park with a new perspective.

All three audience types and a variation of learning styles are carefully accounted for throughout this exhibition. This exhibition experience has a unique ability to actually capture the *Streaker* audience type by immersing them in ambient content and, through a carefully choreographed hierarchy of digital media, actually slow visitors down to transform them into *Strollers* and *Studiers*. This is a goal of most exhibitions however, can be difficult to achieve. The success of *Haus der Berge* lies in the simplicity and seamless levels of engagement.

Van Gogh Alive – The Experience

Spatial projection and large scale motion graphics are used as a way to powerfully place and immerse visitors while quickly orienting them within a exhibition narrative in *Van Gogh Alive – The Experience*, designed by Grande Exhibitions of Australia (Figure 7). The exhibition is designed to travel and is adaptable for any venue. Animation, image, and sound are employed to convey and enliven content for a broad range of visitors particularly the *Streakers*. Visitors are immediately immersed and engaged, but also given subtle opportunities to delve into content at their own pace.

Figure 7
A introductory collage of Van Gogh's most iconic pieces that is adaptable for any venue.

Copyright 2016 by Grand Exhibitions. Reproduced with permission.

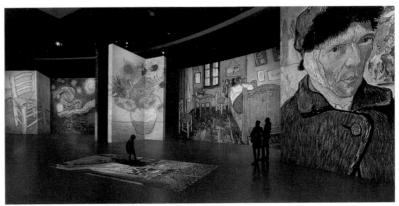

Over 3,000 images and motion graphics transform every surface—walls, columns, ceilings, and floors through forty high definition projectors. The motion graphics and animations are slow and meditative—they dictate the circulation throughout the space. Accompanied by a surround sound classical score, visitors can gain insight in to Vincent Van Gogh's thoughts, feelings, and state of mind as his works are projected at a grand scale and in vivid detail. The experience is interpersonal—visitors feel united with one another—and all can experience the changes in motion design, space, and content at the same time. Visitors are simultaneously given the opportunity to examine Van Gogh's technique, process, and use of color.

Grande Exhibitions (personal communication, August 19 2016) explains the experience, "From the moment you enter, a powerful and vibrant symphony of light, color and sound compels you to leave the world behind and immerse yourself in Van Gogh's paintings—an experience that is simultaneously enchanting, entertaining and educational. Van Gogh Alive—The Experience will stretch the definition of the word 'exhibition' as it stimulates the senses and opens the mind."

The digital media is choreographed in a way that allows for a very broad audience to immediately receive and comprehend content, but also allows for those who want to attain a deeper understanding of the artist's process, life, and time period. Visual-Spatial learning styles are accounted for, as the variation in scale and extreme close ups of Van Gogh's work allow visitors to have an almost microscopic view of his technique (Figure 8). Verbal-Linguistic and Logical-Mathematical styles are accounted for in the collages of maps, advertisements of the time, handwritten letters, and films interspersed throughout the digital collage. Visitors are immediately placed in time and given insight into the artist's life and thoughts (Figure 9).

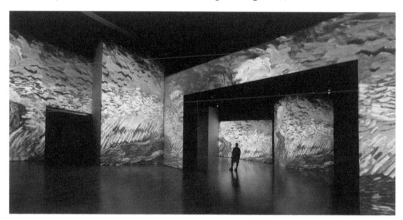

Figure 8
Extreme variation in scale and magnification allows visitors to become immersed in the artist's technique.

Copyright 2016 by Grand Exhibitions. Reproduced with permission.

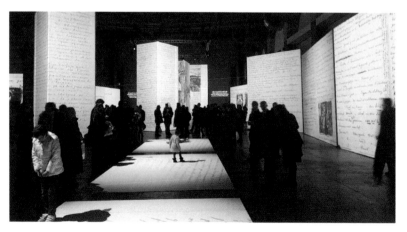

Figure 9
A collage of letters, notes, and sketches is choreographed to give insight into the artist's thoughts, process, and the time period.

Copyright 2016 by Grand Exhibitions. Reproduced with permission.

In conjunction with this fully immersive experience the images are repeated in an interpretive area providing comprehensive information about the art, life, and times of Van Gogh, with large-scale wall graphics of iconic Van

Gogh images and quotes. Here visitors, particularly the *Strollers* and *Studiers*, can find historical detail on the painter's life. Photographs and videos are displayed alongside his works that give insight into his sources of inspiration.

While *Van Gogh Alive—The Experience* certainly captures the *Streakers* as the primary audience—they are immediately captivated, almost viscerally, within the choreography of moving imagery, extreme variations in scale, and sound—visitors are also then given a clear hierarchy of content within the animations and in the interpretive area to satisfy those looking for more detail and context.

ARTLENS Gallery at the Cleveland Museum of Art

ARTLENS Gallery (formerly, Gallery One) is a 13,000 square foot orientation experience to the Cleveland Museum of Art's collection. In 2013, the design team for Gallery One was hired by the museum to rethink the way the museum engaged its visitors and to remove preexisting barriers for visitors who may feel a bit of intimidation or uncertainty when visiting a modern art museum.

The original exhibit design and planning for the Gallery One prototype was conceptualized by Gallagher & Associates and the digital media by Local Projects. The museum wanted to take steps to engage and inform a younger audience of museum visitors, greeting them with technology and a sense of play that is not typically seen in traditional art museums.

In 2017 the second and permanent iteration of Gallery One, called ARTLENS Gallery, opened and strived to allow for "barrier free" interactions with the art, by employing more gesture and motion sensing interactive engagements with the collection and transitioning away from traditional touch screen technology. The digital redesign included the collaboration of several digital media and motion design firms including Potion, Design I/O, Local Projects, and Dome Collective (Alexander, Wienke, & Tiongson, 2017).

This exhibition experience simultaneously caters to both a broad audience of first time visitors of all ages and the *Studiers* in particular. It is actually able to turn first time visitors into *Studiers* through innovative and playful digital media installations. Gallagher & Associates (personal communication October 3, 2016) explains how they looked to address this particular younger audience, "To address our specific audiences the decisions were driven by making the interactions somewhat more playful, and at times, even humorous. We wanted to reduce any perceived intimidation of the content at any point of visitor interaction."

Prior to the 2013 opening, the designers led the museum team through an intricate process to discover why residents were not attending the art museum with their families. The team conceived solutions to make the museum more accessible to residents and to bridge the generational gap. The goal was to create a space that redefines our typical interactions with a work of art by igniting curiosity and creativity through personalization and play. "By facilitating an experience that belonged to them, visitors are more comfortable navigating the museum's collections. Navigating on their own terms dispelled

the intimidation and discomfort that was often experienced in the past," explains Gallagher & Associates (personal communication October 3, 2016).

The experience allows for multiple types of visitors to create their own experience within the museum. Visitors can digitally create their own works of art. They can use their own bodies to digitally replicate the pose of a sculpture in the collection, and access the collection by making different facial gestures that are captured digitally. The initial decision to employ these interactive technologies in a traditional museum setting came through an extensive process over many months. Gallagher & Associates worked with the museum's education team to establish the interpretive mission and goals for the overarching visitor experience. Once these goals were audience-tested, the design team could then identify the appropriate interfaces to convey the content for a spectrum of visitor types.

Upon entry, the visitor is digitally immersed through a forty-foot animated "ArtLens wall" which shows 4,000 works of art in the museum's collection (Figure 10). With this wall, visitors are able to curate their own experience by making connections between the art pieces in the collection. The connections can be simple, such as medium or geographical region, to more untraditional themes such as Love and Lust, Circles, Melancholy, or Shades of Blue as ways to group and curate a collection of art. Once an image of a piece of art from the collection is selected, it is isolated on the wall and arranges itself near similarly themed objects. (Figure 11) The careful movements of elements on the wall are fluid and imply an endless supply of configurations. The visitor can identify an image as a favorite and obtain levels of information and detailed content in a clear and intuitive way. There are options to drill down into complicated content that could not be presented in traditional print. Visitors of all types can make discoveries and follow their own curiosity.

Figure 10
Overall view of the ARTLENS wall- representing the magnitude of the museum's collection.

Copyright Local Projects. Reproduced with permission.

Figure 11
Detail view of the ARTLENS wall.

Copyright Local Projects. Reproduced with permission.

The *Streakers* are immediately captivated and engaged in this grand welcoming experience that represents the breadth of the collection, while also sends the message that this is a personalized experience. The visitor has full control over their visit. Gallagher & Associates explains that the wall is "the perfect interface for engaging visitors in their own deeper connection to the content. It made their engagement in the museum more dynamic and much more personal."

Gallagher & Associates (personal communication October 3, 2016) explains, "The metadata for visitor interaction was comprised of the entire collection, held by the Museum. This would become the basis for all visitor interaction. The goal was to utilize the media to provide a fluid and unique interface for each visitor."

The experience also includes an iPad and mobile application called *ArtLens* that allows visitors to explore virtually endless content and even curate their own personalized visit or take a museum-curated tour. *ArtLens* also offers image recognition software. By holding the screen up to a piece of art, the piece is scanned and particular information is highlighted on screen. Much more information can be obtained here, certainly more then a wall label could hold. It also acts as a real-time navigation device for visitors to find their way within the museum. It is connected to the "ArtLens Wall" and will save favorite pieces from the collection. A visitor's favorites can be used to create a personalized tour or upload to social media. *ArtLens* is continually updated and provides a post-visit experience, in which visitors can access images and objects.

As a continuation of the design team's goal to engage a range of visitors, there is a space for children as young as three and families to play and explore while learning the fundamentals of art making—line, shape, pattern, texture, and shadow. Gallagher & Associates created a Community Advisory Committee comprised of professionals in Early Childhood Development from the Cleveland area who assisted in the development of the curriculum for this area. In an interactive called "Line and Shape," multiple children can draw with their fingers on a large interactive wall that rapidly scans works of art in the collection and places an image with a matching line or geometry underneath the line drawn by the child. Children can also review six works of art and an object or theme in the "Matching and Sorting" interactive system. Children tap on the artwork depicted that matches the requested theme. Multiple levels of difficulty allow for different skill levels and ages to participate in Studio Play.

Multiple stations, each with a unique interactive, allow visitors of various learning styles to engage with the collection. "It is always important to be sure the visitor interaction goals drive the technology," explains Gallagher & Associates. Many of the gesture-based interactive games are clearly geared toward Bodily-Kinesthetic style learning. In "Strike a Pose," visitors position themselves in front of a screen and imitate the pose of a sculpture in the collection. The motion capture system will detect with a percentage of how

accurately the visitor has achieved the pose, and they can then find out more about the piece of art.

In another called "Make a Face," Visual-Spatial and Bodily-Kinesthetic learning styles are accommodated with a webcam that records visitor facial expressions and matches them to facial expressions to a piece of art in the collection. The ArtLens "Pottery Wheel" uses depth-sensing technology to allow visitors to create a sculpture out of virtual clay. The virtual clay reacts and responds to the movements of the visitors' hands. In other gesture-based activities, visitors are able to digitally paint using different techniques used in abstract works of art from the collection, or to rearrange elements of a piece of art to gain a better understanding of the composition, or to zoom in to a painting to reveal great detail.

ArtLens is a successful example of employing motion design within a digital interactive system in a way that engages an entirely new audience for an institution. Since integrating such digital systems in 2013, individual attendance increased by 31% and the attendance of families increased by 29% (Alexander et al., 2017). The experience has the power to turn first time visitors and those typically not engaged in a traditional art museum into *Strollers* and *Studiers*. Through various levels of digital media interactions, a variety of learning styles are addressed—using personalized play to ignite curiosity to delve deeper into the collection and content.

Conclusion

Motion Design is continually evolving and transforming museums and interactive experiences by offering institutions, designers, curators, and visitors more flexibility, sophistication, and authenticity than ever before. The exhibitions referenced here are all examples of successfully choreographed motion design within digital media to engage multiple audiences and learning styles and enable visitors to connect with content on deeper levels then perhaps achievable before. After thoughtful analysis, the possibilities are endless and simply await the innovation of designers and students alike.

Christina Lyons, Assistant Professor and Chairperson,
FIT Graduate Exhibition & Experience Design.

References

Alexander, J., Wienke, L., & Tiongson, P. (2017, April). *Removing The Barriers Of Gallery One: A New Approach To Integrating Art, Interpretation, And Technology.* Paper presented at MW17: Museums and the Web 2017 Conference, Cleveland, Ohio. Retrieved from https://mw17.mwconf.org/paper/removing-the-barriers-of-gallery-one-a-new-approach-to-integrating-art-interpretation-and-technology/

Cleveland Museum of Art. (2017). *ArtLens* (Version 3.1.6) [Mobile application software]. Retrieved from https://itunes.apple.com/us/app/artlens/id580839935?mt=8

Gardner, H. (2011). *Frames of mind: The theory of multiple intelligences.* New York: Basic Books. (Originally published in 1983)

WNET Education. (2004). Concept to classroom. Workshop: Tapping into multiple intelligences. Retrieved from http://www.thirteen.org/edonline/concept2class/mi/

Section 5

Experimental Visualizations
& New Applications

"The simultaneity of past and future is never experienced as fixed, but always in flux."

Steven Hoskins

Fragmented Motion: Split-Screen and Asynchronous Video

I have spent most of my life as a graphic designer, and the past thirteen years as a graphic design educator who teaches and practices in video and motion. The majority of my research is an extension of split-screen. As a video or cinematographic device, split-screen is the division of the kinetic compositional frame into multiple images, shattering the illusion presented by a single frame as a seamless view of reality. Since the early twentieth century, filmmakers and videographers have used split-screen as a multi-narrative effect to imply simultaneity between shots, or imply a simultaneous montage of events, and simultaneous points of view. My experimental use of split-screen suggests the potential of the combinatory visual effect of fracturing split, duplicated and overtly asynchronous imagery.

In my work, I have reconstituted component parts of motion into complex emergent patterns. Time is skewed through a collective composition of split-screens patterned across the compositional frame. At times these are merely a handful of simple divisions, vertically or horizontally, often progressing to hundreds of individual split-screens. Often offset by only tenths of a second these segments reveal camera motions, object motions, or a combination coalescing into new emergent patterns

I reflect on the development of split-screen as a multi-narrative device, especially in regards to its history, and the presumption that action intended to be "in the moment" is simultaneous action. While not an exhaustive survey of its history in cinema, nor its contemporary influence in popular television, I do point out how simultaneity in split-screen originated, and how it began to shift out of synchronization. Asynchronous simultaneity—mixing the moment with the past and future—is fundamental to understanding my work.

Early History of Split-Screen and Simultaneity

The development of split-screen is closely tied both to the potential and the constraints of motion picture technology. In his 1927 epic silent film *Napoleon*, French director Abel Gance used three interlocked cameras to record what would later be presented with three projectors for the film's climax. Later termed "polyvision," this effectively composed a wide-screen triptych vista, foreshadowing the multi-projector process of Cinerama in the 1950s (Brownlow, 1983).

Figure 1
Three-screen climax from Napoleon.

Source: Gance, 1927. Copyright Ciné France.

Gance's interlocked cameras easily predicted the resulting synchronized simultaneity of the action. This is despite the fact Gance's final edit included different shots to avoid the problem with projected seams. The physical delay of a moving object into and across each screen, combined with the displacement of the cameras would lead to the viewer to experience the shift as subtly asynchronous. As in the example in Figure 1, a horse galloping in and out one screen would do so slightly differently in the next. However, the misalignment of multiple perspectives would likely have not have been regarded as a reality-bending effect by an audience still new to the language of motion pictures.

Even before *Napoleon*, segmentation of the compositional frame was deployed to represent a mental model for simultaneity of completely separate scenes. Often, this was conventionalized as a telephone conversation among two or more people. In Lois Weber's 1913 film, *Suspense*, the audience was introduced to a physical boundary, not resulting from projector seams, but within the screen itself.

As a single film technique, split-screen originally referred to the special effect of compositing actors and objects together, through multiple film exposure. In Weber's work, this included ample separation between segments to insure repeated exposures would not overlap, as in Figure 2. While the term would also be applied to superimposed shots—where actors and objects appeared to occupy the same physical space with no apparent seams—it is in examples like *Suspense* that split-screen became synonymous with overtly separating shots into shapes. In these early examples of split-screen, whether overtly bounded or not, the narrative reading of these shots as occurring simultaneously is unquestionable.

Figure 2
Split-screen from Suspense.

Source: Weber, 1913. Public Domain.

By the 1950s and 1960s, cinema embraced this physical boundary, often dividing the screen in half, to present two or more shots. Simultaneity was often understood, and necessary, for the narrative to unfold. Among the influential uses of weaving a telephone conversation across split-screens are Stanley Donen's *Indiscreet*, and Michael Gordon's feature film the following year, *Pillow Talk*, both from the late 1950s.

In *Indiscrete*, Donen avoided film censorship norms by editing Cary Grant and Ingrid Bergman to converse together while suggestively appearing to share a bed. In Gordon's romantic comedy an identical side-by-side split-screen was formally key to connoting the emerging romantic theme between the characters, played by Rock Hudson and Doris Day in Figure 3. The actors play footsy from their respective bathtubs while the conversation leads to an evening date. The dialog is easily understood to be concurrent. But it is the implied eroticism of feet meeting in the center, of characters taking a bath together, that could not be achieved without the use of split screen.

There were other notable uses of split-screen to expand this convention. The mental ideal of simultaneity became less pivotal, but not completely disregarded as the underlying reality. Some of these employed the ensemble of multi-projector experiences, others as fractured segments of the compositional frame. Occasionally this was used to present a simultaneous montage of shots, other times multiple points of view of the same, or nearly the same, action.

John Frankenheimer's *Grand Prix*, 1966, used coordinated and simple divisions of the screen to mix different points of view of the same action (such as gears shifting and engine detail combined with expositions of the racing). Frankenheimer also included deliberately compartmentalized segments understood to be out of time—much like a voice over that isn't part of the race, but reflective of it. Simultaneity is intentionally broken for the narrative effect.

Two years later, in the 1968 version of *The Thomas Crown Affair*, director Norman Jewison depicted a game of polo simultaneously from many more points of view and considerably more segmentations. Like Figure 4, the compositional frame is divided into 6 or more divisions and of varying dimensions showing riders with crops, motion-blurred and chaotic movement, and spectators observing.

Both films also use lock-step splitting and repeating of the single shot, as seen in Figures 5 and 6. This is very much a stylistic look—a kind of synchronized swimming effect where the audience's attention is diverted away from the specific motion, in favor of a gestalt of the movement as a whole. The result is a considerably different narrative intent than a montage of multiple points of view where the focus is on the differences of the screens rather than the sameness, or even the similarities.

The reproduction of the same shot multiplied and repeated created a curious new symbolism in cinema. It also became quickly overused. But for a brief time, it appears to be an extension of replicated and repeated mass culture iconography found in Pop Art, and at least suggestive of mirrored kaleidoscope motifs found in Psychedelic Art that same decade.

Figure 4
Split-screen from
The Thomas
Crown Affair.

Source: Jewison,
1968. Copyright
The Mirisch
Corporation.

Figure 5
Split-screen from
Grand Prix.

Source: Franken-
heimer, 1966.
Copyright Warner
Bros.

Figure 6
Split-screen from
The Thomas
Crown Affair.

Source: Jewison,
1968. Copyright
The Mirisch
Corporation.

Several particularly influential films in split-screen history were released just prior to these two feature films and reflected the sophisticated understanding of this effect as it became more ubiquitous. The 1964 New York World's Fair featured Charles and Ray Eames' 22 screen installation, *Think*, for the IBM pavilion, and Francis Thompson's three projector film, *To Be Alive*, for the Johnson Wax Pavilion. Both installations influenced Frankenheimer prior to *Grand Prix*, and legendary Canadian director Christopher Chapman, who would show his own highly influential three-screen short film, *A Place to Stand*, at Expo 67 in Montreal (Keating, 2014).

Also appearing at Expo 67 was the notable five-screen film, *In the Labyrinth*, directed by Roman Kroitor, Colin Low and Hugh O'Connor. In several scenes, *In the Labyrinth* deployed a technique reminiscent of the 3 interlocked cameras used by Abel Gance. Projected onto its enormous cross-shaped surface these scenes created a similar shift of perspective, as in the example in Figure 8.

This created an asynchronous-like delay for an object in motion moving from one screen to another. The reading of this film and its technological interpretation of the fragmented imagery across 5 enormous screens provided an immersive and spiritual encounter with a transient reality. The mosaic of moments, not altogether in perfect synchronization, created an ethereal intersection between time and place within its imagery.

Figure 7, 8
Five-screen projection from In the Labyrinth, *1967.*

Source: Kroitor, Low & O'Connor, 1967. Copyright National Film Board of Canada.

Asynchronous Simultaneity

Asynchronous split-screen focuses on this ethereal intersection between time and place. The mosaic of moments converges on a kinetic gesture because the experience of absolute time is suspended. The audience can see and recognize the *flow* of time through a portal into the immediate before and after any moment. They exist in a kind of rolling limbo to focus on the motion itself.

While sharing similarities to many of *In the Labyrinth's* multi-projector effects, my research focuses overtly on asynchrony to visualize elaborate relationships between segments within the compositional frame: between the part and the whole. This is not a whole built from simply replicated and repeated shots. It is a whole built by emergent kinetic relationships *across segmentations*: relationships that can only be created through asynchrony.

All of my work uses tightly structured frame proportions. The boundaries between segments vary from subtle to sharp—depending on the velocity of the subject, or the camera, or both. This is particularly true if the segments sub-divide a single image. This is the case in some of my work (as seen in Figures 9, 10, and 11).

In these moments, there is an offset of the time code across a handful, or even dozens, of individual segments, ordered in a direction from one corner to another, or from one side to another. The velocity of an object in motion and the camera's in relationship to an object creates the subtle or rapid motion over the entirety of a composition. This is perceived as a kind of rolling existential moment. Motion is captured in undulating pieces. Time is liquid. The moment is in question.

This is often the simplest of gestures. A flag is slowly seen to slip into a grid of asynchronous parts. A conspicuously large close up of an eye opens, closes, and opens again to reveal fragmented pieces. Sometimes panning camera movements on an otherwise static object provide the movement.

Figure 10
Emergent kinetic relationships form across segmentations from Connecting.

Copyright 2009 by Steven Hoskins.

Figure 11
Subtle boundaries between segments of a single shot using 100 split-screens from Tether.

Copyright 2008 by Steven Hoskins.

Figure 12
Early experiment in asynchronous video with camera panning on a static subject from Miniatures.

Copyright 2004 by Steven Hoskins.

Occasionally these may be, or become, separate framed shots. Flags transition progressively to smaller divisions. An eye transitions into an increasing number, staring back at the viewer. The distinct shots are the same, or consist of a set of the same shots, but are not synchronized. Similar to the subtle shifts in perspective of Abel Gance's interlocked cameras, the source timecode is shifted from 1/30th to half of a second. As in those polyvision projected films, the same subject in motion is delayed from one segment to another. See Figures 13 and 14.

Figure 13
Transitioning from a single to separate framed shots in Flag Waving 1.

Copyright 2008 by Steven Hoskins.

Figure 14
Transitioning from a single to separate framed shots in Eye Pieces Number 1.

Copyright 2012 by Steven Hoskins.

Flag waving

In 2003, I began my *Flag Waving* series specifically to work out the complexity of matting split-screens together in a digital video. Early in that process I accidentally "bumped" the time code of one segment and immediately recognized that the turbulent forms of flags became intensified, but in a choreographed and deliberate manner.

By the time I finished *Flag Waving 1* in 2008, it contained many of the asynchronous outcomes I would return to work on in later years. The subject is the American tradition of hierarchical flag placement below the national flag—in this case, the state flag of New Mexico. When shot from below, the lower flag appears "in front." As the wind rises and falls, this cropped close-up becomes an undulating dance between the two flags: cavorting together at times, calming in unison, and then suddenly straining to pull away—each flag jockeys for attention.

Flag Waving 1 uses a very basic formal structure progressing from a single to eventually 256 screens mid-way through. After an initial division from the single screen into two, and then two into four split-screens; the video evolves using subdivisions of four. Four screens become 16, 16 screens become 64, 64 become 256.

Timed to the rhythmic swooping of the flags across the compositional frame, the first transition into two split-screens happens subtly, and entirely by subdividing the full image in two. By slowing the timing of the right half, it slips immediately and progressively out of synchronization with the left.

Using the rhythmic swooping again, discreet screens appear replacing the larger image. By 16 split-screens each vertical column is replaced with a loop of unique but asynchronous shots, spreading upward and outward from an unseen pole in the center.

This cycle then repeats like living cells dividing: each screen slips again into further subdivisions of smaller discrete screens. The chaotic and irregular movements ultimately converge in both individual columns and across columns. A key moment occurs when all columns share the same video loop divided into 256 split-screens. The system of motion now moves together. 15 seconds of time passes concurrently across the compositional frame from one corner to the other. 256 waving flags merge into one wave. A whole—a new waving flag—emerges with its own undulating ripples and folds.

By shifting time across two, or even hundreds of split-screens, not only is the window of past and future preserved, but the movement becomes self-choreographed. Undulating waves—both soft and sharp movements—flow through the compositional frame. It's the same visceral reaction to flocks of birds or schools of fish forming fluid but well-defined patterns—the group becomes an organism. These small multiples, based on a simple set of rules, coalesce into sophisticated motion.

Figure 15, 16
Sub-divisions of 4 progressing to 256 split-screens from Flag Waving 1.

Copyright 2008 by Steven Hoskins.

Figure 17
Flags coalescing into highly sophisticated motion from Flag Waving 1.

Copyright 2008 by Steven Hoskins.

Flag Waving 3 uses the same multi-column patterned movement, but with only 25 split-screens and a single video source. By cropping the original source 25 different ways, no screen is an identical copy. The 25 segments are skewed by both cropping and synchronization. This becomes more complex through a tilt-like camera movement by sliding the crop down over time to reveal more of the flag detail. The highly graphic forms of the Qatari national flag provide additional dynamism to the motion.

Like a dancer's pirouette, the flag turns and whirls in circles. The final part of the video amplifies this dance by using a nearly synchronized and similarly cropped set of videos across 5 horizontal rows. Part stylistic homage to the lock-step splitting and repeating of the 1960s, the degree of asynchrony is subtle, yet absolutely crucial. The middle horizontal row takes "lead."

Figure 18
Segments skewed by both cropping and synchronization from Flag Waving 3.

Copyright 2008 by Steven Hoskins.

15 years

In 2009 I created a reverse aging video based on images by California artist and illustrator, Dan Hanna. In the early 1990s, Hanna began an ambitious and highly structured photographic sequence of daily self-portraits. He constructed a circular apparatus to position two film cameras to record paired images simultaneously. Inspired by the circular nature of seasons, his own impressive stop-motion experiments marked daily orientation changes mapped to the position of the earth's rotation around the sun. Hanna's duel camera provided two simultaneous points of view of his self-portraits.

In 2008 he allowed me to use his collection of over six thousand paired images. After months of cropping and processing each image, I recomposed a sequence into 15 years of continuous stop-frame motion, from 2008 back to 1993. I divided these into split-screen vertical segments to amplify the horizontal flow of time from older to younger. The result was a traditional left and right split-screen but further segmented each into 16 vertical slices.

At any one moment during the first 3 minutes of the video, a window of 16 days is viewed. Past and future are presented simultaneously, rolling through a reverse direction of time. The reading of this video creates a dialectic between regressive and progressive physical changes in appearance—e.g. gradually less saggy skin, gradually more hair. Reversing this flow at the end, the video "rewinds" to the future. The sense of the present moment, the past and future, slip across the screen. Time is a moving window.

Figure 19
Time is a moving window in 15 Years, *with images by Dan Hanna*

Copyright 2008 by Steven Hoskins.

Vertical water and slipstream

This slippage of time is most pronounced in both *Vertical Water* and *Slipstream*, from 2009 and 2011 respectively. Like much of my work from 2008–2012, both movies predominantly use two adjacent split-screens frames on the left and right. To accomplish this, a vertically oriented source video is angled 90 degrees, allowing the areas closest to the earth's horizon to either meet at the center or oppose each other on outside edges. The center is intentionally blended to suggest seamlessness, even though the two shots are asynchronously mirrored and in opposite timing. One side moves in real-time, the other in reverse.

In its long duration opening, *Vertical Water* also uses 14 horizontal split-screens. Ribbons of a reflective ocean surface are interwoven in a highly abstract matrix. These rows slowly drift into synchronization, and then out again, transforming into progressively more distanced shots of rhythmic vertical waves receding and advancing. Each shot in the 9 minutes of the video reveals an increasingly indeterminate world of top and bottom, before and after.

Figure 20
Time drifts into synchronization from Vertical Water.

Copyright 2009 by Steven Hoskins.

Figure 21
An indeterminate world of top and bottom, before and after, from Vertical Water.

Copyright 2009 by Steven Hoskins.

Slipstream is a motion study of high-speed cloud formations that fluidly weave together into ethereal skyscapes. In addition to the two principle split-screens, it uses 15 horizontal rows and 40 vertical columns alternating from shot to shot. In a couple of moments, transitions between shots are tightly interwoven across all rows and columns, creating a matrix of 600 split-screens.

Unlike *Vertical Water*, the segments are offset by as little as a 1/15th of a second. The opening and ending use a single, full-frame source and appears to move more slowly into eventual segmentation. The result is a look similar to a feedback trail or visual echo popular in the 1960s broadcast video—sometimes called a "howlround" effect. However, for much of the video, this slight offset is applied to faster moving formations.

Applied from either the center outward or from the bottom to the top, the natural perspective distortion of the clouds is intensified. This, in turn, changes the apparent speed in various portions of the video.

In part due to the strangeness of the altered horizons, and in part to the push and pull momentum of its subjects, both *Vertical Water's* and *Slipstream's* split-screens are more tightly interwoven into the reading of time as a slippage. Directional movement between foreground to background is often very vague.

Figure 22, 23
Real-time and reverse high-speed clouds in split-screen from Slipstream *(left).*

Copyright 2009 by Steven Hoskins.

600 split-screen transition, and a howlround-like effect from Slipstream *(right).*

Copyright 2011 by Steven Hoskins.

To Be in the Moment

What is intentionally vague in all my work is the experience of what it means to "be in the moment." In single-channel kinetic imagery, media unfolds in a linear sequence where the present moment is never in doubt. In traditional split-screen, the present is either tied closely to the narrative structure, formally or casually implied, or overtly broken.

The mental processing of any split-screen is akin to multitasking: the ability to attend to more than one moment at the same time. Early uses of the effect often wove its application into a linear narrative that might have been handled easily with common editing techniques such as cross-cutting or parallel editing.

When presented in the same compositional frame as two or more segments, the audience gains a disembodied, holistic view of the action, switching focus from one point to another. As more segments are introduced, focusing is more difficult, especially as lines of action contrast rather than integrate or at least complement each other.

I have observed asynchrony of the same or similar action, by definition, maps closely the lines of action across the segments. It might not matter how separate the time code is across segments. Chaos inherently becomes organized. Structure emerges. Time is not concurrent but recognized as a flow. The simultaneity of past and future is never experienced as fixed, but always in flux.

From its earliest conception, split-screen embraced narrative that is dynamically and endlessly self-referential. That, at least, is the potential. Whether played out as simultaneous events in a storyline or fracturing closely timed moments, the result is—and the focus is upon—the joinery that brings them back together.

I believe there is an undeniable visceral attraction to split-screen in any form—in 2 or 3 dimensions, in kinetic or static imagery. This is much more than its distinction apart from a pervasively single-channel culture. As creatures who rely fundamentally, perhaps instinctively, on pattern recognition within the environment, this attraction is not at all surprising. Control of that patterning creates a new conceptual space to define sequential and non-sequential narratives. Such a definition will distinguish narrative as operating on a holistic and elemental level simultaneously—applicable to any circumstance where particulate parts reassemble for a richer sense of both part and whole.

Steven Hoskins, Associate Professor, Virginia Commonwealth University

References
Brownlow, K. (1983). *Napoleon: Abel Gance's Classic Film*. New York: Alfred A. Knopf.

Frankenheimer, J. (Director). (1966). *Grand Prix* [Motion picture]. Metro-Goldwyn-Mayer.

Gance, A. (Director). (1927). *Napoleon* [Motion picture]. Ciné France.

Gordon, M. (Director). (1959). *Pillow Talk* [Motion picture]. Universal International Pictures.

Jewison, N. (Director). (1968). *The Thomas Crown Affair*. The Mirisch Corporation.

Keating, P. (2014) *Cinematography*. New Brunswick, New Jersey: Rutgers University Press.

Kroitor, R., Low, C., & O'Connor, H. (Directors) (1967). *In the Labyrinth*. National Film Board of Canada.

Weber, L.(Director). (1913). *Suspense* [Motion picture]. Rex Motion Picture Company.

Author's works cited are Copyright 2004–2015 by Steven Hoskins, and available at vimeo.com/asynchony.

A conversation with
Isabel Meirelles, author of Design for Information

Isabel Meirelles is a designer and educator whose intellectual curiosity lies in the relationships between visual thinking and visual representation. She is a Professor in the Faculty of Design at OCAD University in Toronto, Canada. Her professional experience includes architecture, art, and communication design.

Isabel is the author of Design for Information: An introduction to the histories, theories, and best practices behind effective information visualizations. *Her research focuses on the theoretical and experimental examination of the fundamentals underlying how information is structured, represented, and communicated in different media.*

On discovering the potential of information design and motion design

My career in graphic design started in São Paulo, Brazil as an editorial designer. With the popularity of the Web in the late 90s, I became fascinated by the potential for incorporating time and interactivity in the communication of information. This prompted me to go back to school and pursue a Master's degree at the Dynamic Media Institute at Massachusetts College of Art and Design in Boston. At the time, I found very few books discussing theories or practices of motion and interaction. My Master's thesis, Dynamic Visual Formation: Theory and Practice, examined the creative process of image making in computational media, and proposed a theory of dynamic visual language (see *Visible Language Journal, 39.2:* Dynamic Visual Formation, pp. 100–120).

I see four opportunities for using motion in information design and visualization: in storytelling videos/animations, in animated interactive visualizations, as transitions, as encoding. I will briefly explain them, and provide a couple of recent examples, mainly from journalism.

Storytelling videos/animations

We are experiencing a resurgence of videos online, what is normally categorized as multimedia. The trend includes a large number of videos and podcasts produced by major news organizations that are both engaging and informative. The recent popularity of videos might be related to the increasing number of people accessing the news in mobile devices. In general, the videos are short (2–4 minutes long) and present material that allows viewers to watch on the go. Take for example, the long-standing British weekly news magazine (published since 1843), The Economist, which now has an YouTube channel (youtube.com/EconomistMagazine) offering video graphics explaining current news as well as complex statistical information. On the other end of the

spectrum are young organizations, such as Vox.com (launched in 2014) that produces a large number of multimedia, including interesting data storytelling videos (youtube.com/voxdotcom).

Figure 1
An animated video graphic produced by The Economist describing rising obesity rates in different regions of the world.

Source: Economist Films, 2018.

I would like to exemplify with a noteworthy visual story by *The New York Times*, the award winning video "One Race, Every Medalist Ever" by Kevin Quealy and Graham Roberts. It examines the history of the men's 100-meter sprint Olympic medalists for the occasion of Usain Bolt's Olympic record in 2012. The video has a well defined structure with beginning, middle, end. It uses several strategies commonly found in films, such as changes of camera angles, which enables different perspectives and comparisons of the statistics under discussion. Both the visuals and the audio narration provide context to the numbers, while also humanizing the data, in this case the sprinters. My favorite part is the effective use of sound to convey a quantity, more specifically the amount of time that separates recent athletes from the fastests humans in the 19th-century.

Figure 2
Motion design is used to tell the story of Usain Bolt's 100 meter Olympic victory as compared to other Olympic sprinters over time.

Source: Quealy & Roberts, 2012.

Animated interactive visualizations

There are different types of what I am calling animated interactive visualizations, from interactive videos that play like a normal video that stops and invites viewers to interact with the content, to interactive visualizations that use time as the main structure for their presentation. An example of the former is the "Giant Slalom" story by Mike Bostock, Alexandra Garcia, Joe Ward and Georges Knowles (2014) at *The New York Times*. The visual story invites viewers to immerse themselves in the movie while also encouraging interaction

with the content. It functions more like a scrolling website than a constrained video format. Sports have provided many opportunities to generate and showcase animated interactive visualizations and reveal interesting statistics. In this case, the story presents the unique style of skiing that Ted Ligety had perfected for many years intercalated with detailed visual explanations and commentary, including those by Ligety.

Figure 3
Ted Ligety's unique style is shown through augmented video which graphically displays the angles he achieves at mid-turn during a slalom run.

Source: Bostock, Garcia, Ward & Knowles, 2014.

Sound is an important component in these types of presentations. The narrator usually provides context to the story while orienting the viewer to key places highlighted in the visualization. The latter sometimes is comparable to the annotation layer in static and visualizations, in that the narrator acts more like a commentator who directs the viewer's attention to key values in the graph, and succinctly summarizes findings in the data analysis.

The presentations of the Swedish statistician Hans Rosling are good examples of the narrator's role as a commentator, facilitating our understanding of changing values in animated visualizations. In his well-known first TED talk in 2006, Rosling grabbed people's attention by presenting statistics about the wealth and health of countries around the world as an animated scatter plot displaying trends over time. The visualization was created with his custom-made software, Gapminder Trendalyzer, that converts statistics into time-based and interactive graphics. But it was Rosling's passionate presentation that made it into a remarkable experience, a combination of a narrator with a sports commentator. Celebrating his accomplishments early in 2017, when he passed away, many referred to Rosling as the "man in whose hands data sang."

Figure 4
Hans Rosling's dynamic presentation of global trends in health and economics at the 2006 TED conference.

Source: Rosling, 2006.

I am certain we will see in the near future good examples of Virtual Reality (VR) and Augmented Reality (AR) visualizations that use both motion and interaction to depict and communicate complex information, but I will leave those for another conversation.

Motion as transition

Besides using motion to present events that unfold over time, motion is also effective as transition between scenes. This is also the case with transitions in visualizations, including statistical graphs that are triggered by interaction. The value resides not only in keeping the levels of engagement with the material, but mostly in preserving continuity, facilitating object constancy for changing parameters, as well as directing the viewer's attention to points of interest. This mostly happens as the initial and end states are static (still images), while only the transition carries motion. I will give a couple of examples of interactive visualizations that use time-based transitions in their presentation flow.

Similar to clicking on a button to move to the next step in a story, scrolling down a web page has been used in recent times to trigger actions that might result in moving images and text, playing an animation, displaying a new state in the visualization, among other features. Although the technique is somewhat controversial, it has gained popularity and even the nickname of scrollytelling. There are various types that we currently see in the news. The Pudding, which publishes visual essays to explain ideas debated in culture (pudding.cool), have experimented with various types of scrollytelling techniques. A recent example is "The Language of Hip-Hop" that explains how they examined the lyrical similarity among Hip-Hop artists by looking at 26 million words from the lyrics of the top 500 charting artists on Billboard's Rap Chart (about 50,000 songs). Scrolling down the page triggers time-based transitions of elements in the visualizations, such as changes in scale, position, area of focus, and so on.

I will give two other interesting examples published in 2015. First, the investigative data story by *The Guardian*, "Homan Square, A portrait of Chicago's detainees," that uses scrolling to trigger a set of visualizations depicting the subject, from the big picture to individual stories that are each introduced with smooth transitions.

Figure 5
Stimulating transitions guide viewers from one content area to the next.

Source: Ackerman, Stafford, & The Guardian US Interactive Team, 2015.

And second, "Greenland is Melting Away," a story published by the *The New York Times* (Davenport, Haner, Buchanan, & Watkins, 2015). The time-based transitions are anchored on a square as a frame of reference to depict macro/micro geographic views that is reminiscent of the famous Eames movie, *Powers of Ten*. The time-based transitions facilitate perception of changes mainly because the context remains the same.

Motion as encoding

Finally, I would like to discuss the use of motion to encode data. Most of the time, we see static visual variables encoding data, such as color or scale, but

there are opportunities for encoding data using motion that can be effective and intuitive. *The Wind Map* by Fernanda Viégas and Martin Wattenberg from 2012 is an excellent example (hint.fm/wind/). The animated map displays wind patterns across the United States using data from the National Digital Forecast Database that is revised hourly. Motion encodes the wind flows and present them as dense particle trails of varying weights, where faster air is represented by thicker and whiter trails.

Figure 6
The Wind Map shows the ever-changing direction and speed of wind across the United States.

Source: Viégas and Wattenberg, n.d.

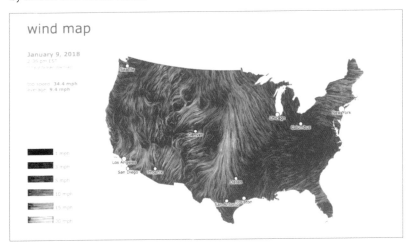

I hope this gives a brief introduction to the potentials of motion in information design and visualization recent practices.

References
Ackerman, S., Stafford, Z. & The Guardian US Interactive Team. (2015). Homan square: A portrait of Chicago's detainees [Interactive webpage]. *The Guardian.* Retrieved from https://www.theguardian.com/us-news/ng-interactive/2015/oct/19/homan-square-chicago-police-detainees

Bostock, M., Garcia, A., Ward, J., & Knowles, G. (2014). Giant slalom [Interactive webpage]. *The New York Times.* Retrieved from http://www.nytimes.com/newsgraphics/2014/sochi-olympics/giant-slalom.html

Davenport, C., Haner, J., Buchanan, L., & Watkins, D. (2015). Greeland is melting away. *The New York Times* [online]. Retrieved from https://www.nytimes.com/interactive/2015/10/27/world/greenland-is-melting-away.html

Economist Films. (2018). *The global obesity crisis* [Video]. Retrieved from https://films.economist.com/daily-watch

Quealy, K. & Roberts, G. (2012). One race, every medalist ever. [Interactive webpage]. *The New York Times.* Retrieved from http://www.nytimes.com/interactive/2012/08/05/sports/olympics/the-100-meter-dash-one-race-every-medalist-ever.html

Rosling, H. (2006). The best stats you've ever seen [TED Talk Video]. *TED.* Retrieved from https://www.ted.com/talks/hans_rosling_shows_the_best_stats_you_ve_ever_seen?language=en

Viégas, F. & Wattenberg, M. (n.d.). *Wind map* [Website]. Retrieved from http://hint.fm/wind/

A conversation with
Matt Pasternack, *InfoMotion*

Matt's work is centered on storytelling through the use of motion design. Now Director of Product Management at Wiretap, he is the former Design Director at InfoMotion, the developers of the 94Fifty Smart Sensor Basketball. This product was the first of its kind to utilizing embedded motion sensors to measure a basketball player's skill in real time.

Tell us a bit about 94Fifty?

94Fifty is a basketball with an embedded smart sensor that monitors and assesses your basketball mechanics. The data collected by the sensor is visualized through a mobile or tablet app, giving the user real time feedback on their shot and dribbling accuracy, shot trajectory, and speed.

So the primary focus of the company is to capture motion and translate it into visual information that is helpful to athletes.

So you're able to record and analyze the physical motion of an athlete when they're shooting or kicking a ball, or doing aerobic exercise like jumping rope?

Yes, but the challenging part is communicating the story. Especially since not many people have ever heard of InfoMotion or what the product is capable of doing.

So how did you overcome this challenge?

We had to create a series of motion graphic narratives that would show people how the product worked, but more importantly the experience it would enable.

Figure 1
The 94Fifty interface displays real time feedback on a player's shooting and dribbling accuracy.

Figure 2
94Fifty's mobile app interface is superimposed on a video so the viewer can see what the athlete is experiencing.

One pain point was communicating that there are sensors inside the ball that connect to an app. Our ball looks exactly like any other basketball you would see in Dick's Sporting Goods. So, communicating that the 94Fifty ball is different was something we were able to do through motion design and storytelling. It was a way to communicate a really high tech product in a simple and effective format. We could show someone using the ball and then show the visualization of the data on the app in a concise way.

And because the ball is part of a larger product eco-system which includes an Android and iOS app and Google Glass, we realized that the story of how all these parts are connected was extremely important. In one of the videos we produced, we superimposed graphics over a player's head, so the viewer could see simultaneously the activity of the player and the feedback he was getting from the app. This was a great way to show the connection of the app on a phone with the basketball without getting bogged down with a bunch of technical jargon.

Yes, what I find interesting here is that you are able to reveal what people are seeing and hearing in the app that normally would not be evident, concurrent to the physical activity. So through this medium you can actually include the viewer on what the player is discovering that is usually one to one experience.

That's a really good point. So many apps have come out in the last five years, all with videos showing you how the app works, but separate from context and user interaction. They typically just show a series of screens with some narration. On this project, we intentionally wanted the viewer to see the athlete looking at a device, seeing his reaction to the device, and seeing what was on the device all at the same time. We wanted all of this to be part of one composition, rather than being a separate layer that was just slapped on later. So you see an instance where the information the the athlete is hearing moves as he moves. It almost appears that it's projecting out in front of him.

Figure 3
94Fifty's promo video display's what the athlete is hearing through the mobile app.

Figure 4
The 94Fifty's app provides multimodal feedback. Motion design was a key element used in communicating this to its audience.

I think what that does is that it couples the relationship between the app, the information, and the person engaged with it.
Right, I just felt that if it was a static overlay on the screen, people may not get the relationship between the app and ball and the movement also draws attention to it.

And then the audio was an important component to the sequence as well. The app gives you audio feedback which at times is more critical to the athlete. What the app is telling you, or I should say, "What the digital coach is telling," can be more meaningful at a particular time than what the actual user interface is displaying.

Since audio was so important to the experience, we needed to communicate what was going on as the athlete you see in the video is wearing headphones. We integrated the same style within the video by mapping the player's motion to the graphic display of the audio.

There's a part of this sequence I wish to point out. We hear a voiceover that says, "Keep it on the fingertips, no palm." And as the graphic moves with the player, there's a moment when the graphic partially leaves the screen, but it doesn't disrupt our ability to consume the content because of the channel of audio. The live video, graphics, and audio the player is hearing through his headphones compliment one another very well. I find this one of the real benefits to working in the space of motion design.

Yes, that's a very good point. Within this composition, there's the element of audio and music. While the music plays a huge part in establishing a mood, the audio voiceover calls out the key moments in the narrative. For motion designers, this is something that can not be underestimated.

So, the whole goal of this video is to show the viewer what's actually going on in the app technically so they understand what's possible and how to get the most out of the app, while at the same time drawing them in emotionally. We wanted to tell a complete story that would teach the audience something through an empathetic human driven story, instead of just outlining a bunch of specs.

So it's more about showing what the ball and app enable for this player, correct?

Yes, we wanted to use motion design to describe an experience. We hope the viewer becomes more emotionally vested when they see the player really trying to improve their skills through the app and how it is supporting his goals. Motion design was a key element used in telling the 94Fifty story.

Image Reference

94fifty. (2014). *Meet the 94Fifty® smart sensor basketball* [Video]. Retrieved from https://www.youtube.com/watch?v=TU7fM6pUohc

Section 6
Educating Motion Designers

R. Brian Stone
Notes from the Classroom

While the discussion of teaching and student work appears in almost every part of this collection, this section explicitly opens the discussion to education and the experience of today's design students with motion design. As digital natives, our students are exposed to all of these technological forms that allow motion design to permeate our experiences, but as future designers, we need to help them develop the tools, framework, and language that will allow them to design communication in motion.

My work with motion in the classroom has evolved over the years and what follows is a brief overview of my own teaching philosophy and approaches to teaching motion design. In my career as a teacher, I have had the good fortune working with students from the United States, Brazil, Taiwan, Singapore, and Germany. With each engagement comes an opportunity to experiment, learn, and grow. Each student has brought to bear a unique aesthetic and perspective on how motion may be used to communicate, entice, or excite. I have learned as much from them as they have from me, these interactions have shaped my teaching.

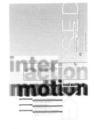

Figure 1
Longstanding Graphic Design programs are now integrating motion studies through coursework, curriculum revisions, and workshops as the case of the 'Interaction Motion Exposed' workshop at the University of the Arts.

Copyright 2006 by Hans-Ulrich Allemann. Reproduced with permission.

Depending on how you look at it, over the past six decades, Design Education has not really changed and Design Education has changed quite significantly. Many of today's educators, for example, come from a formal background rooted in Bauhaus foundational studies and principles. Point, line and plane, contrast, figure/ground, and gestalt theory to name a few—those foundational concepts that were part of design education of previous generations continue to be applied effectively today. But the question now is how are these principles appropriately applied in the context of motion design? Do they have the same relevance or impact? The concept of rhythm for example, takes on a whole new dimension when viewing moving images, as does scale, depth, juxtaposition, positive and negative space, and composition.

In the past, typographic and visual elements lived solely on the page. Today, they live on and off the page—statically and kinetically. This shift begs the question, how do we articulate a new, extended, or complementary set of foundational principles that take into account the properties of motion-based communication, while at the same time fully understanding how our audiences perceive and react to moving messages? Principles that fully embrace the inherent qualities of motion, like time, speed, depth, transition, metamorphosis, inertia, even gesture. Are we at a time in which this expanding palate of form and communication lead to a new visual literacy or

motion literacy? The importance of these questions to educators, practitioners, and innovators, as well as the consumers of motion seem obvious.

Teaching motion design is not without challenges. Students must grasp new and existing principles and apply them in a time-based context. Transition, metamorphosis, reveals, parallax, cause and effect, mimicry, intonation, personification are just a few concepts that are amplified in the kinetic sense. Complicating matters is that the development of ideas must be balanced by the ability to actually execute those ideas. Time-based authoring tools are now widely available, but may be difficult to master considering the constraints of an academic term.

Instructors are faced with an equal set of challenges. Crafting projects that strike a balance between conceptualization, communication, and execution is a challenge. Finding the proper place to incorporate motion-based coursework in curricula is up for debate. Some advocate that it should be a thread of coursework unto itself—a motion design major or degree program. Other programs believe its introduction at the beginning of a student's education is best while others believe it is better suited for advanced study.

I would argue that it should be fully integrated across all years of a curriculum, as with other core competencies like typography, color, and contrast. Unfortunately, this is easier said than done when examining course structure, program accreditations, costs, and faculty expertise.

In the end, motion design is about communication, but it has added layers of complexity that requires time to fully master. It is my belief that Motion Design education is a broad, lengthy, and shared responsibility. In this space, the relationship between academia and practice is symbiotic and mutually beneficial. The range of application and the speed at which the field is changing is such that a motion designer's education will and must continue throughout a professional career. Therefore, a collaboration between academia and professional practice and a platform on which to do so is of great value.

An evolution

Coming off the heels of the desktop publishing movement of the 90s, more and more electronic media tools began to infiltrate design programs. Applications like Flash and Director were gaining attention, and many of my peers struggled to find seamless ways to integrate these tools into their programs. Like others, I began conversations with my colleagues about integrating motion studies in our curriculum in an effort to place the focus on communication and not vocation. My first few course iterations were centered on "type in motion," inspired by the work of Saul Bass and later Kyle Cooper and R/Greenberg Associates. I mirrored work being done by Professors Christopher Pullman at Yale University and Dan Boyarski at Carnegie Mellon University. As a small community, we did interesting, thought-provoking work and shared widely with our peers at other institutions—it was a grassroots effort that grew organically over time. One of my proudest accomplishments as a teacher is that several of my former students are now themselves educators in this space.

Over the past 18 years, my teachings evolved from "type in motion" to Motion Design, now inclusive of a broader range of activity. My students have applied motion in their studies of interface and interaction design, data visualizations, television promos, identity design, and narrative storytelling.

Motion design has a higher degree of complexity but it is still about process, similar to any other design application. My contention is that students of motion design must first become critical observers of movement. We should encourage our students to take every opportunity to really see and analyze how humans and objects move and react to movement. There is much to learn from watching dance, sports, children, animals, and nature. Studying the nuances, aesthetics, and physics of how things move in the world helps build a vocabulary or library of resources for the student. Having this grounding affords the student the ability to translate a range of motion aesthetics in their design projects. It provides them the ability to take an abstract forms like an ellipse, and give it the character of something heavy or buoyant, playful or lethargic, or elastic or rigid.

After developing an understanding of the basic characteristics of motion, students can then look at how elements interact dynamically with other elements. Newton's third law states, "For every action, there is an equal and opposite reaction." Motion does not exist in isolation. There are always forces that influence the reaction and interaction of elements and components. This concept has relevance to responsive products such as product interfaces, scenarios in which type, graphics, or live video have some level of engagement with one another, or to make a distinction when objects are constrained within a screen's frame versus when they move off the screen (as if the screen were a window).

As students build their vocabulary and gain some degree of technical proficiency, projects may begin to branch into varying degrees of complexity. This challenges the student to think about design process in slightly different ways, akin to how composers score music, choreographers script dance, or directors organize a theater performance.

Figure 2
This three phase model is useful in establishing a framework for motion design projects.

Models from narratology may be leveraged to help give structure to how motion based projects are organized and paced. One such model is Anticipation› Event› Reaction (Figure 2) as applied to this project by Sarah Bush. The project moves beyond only mimicking the physical properties

of the word Flicker (Figure 3), but pushes to a level of anticipation through timing and innuendo as the viewer attempts to decode the message before its resolution. The event is a series of flickering letterforms and the background randomly shifts between black and white flashes. The reaction is typically surprise or laughter as the viewer realizes that the resolution is not what they may had predicted.

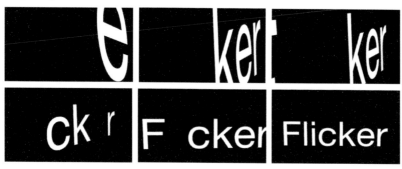

As students are introduced to the idea of building narratives, a useful model to apply is that of the story arc. It provides a framework to move a narrative toward a transformative end. Begin with crafting an *exposition* which sets the tone and context for the story. Build momentum through the layering of complexity that moves to a *rising action*. As the story reaches its peak, the *climax* shows an impactful point of change or reveals a big idea. The *resolution* is the conclusion of the narrative.

This 3 minute video (Figure 4) designed by Avery Hsiao and Ueiting Huang from Shih Chien University, Taiwan, tells an interesting and surprising story of the octopus. Its exposition sets the context by discussing the octopus as part of the cephalopod family and typical myths associated with the creature. The narrative builds through rising action by laying out several interesting facts about the octopus such as its ability to camouflage and use tools. The climax describes the octopus as so unique, it could be an alien. The resolution speculates that the octopus is shiftly enough to be living among us, looping the story back to some of the myths described at the outset of the story.

The inherent multidisciplinarity of Motion Design, well-explored in this collection, offers many opportunities to collaborate and cross-pollinate. Designers and animators, typographers and cinematographers, musicians and illustrators, all have a role to play. Higher education is the ideal place to foster these fruitful collaborations, potentially leading to new foundations, design strategies, and communication forms such as moving posters, motion books, or dynamic advertisements.

There is much to be learned from a continuing dialogue between practitioners and educators. The ultimate goal for both is to elevate the discipline as a whole. The need to create clear communication is foundational to what we do. This is a fundamental principle that has not changed. Motion design is about messages that move—kinetically and emotionally. A robust education gives the next generation of motion designers the grounding needed to tell great stories and create moving experiences through motion.

Figure 5
Motion design as an exploration into new application areas. This 'moving poster' changes from a daytime to evening presentation to amplify the 24 hours of LeMans race.

Copyright 2017 by Alexander Kielwein. Reproduced with permission.

Figure 6
This 'moving poster' uses paint splatters to depict and reveal the dynamic nature of the Magic City exhibition.

Copyright 2017 by Anja Buchmaier. Reproduced with permission.

"Introducing motion literacy in the under-
graduate design classroom through
a systems-based approach provides
codification of the design

properties involved with mapping a
time-based system. It enables students
to work from a structure for which to
create motion."

Heather Shaw
Understanding Motion Literacy through Systems and Behaviors

This chapter will provide a brief historical survey including the Dadaist films
from the 1920s and graphic notation from the 1950s. The works selected
for this chapter showcase visual music composition and filmmaking that
revolutionize traditional structures and media for their time. These histories
serve as exemplars for developing a language for motion, and for crafting
motion design pedagogy. However, this chapter is not intended to be an
in-depth history lesson; nor is it an exhaustive collection of classroom
assignments; instead, the purpose is to analyze and codify these works into
organizational structures to be used for teaching two key components of
motion literacy: *Systems* and *Behaviors*.

Understanding systems through graphic notation
Sound is an integral component to motion literacy; but it's often skimmed over
in design pedagogy and in the design classroom. This is due to the fact that
sound literacy has not traditionally been part of the discipline. The advent
of interactive media resulted in motion as a critical component in design
curriculum; but with motion comes a need for understanding the importance
of sound.

Studying graphic notation enables non-musical design faculty to understand
music terminology from a visual perspective. Composer Cornelius Cardew
wrote, "Graphic scores are designed for people who have avoided a musical
education but somehow acquired a visual education" (Walters, 1997, p.
32). This chapter will articulate how these works serve as a theoretical and
conceptual foundation for teaching motion literacy in an undergraduate
design classroom.

The 1950s sparked an age of avant-garde music composition. Composers such
as John Cage, Cornelius Cardew, György Ligeti, and Karlheinz Stockhausen
pioneered new ways in which music was concepted, notated, and performed.
Diverting from traditional music notation; their processes for creating abstract
music serve as informational and architectural guidelines for vocal, orchestral,
and digital performance.

> Yet for a couple of decades, from the 1950s to the early 1970s, composers
> questioned every convention to produce an extravagant body of exuberant,
> ornate and sometimes totally baffling "graphic scores." (Walters, 1997)

These contemporary approaches to visual scores also changed the way a
musical composition was traditionally read and played. Graphic notation

visually maps a system for a music or sound composition; with the expectation that someone could decipher the visual notations, the rules associated with the visual notation, and perform their interpretation of that piece. The graphic notation featured in this chapter are crafted with purpose and structure beyond decoration.

Introducing motion literacy through a systems-based approach teaches students that motion is not an arbitrary collection of movements on screen; its goal is to provide structure, logic and meaning. The examples of graphic notation featured in this chapter are used as examples to propose three distinct categories of systems for motion:

1. Determinate Systems: explicit rules set that enable varied outcomes;

2. Interpretative Systems: implicit rules set, but the interpretation of these rules lead to spontaneous outcomes;

3. Indeterminate Systems: rules set based on chance and variability, which lead to random outcomes.

Determinate systems

Determinate systems have an explicit rules set, but these rules enable opportunities for variable outcomes. Composer György Ligeti's (1923–2006) electronic composition *Artikulation* (composed in 1958) is a good example of a determinate system. Conceptually linked to phonetics; Ligeti stated that: "The piece is called 'Artikulation' because in this sense an artificial language is articulated: question and answer, high and low voices, polyglot speaking and interruptions, impulsive outbreaks and humor, charring and whispering" (Ligeti, 1970, p. 7).

Ligeti created a series of electronic sound segments, each a singular unit of speech. These "phonemes" were then grouped by category into various bins, and Ligeti devised a complex formula for the selection and length of each (Antokoletz, 2014). *A History of Twentieth-Century Music in a Theoretic-Analytical Context* states that Ligeti "went through a process of grabbing randomly, without-looking, similar 'phonemes' out of their bins, combining them into 'texts', and then cutting these in half, down to 'words'" (Antokoletz, 2014, p. 372). *Artikulation* has been described as spontaneous, and although Ligeti's compositional methods involved chance in selecting the sound segments, his rule set is algorithmically predetermined. Ligeti's original notation is comprised of several charts and tables, calculating a deliberate sequence of actions, thus ascertaining this work as a determinate system.

In 1970, graphic designer Rainer Wehinger created a "Hörpartitur" or "score for listening" for the piece, which serves as visual transcription to accompany *Artikulation*. Wehinger's design codifies the main sonic characteristics: a timeline measured in seconds; shapes and colors instead of the notes on a staff; colors representing timbre and pitch; dots for impulses, and "combs" for noise (Toop, 1999). His design also includes a legend explaining the shapes and their encodings, and Ligeti approved of Wehinger's graphically dynamic score. Prior to digital tools, Wehinger's visual score is a captivating visual

design specimen that articulately maps a time-based piece to a static medium. In 2007, Donald Craig scanned Wehinger's score and synchronized it to Ligeti's composition for YouTube, illuminating how easily the score can be followed when paired with the music.

Figure 1
Artikulation
*(Wehinger's score
synched to Ligeti's
composition).*

*Source: Craig,
2007. Copyright
by Donald Craig.
Reproduced with
permission.*

Introducing determine systems in the undergraduate design classroom can be approached in various ways; and is not limited to only motion-based projects. Using paragraph styles for print and cascading style sheets (CSS) for web are basic examples of explicit rule-sets that govern hierarchy, structure, and form. Requiring students to use paragraph styles introduces the use of a rules-based system for a typographic composition. Teaching students beginner web development through HTML and CSS is congruent to teaching paragraph styles for print; it builds a construct for students to see relationships of rules to form. The process involved with CSS coding enables students to experience how a simple modification to a CSS property can visually alter an element across multiple web pages. Introducing media queries for responsive web design adds a layer of complexity for teaching determinate systems. Media queries allow the content of a website to adapt to various screen resolutions, such as a laptop, tablet, or phone. Designing with media queries requires students to consider the changes in the stacking order of the individual web page elements (such as navigation, images, and text content) as the website adjusts for various screen widths. As a result, motion is a by-product of responsive web design in order to accommodate these shifts and adjustments in design. This is one example for introducing determinate systems in design education—whereas the CSS rules-set for the design is explicit. Its hierarchy and structure is designed to accommodate various devices, allowing for varied outcomes.

Artikulation is exemplary of a determinate system through Ligeti's process of creating a pre-determined rules set that enabled variable results for the music's composition. Both aspects of *Artikulation*—Ligeti's process of composing, and Wehinger's visual score—serve as great tools for teaching determinate systems. It exemplifies how Ligeti's rules-set created variability each time the rules were executed. Ligeti's *Artikulation* is groundbreaking not simply for its compositional make-up, but also for its reversal of a time-honored process. Wehinger's visual score is subsequent to the music, where typically the score is created first. Furthermore, Wehinger's visual codification of *Artikulation* functions as a sophisticated information design piece in its visual mapping of abstract shapes to sound.

Interpretative systems

Interpretative systems have an implicit rules set, but the interpretation of these rules by various individuals lead to varied and spontaneous outcomes. John Cage's *Aria* (composed in 1958) is a classic example of an interpretative system. Designed for singing, this visual score uses handwritten gestural notation to represent time horizontally and pitch vertically. Color designates singing style. His notations can be sung by a voice of any range; each vocalist's interpretation of the rules creates a different "song" each time.

Figure 2
John Cage's Aria.

Progressive composer Karlheinz Stockhausen (1928–2007) grew out of a period of radical innovation in postwar Germany, defining a new era in music history. His music compositions grew from "an aversion to music with a 'continuous periodic beat' in response to the Nazi party's influence with 'marching' music for radio" (Marconie, 1976, p. 8). Jazz became a heavy influence in Stockhausen's work as it "offered an alternative to the beat regimentation he despised" (Marconie, 1976, p. 8). His piece, *Kontakte* (1960), took over two years to complete and was constructed while Stockhausen was sharing studio space in Cologne with Ligeti. Despite Stockhausen's appeal to jazz, his work has been criticized by Ligeti for its extreme "plannification" in its design, with intense attention to every detail. Kontakte is designed for two performance versions; one for electronic sounds and the other for piano and percussion.

Stockhausen's plan for the performance included a series of fixed parts of instruments and tape; but the instrumentalists (three percussionists and one piano) could respond freely to the tape recording during the performance, with no written score. But when it was rehearsed, the musicians didn't know what to do. As a result, Stockhausen provided loose instructions for the musicians to react to the tape. He intended the performers to "engage in a musical tennis match, with the players serving and returning balls of sound to one-another" (Marconie, 1976, p. 144).

Although musical improvisation was not a new concept, *Kontakte* introduces performer participation in reaction to an electronic recording. This "reactive imitation style" (Marconie, 1976, p. 144) for performer participation is what makes *Kontakte* groundbreaking in its process. Writing for *The Guardian*, author Tom Service (2013) states, "What gives Stockhausen's music its vitality is precisely the tension between a desire for structural experimentation, and the irresistible energies of its surfaces."

Stockhausen's performance instructions—combined with each performer's interpretation of those rules and improvisation—is what makes *Kontakte* exemplified as an interpretative system.

Figure 3
Kontakte.
Stockhausen's instructions were intended to be used as a reference for improvisation during a performance.

Copyright 1995 by Stockhausen Foundation for Music. Reproduced with permission. All rights reserved.

Musical composer Cornelius Cardew (1836–1981) is most known for his graphic score *Treatise* (derived from Ludwig Wittgenstein's book *Tractatus Logico-Philosphicus*). It has been described as the "Mount Everest" of graphic scores and was written from 1963–1967. According to the Block Museum's "Treatise, An Animated Analysis" (www.blockmuseum.northwestern.edu) this visual score contains 193 pages of numbers, shapes, and symbols whose interpretation is left to the performer. In Cardew's *Treatise Handbook* (1967), he describes the musical composition as striving to be an "articulated network [...] that it's representation is decisive and authoritative, with the subtleties of design precise [...] It should not be purely decorative" (Prévost, 2006, pp. 102–104).

1961 is a pivotal point in the making of *Treatise*. Cardew enrolled in a graphic design course in England, while studying the writings of prominent philosopher Ludwig Wittgenstein (Prévost, 2006). Wittgenstein's (1922) notable work, *Tractatus Logico-Philosphicus* studies the impact of words and their interpretation in the minds of the receiver; and, as a result, people should speak with careful precision: "Whereof one cannot speak, thereof one must be silent." The interpretive nature of language is what most interested Cardew,

and the notion of "interpretation as an activity" became the basis for his score (Prévost, 2006). This slamming together of graphic design and Wittgenstein's philosophy created the perfect storm for the development of *Treatise*.

Figure 4
From Treatise *by Cardew. The score uses organizational design principles from Gestalt Psychology and has recurring visual elements throughout.*

One could argue that *Treatise* is designed as an Indeterminate System due to the interpretative nature of the rules being accountable to the performer; particularly because there is no fixed or literal meaning for each of its graphical marks. However, the score uses organizational design principles from Gestalt Psychology (proximity, similarity, continuation, closure) with consistent recurring visual elements throughout. Furthermore, the consistency of these elements can be interpreted musically through pitch, dynamics, duration, and timbre. For example, a persistent "lifeline" present throughout the piece is often handled by performances to divide up the material amongst separate instrumentalists:

> The score must govern the music. It must have authority, and not merely be an arbitrary jumping off point for improvisation, with no internal consistency [...] the score must present something decisive and authoritative. (Block Museum of Art, n.d.)

Although Cardew is leaving the interpretation (and performance) of his graphic notation to the musicians, the recipe is symbolically consistent. Therefore, the performers can create an agreed upon set of actions tied to the individual symbols within the notation, and perform from a shared understanding of the score.

Interpretative systems can be introduced in the undergraduate design classroom through teaching algorithmic thinking. An algorithm is a set of sequential instructions designed to perform a specific task or function. Understanding and learning how to structure an algorithm teaches students the value of creating a rules-set that allow for varied and spontaneous results.

Design faculty do not need to be expert programmers to teach algorithmic processes in undergraduate design curriculum. Algorithms can be introduced conceptually by having students write *pseudocode*—a detailed description of what a computer program would execute—but expressed through common vocabulary. Pseudocode introduces students to computational thinking prior to learning any programming languages. It lists all the steps a program must perform without needing any specific syntax associated with a programming language. Algorithms can be introduced at a beginner level by having students create a repeat pattern by writing out all the instructions needed in the making of the pattern. These written instructions become the pseudocode that documents all the visual properties associated with an object's repetition in the making of the pattern; including changes to scale, opacity, rotation, location, position, repetition, and frequency. Once students have the written instructions for the creation of their patterns; they "swap" their pseudocode with another student in the class, and try to recreate each other's patterns based solely on the written rules-set. True to the definition of an interpretative system, each student's interpretation of their peer's pseudocode creates patterns that are varied and spontaneous.

Figure 5, 6
Student pattern created from algorithms. (left)

Copyright 2016 by Alexandra Fletcher. Reproduced with permission.

Student pattern created from algorithms. (right)

Copyright 2016 by Jacob Viana. Reproduced with permission.

The second phase of this assignment introduces motion into the students' patterns. Students use Nodebox, a generative visual programming environment that allows students to translate their pseudocode to real code in the re-creation of their patterns. Nodebox enables students to apply a range of values (called "variables") associated with the visual properties that make up their pattern; including changes to scale, opacity, rotation, location, position, repetition, and frequency over time. The process of attaching variables to the visual properties associated with each student's pattern enables them to experiment with a range of outcomes associated with their system.

This beginner assignment introduces students to the process of creating and executing a rules-based system. It enables them to safety test the boundaries of their rules, surrender preconceived notions of what the outcomes should be, and witness their peers' interpretations of those rules. Just as Cage's *Aria* is designed for any voice, having students design for interpretation enables

them to create a rules-set for a broader group of participants. This fosters experimentation, and allows student to witness spontaneity in the results. This is unlike traditional design methods, wherein the tendency is to have every visual detail meticulously positioned and crafted.

Indeterminate systems

By definition, an indeterminate system uses simultaneous equations that have more than one solution. Within a design context, indeterminate systems can be defined as a rules set based on chance and variability; which lead to random outcomes. Indeterminate music (also referred to as aleatoric music) is the practice of certain details being left to a performer, an editor, or conductor as the composer provides an incomplete picture.

Composer John Cage (1912–1992) and his partner, dance choreographer Merce Cunningham (1919–2009), experimented with the use of indeterminate systems in their work using a methodology called "chance operations." The inspiration was drawn from the I-Ching, an ancient divination manual that provided spiritual guidance through randomly generated methods such as coin tosses. The core principle of the I-Ching is to remove one's own intention from the work and surrender it to the divine.

Cage employed chance operations in the design of *Notations* (1969), a collection of graphic and conventional scores compiled with Alison Knowles. The publication contains written passages from 269 composers, each passage not having more than 64 words that were written specifically in response to a questionnaire. Composers include a vast range of artists; including The Beatles, Leonard Bernstein, and Yoko Ono. The book's design has been referred to as a "typographic curiosity: the text was edited and set using chance operations, so that letter size, weight and font change in mid-word" (Walters, 1997, p. 28) According to Cage "Not only the number of words and the author, but the typography too—letter size, intensity, and typeface—were all determined by chance operations" (Cage, 1969).

From a design educator's perspective, *Notations* is an excellent example for showing the use of an indeterminate system for a printed book. The volume contains 250+ pages (lacking any printed folios) and is a visual and typographic delight. But to look beyond superficial aesthetics, the design is conceptually and systematically rigorous for determining the variations in font sizes, image to text, and compositions. Notations, sequencings and visual dynamics are a unique consequence of Cage's approach to indeterminate music composition. Although the book is not technically considered a work of motion, it is a valuable medium for teaching sequencing and systems in design education.

Cage's explorations with indeterminate systems suggest that by refusing to impose his own patterns onto his compositions, he was exposing more of the innate complexity of the world (Edmeades, 2014). *Music of Changes* (1951) is a solo piano piece composed for friend and peer of the New York School, David Tudor. It is considered to be a groundbreaking piece of indeterminate music as it uses chance throughout. Referencing the I-Ching's name ("Book of

Changes"), *Music of Changes* uses square-like charts as a tool for introducing chance into three main parameters to the music: volume, duration, and dynamics. Cage's main contribution to musical composition was to shift the attention from the end product, but to the compositional process (Marconie, 1976). His indeterminate works challenge the listener to suspend expectations for regular or semantic patterning in the composition and to simply engage in the auditory experience.

Indeterminate systems can be introduced in the undergraduate classroom by having students develop a tool with a range of functions; allowing for many possible outcomes based on the tool's use. Once example is having students create a drawing tool that enables anyone to contribute to an expressive visual mark-making process. Similar to the pattern project, faculty do not need to be expert programmers to facilitate this type of project; tools can be approached as analog or digital contraptions. Students' tools must have visible and variable constraints so that participants can easily interpret the tool's functionality, and there are conditions designed within the system to allow for spontaneity as part of the drawing process. Essentially, the drawing tools must be designed to facilitate infinite visually diverse outcomes from its use.

For example, one student's project integrated color as a random function. Participants using this tool could control the shapes they made; however the color output was randomly generated. Inspired from Cage's emphasis on the process of making music versus controlled scripting of the finished

composition, this assignment enables students to value the range of spontaneous outcomes driven by their tool's variability. These tools transition students to appreciate the process of facilitating drawing as an experience; rather than drawing as a goal-oriented activity (although several of the "drawings" can be surprisingly exquisite). This assignment advances students' attention towards creating tools that seek to engage and delight their participants.

Table 1
Summary of Systems and Composers.

System	Composer	Works
Determinate System: *Explicit rules = Varied outcomes*	Geörgy Ligeti	"Artikulation" (1958)
Interpretative System: *Implicit rules = Spontaneous outcomes*	John Cage Karlheinz Stockhausen Cornelius Cardew	"Aria" (1958) "Kontakte" (1960) "Treatise" (1967)
Indeterminate System: *Chance rules = Random outcomes*	John Cage	"Notations" (1969) "Music of Changes" (1951)

Understanding behaviors through cinema

Motion is comprised of a series of actions that take place over space and time. Behaviors define an object's transformation in motion. They are the inherent characteristics—direction, gesture, displacement, kinetics, physics, and velocity—that define movement of an object. If systems are the defining structure for sequencing and outcomes, then behaviors are the action, or the "verbs" for motion.

Deconstructing behaviors in motion design teaches students the implications that movement creates. Behaviors serve two very different functions: 1) for kinetic expression, and 2) for creating connections between content. Both are important, and their use must be predetermined to avoid adding "motion as a decoration" in any project or assignment. Behaviors, like color and typography, should be included in curriculum as a core competency, and should be integrated into projects with purpose and intent. The following text will briefly highlight the importance of film transitions vis-à-vis interface transitions. Interface transitions are indicated by motion that is triggered by human interaction; also known as *semantic animation*. The movement is intended to enabler a user to understand their location within an interface.

Transitions and semantic animation
Early 1900s cinema began to establish a language of film editing with the purpose of assembling various shots into a coherent story. Editing techniques such as cross-cutting, parallel editing, and transitions enabled filmmakers to juxtapose and connect both time and place within a story. Transitions are a vital tool for connecting various types of seemingly unrelated content, particularly if taken out of context.

Understanding transitions in film is imperative towards understanding digital and screen-based interactions today. Transitional elements—wipes, dissolves, fades, etc.—are common film archetypes that have been adapted and

modified for interface. However, interactive media has expanded the variety of motion-based behaviors needed to communicate within the complexities of digital space. Unlike traditional film media, which is typically linear and two-dimensional, digital interactions are nonlinear, and screen space is abstract and four-dimensional. The article "Motion with Meaning: Semantic Animation in Interface Design" introduces the term semantic animation—that individual screens cannot be handled as separate entities if the transitions between them are animated. Authors Amin Al Hazwani and Tobias Bernard propose that animations in interface simulate the experience as one continuous space to the end user. Film editing uses transitions to connect a series of shots into a linear, cohesive narrative for a viewer, while interface uses semantic animation to connect various screen elements to create the illusion of a single, continuous space to an end user:

> Instead of designing screens and then adding transitions between them, start by designing individual components and thinking about how they change and move in different contexts. With that in place, layout and animations will come together naturally, following the semantic structure of the content. (Hazwani & Bernard, 2016)

A simple example of this is the "Photo" app for the iPhone interface: when a thumbnail image is clicked in the photo collection, the image scales up to fill the phone's screen. The thumbnail's expansion into the existing screen space facilitates a continuous and seamless experience for the end user. Considerations for animation in interface completely changes the nature of prototyping in the classroom. Typically, students are tasked with wireframing individual screens for an interface, and connecting those screens using an intuitive, open-source prototyping tool. Such tools offer an array of basic "macro-transitions" via swipes, taps, double taps, slides, etc. However, many of these tools cannot accommodate the necessary micro-transitions described by Hazwani and Bernard's semantics, thus limiting a student's ability to conceptualize and prototype more complex transitions beyond merely linking a series of screens. There is a need for more affordable, robust motion-based prototyping tools that enable students to experiment and explore the value of micro-transitions in interactive work.

Kinetic expression
Kinetic expression is used to convey the emotional quality (or lack thereof) of an object through motion. Chuck Jones' animated interpretation of Norman Juster's book *The Dot and the Line: A Romance in Lower Mathematics* is a contemporary example of kinetic expression. Jones' brilliant use of anthropomorphism created a cast of believable characters in a love triangle using only a dot, a line, and a squiggle. The kinetic expression of the main characters in this story—a straight line hopelessly in love with a restless dot who is attracted to a bohemian squiggle—evoked humor and empathy from audiences. Jones's animation was awarded an Oscar in 1965 for Best Animated Short Film.

The value of kinetic expression can be contextualized through studying the Dadaist film movement. The 1920s avant-garde cinema challenged expectations for film as a creative and interpretative medium. Dadaist filmmakers such as Viking Eggeling, Hans Richter, and Walter Ruttman believed that film was governed through its own laws for creative expression. It became a medium for exploring abstraction as a form of universal language. The Dadaist movement grew from a negative response to World War I, and embodies a philosophy that defied war, conflict, and cultural and intellectual conformity. Beyond cinema, its influence spanned the visual arts, literature, theater, and graphic design.

Hans Richter (1888–1976) was a German pioneer of Dada and the avant garde film movement. He is referred to as a "universal artist" as he participated in a range of creative activities including painting, writing, and creating both abstract and documentary films (Read, 1965, p. 7). Historically, the Dada movement is recorded as only lasting until 1923; however Richter's films were made between 1921 to 1927. This is due to two artistic streams in Dada: the deconstruction of conventional artistic trends and reformation of the elements as a result of this deconstruction. This intersection of deconstruction and reconstruction is where Dada and constructivism become closely related in Berlin and Zurich (Foster, 1998, p. 73–74). Constructivism is characterized by the systemization of forms, a fixed syntax, and logical composition (Foster, 1998). There is some conflict in classifying Richter's films as constructivist rather than Dadaist, as most of his films were designed through constructivist principles. However, this classification is specific to the visual aesthetics of the work itself, whereas the overall philosophy in Richter's purpose for making work points to Dadaist ideologies.

> I want to paint completely objectively and logically, ...according
> to principles like those in music, with long and short note values.
> (Foster, 1998, p. 74)

Richter also worked in collaboration with Swedish avant-garde artist and filmmaker Viking Eggeling (1880–1925). They believed that Dada was a movement, not merely a style, and in 1920 they drafted a proclamation titled "Universelle Sprache," which translates to "Universal Language" (Foster, 1998). The eight-page manifesto proposed "the basis for such language would lie in the identical form perception in all human beings and would offer the promise of a universal art as it had never existed before [...] one should be able to rebuild men's vision into a spiritual language in which the simplest as well as the most complicated, emotions as well as thoughts, objects as well as ideas, would find a form" (Richter, 1965, p. 144). This sparked the notion of kinetics as a means for representation.

Richter and Eggeling began exploring kinetics through a process of creating drawings, called "orchestrations," that were drafted on long sheets of paper. These studies are reminiscent of visual constructivist aesthetics; however their length and composition suggest motion. Richter and Eggeling's "orchestrations" ultimately lead to filmmaking as the next medium for

exploration. Together, they conducted experiments in "non-objective" cinema, and sought to establish a universal language with an emphasis on movement (Foster, 1998).

Richter's first film, *Rhythmus 21* (1921), was based on the "vehicle of forms" (Foster, 1998). The film is completely devoid of any representational image; instead, the film was used for animating rectangular shapes on the screen. Throughout the course of the film, various graphic forms increase and move within the frame. The background also switches from black to white, a process Richter referred to as "Kontrast-Analogie" (contrast analogy) where he interspersed film negative with positive (Foster, 1998).

In 1922, Richter paired up with Werner Gräff, a Bauhaus student recommended by Theo van Doesburg (a fan of Richter's work) to create *Rhythm 23*. Their short film abandoned all representational imagery and worked strictly with rigid forms and symmetry. It lacked any rounded or curved forms, juxtaposing negative and positive space through the use of squares and rectangles. The film premiered in Paris during "Le Coeur à Barbe" in July 1923 (Foster, 1998).

Figure 9, 10
Still from "Rhythmus 21" (left)

Source: Avant-Garde Cinema, 2012a.

Still from "Rhythm 23" (right)

Source: Avant-Garde Cinema, 2012b.

Inspired by Richter's formal and structured approach to film, Viking Eggeling completed *Symphonie Diagonale* (1924) using cut paper, tin foil figures, and photographed frame-by-frame. In 1922 Axel Olson, a young Swedish painter, described Eggeling's work as to "evolve a musical-cubistic style of film—completely divorced from the naturalistic style." *Symphonie Diagonale* emphasizes the objectivity in the movement, true to the Dadaist philosophy ascribing to a universal language for representation. It shows an analysis of movement through clearly defined lines and shapes, with a mechanical, metronomic tempo. In an on-screen intoduction, Frederick J. Keisler writes:

> Made in 1924, *Symphonie Diagonale* is the best abstract film yet conceived. It is an experiment to discover the basic principles of the organization of time intervals in the film medium.

Unlike Richter's work, Eggling implements the use of rounded, organic shapes intermixed with angular graphic forms. It also contrasts Richter's need for structure and symmetry; by comparison *Symphonie Diagonale* is slightly more playful through its use of asymmetry and bulbous forms. These visual "instruments" evolve, transform, and progress in visual rhythmic sequences.

These parameters of "instruments"—rhythm, dynamics, figures, and shape—
are analogous to the parameters of rhythm, pitch, phrasing, and timbre found
in musical composition (Valcke, 2008, p. 171). In May 1925, it premiered in
Germany, but Eggeling's prestige was short lived, as he died sixteen days later
at age of 45.

Artistically motivated, Walter Ruttman (1887–1941) was born in Germany,
studied architecture, painting, and worked as a graphic designer. As a
filmmaker, he created a new technical means for working with film through
creating painterly, abstract image sequences. His film *Lichtspiel Opus I*
premiered in Germany in 1921, and was the first abstract film to be publicly
screened (Valcke, 2008, p. 173). His animations were created through a
process of painting on glass plates beneath the camera; he would shoot after
each brush stroke or alteration as the paint could be modified or wiped away
easily. Later in the process he combined painting with geometric cut-outs on
a separate layer of glass (Valcke, 2008).

There are two distinct features that makes Ruttman's approach to film
different from Richter and Eggeling. First, Ruttman considered sound as
integral to his animation. Composer Max Butting was commissioned to
compose a score for a string quartet to accompany *Lichtspiel Opus I.* Ruttmann
wanted the music to be closely aligned to the animation, and provided
instructions to ensure that the music precisely synchronised with the visual
elements unfolding on the screen. This is unlike Eggeling and Richter's works,
which were not designed with a score (although various scores have been
composed later for Eggeling's *Symphonie Diagonale*).

Second, Ruttmann's visual style is far more playful and impressionistic than
Eggeling and Richter's work; his painterly approach and film technique
produce an organic, humanistic feel through color, shape and movement.
While Eggeling and Richter pursued objectivity in their work, focusing on
figures, forms, and time relationships between visual elements, Ruttmann
appears more concerned for using film as an artistic medium for kinetic
expression. William Moritz (1997), author of *Restoring the Aesthetics of Early
Abstract Films* describes his work as "using movement and colours to create
choreographies [...] to differentiate certain shapes, movements or repetitions,
but [also] sometimes to establish general mood or atmosphere."

The Dadaist filmmakers represent an abstract visual language for kinetic
expression. Eggeling and Richter's films are remarkable for their success

Figure 13, 14
Stills from
Lichtspiel: Opus 1
(1921).

Public domain.

in creating an "objective" and universal language. It is nearly impossible to interpret any visual narrative or emotive quality from their films. *Rhythmus 21, Rhythm 23,* and *Symphonie Diagonale* exhibit kinetic expression through basic design principles associated with visual properties of motion: shape, color, surface, scale, and opacity. Both Eggeling and Richter handle the framing for animation as staged space; the graphic elements simply appear and disappear within the confines of the camera's frame. Just as their original "orchestrations" were confined to the page, the graphics in their animations rarely move beyond the confines of the frame.

Conversely, Ruttmann's *Lichtspiel Opus I* elicits a greater emotional and interpretative response when viewed. The addition of color and organic forms reveal more advanced behaviors associated with motion: direction, gesture, displacement, physics, and velocity. Also, Ruttmann's framing further explores the boundaries of space as a window; the graphic elements move in and out of frame, as if to enter and leave our field of vision on their own accord. This is vastly different from other Dadaist films, which are compositional displays with limited movement within the confines of the frame. *Lichtspiel: Opus 1's* anthropomorphic use of behaviors, innovative spatial framing, and synchronicity of music make Ruttmann's work pivotal in teaching more advanced concepts in motion literacy.

Behaviors	Vehicles for Expression
Transitions: Film Media	Cut, fade in/out, dissolve, wipe, iris
Semantics: Interactive Media	Zoom, stack, expand/contract, fade in/out, push, slide
Kinetics: Film & Interactive Media	Scale, rotation, direction, gesture, displacement, physics, velocity, frequency

Table 2
Summary of Behaviors.

The use and implementation of "motion" means different things to different areas of professional practice. It is a complex interdisciplinary area that spans film, animation, gaming, design, and interactive media. It also involves the study of psychology (what makes motion meaningful) and computer science (motion-based computation and interaction). This chapter only scratches the surface of identifying two key aspects of the discipline, specific to the qualities and properties of motion itself.

Introducing systems

Introducing motion literacy in the undergraduate design classroom through a systems-based approach provides codification of the design properties involved with mapping a time-based system. It enables students to work from a structure for which to create motion. Following is an example of a first-year design assignment inspired from Rainer Wehinger's "Hörpartitur." Students create visual score that represents 15 seconds of music. Their work must consider the properties described in Table 3.

Table 3
Examples for how sound properties can be mapped to visual design properties.

Sound Properties		Design Properties
Rhythm	=	Horizontal (X-axis) position in space
Pitch	=	Vertical (Y-axis) position in space
Tempo	=	Frequency / Repetition
Volume / Dynamics	=	Scale
Tone / Timbre	=	Opacity

Additionally, students are limited to using only a circle, square, and triangle to visually represent three key sounds or beats in the music's structure, tone, and dynamics. The diagrams chart the properties heard in the music, and are more than an interesting collection of shapes and composition. The examples show how mapping location (x- and y-axis), frequency/repetition, scale, and opacity can create visual dynamics from a auditory piece.

Figure 15
Student visual score for "Turn Blue" by The Black Keys.

Copyright 2016 by Alexandra Fletcher. Reproduced with permission.

Figure 16
Student visual score for "Marble Machine" by Wintergatan.

Copyright 2016 by Raine Ferrin. Reproduced with permission.

Figure 17
"Tin Man" by Future Islands.

Copyright 2016 by Lauren Cowe. Reproduced with permission.

Integrating behaviors

Establishing systems-thinking amongst design students enables them to move towards integrating behaviors into the work. This also provides a reason and a rationale for why objects move the way they do. The second phase, shown in Table 4, involves consideration for motion behaviors.

Sound Properties		Design Properties	Motion Behaviors
Rhythm	=	Horizontal (X-axis) position in space	Direction
Pitch	=	Vertical (Y-axis) position in space	Direction
Tempo	=	Frequency / Repetition	Velocity
Volume / Dynamics	=	Scale	Gesture, physics
Tone / Timbre	=	Opacity	Gesture, physics

Table 4
Examples for how sound and design properties can be animated via motion behaviors.

Students used their hörpartiturs as a source for animating the shapes to the same 15 seconds of music. The following examples exhibit the students' abilities to connect the structure from their systems to the behaviors in their animations.

Figure 18, 19
Student animation, "Turn Blue" by The Black Keys.

Copyright 2016 by Alexandra Fletcher. Reproduced with permission.

Figure 20, 21
Student animation, "Marble Machine" by Wintergatan.

Copyright 2016 by Raine Ferrin. Reproduced with permission.

Figure 22, 23
Student animation, "Tin Man" by Future Islands.

Copyright 2016 by Lauren Cowe. Reproduced with permission.

Results

This beginner assignment challenges first-year undergraduate students to consider how a circle, square, and a triangle can be used as symbolic representations of sound and investigate how these simple shapes can be used as a vehicle for interpreting pitch, rhythm, tempo, volume, and other musical concepts. Through this process, students explore the power of graphical shapes to represent structure and form, both for static and dynamic media. They also investigate how a circle, square, and a triangle can be used to visually and dynamically convey the sounds they represent. Various "tones" in the music are expressed through the handling of each individual shapes' form and context. Akin to Wehinger's process, a sound-based system is used as the basis for developing a dynamic and expressive visual composition.

Lastly, students use music as a system to dictate each shape's behaviors, including scale, rotation, direction, gesture, displacement, physics, velocity, and frequency.

Conclusion

An understanding of systems for motion is integral to design curriculum, regardless of outcome or medium. It sets the foundation for teaching design using rules-based methods. It transitions students to value a range of unexpected outcomes associated with their rules set. It also enables them to accept and embrace chance from a range of unexpected outcomes with user participation, and breaks down student preconceptions of their work as a "precious" artifact. Creating interactive systems enables students to allow others to test the boundaries of their logic; it challenges their assumptions and prepares them to value the range of unexpected results from participant engagement.

Behaviors are their inherent characteristics—direction, gesture, displacement, kinetics, physics, and velocity—that define the actions, or verbs, associated with motion. Behaviors define an object's transformation over time. Just as students must learn visual principles for design, they must also be able to define behaviors for motion. Studying behaviors specifically for kinetic expression and for connecting content enables students to integrate motion with purpose and meaning.

Heather Shaw, Associate Professor, Design Department Chair, Lesley Art + Design

References

Antokoletz, E. (2014). *A History of Twentieth-Century Music in a Theoretic-Analytical Context.* New York, London: Routledge.

Avant-Garde Cinema. (2012a). *Hans Richter - Film Ist Rhythm: Rhythmus 21 (c1921)* [Video]. Retrieved from https://vimeo.com/42339457

Avant-Garde Cinema. (2012b). *Hans Richter - Rhythmus 23 (c1923)* [Video]. Retrieved from https://vimeo.com/42256945

Block Museum (n.d.). *Treatise – Cornelius Cardew – An animated analysis* [Interactive website]. Retrieved August 16, 2016. http://www.blockmuseum.northwestern.edu/picturesofmusic/pages/anim.html

Cage, J. (1969). *Notations.* New York, NY: Something Else Press.

Cardew, C. (1971). *Treatise handbook : including Bun no. 2 [and] Volo solo* [Musical score]. New York: Edition Peters.

Craig, D. (2007). *Ligeti - Artikulation* [Video]. Retrieved from https://www.youtube.com/watch?v=71hNl_skTZQ

Edmeades, L. (2014). Intention and (in)determinacy: John Cage's 'Empty Words' and the ambiguity of performance. *Australian literary studies, 29* (1–2), 120–129.

Foster, S. C. (1998). *Hans Richter: Activism, modernism and the avant-garde.* Cambridge, MA: MIT Press.

al Hazwani, A., & Bernard, T. (2016, January 19). Motion with meaning: Semantic animation in interface design. Retrieved from http://alistapart.com/article/motion-with-meaning-semantic-animation-in-interface-design

Holmes, T. (2012). *Electronic and experimental music: Technology, music, and culture (4th Ed.)*. New York, London: Routledge.

Ligeti, G. (1970). *Artikulation: An aural score by Rainer Wehinger* [Musical score]. Mainz: B. Schott's Söhne.

Maconie, R. (1976). *The works of Karlheinz Stockhausen*. London, UK: Oxford University Press.

Moritz, W. (1997). Restoring the aesthetics of early abstract films. In J. Pilling (Ed.) *A Reader in Animation Studies*. Sydney: John Libbey.

Prévost, E. (2006). *Cornelius Cardew: A reader*. Essex, UK: Copula, Matchless Recordings and Publishing.

Read, H. (1965). Introduction. In H. Richter, *Hans Richter: Autobiographical text by the artist*. Neuchâtel, Switzerland: Éditions Du Griffon.

Richter, H. (1965). My experience with movement in painting and in film. In G. Kepes (Ed.) *The nature and art of motion* (144). New York: George Braziller.

Service, T. (2013). *A guide to Karlheinz Stockhausen's music*. Retrieved from http://www.theguardian.com/music/tomserviceblog/2013/may/07/contemporary-music-guide-karlheinz-stockhausen

The first masterpieces of abstract film: Hans Richter's *Rhythmus 21* (1921) & Viking Eggeling's *Symphonie Diagonale* (1924). *Open Culture* [Website]. Retrieved from http://www.openculture.com/2016/03/masterpieces-of-abstract-film-hans-richters-rhythmus-21-1921-viking-eggelings-symphonie-diagonale-1924.html

The School of Life. (2015). *Philosophy – Ludwig Wittgenstein* [Video file]. Retrieved from: https://www.youtube.com/watch?v=pQ33gAyhg2c

Toop, R. (1999). *György Ligeti*. New York, London: Phaidon Press.

Valcke, J. (2008). *Static films and moving pictures. Montage in avant-garde photography and film [Ph.D. Thesis]*. University of Edinburgh.

Walters, J. L. (1997). Sound, code, image. *Eye Magazine, 7 (26)*, 24–35.

Special thanks to:

Edition Peters Group, 70-30 80th Street Glendale NY 11385, www.edition-peters.com for the excerpts from John Cage's *Aria* and Notations and Cornelius Cardew's *Treatise*.

Stockhausen Foundation for Music, 51515 Kürten, Germany, www.karlheinzstockhausen.org for the excerpt from Karlheinz Stockhausen's *Kontakte*.

All Stockhausen scores, CDs and books can be ordered at www.stockhausen-verlag.com.

Practitioner Perspectives
On Educating Motion Designers

Looking at the careers of the practitioners featured in this collection, it is clear that there are many different possible paths to become a motion designer. It may begin through formal studies in graphic design, filmmaking, photography, illustration, or animation, but it is the synthesis of abilities that lead to becoming a motion designer of accomplishment. The practice involves the mastery of tools, the ability to think conceptually about time-based narratives while integrating a multitude of forms and dimensions such as movement, sound, imagery, video, and text. But, as you peel back these layers of complexity, motion design is still centered on problem solving and communication.

Here we have collected reflections on education and advice to students from our contributors who share the benefit of their experience. Their words of encouragement are aimed at students and teachers alike. They all show a vested interest in contributing to the dialogue of teaching and provide environments for learning in their own practices. They establish for us an optimistic outlook that focuses on maintaining balance between ideation, skill building, process, communication, and collaboration.

Kyle Cooper, Prologue Films

It's important for students to develop a fundamental ability to solve problems conceptually, a fundamental understanding of typography, the ability to create something beautiful, and the ability communicate things emotionally, especially if you're working in sequential media. But I still favor someone who has refined their skills in one specific area. That could be typography or color or drawing or maybe a particular software package. I know people want to embrace the liberal arts attitude and not just teach software programs, but we always have to have *somebody* in the studio who is a master at Adobe Illustrator, or After Effects, or Maya.

I love people that have big ideas and can communicate their big ideas in writing, or with reference material, or with really beautiful Photoshop or hand drawn storyboards. It all depends on their aptitude and what they want to do. A lot of corporations now see the success of Apple and see the success of companies that care about design. But, as Paul Rand used to say, design is design. So if you tell me that the future is going to be this particular software or this particular method of delivery of motion graphics, or 3D or VR, I still believe the same problem solving and design skills apply. There are more things available to us and more situations that we can design for, but I'm always going to go back to trying to have an idea first. *What's the idea? What's the point I'm trying to make? What's the story I'm trying to tell? What do I want to make you feel?*

My biggest advice to students is to not listen to the negative voices in your head or the naysayers that in my experience have been pretty prevalent. Don't be discouraged. Don't listen to people that say it's impossible. *Whatever your hand finds to do, do it with all your might*, which is a biblical quote that just means identify what your role is and no matter what the job is, work hard and do the best that you can. I know that's a generic piece of advice, but I'm

from New England, and I sometimes listen to New England Patriots Coach Bill Belichick who tells players "do your job." The do your job mentality is to do the best you can at what it is that you and your teachers have determined are your strengths. And sometimes you'll need outside encouragement to find out what you're really good at. And then work really hard to bring it out.

Bob Greenberg was pretty good with me in the sense that he continually challenged me to take on new things. So, when I would begin to feel like I was getting pretty good at editing, he would ask me to try shooting something. So over 8 years I was introduced to a range of skills that involved directing live action, editing, storyboard development, and supervising animation. You want to keep trying to get more creative arrows in your quiver. Be open to building on the foundation of one skill that you've perfected.

But, I have a soft spot for students that care about typography and can make something beautiful. In a pinch, if you need to have a concept and make it look good and you can make nice storyboard frames, it doesn't matter to me if you know how to use Maya or After Effects. I can always get somebody to animate your storyboards. We're trying to sell the idea so I'll never discourage anybody from refining their visual sensibilities.

Read more from Kyle Cooper on page 200.

Daniel Alenquer, *Playerium*

I would offer three main points for students to consider. The first is about learning the technical tools. The second is about improving the skills that allow you to work and collaborate with other people. And the third is about understanding theoretical frameworks.

First, learning the tools is a very important aspect of designing motion. Having ideas is great, but if we can't make our ideas a reality, they're useless. It's extremely important that students learn the technical aspects of motion design that will enable them to materialize their dreams and visions. I've seen many excellent ideas that never came to fruition because of a lack of technical know-how. This means both digital tools and physical tools—doing experiments with objects or different artifacts. Learning how to use the tools is what will enable you to actually bring your ideas to life.

But don't waste time in college learning those tools. Do it at night. Do it on weekends. Practice at home. I think college is a space where you should learn the *framework*. You should learn the *principles* behind things and challenge yourself intellectually.

The second point is to realize that work rarely happens in isolation, especially in game design. For example, one of our clients, Capcom (a Japanese game developer) released a game in January 2017 called *Resident Evil* for PlayStation Virtual Reality. This is a game that was first created almost 20 years ago and they've sold around 80 million copies. Hundreds of people are involved in a project like this and, more often than not, thousands of people are involved in the process for creating a console game.

People working in design have become more and more specialized. There are 3D artists, technical artists, programmers, concept artists. We all have to work together in order to make things happen and the final product relies on good communication between everyone who's involved. Communication is vital with this much collaboration and being in college is a great way to practice those skills. The better the students can communicate, the more likely they'll be able to be successful.

Finally, the theoretical frameworks. It's important to use your time in school as a space to experiment, as a space in the time to understand the *principles* behind what's happening. For motion design, I think you learn as much as you can to understand how people react to different types of motion. Experiment with and test how to construct and build types of motion to communicate certain concepts.

Explore and test these concepts and ideas as much as you can while you're a student, because by the time you start working, often there's not enough time to reflect. It happens in longer cycles. It might take you a year or more to reflect back on the work you've done and the impact that it has, but in school, the short, small experiments allow you to learn faster and move faster because the objective of the experiment is different. School gives you enough freedom to explore, experiment and really *understand* the principles behind motion. That's something that should be treasured.

There has to be a bridge between academia and industry—they complement each other and there should be a close connection. The way to go about that is, from my perspective, to develop projects together—projects that allow students to work directly with professionals, with practitioners.

Project work is the best way to learn for both parties because both need to learn. When you're in professional practice and you're working on products, maybe games or interfaces or movies, there is a different set of problems and objectives than the ones you have in school. The major goal as a student is to learn new things, to figure out new solutions for problems that we face everyday. When you're in industry, for as much as you want to learn and grow, a lot of your time is invested in getting the product right, in getting that solution to fit a certain target audience, based on the needs of your client.

Because these objectives are different but equally important, academia and the industry have to have a constant exchange of information, of thoughts, of theories, of solutions—really sitting side by side and working together.

That exposure is important for students—to get feedback from people that are in the industry—but it's important for people in the industry to get that feedback from students as well. Sometimes there is a generation gap. Sometimes there is a mindset gap. The gap is great because when you get together you get to see things from someone else's perspective and that's where learning comes from on both sides.

I've been involved in these types of academic-industry projects—collaborations between schools and companies in Brazil and collaborations with the National

University of Singapore and Singapore Polytechnic in Singapore. These projects were great opportunities because, from the industry side, we wanted to understand how students solve problems. Students have more time and energy to experiment, so it's a great way to generate ideas for new ways of doing things and new solutions.

This doesn't apply only to motion design, but really every area. I think it's important to have that collaboration between the industry and academia and to do it in a way that students and practitioners can sit side by side, exchange information, and give each other feedback.

Read more from Daniel Alenquer on page 127.

Karin Fong, Imaginery Forces

What I always say to students is study and really hone the craft. I have such a high value of both concept and craftsmanship. I jokingly say, but it's not really a joke, "If it doesn't look good still, it won't look good moving" because I think a lot of people get seduced by motion. It's a very seductive thing. Like my mentor, Kyle Cooper would always say, "Make every frame a poster"—and it's kind of true!

You'll see students who have done beautiful print based typography with attention to detail, and for some reason when they get to their motion piece there's typography that they would have never set for a book, or a composition that would never fly for a poster, or photography that isn't properly lit. I don't know if it's because they're rushing to put it all into the motion piece, but all of those things matter. Beautiful type matters, beautiful composition matters, proper lighting matters. My goodness, it matters that you have a script and a story that you believe is worth telling. Maybe there's a feeling that if it's moving people don't notice, but I think it's all something to pay attention to. When I look at reels or portfolios, I like to see that attention to craft and detail and pride in the work.

I also think writing is really important. As I have traveled through my career, I realize that presenting an idea is extremely important, whether you're in front of people in a room or you're sending it as a written treatment. When you're shooting something, often you have to describe it in writing because it doesn't exist yet. So if you want to really make your ideas sing you do have to sell them in some way so writing becomes very important.

Valuing interdisciplinarity

Another thing I do wish for students (and for myself)—it's that you shouldn't only look to motion design or design in general as your inspiration. I mean, looking around at all types of disciplines is extremely valuable.

One thing I do regret is that I never took sculpture in school—because sculpture provides an understanding of three dimensions. And it is a time-based art, because, like architecture, you can't experience the sculpture in one frame or one moment. You have to walk around it or experience it as a dimensional thing. And by being in dimension it is time-based.

And so, looking at sculpture, architecture, photography—not just looking at references that pertain directly to this business is really valuable. There is so much [motion design] available, and strikingly good quality too, like film and television, and broadcast, and animation. These are wonderful things, but I do think getting outside of that and traveling and looking at other art forms and reading is all going to help you bring new ideas to your art.

Read more from Karin Fong on page 220.

Guy Wolstenholme and Jon Hewitt, Moving Brands

It's a really exciting time to be working in the area of motion design and moving images. We're excited about augmented reality and the VR spaces on the horizon. Those areas feel like they're pulling together all of the things we've been talking about for so long at Moving Brands. Spatial sound, textured elements, movement, color, and the properties of things and how they behave in space.

There has been a lot of emphasis on designing for screens and the rules being defined by the screen and their different ratios. The idea that screens may soon be irrelevant suggest that the rules will be changing and design will be about opening story worlds. People who are doing animation and motion will need to define that space because it's their space to own.

The processes are becoming easier. That is to say, the tools are becoming easier to use or more accessible. We believe that students should have an understanding of 3D packages and compositing software that allows you to bring many elements together.

I think students should also explore the area of game engines. We've noticed that some of the textural things that are happening are based on the game engine world, where you're texturing something for a game engine. The game engine can do all of the hard work, where actually you're giving the texture the correct properties, whether that's a metallic thing or a shiny-gloss thing or whatever it is. Once you've given it the right properties, the engine is actually visualizing things real time on the GPU [graphics processing unit]. This is interesting in the work flow sense because you're no longer texturing for a specific output. You're just giving the thing the right properties and then it will just live in whatever world it needs to live.

Another point of advice comes from Finnish architect Eero Saarinen, who talked about always designing for the next largest context. So, when you're designing a chair, think of the room that it's situated in. When you're designing a room, think of the house. When you're designing a house, think of the town that it sits within. You should always think about that next largest context. We see young graduates who are very focused from the outset on motion design tools. For us, it gets interesting when you think about the context in which piece of motion work is seen.

We can see an example of this through the genius of Charles and Ray Eames in the work they did for the New York World's Fair in the mid-60s. They were

using film to communicate these very complicated ideas about IBM and the shifting trajectory of technology. They designed this amazing multi-screen experience from start to finish and motion was an integral part of it. They considered not only the film itself, but the seating of the viewer and the choreography of these non-standard screen sizes all working together to tell the story in a really beautiful way. So always take a step back and think about how a piece of motion is going to be experienced, how's it going to be seen, and in what context.

The last piece of advice that we always give to students or young graduates is to expand their points of reference. If you're only looking at other animators or other motion designers, then your world of reference gets very small. Look at architecture, look at biology and science—look for interesting references beyond the world of what's already been produced for animation, film making, and motion design. That's something we're always trying to push towards.

Read more from Moving Brands on page 134.

Isabel Meirelles, author of Design for Information

Similar to other design practices, designing visualizations requires a good grasp of the project's goals and audiences. It is important to carefully match the tasks in the visualization to our audience's needs, expectations, expertise, etc. From gathering and structuring data to encoding and representing information, the visualization process requires ethical considerations. I cannot stress enough the importance of developing critical abilities, and helping our students become critical thinkers in addition to competent designers.

I also find it crucial to learn the fundamentals of cognition and visual perception, that includes understanding perception of motion. As I wrote in the book, information visualization depends upon cognitive processes and visual perception for both its creation (encoding) and its use (decoding). If the decoding process fails, the visualization fails.

It is beneficial to learn basic programming skills so as to be able to visualize larger datasets. With the omnipresent access to large amounts of data, computational techniques have become integral to the burgeoning practice of visualizing data. In addition, there are many opportunities for incorporating motion in interactive visualizations, such as in the cases of devising effective transitions and encodings that are achieved programmatically. I will not recommend a specific language or library, as they change with time. But, I would strongly encourage learning the basics of website coding.

Finally, I would encourage students to keep their eyes and ears open to what happens around them, including our histories and cultures. Simply put: be curious, always!

Read more from Isabel Meirelles on page 276.

Jakob Trollbäck, Trollbäck+Company

Get inspired by other people but try to do something that you haven't seen before—I think that that's a fine piece of advice. But then I realize that since I'm completely self-taught as a designer, I taught myself actually just by imitating other people. I was imitating Jan Tschichold and Josef Muller-Brockmann—trying to be as good as they were.

But I can say this—motion graphics is riddled with trends and I could never stand that. One year, there's this effect where everything is looking a certain way and I feel like it's more important that you find your own stuff. I guess that's because I could never do anything that someone else has done because it would just make me embarrassed. In the same way as we [at Trollbäck+Co] have literally never repeated ourselves. After thousands of projects, some works are clearly related, but we have had clients come to us and say, *can we get something that looks like your other project because we really like that*, and we've said no because we had already done it.

During the learning process, you have to dissect what other people are doing and understand it, but I think that I became good at what I'm doing only because, after having studied and looked at other people, I just spent all of this time with the computer, playing around with it and trying to find something interesting. I think this time spent experimenting is so important.

Then, you have to be very self-critical because it's gratifying to be a creative person, to create something. Especially as a young student, you can fall in love with something that you made just because you've done it. And it's fantastic because in every new project, you give life to something, in a sense, especially if there's something in motion. That's fantastic. But then we also had to look at it and ask, *am I adding something? Is this something new or is this something that has a particular feeling?* I think that there are two kinds of students—some are just so incredibly happy with everything that they're doing and others are are disappointed in everything they're doing. I think that the people who are disappointed in the end are going to be better designers.

When it comes to hiring, I look for someone who has work that feels unique. I hire people who were good at typography and seem to have good ideas. I'm not going to hire someone who's not good at typography. I'll hire a 3D animator or something, but if they're a designer, they have to be good at typography. I see some work from someone that I can see has done nice illustrations and maybe even nice animations, but, for me, it's much more about the typography. Have you figured out something new to do with it? And then, it's got to be someone who is working really, really, really hard because otherwise, you're not going to cut it. You're wasting everybody's time if you're not working hard. You're wasting your own time.

Obviously, educators need to be up to date with what's happening in the profession, but I still think that it's more about just having those kids work their butts off and teaching them about different aspects of the profession. And just be badass teachers. Tell the students that there's a tremendous need for good people in this field but there's not enough of them.

I would hire five people tomorrow if I could find five great people. Even if we don't have business for five more people tomorrow, I would make business for them because if they're tremendous, they're going to bring in business.

Read more from Jakob Trollbäck on page 158.

Index

McMurtrie, Douglas C. 90

Megert, Peter VI, XVI

Meirelles, Isabel XIX, 276, 317

Ménard, Nicolas 214–217

metaphor XVI, 36, 57, 60, 66–68, 70, 76, 81, 85–88, 97, 144, 164, 166, 171, 202, 223, 237

metonymy 68–70, 81, 85–87

Metz, Christian 48, 53

Microsoft 169, 172, 175, 178

MIT Media Lab 59

Mock, Rebecca 211–212

Moholy-Nagy, László 46, 125

Moholy-Nagy, Sibyl 47

montage 40, 53–54, 91, 141, 224, 237, 262, 264–265,

Mooney, Aoife XIX, 182

Moving Brands 134, 316

movie title (see also *film title*) XII, 4, 8, 22, 32, 42, 140, 158, 200, 201, 221

Mucha, Alphonse 205

Muller-Brockmann, Josef 318

multiple intelligences (theory of) 247, 249

Murnieks, Andre XIX, 164

Murray, Janet 58

music notation 293

Muybridge, Eadweard XVI, 39

N

naïve realism 98–99, 102, 106

narrative structure 32, 39, 45–46, 48, 51, 54, 96–97, 99–101, 103–106, 274

narrative theory 48

narrative unit 49, 100

natural language processing (NLP) 164, 174

neue Grafik XVI

New York Times (The) 97, 141, 211–212, 277, 279

non-linear XVIII, 12, 58

Norman, Donald 54

Normoyle, Catherine XIX, 228

O

object relative displacement 118

OCAD University, Ontario College of Art and Design 276

Ohio State University (The) VI

open source 50

Osgood, Adam XIX, 205

P

parallax 207, 289

Pasternack, Matt XIX, 281

Peacock, David XVIII, 139

Peirce, Charles Sanders 53

perceptual learning XIV